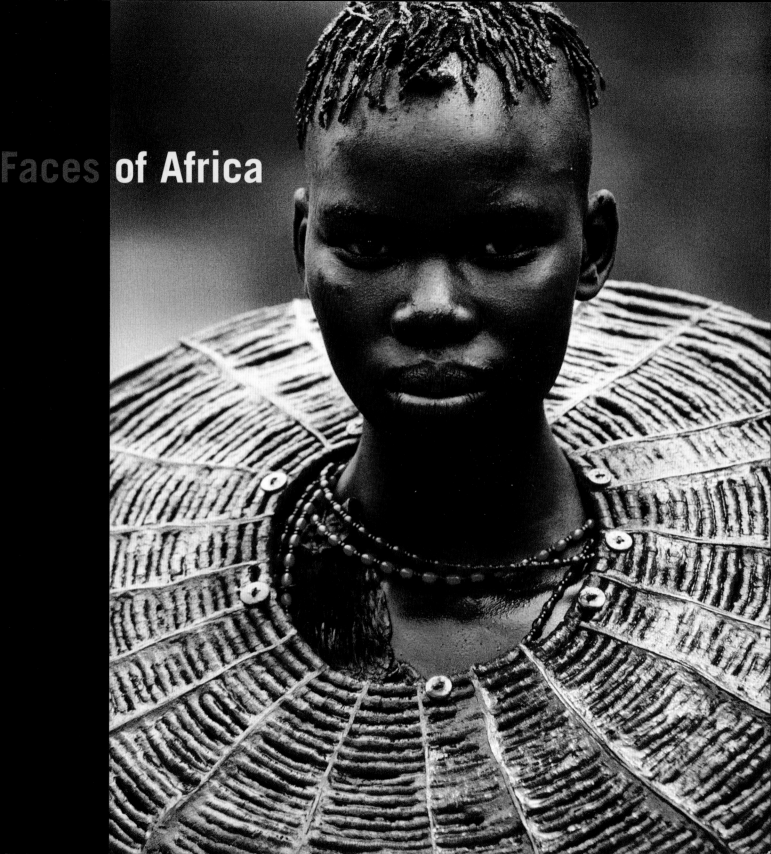

Faces of Africa

CAROL BECKWITH & ANGELA FISHER

Thirty Years of Photography

Faces of Africa

NATIONAL GEOGRAPHIC

WASHINGTON, D.C.

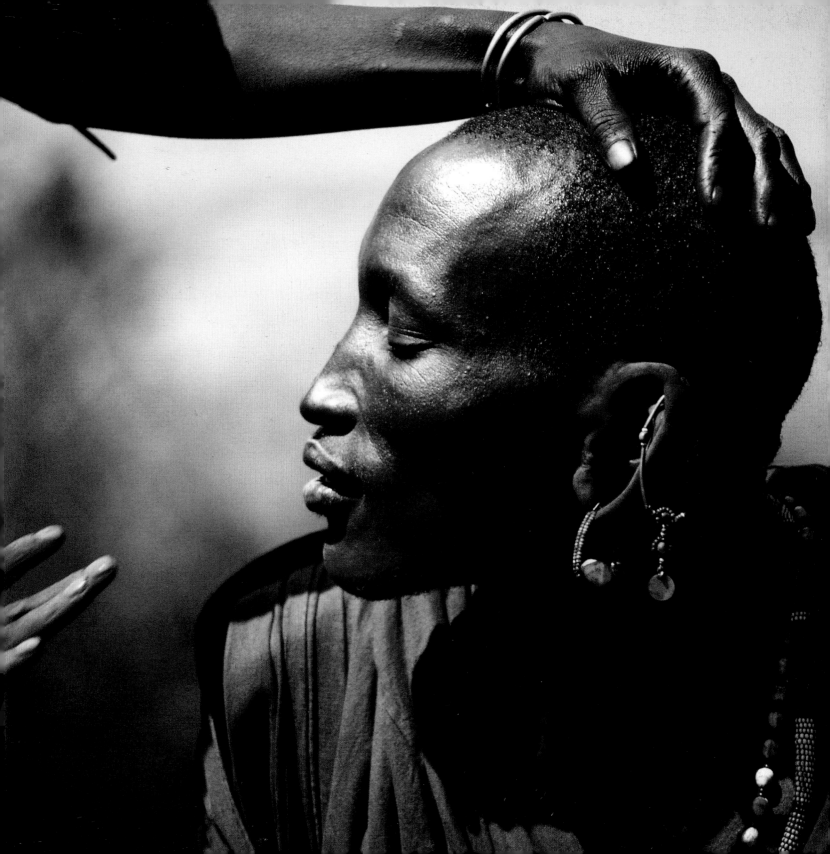

The genesis of *Faces of Africa* took place in the Great Rift Valley of Kenya, where Donald Young, Barney Wan, and Kuki Gallmann gathered to explore with us the underlying themes that define traditional African life. With unflagging energy and dedication, Donald Young went on to work with us in Nairobi and later in London, helping us to develop visual themes and craft our chapter introductions. Donald's understanding of traditional African life, after 30 years in Africa as an historian and safari guide, coupled with his belief in our work, has made him an invaluable partner in the creation of *Faces of Africa*. We thank him for his immense contribution to our book and his enduring friendship and support over the years.

We also wish to express our deepest gratitude to Karel Nel for exploring and expanding our definition of portraiture. Karel has been one of our greatest mentors, sources of inspiration, and guiding lights during our many years of work in Africa, challenging us always to take one step further.

Two extraordinary young women, Hilary Hurt and Petra Fitzgerald, have dedicated hundreds of hours to bring *Faces of Africa* to life. They have honed and perfected their skills—from design to text—with undying energy and enthusiasm, often keeping us going through weekends and into the wee hours of the night. Born in Kenya, and coming from the generation following ours, they have been able to bring fresh eyes and inspired perception, as well as knowledge of technology, into our lives. We thank them for their immeasurable contribution and special friendship.

Melanie Doherty came to us from San Francisco to create the design for the book and in the process charmed us with her sensitive eye, her open "Buddhist" spirit, and her untiring ability to work long hours—sharing our excitement over the material.

Lisa Lytton, our talented editor, has been encouraging, supportive, and unflagging in her belief in our work. She has helped us realize our vision and revealed a remarkable talent for making the impossible possible.

At National Geographic we thank Nina Hoffman, president of the Book Division, for her support in publishing our work; Marianne Koszorus for her sensitive eye in design and helpful advice, and Becky Lescaze for her expert editing of our text.

In London we express our deepest gratitude to Maria Alexander for 20 years of managing our studio and to Chad Hall for keeping the home fires burning with dedication. For their editorial review of text and design, we thank Barney Wan, Eve Arnold, Chad Hall, and Yorick Blumenfeld.

We thank our families in America and Australia—Leo and Marylyn Beckwith and Simon Fisher—for a lifetime of support and love.

But most important, this book would not have been possible without the unstinting generosity, loyalty, and friendship of our many African friends from every corner of the continent. For their willingness to open their worlds to us in a trusting, openhearted way, we give them our most heartfelt thanks.

ACKNOWLEDGMENTS

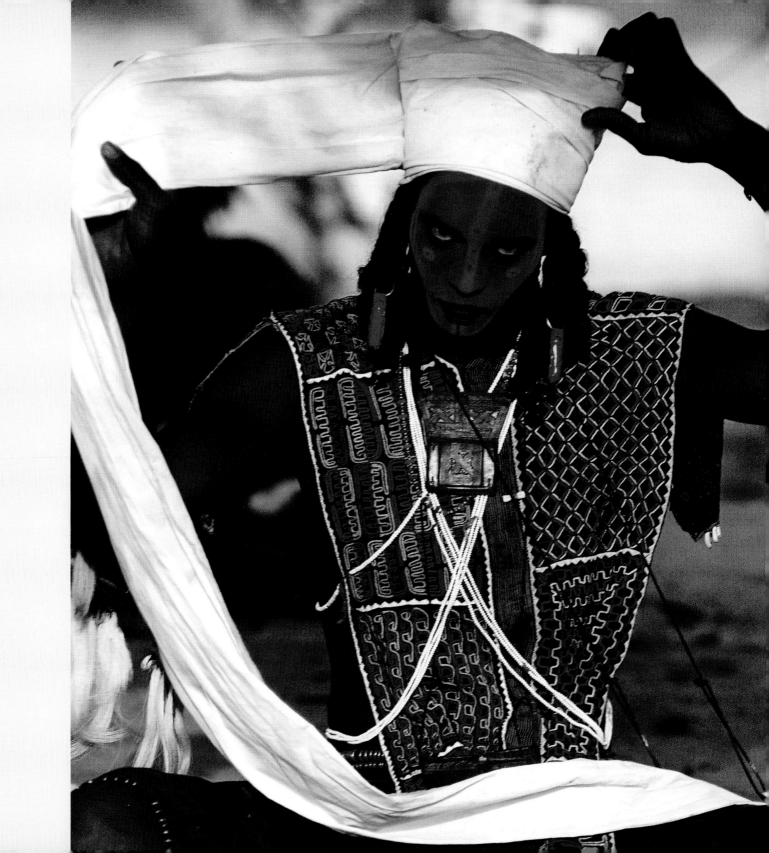

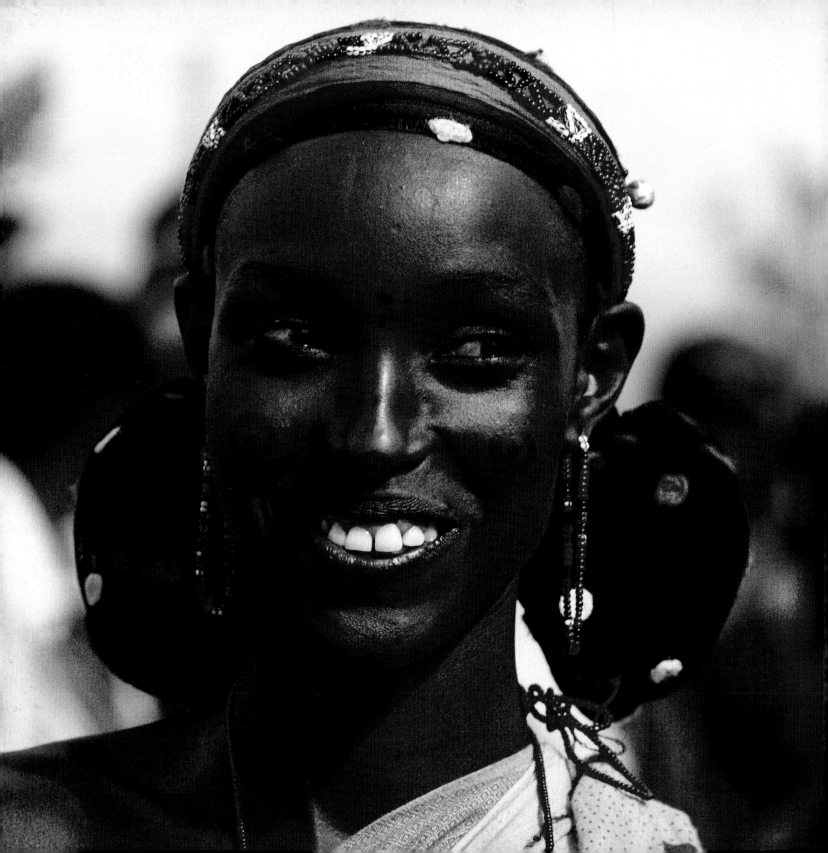

Koru
ETHIOPIA

A young woman's
face expresses her joy
at meeting her friends
at the weekly market.

CONTENTS

THIRTY YEARS AGO, WE BEGAN A RELATIONSHIP WITH THE AFRICAN CONTINENT THAT would profoundly alter and shape our lives. Our journeys would take us over 270,000 miles, through remote corners of 36 countries, and to more than 150 African cultures. We would experience an extraordinary diversity of cultures, lifestyles, and belief systems, which would make us look differently at our own lives. Each time we return to Africa, its people continue to inspire and energize us.

Faces of Africa reflects our personal interpretation of the themes that we feel are common to traditional African cultures. Our photography goes beyond classic portraiture to embrace the poetry of nuance, gesture, hints of presence, and the unique stamp of an individual in time and place. From "On Becoming" to "Returning to the Ancestors," our book encompasses the full cycle of African life.

We believe it is important to tell the stories behind news headlines, which often overlook unique cultures that have been in existence for thousands of years. From Africa we have learned the value of rites of passage, which define what is required of a person at each stage of life. We have been touched by the wisdom of elders and inspired by belief systems that keep people in harmony with their natural environment, their spirituality, and their communities. To have photographed so many traditional cultures of Africa has been a privilege and an honor.

Although many customs are in transition today, we believe the bedrock of tradition in African societies is still a powerful and unifying force—and one to be celebrated. A tradition we most esteem is the African concept of reciprocity: the belief that anything given must be returned with added value. It is our hope that through our photographs we might give back a small part of what Africa has given to us, and through our documentation help preserve its rich heritage not only for future generations of Africans, but for the world at large.

CAROL BECKWITH & ANGELA FISHER

WODAABE

NIGER

Inyé casts a seductive glance at the young nomad girls attending the Geerewol festival.

INTRODUCTION

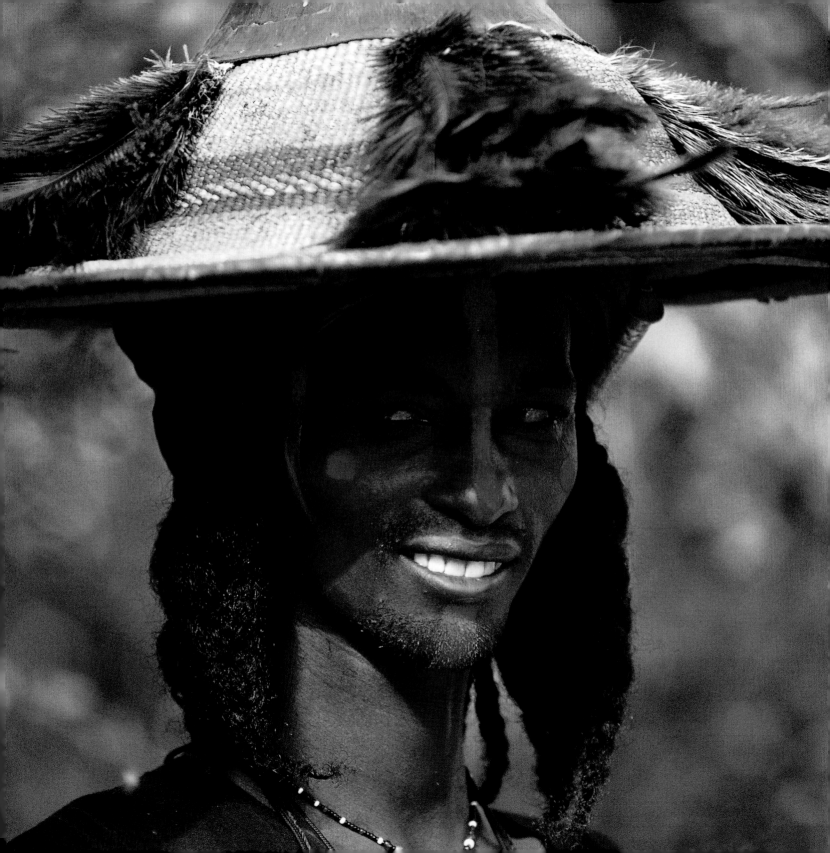

AFRICA'S DIVERSE TERRAIN ranges from equitorial forests to ancient deserts and from mountain strongholds to savanna grasslands. To reach the distant corners of the continent we traveled by mule train, camel caravan, dugout canoe and Land Cruiser. We came to realize that the challenge of survival in these difficult environments has forged the strength and indomitable spirit of the African character.

Preceding pages:

POKOT

KENYA

Page 1: A young girl wears a necklace of beads cut from the stem of an asparagus tree.

MASAI

KENYA

Page 2/3: Naikosiai is painted with ochre for his role as best man at the marriage of a friend.

WODAABE

NIGER

Page 5: Morodo wraps a 12-foot turban around his head and lightens his face with a yellow powder for the Yaake male charm dance.

1. Rashaida	18. Pokot	35. Ga
2. Beja	19. Masai	36. Fante
3. Afar	20. Swahili	37. Ashanti
4. Kotu	21. Barabaig	38. Kassena
5. Falasha	22. Ndebele	39. Lobi
6. Amhara	23. Pedi	40. Krobo
7. Surma	24. Zulu	41. Adioukrou
8. Karo	25. Himba	42. Senufo
9. Geleb	26. Ngbende	43. Bobo
10. Bodi	27. Kirdi	44. Fulani
11. Hamar	28. Tuareg	45. Bozo
12. Konso	29. Wodaabe	46. Dogon
13. Oromo	30. Hausa	47. Songhai
14. Nuer	31. Yoruba	48. Bella
15. Dinka	32. Taneka	49. Bassari
16. Somali	33. Somba	50. Berber
17. Luo	34. Ewe	51. Hassania

MAP OF AFRICAN CULTURES
INCLUDED IN *FACES OF AFRICA*

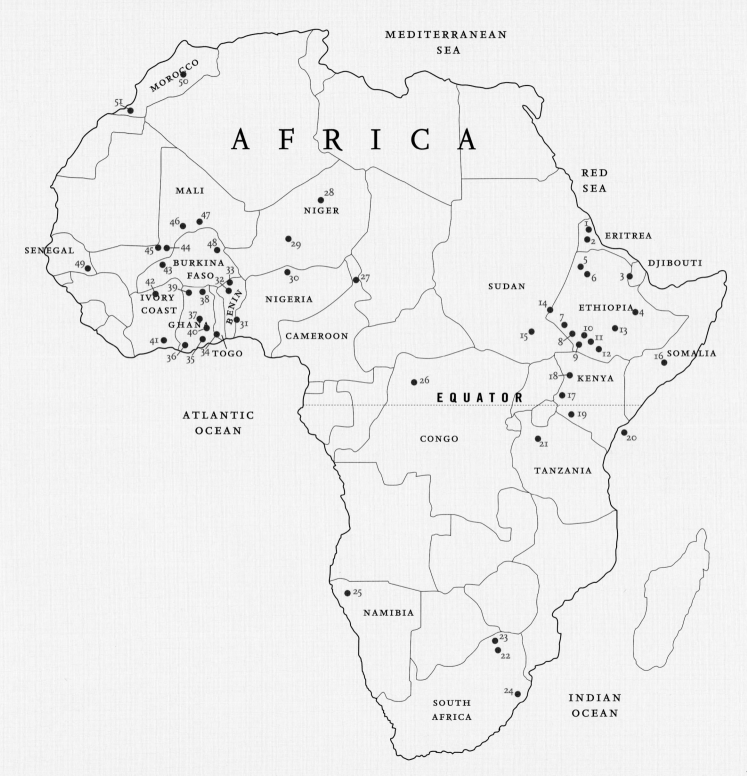

MEDITERRANEAN
SEA

AFRICA

RED
SEA

MOROCCO
50

51

MALI

28
NIGER

46 47

SENEGAL

45 44
49 43 48
BURKINA
FASO 33
42 39 32
IVORY 38
COAST 37 BENIN
GHANA 40 31
41
36 35 34 TOGO

29

30

27

NIGERIA

CAMEROON

1
2 ERITREA

5
6 3 DJIBOUTI

SUDAN

14 ETHIOPIA
7 4
15 10 13
8 11
9 12
16 SOMALIA

26

EQUATOR

18 KENYA
17

19

ATLANTIC
OCEAN

CONGO

20

21

TANZANIA

25

NAMIBIA

23
22

24

SOUTH
AFRICA

INDIAN
OCEAN

A NEWBORN BABY CRIES AND ANOTHER AFRICAN JOURNEY BEGINS. Minutes after she emerges from the womb, we watch a Kassena baby from Ghana undergo her first ritual in what will be a lifetime of rituals. On another day, on the other side of Africa, a Masai man bows his head as his mother cuts the long braided hair that had proclaimed his status as a senior warrior. We see tears stream down his face as he symbolically ends one chapter of his life and begins another as a mature man.

Africa is a continent of rituals: a land where the process of "becoming" is celebrated at every stage of life as an essential part of the journey of the individual and the identity of the culture. In Krobo society in Ghana, young girls are taken at puberty and trained for three weeks by their ritual teachers to be model wives and mothers. Among the Bassari of Senegal, young male initiates undergo a ritual "re-birthing" in the sacred forest to prepare them for manhood. These rites of passage are examples of the importance African societies place on teaching the role an individual plays in the community.

In Africa the place of every man, woman, and child is defined within the framework of the extended family, age grade, ethnic group, and nation. These roles in turn give individuals a sense of belonging and purpose, and the sure knowledge that they are valued, qualities that we feel have been lost in the Western world. In our 30 years of travel in Africa, we have come to admire how African traditional cultures define the parameters of a person's life and provide a guiding light for his or her journey.

KASSENA

GHANA

A baby's first bath with cold water serves as both a ritual awakening and a way to stimulate circulation.

ON BECOMING

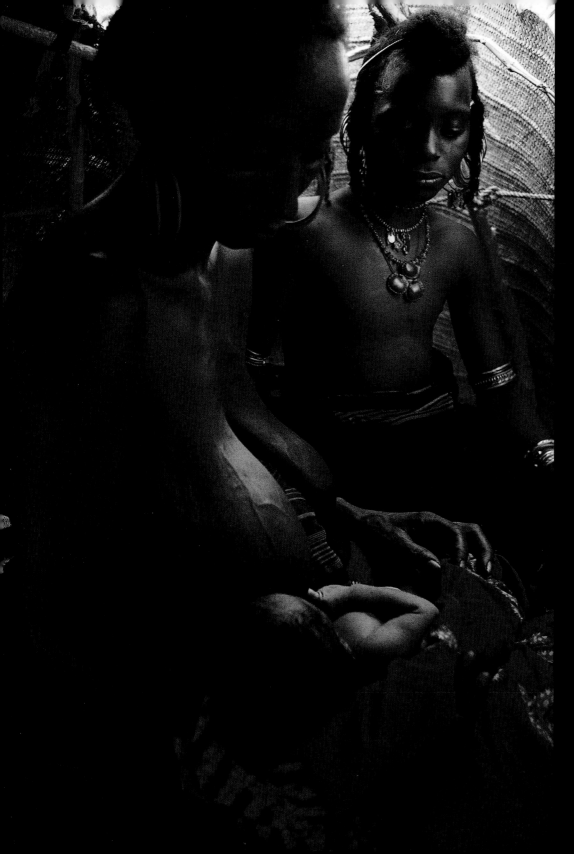

WODAABE

NIGER

Magogo nurses her newborn
daughter while Shai looks on. The
child will receive a ritual baby name
when she is three days old. If she
survives to age 12 (not always a cer-
tainty in the harsh desert climate),
she will be given her adult name.

WODAABE

NIGER

Mowa plays with her granddaughter
Hadijah. A Wodaabe mother may
never address her firstborn directly
by its name, a protection from
its possible loss in a world where
infant mortality is high.

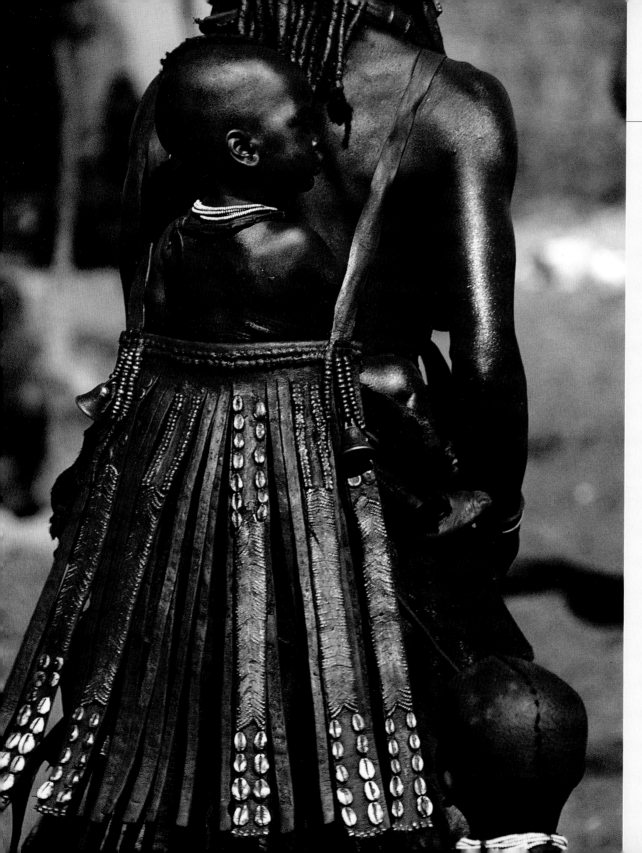

A mother carries her baby
in a back sling made of
leather and cowry shells.
The Himba believe a baby
left alone may be taken
by evil spirits.

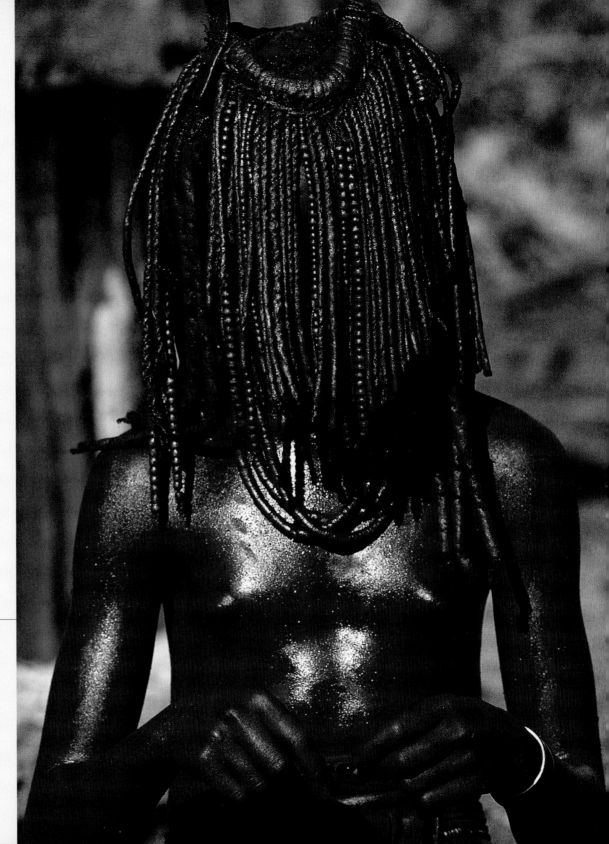

HIMBA

NAMIBIA

A young girl wears a face veil
of beads and twisted cord,
covered with ochre and
animal fat. This veil indicates
that she is in transition—
"No longer a girl,
but not yet a woman."

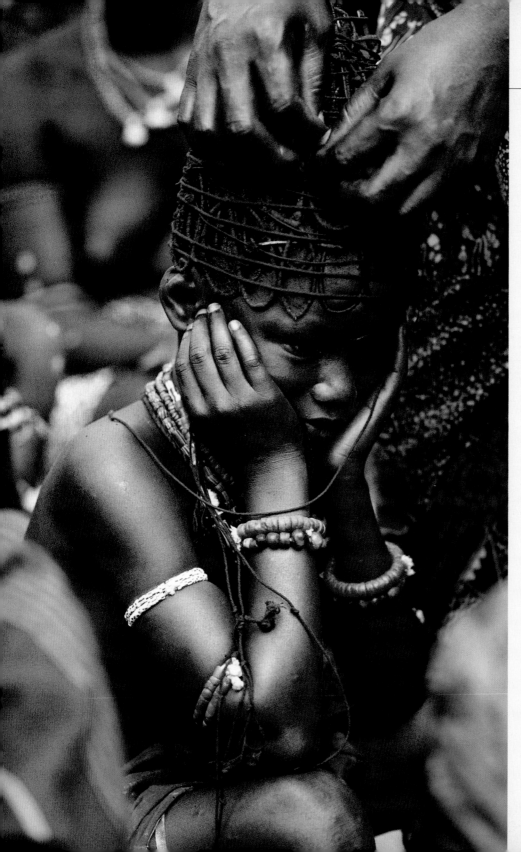

Krobo

GHANA

A special headdress made of bent cane covered with charcoal and oil is fashioned on the head of a young Krobo girl to signify that her virginity has been established and she is now ready to continue her initiation into womanhood.

Bassari

SENEGAL

Before Bassari boys can be taught the knowledge of manhood, they must first be regressed to infancy—where they literally crawl on the ground and need to be fed. Having "erased" their childhood identity, elders in the sacred forest will teach them what they need to know to be reborn into men.

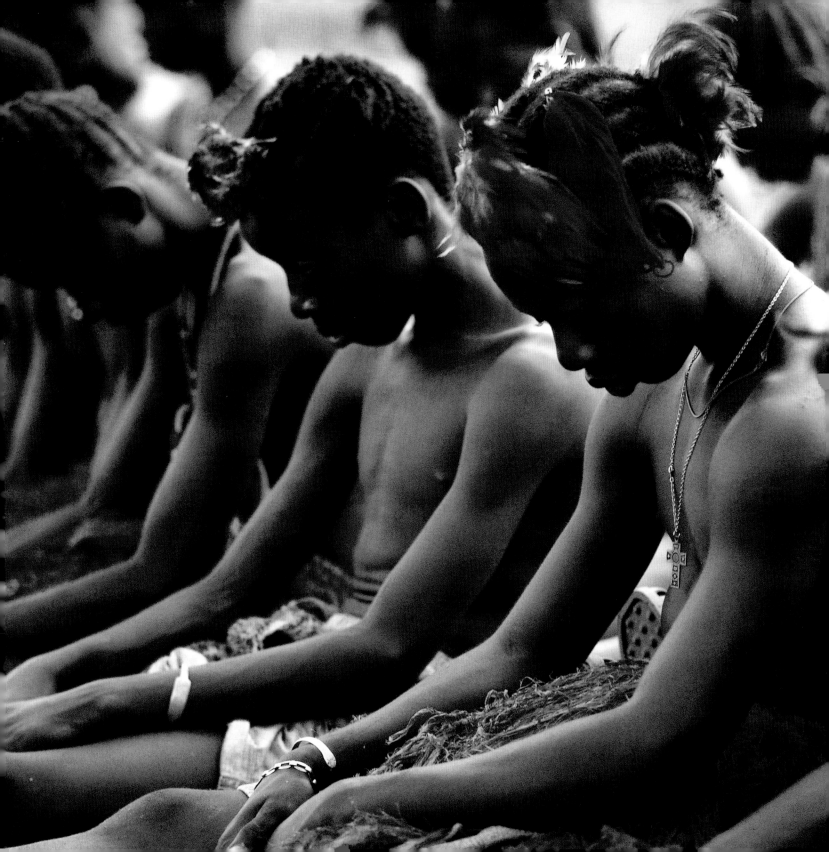

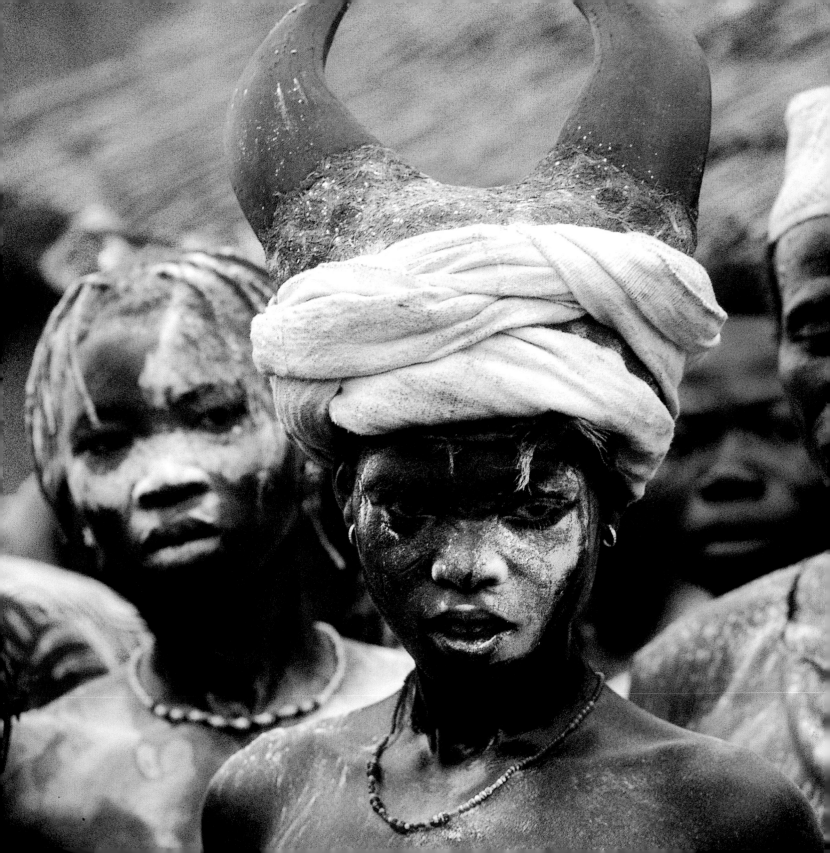

TANEKA
BENIN

Following her older brother's circumcision, his sister wears his sacred cow-horn head-dress. In doing so, she announces to the village her brother's transition into manhood. The white powder on her face symbolizes her link to the spirit world.

MASAI
KENYA

As a rite of passage, an initiate who has not cried out during his circumcision at age 18 is allowed to shoot colorful birds with his bow and arrow and create a headdress announcing his new status as a warrior.

To enter manhood, a Hamar
initiate must jump across the backs
of up to 40 bulls held tightly
together in a line. Proof that he has
achieved this amazing feat are the
fresh oil on his body and the look
of quiet triumph on his face.

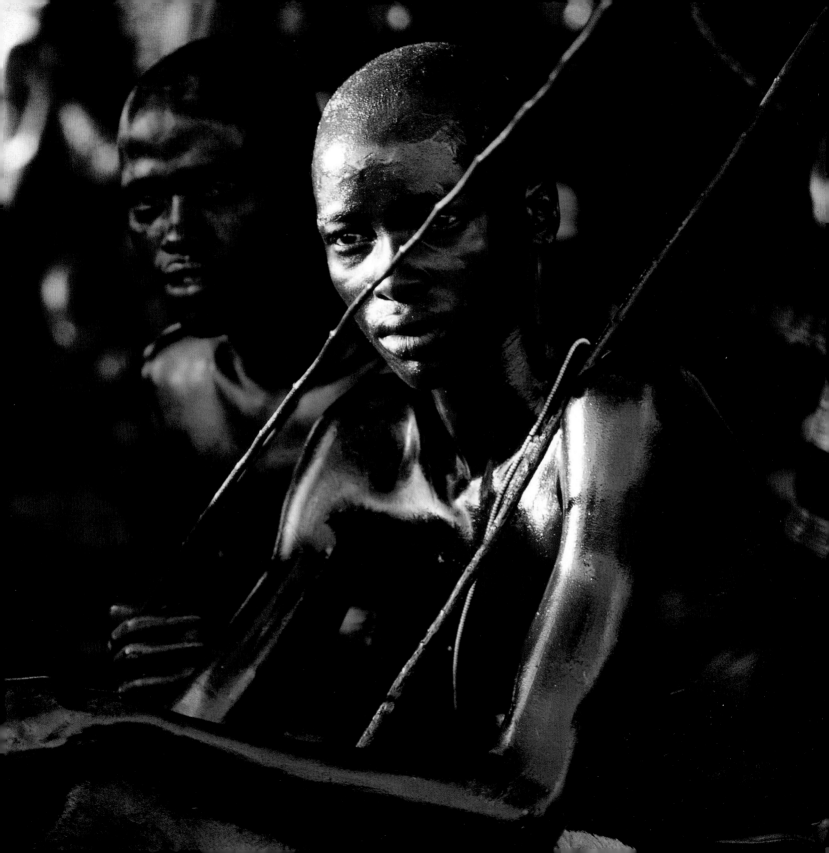

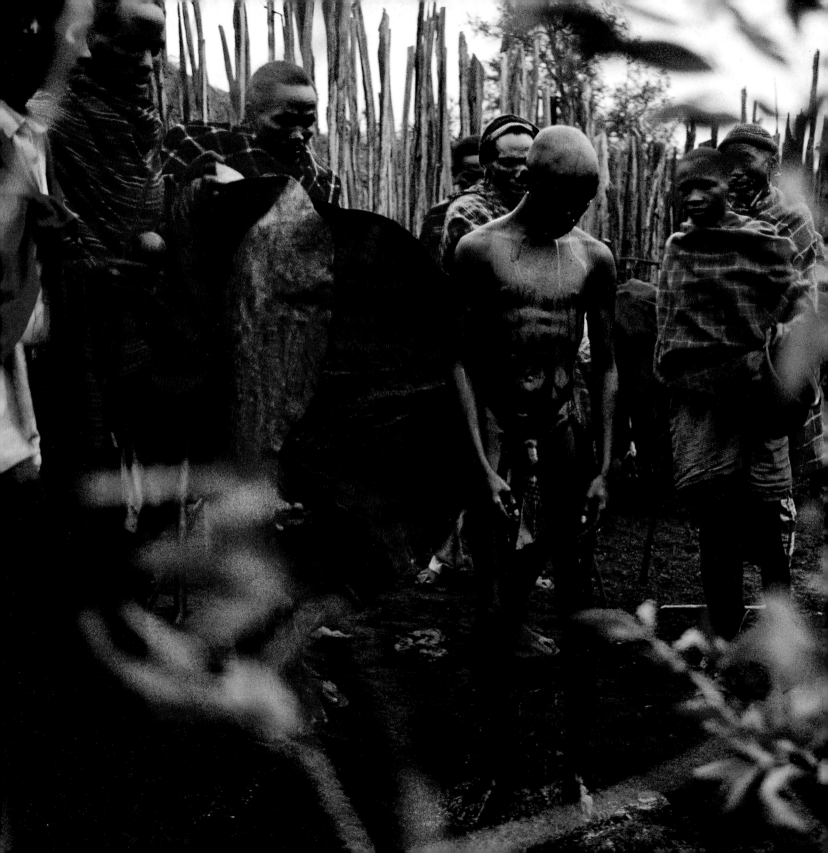

MASAI
KENYA

A Masai male awaits circumcision
at the entrance of the cattle kraal.
His body has been washed with
cold water kept overnight in a
bucket containing an axe head to
numb his senses. He will be seated
on the hide held up behind him.
Should he cry out in pain during
the operation, he will be deemed
a coward and will bear this shame
for the rest of his life.

No Masai woman has ever wit-
nessed this ceremony. We were
privileged to be invited to record it,
as honorary members of the family
we had known for ten years.

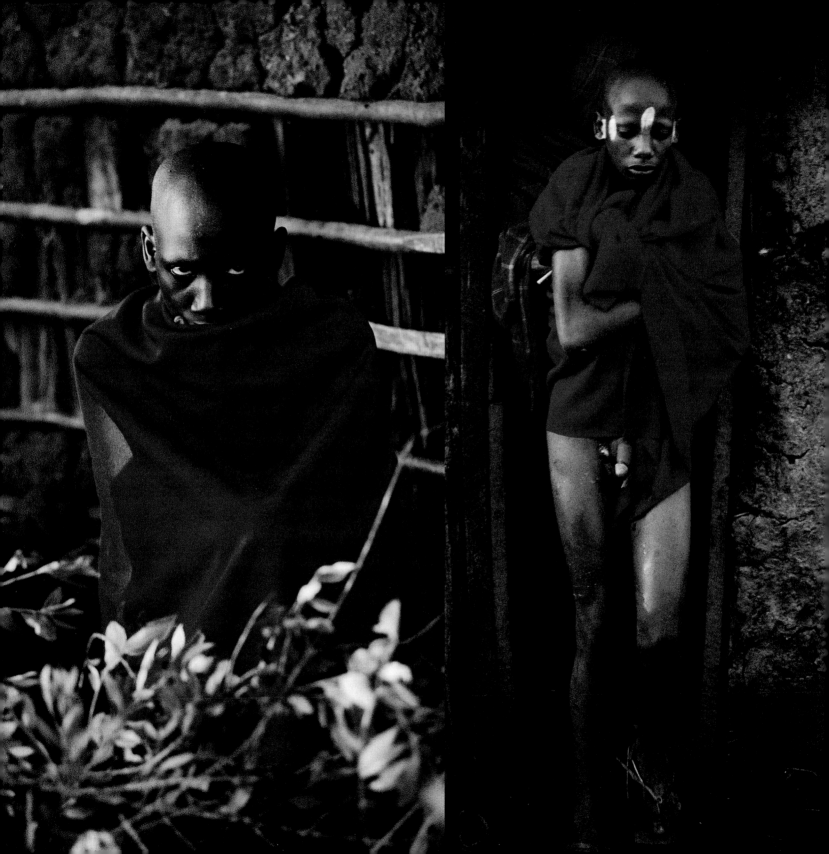

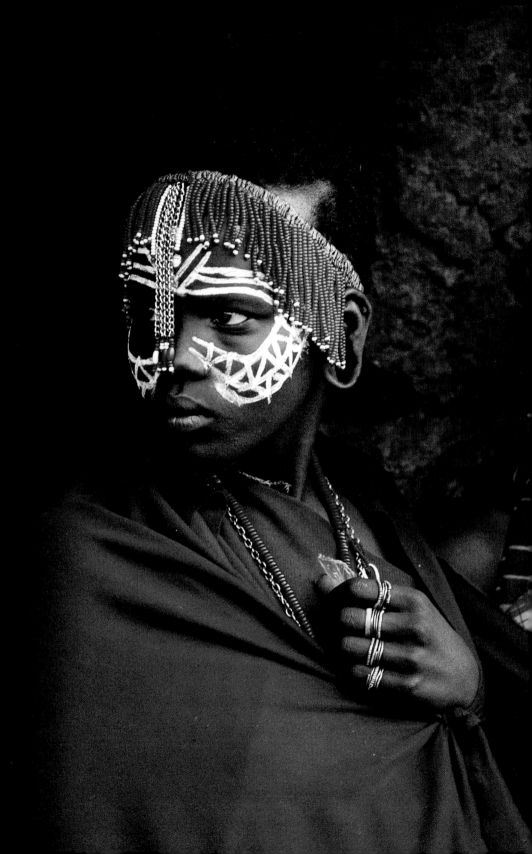

MASAI
KENYA

A boy anxiously awaits his
circumcision (far left), praying he
will have the courage not to cry out.
Following his operation, he is helped
into his mother's hut, where he will
be given fresh cow's blood to rebuild
his strength.

MASAI
KENYA

During the healing period
following her circumcision, a girl
sits at the entrance to her mother's
hut, wearing the jewelry and
chalk make-up of a girl who must
not be seen by men during her
three months of recovery.

Following their circumcision, two
girls wear ritual white face paint
and blackened cowls made of soft
hides covered with charcoal and oil.
They will wear this attire indicating
their untouchable status for a
period of several months culminat-
ing in the Lepan ceremony, at which
they will formally enter womanhood.

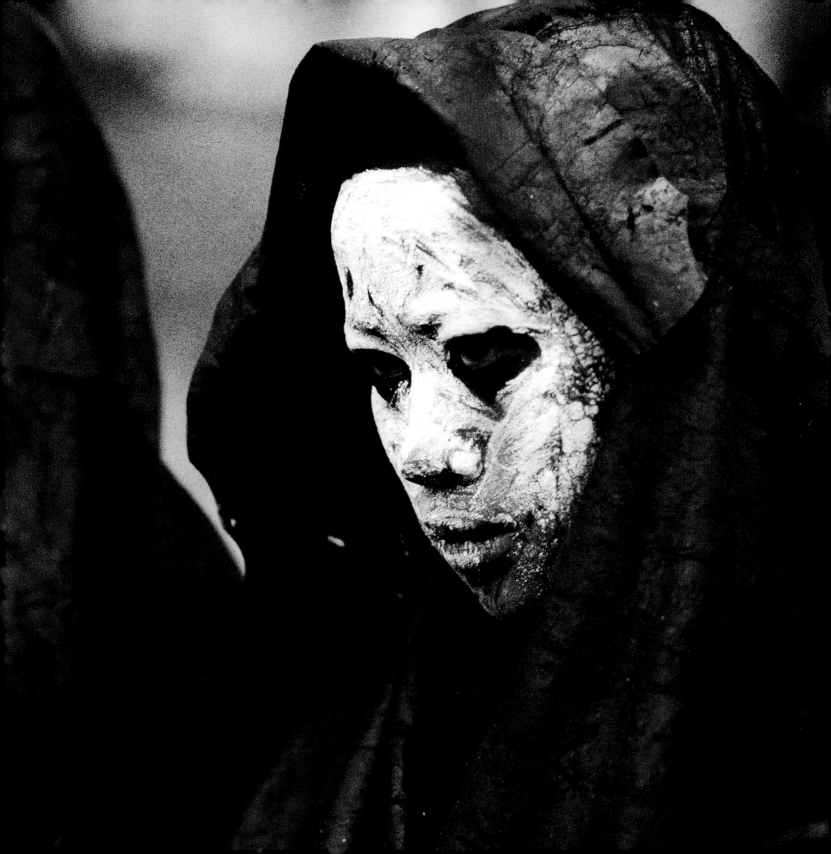

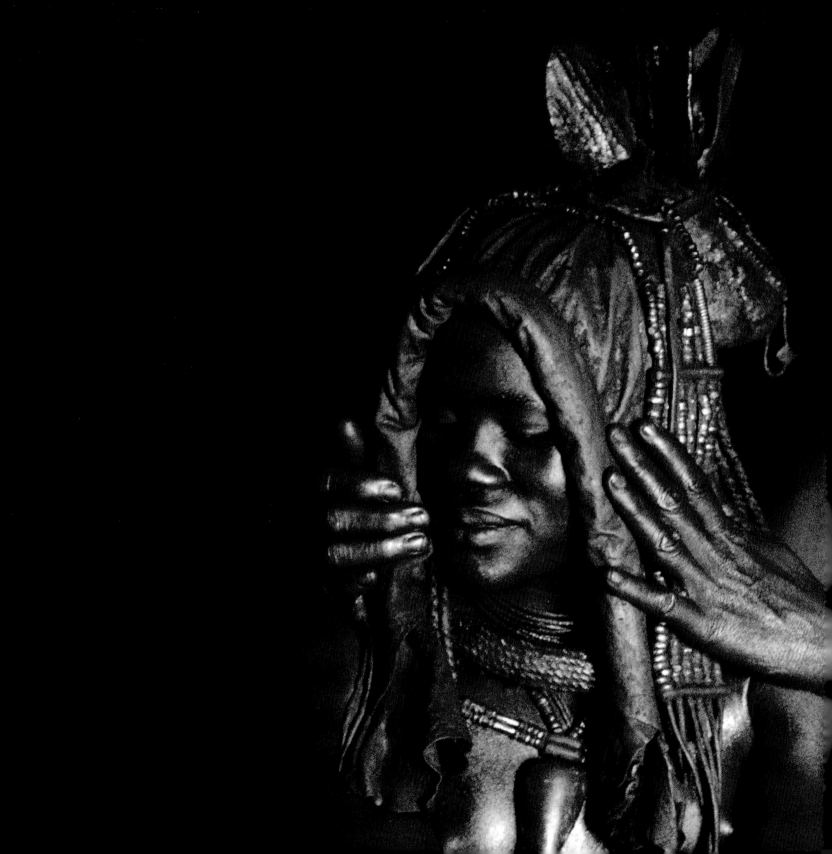

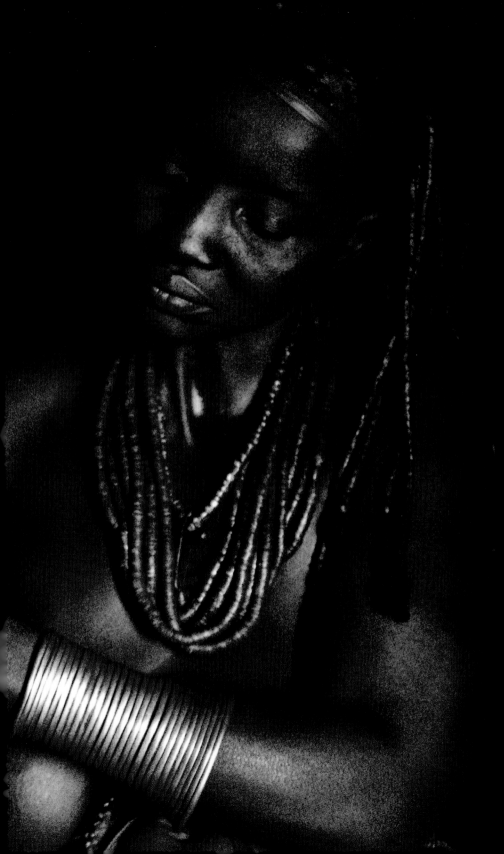

In the darkness of her hut,
we watched a Himba mother
lovingly give her daughter
the treasured Ekori head-
dress, handed down from
generation to generation at
the time of marriage. When
her daughter leaves home
she will roll forward the coil
of hide circling her face so
that she can see only forward.
We were told this prevented
the young bride from feel-
ing the pain of separating
from her family.

31

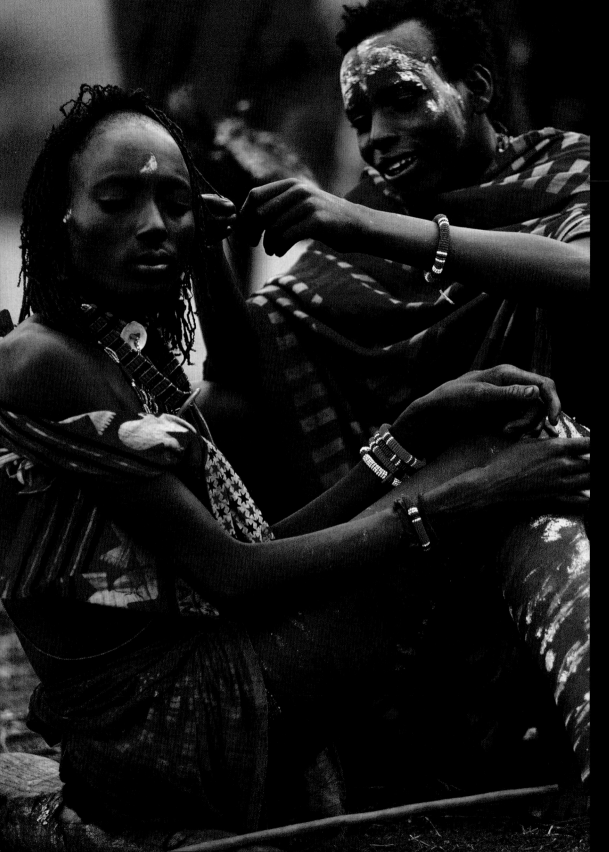

MASAI

KENYA

A warrior's hair is carefully tressed and covered with ochre and animal fat in preparation for the four-day graduation ceremony, during which he will become a junior elder.

MASAI

KENYA

At the climax of his passage to manhood, a warrior's long hair, symbolic of his status, is shaved off by his mother. His sadness reflects both the end of this peak period of his life and the final bonding with his mother.

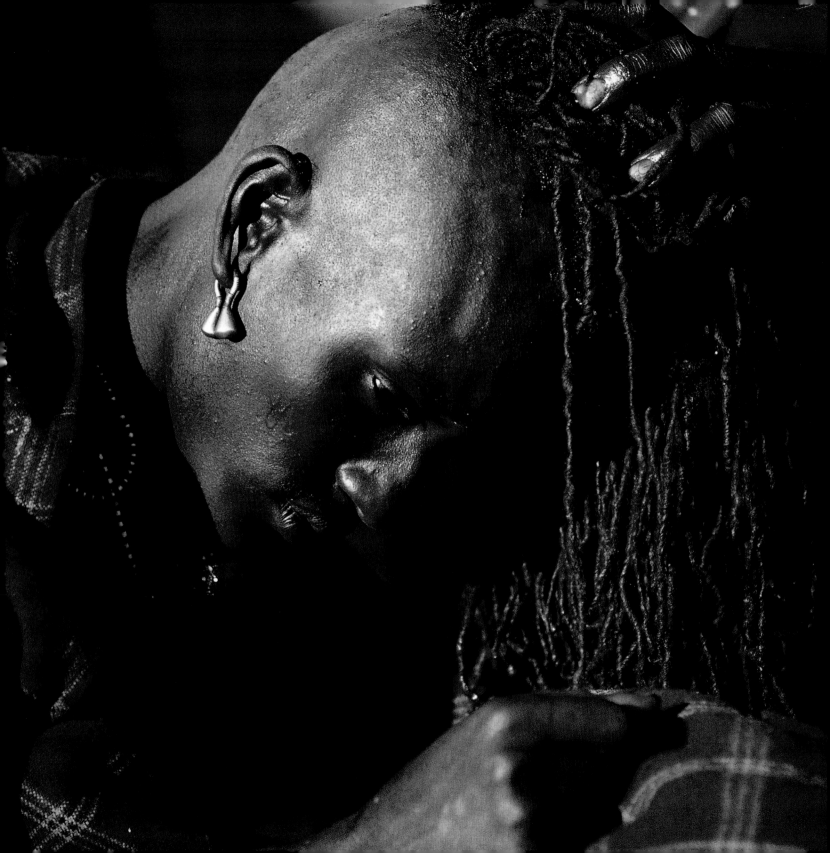

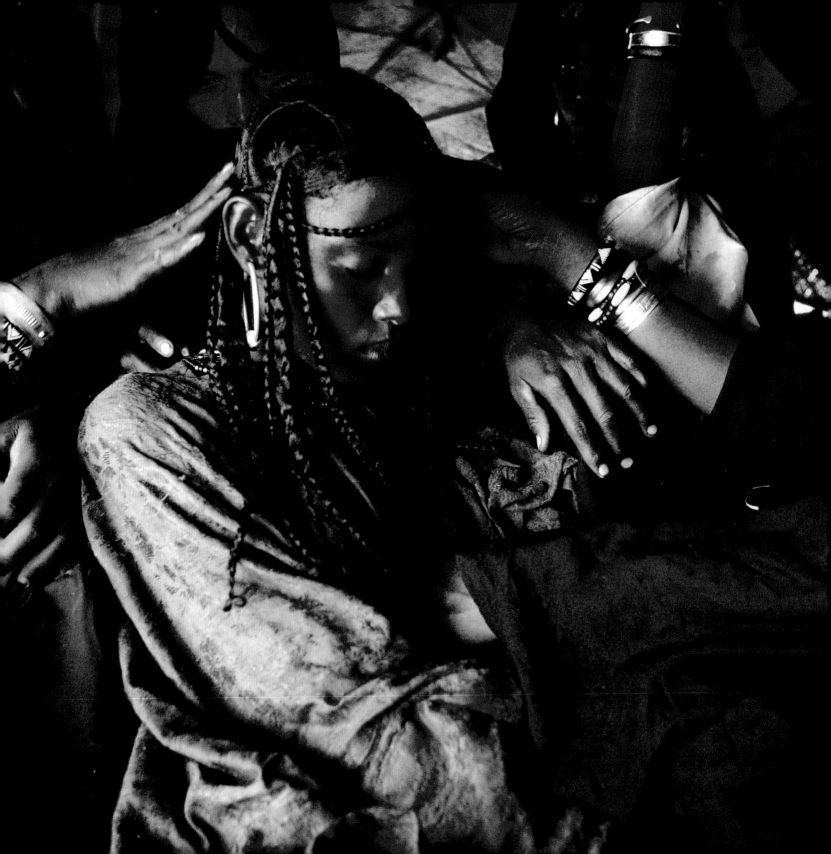

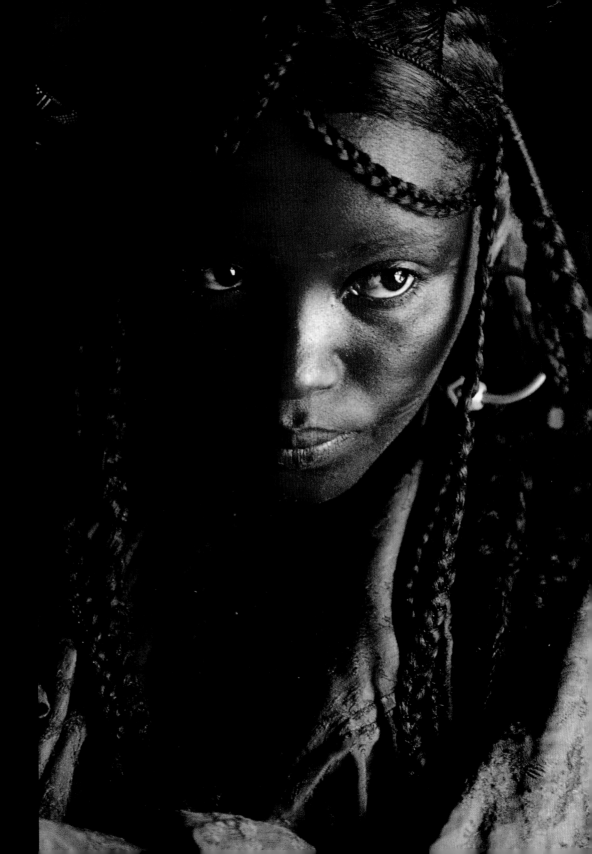

TUAREG
NIGER

Left: On the day of her marriage, Assalama's hair is tressed by the wives of the metalsmiths, who are renowned for their ability to work with fire and considered to hold special ritual powers. Should anyone else prepare the hair of the bride, it is believed that it would soon fall out.

Right: Awaiting the arrival of her husband, Assalama anticipates the first seven nights she will spend with him in a specially built nuptial hut.

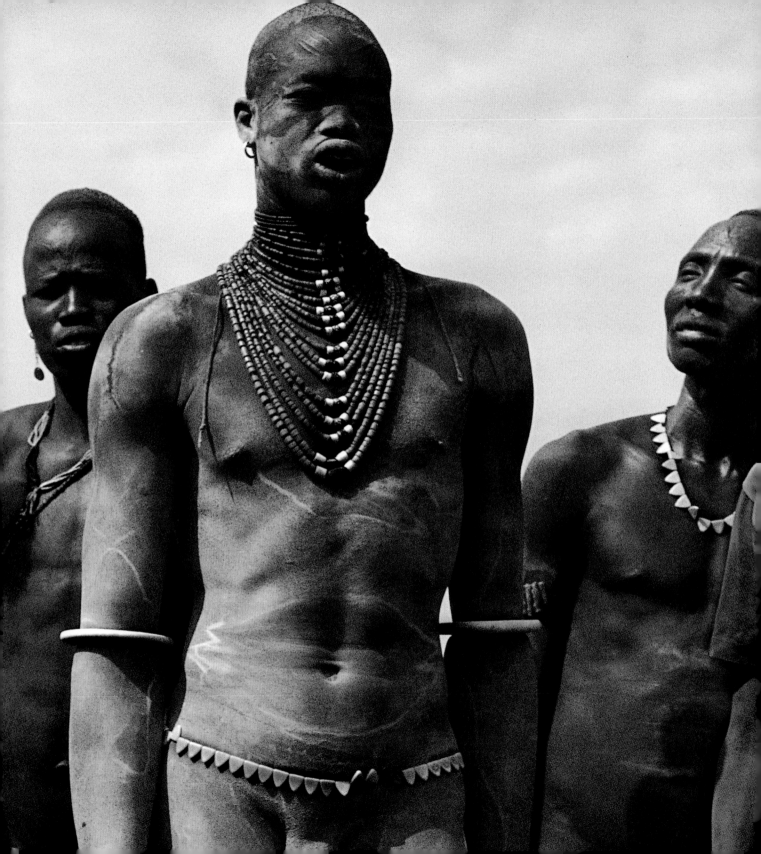

FIFTEEN STURDY MULES LOADED WITH SUPPLIES FOR SIX WEEKS CARRIED US ALONG ROCKY TRAILS over 10,000-foot mountain ridges and through thick forests teeming with black-and-white Colobus monkeys. Hornbills flew over our heads, their haunting calls breaking the silence of the forest.

To visit the Surma, in an unmapped, remote region of southwest Ethiopia, we travelled as the explorers did: on foot and by mule. Having arrived at our destination, we spent the next six weeks walking up to 30 miles a day in search of Surma ceremonies. We lived as the Surma did: sleeping on the ground, washing in cold streams, and eating from a communal pot.

We could tell many stories about our adventures, but we rarely comment on the often challenging conditions of our travels, for one simple reason: Time after time, the African people have demonstrated how they not only survive the planet's harshest climates, but draw their identity and strength—their powerful sense of being—from their surroundings.

This ability to transform adversity into inspiration, coupled with the sure knowledge of their role in their community, gives individuals the sense of place and strength of being that are foundations of African traditional societies. We have seen how even in the most challenging terrain, African men and women live their lives with an innate sense of dignity, enduring strength, and quiet pride.

DINKA

SUDAN

A seven-foot-tall
herder, covered
with white ash, belongs
to the clan who call
themselves moniyang—
the men of men.

SENSE OF PLACE
STRENGTH OF BEING

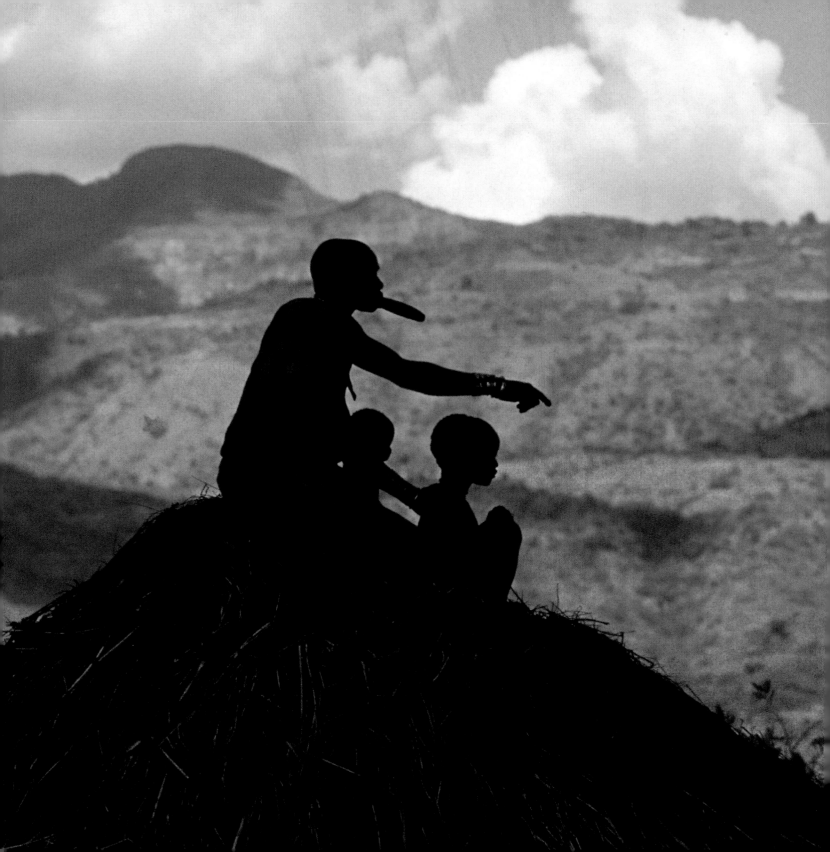

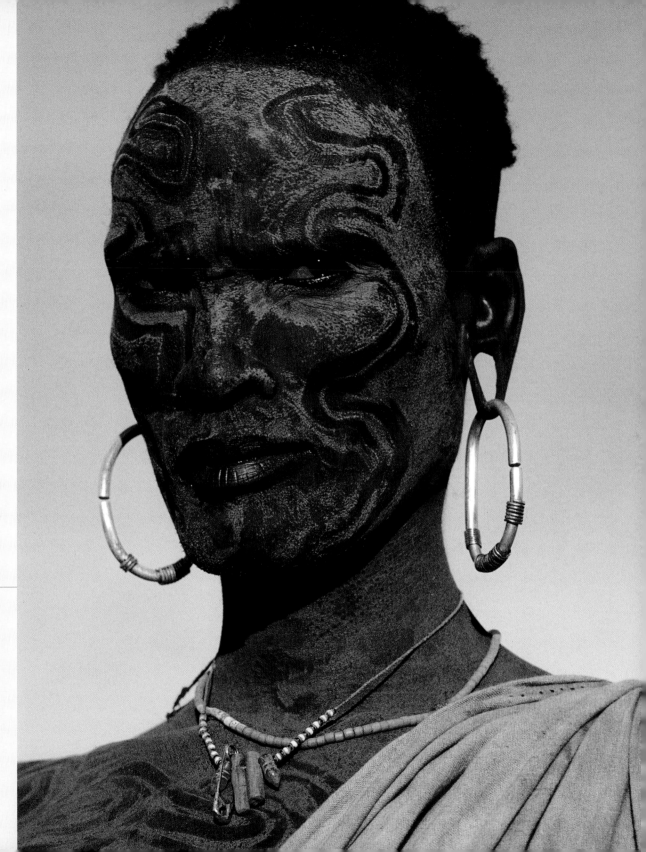

S U R M A

ETHIOPIA

Mountain peaks fram-
ing the Kormu Valley
define Natunya's world.
Here, she sits on the
thatched roof of her
hut with her children.

S U R M A

ETHIOPIA

Muradit, a fierce and
renowned Surma stick
fighter, paints his face
with white chalk to
intimidate his enemies at
the Donga stick fights.
He will fight to prove
his masculinity and
to win a wife.

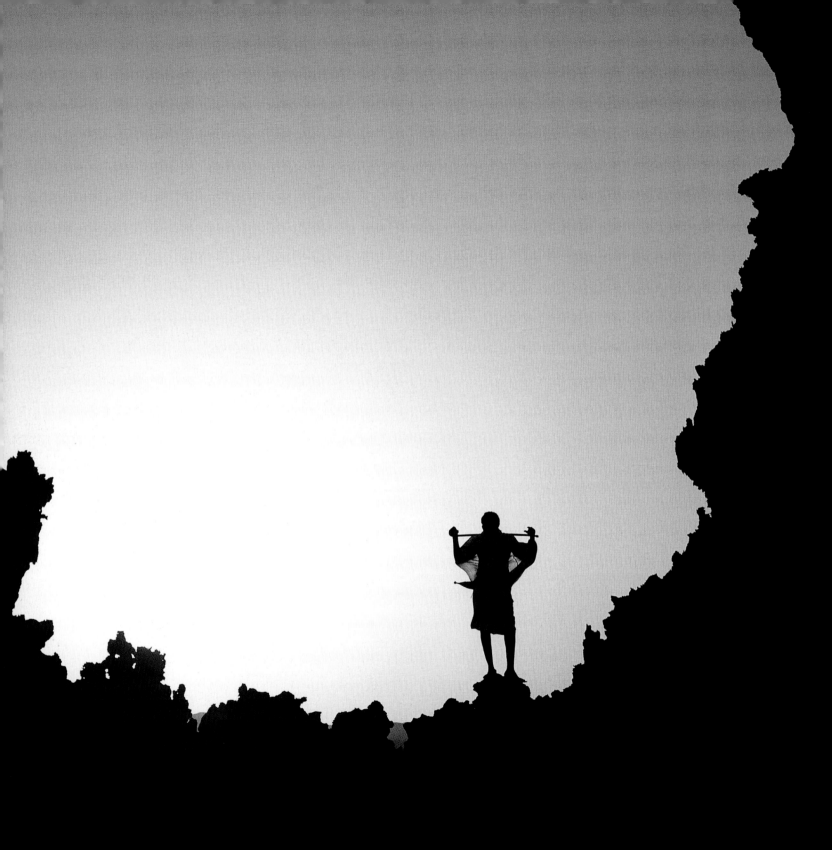

A nomad from the Danakil Depression survives in one of the most inhospitable environments in the world, where daily temperatures rise to over 135°F. This landscape of craggy rock and searing wind presents a daily challenge for survival, but also defines the character of the Afar people.

WE FOUND OURSELVES IN ONE OF THE MOST HOSTILE CORNERS OF AFAR COUNTRY, NEAR LAKE ABBE. Our Land Rover broke down as we sank deep into the soft sand. We imagined ourselves in a lunar landscape, a white-and-grey world not unlike what the astronauts saw when they first landed on the moon. Surrounding us, the soaring cliff wall was razor-edged and composed of dark, forbidding lava. This is the entry in our journal of January 21, 1988, written with our friend and author Graham Hancock (imagining ourselves as early explorers and this our last message to the outside world):

"Here we are in one of the most inhospitable environments known to man. Human life struggles but fails to survive here. The Awash River dies within 10 km of where we now sit, frustrated in its effort to reach the sea. Drained of our vigour by the merciless midday sun, we await our uncertain fate. Ahead of us we see the razor-edged shapes of an alien landscape shimmering in the intense heat haze. We think of leaving on foot; we may be gone for some time, distances are hard to judge. We believe a nine-hour walk of 45 km lies ahead. What else is there to do but try?"

With a dignified presence, a
Tuareg nomad maneuvers his way
to the well through a herd of long-
horned Zebu cattle. For ten months
of the year not a drop of rain falls
in this parched Sahelian landscape.
Survival is at stake and
stamina tested

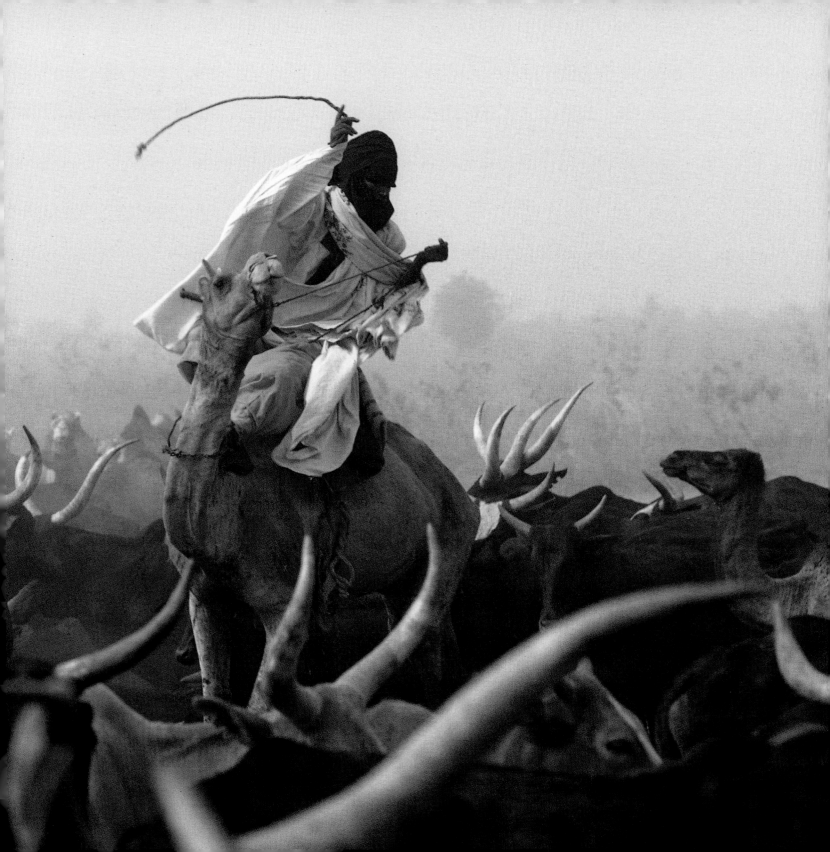

IN THE COURSE OF FOUR YEARS OF RECORDING CEREMONIES IN ETHIOPIA, we had never succeeded in convincing one of our guides to take us into the Danakil Depression to visit the Afar nomads. Every single Ethiopian male we approached feared these fierce desert warriors armed with sharp traditional swords and known for killing their enemies.

From the writings of early travelers, we learned that in order to marry an Afar girl, a warrior must present her with the testicles of his enemy.

It took us a long time to assure our Ethiopian guide, Zewge, that this was a tradition of the past, no longer in practice. Throughout our fieldwork, Zewge's terror was palpable, and he started to relax only when he returned to Addis Ababa one month later with all his body parts intact!

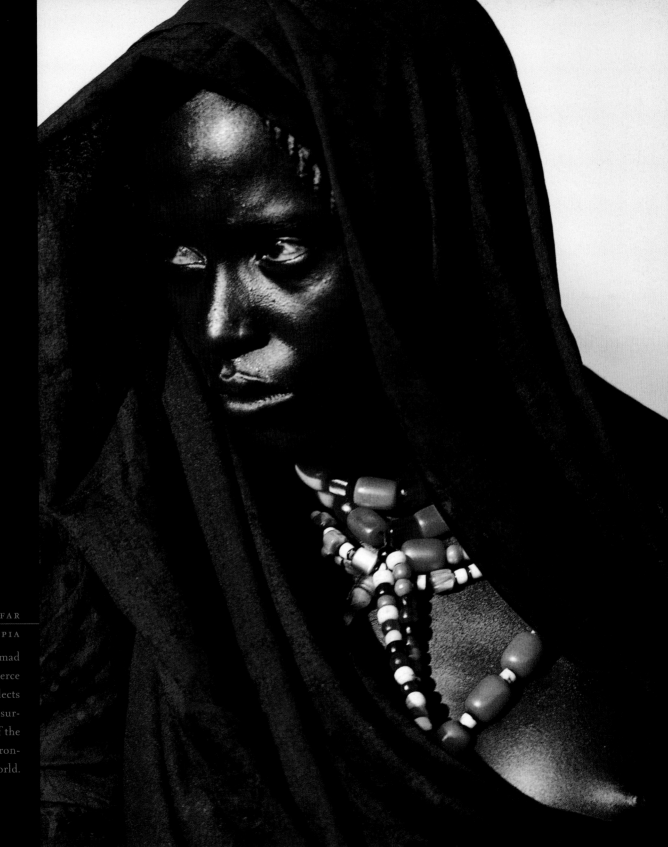

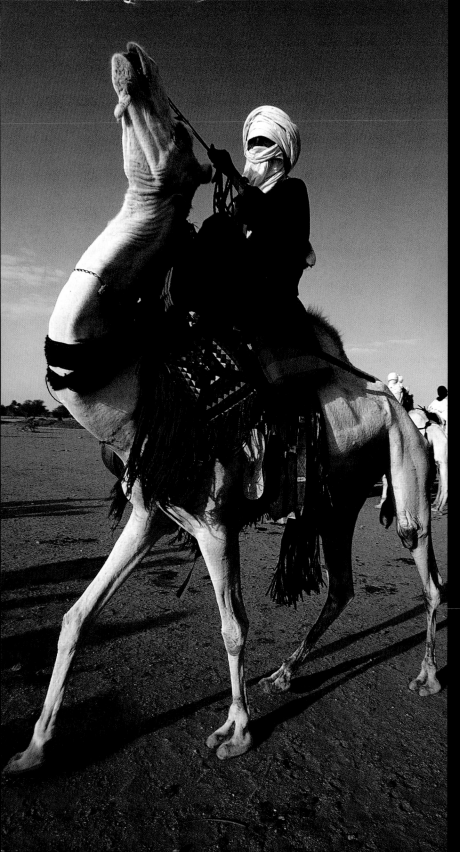

Right: An elder wrapped in a 12-
foot-long indigo turban studded
with protective silver amulets
fulfills his role as guardian of the
Emir of Katsina during the
annual Sallah festival.

TUAREG
NIGER

A nomad proudly shows off
the beauty of his camel, whose
elegant, stately pace reflects the
high status of his owner. Known
as aristocrats of the desert, the
Tuareg are great camel caravanners,
renowned for their navigation
of the Sahara.

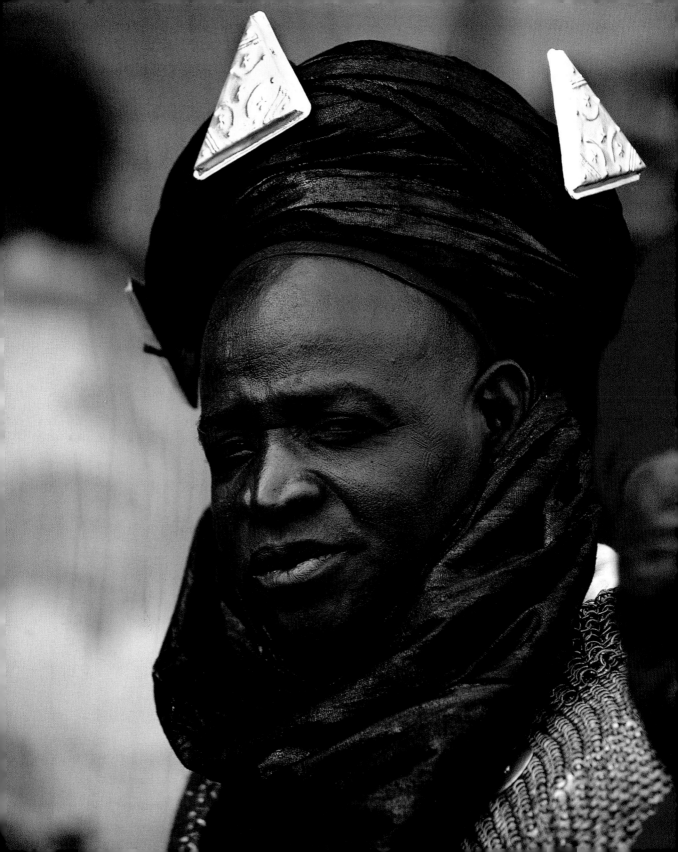

WE DROVE DAY AND NIGHT, NAVIGATING OUR WAY THROUGH DRY RIVERBEDS STREWN WITH BOULDERS to attend the annual gathering of the followers of Sheikh Hussein in the remote Bale Mountains of southern Ethiopia. Arriving at the break of dawn, we joined thousands of pilgrims, some of whom had walked for as long as six months to celebrate the wonders of this 13th-century mystic saint.

Each afternoon devotees would gather beside the mosque of Sheikh Hussein to chant phrases honoring the much-revered saint. The chant leader would call out a verse and then point his staff at the audience, who called the last words of the chorus. Under the leadership of the man in the photograph, the chanting built to such a crescendo that many people in the crowd fell into ecstatic states of worship.

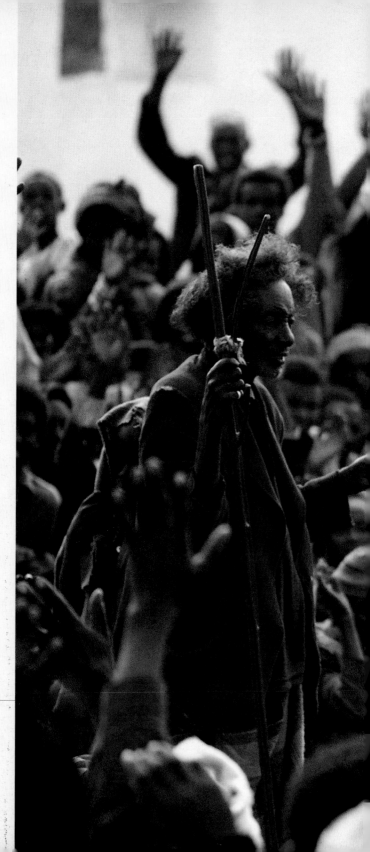

OROMO

ETHIOPIA

A pilgrim initiates call and response chanting at the annual Sheikh Hussein gathering.

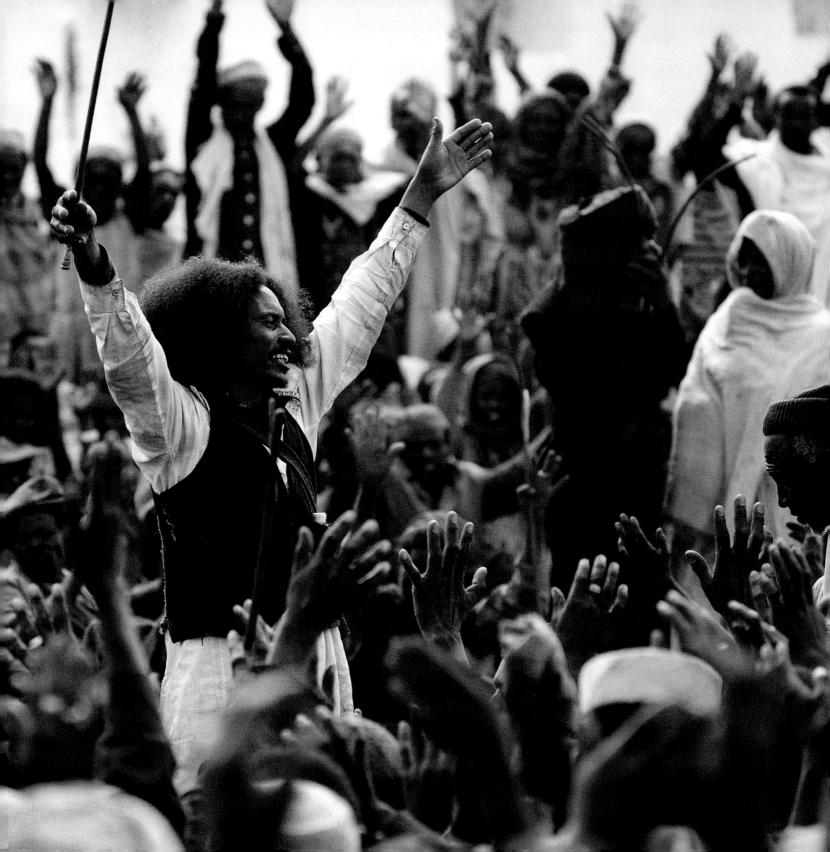

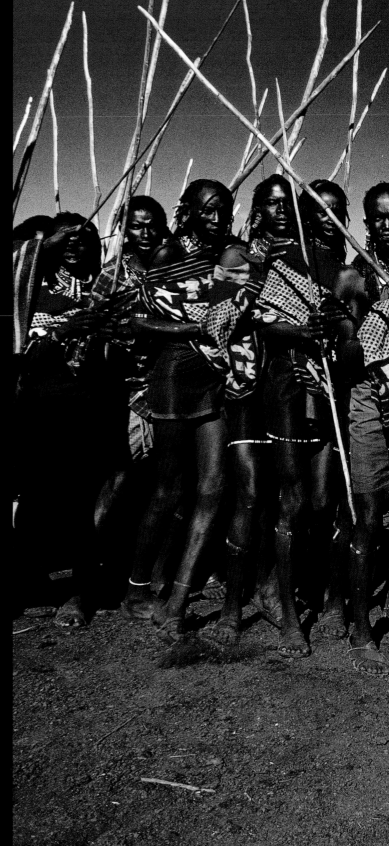

MASAI
KENYA

Warriors arrive at the
ceremonial grounds for
their ritual passage into
manhood. Symbolic of
great courage and power,
the lion's-mane headdress
is worn to announce both a
man's prowess as a warrior
and his love of the African
grasslands he shares with
the king of beasts.

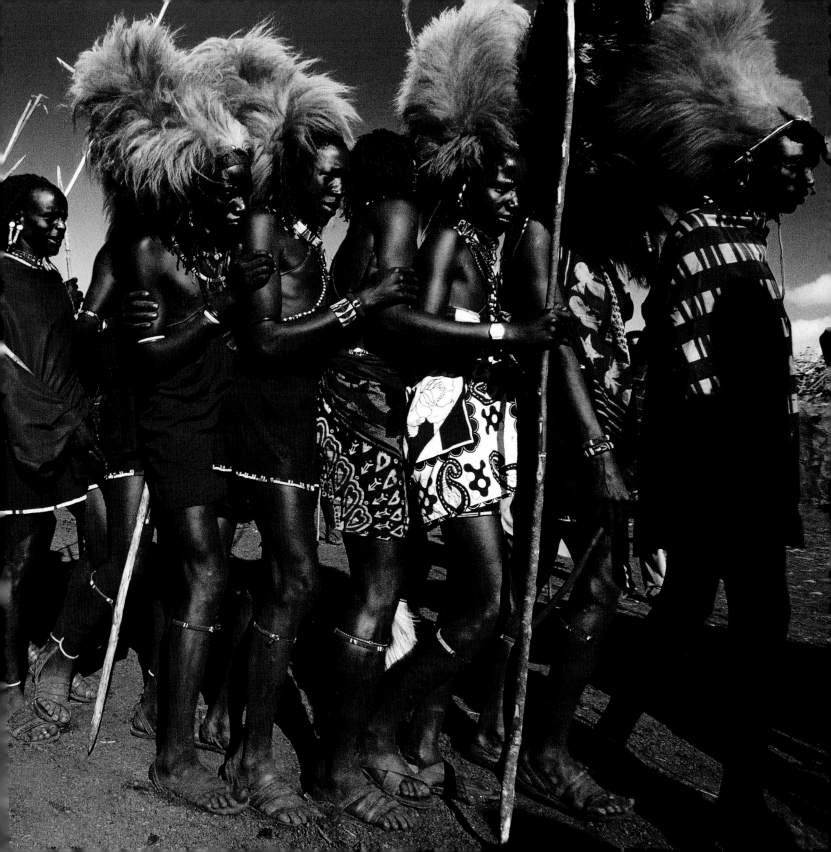

"WE WERE AWAKENED IN THE MIDDLE OF THE NIGHT BY THE WILD, IMPASSIONED CRIES OF MASAI WARRIORS, frantic in their efforts to retaliate against their enemies, the Sukuma.

Shortly after midnight, the Sukuma, concealed by the dark moonless night, had entered the *manyatta* armed with bows and poisonous arrows and stolen more than 2,000 head of cattle—one of the biggest raids of the century. Seven Masai warriors, defending themselves with spears, were shot with arrows containing the lethal poison.

Within hours Masai warriors from all parts of the Serengeti gathered together, with uncontrollable emotion, to prepare a warlike strategy to retrieve the stolen herds. We were only allowed to peek out from our hut, for fear of being caught in the crossfire. What we saw were some of the fiercest and most fearless warriors on the continent assembling by the hundreds to go to war. Many fell into *emboshona,* a fit-like state induced by high emotion—some foaming at the mouth, their bodies going rigid, and their spears flying in all directions. A deep, tense guttural hum, punctuated with bloodcurdling warlike cries permeated the manyatta. The warriors formed a phalanx. Time was of the essence; the Sukuma would move at speed to conceal the stolen herds.

Just as the warriors were about to leave the manyatta, a messenger arrived on foot from the government office in Arusha. The Masai were not to retaliate; the government would take over, find the stolen herds, and return them to their rightful owners. With great effort, the elders managed to stop the impassioned warriors and convince them to wait.

The government never went after the stolen herds, and by the time the Masai learned of this betrayal, 2,000 head of cattle had disappeared, never to be found. For the Masai, who believe that Engai (God) gave them all the cattle on Earth as their birthright, the theft of 2,000 animals, and being denied the right to retrieve the stolen herds, was a profoundly crushing blow that would haunt them for years to come."

The preceding excerpt is from our Masai journal, written in Tanzania in 1978 while we were living in a warrior camp overlooking the Serengeti plains.

MASAI

KENYA

A proud warrior wears an impressive headdress made from ostrich feathers. Throughout the 19th century, Masai warriors wore headdresses just like this one to strike fear in the hearts of their enemies.

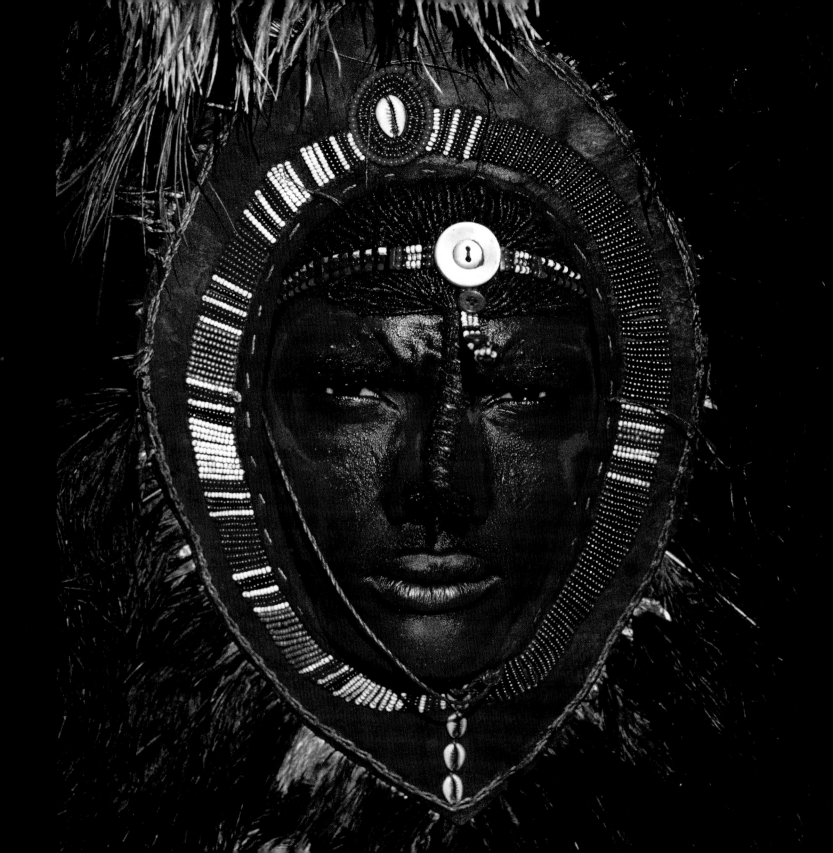

Facial scarification serves both as a
means of establishing tribal identity
and a way to enhance physical beauty.
The curved pattern of cow horns on
the forehead of this serene woman
indicates that she is from a cattle-
herding family and comes from
a gentle and more fertile
part of Afar country than the
harsh Danakil Depression.

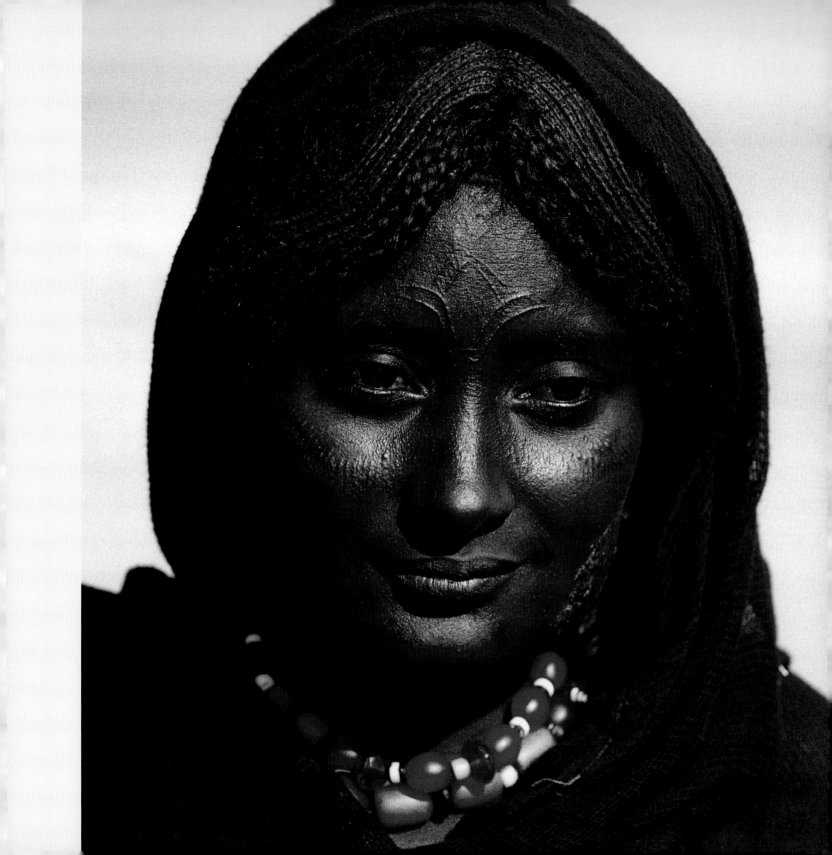

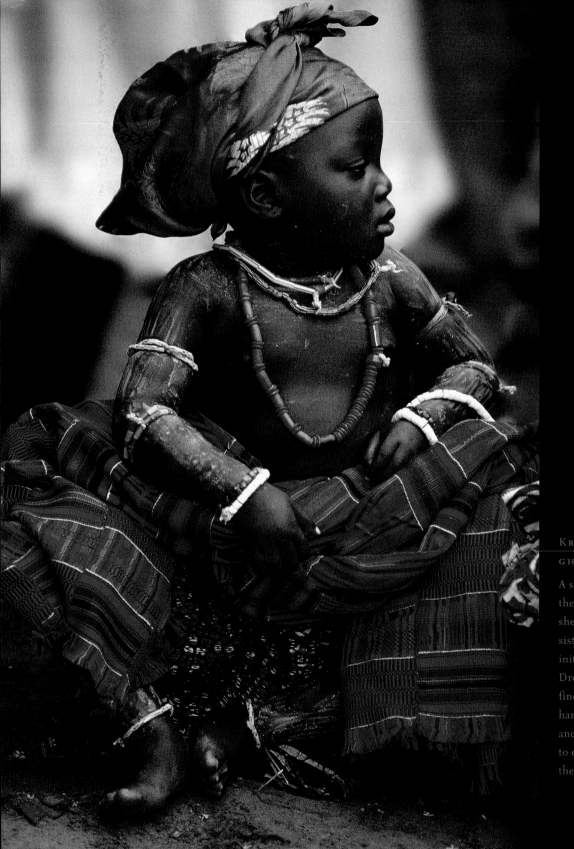

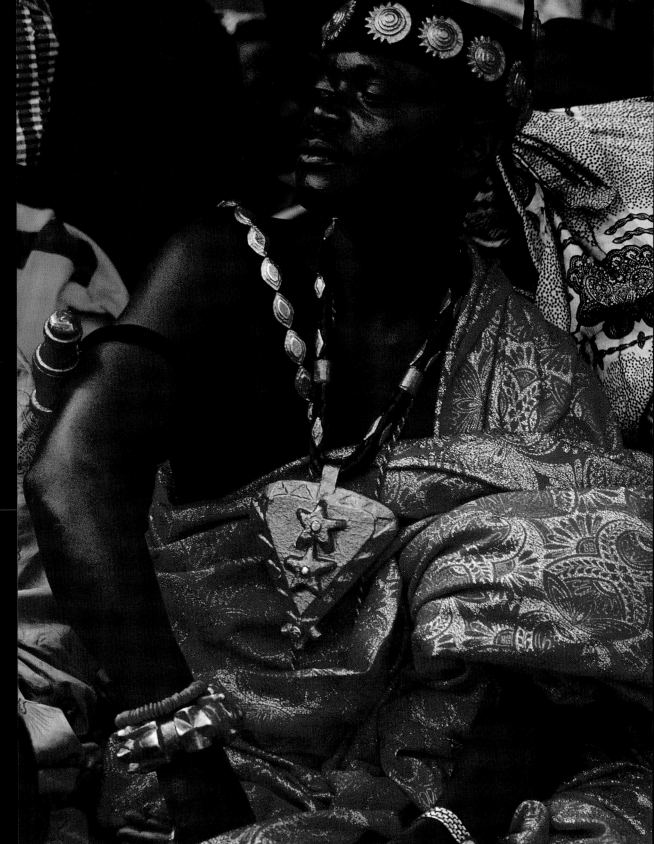

Following her initiation into
womanhood, a Fante girl adorns
herself with ancient glass trade
beads and an impressive hooped
hairstyle. She takes on the confident
allure appropriate to her new
mature role in life.

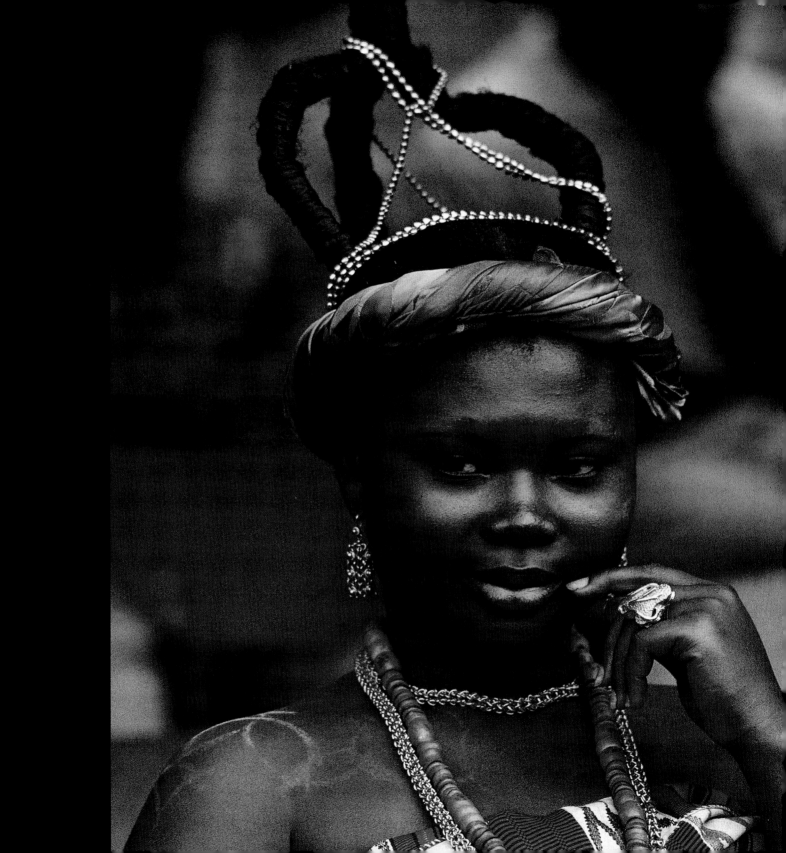

Recognizable by his impressive
eagle-feathered headdress featuring
a pair of golden ram's horns, the
royal sword bearer, Mponponsuo,
attends the 25th anniversary of
the Ashanti king. In a six-hour
procession attended by 70,000
subjects, he plays the vital role of
protector of the king—by warding
off evil and absorbing any physical
threat to his master. His ritual
paraphernalia is believed to protect
not only the souls of the royal court
but the entire Ashanti nation.

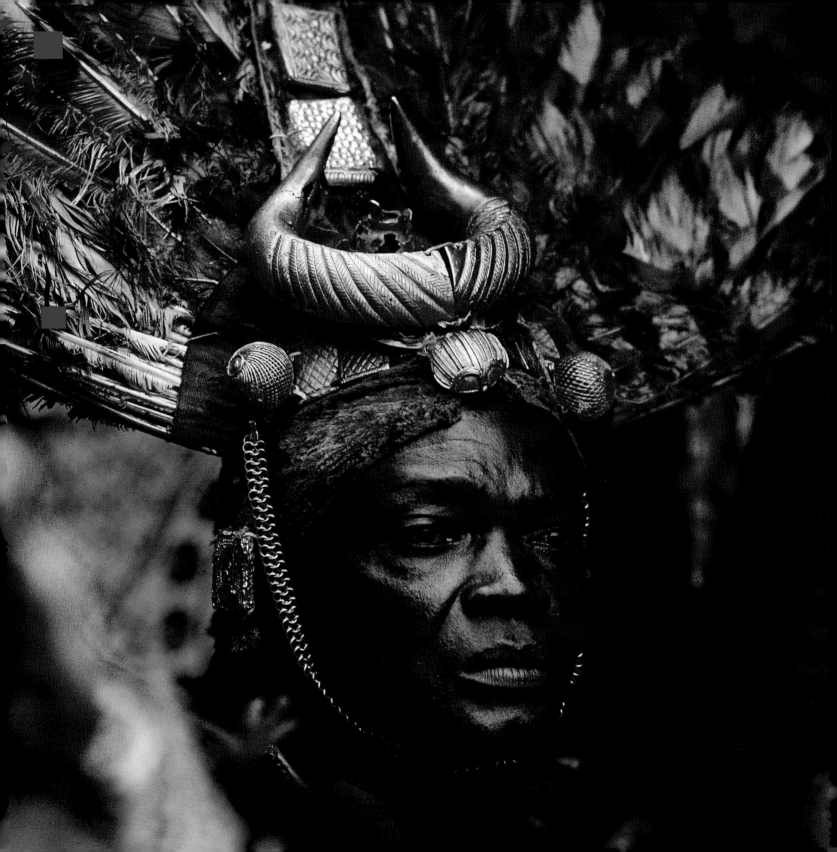

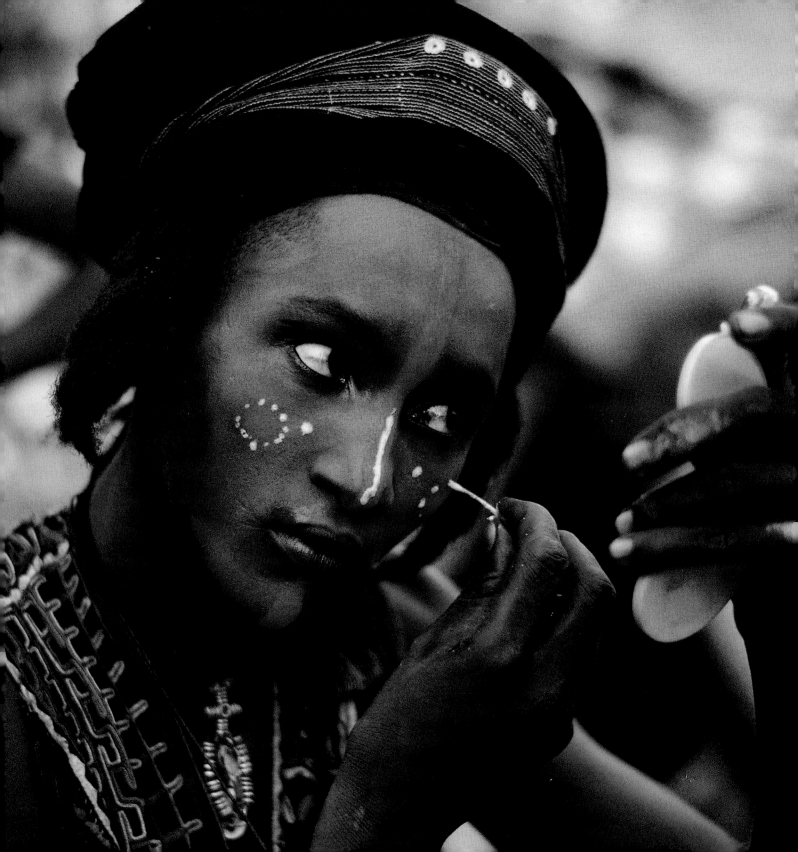

OF ALL THE CEREMONIES WE HAVE RECORDED ON OUR AFRICAN JOURNEYS, OUR FAVORITES HAVE BEEN THE ENDLESSLY NUANCED RITUALS OF COURTSHIP—the ancient rite of winning hearts and seducing body and soul, performed with a distinctively African flair.

In a continent where life is often precarious, and the carefree days of youth are by necessity compressed within a few short years, the joys of courtship and the art of seduction take on a heightened intensity.

For us, the courtship rituals of the Wodaabe beautifully illustrate the important role that seduction plays in traditional African life, and it was while working with these desert nomads of Niger that we found ourselves having a more personal involvement than we expected.

Mokao, a handsome Wodaabe man, had fallen in love with Carol, but Wodaabe tradition prevented him from expressing his feelings. Taking Angela aside, Mokao explained that he wanted to meet Carol's father to determine how many camels would be required to win her hand. He volunteered to ride to Boston on the fastest camel he possessed, and asked how long it might take to make the round-trip ride.

Mokao was gently discouraged from pursuing his courtship, but as we walked to the next village, he followed Carol and knelt to gather sand where her feet had trod. He took the sand to put in a leather talisman that he wore around his neck. When we asked him why he did this, he announced: "By wearing your footsteps over my heart, I know you will return to me and bring your father's blessing."

WODAABE
NIGER

A male charm dancer applies face makeup to attract the females who will judge his performance.

ART OF SEDUCTION

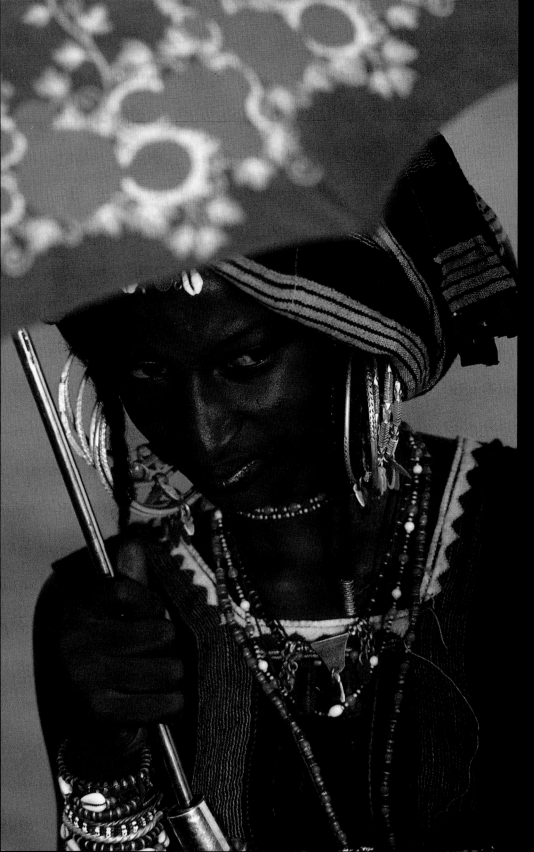

Right: For the male charm dance,
Morodo lightens his skin
with yellow powder, lengthens
his nose with a long line, and
brightens his eyes and teeth with
an outline of kohl.

Left: Concealed behind her
umbrella, a female judge discreetly
studies the male charm dancers.

Following pages:

WODAABE

NIGER

Once a year, on the southern edge
of the Sahara Desert, up to a
thousand Wodaabe nomads come
together for a courtship ceremony
called the Geerewol. At this time,
the men display their charm
and beauty in a series of competi-
tive dances, and the women judge
them—selecting husbands,
boyfriends, and lovers.

Forming long lines, the men rise
up and down on tiptoe, showing off
their long, lithe bodies. They change
expressions every few seconds,
rolling their eyes and exposing
their gleaming white teeth. The
Wodaabe say, "It's through the
strength of the eyes that marriages
are made."

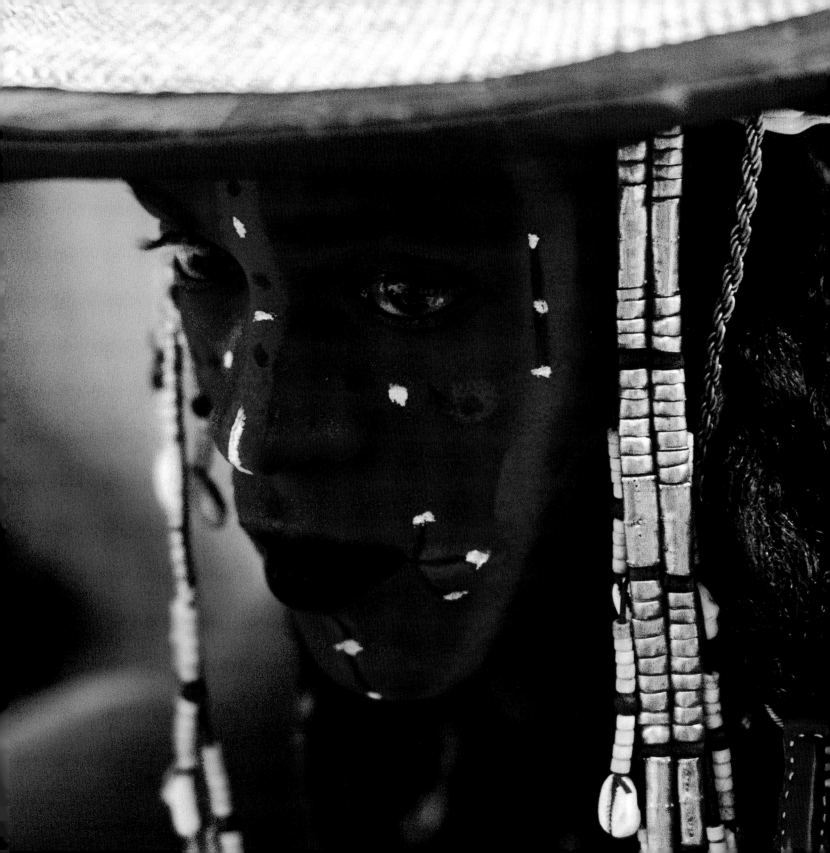

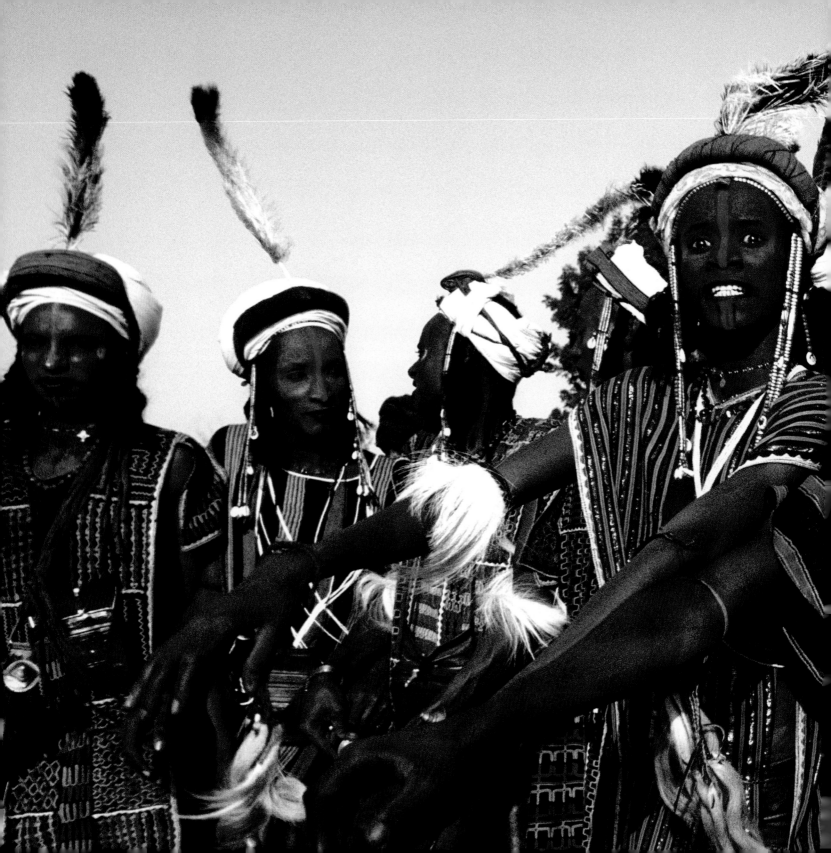

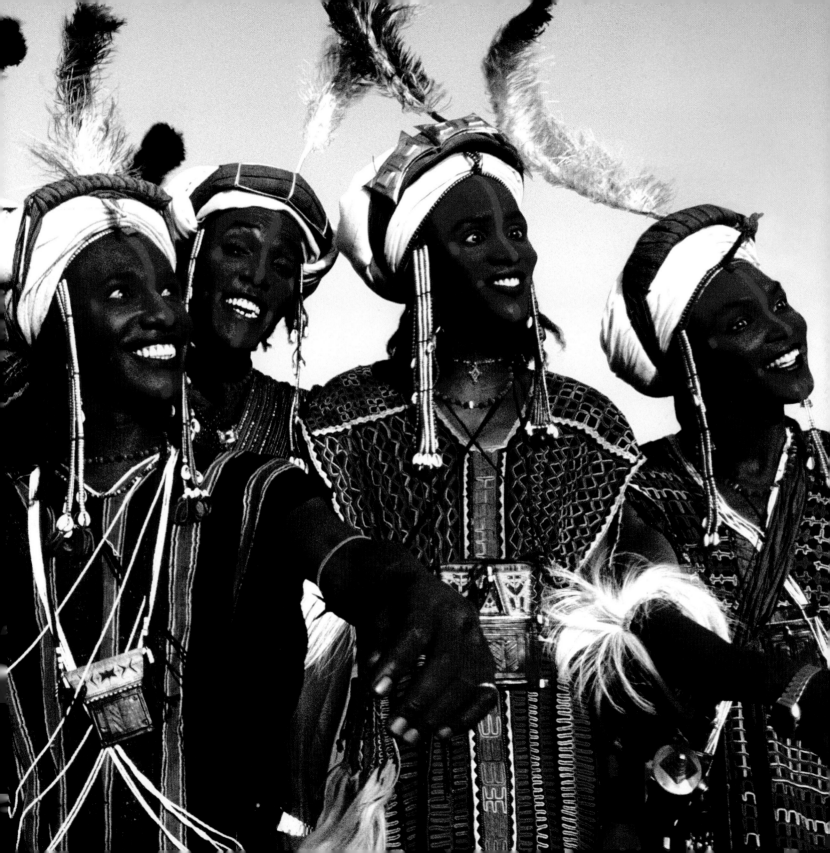

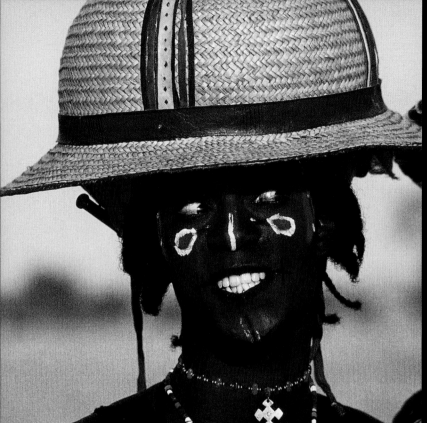

All images:
Male charm dance finalists

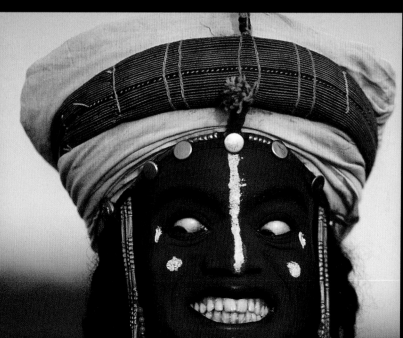

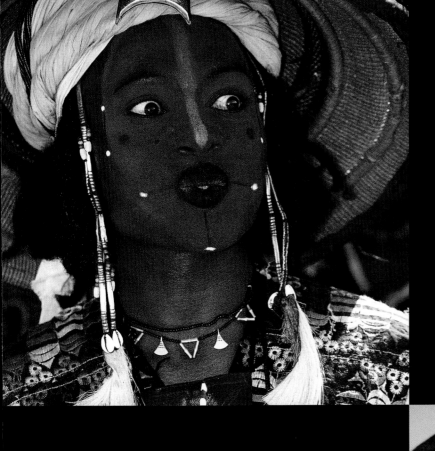

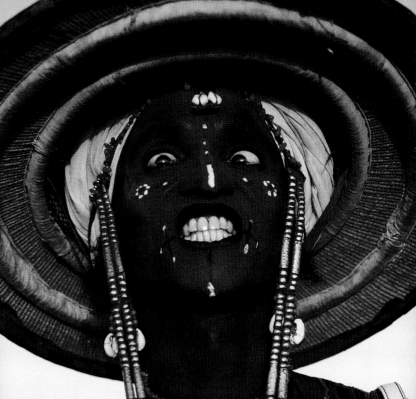

Djajeejo, winner
of the charm dance

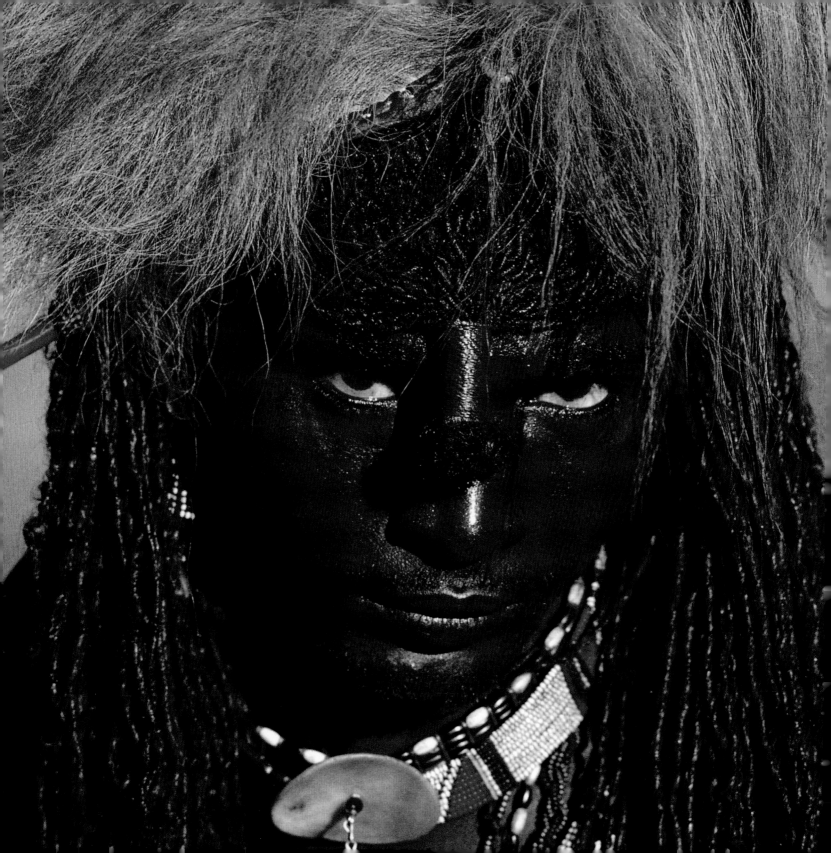

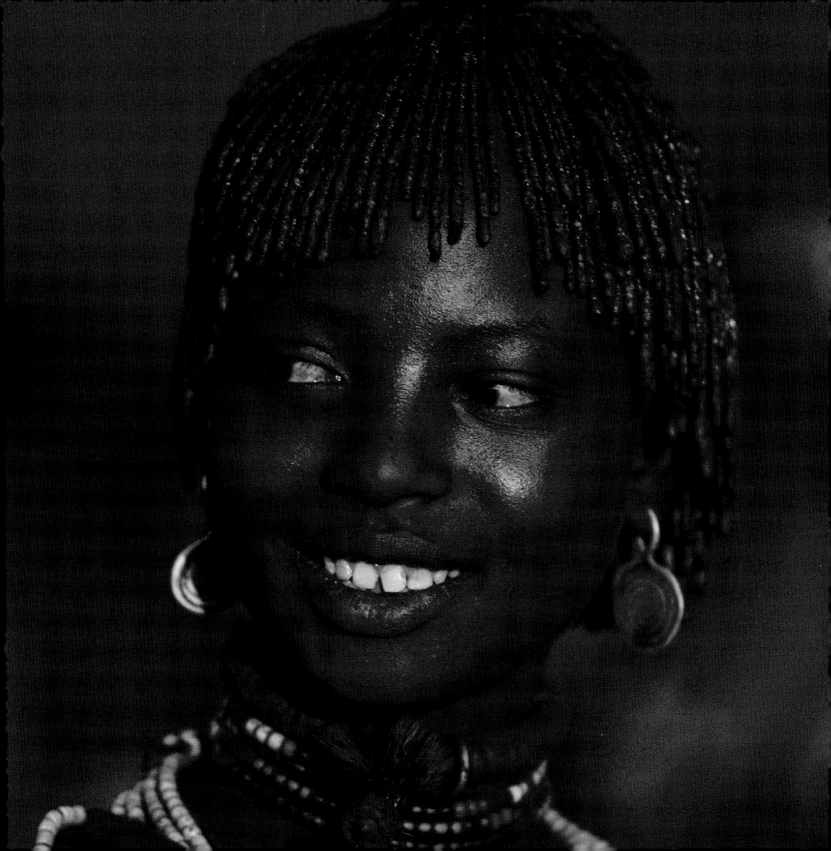

Preceding pages:

MASAI
KENYA

Left: Wearing his lion mane head-
dress over ochred locks, a warrior
glances seductively at the young
females he is about to woo.

HAMAR
ETHIOPIA

Right: A young girl, ochred for
beauty and casting a most flirtatious
smile, wears the provocative hair-
style of an unmarried female.

MASAI
KENYA

Masai girls accompany their warrior
boyfriends at a ceremonial dance.
The beaded collars and headbands
the girls wear are designed to bounce
rhythmically to enhance their body
movements. Traditionally a Masai
girl may select three lovers from
among the warriors. This is the one
time in her life when she is allowed
to enjoy freely chosen relationships.

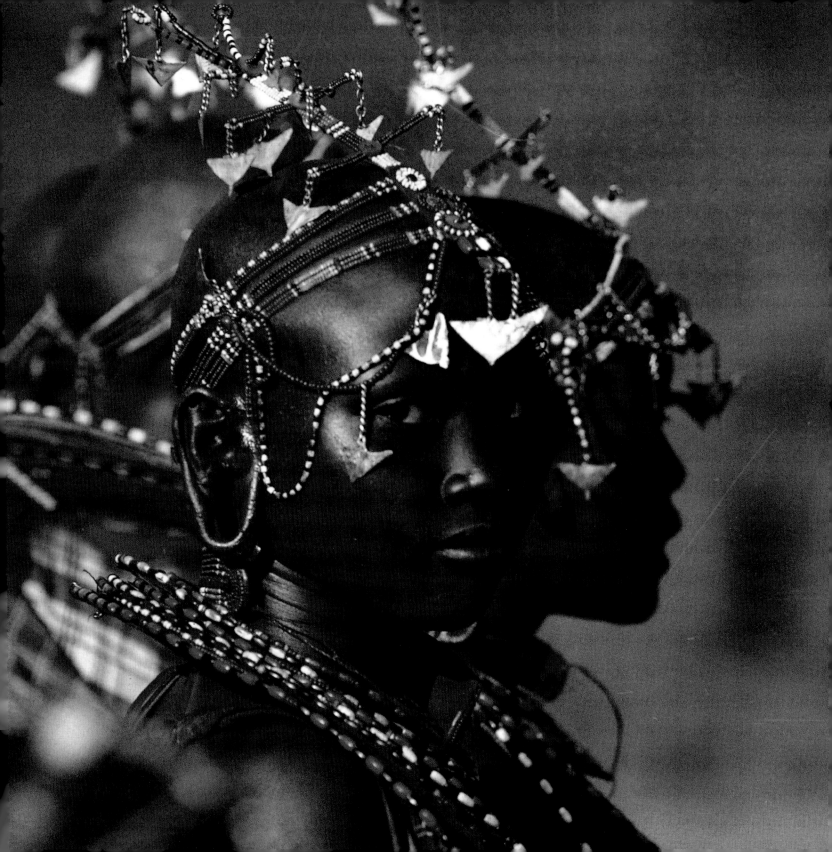

His teeth filed for
beauty, an Afar warrior's
irresistible smile attracts
the gaze of young girls
in the nomads' weekly
market.

Right: Wearing a
colorful necklace of
protective leather
talismans, an Afar girl's
subtle and alluring
glance draws young
nomad warriors to
her side in the Bati
marketplace.

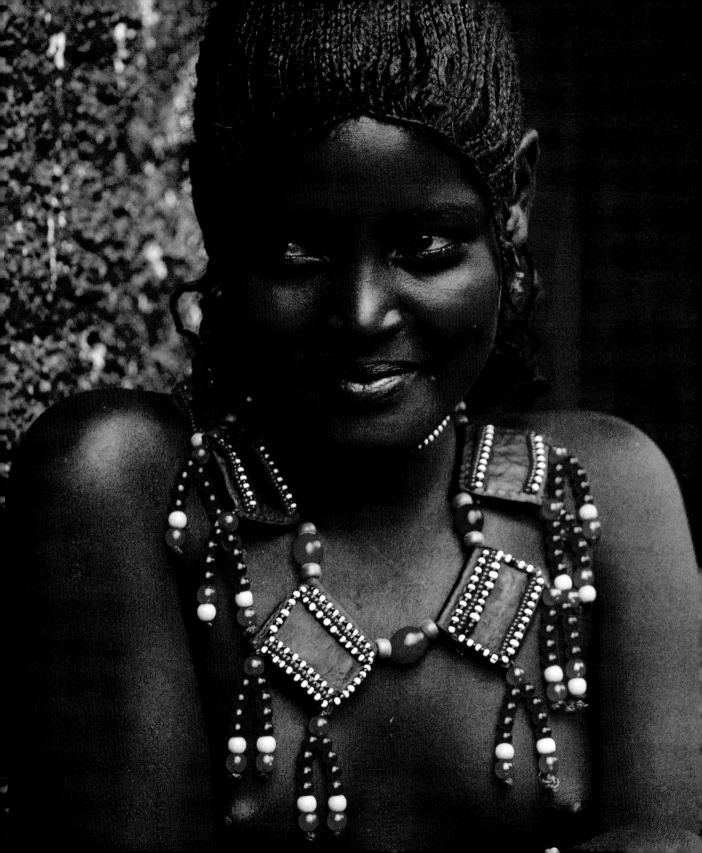

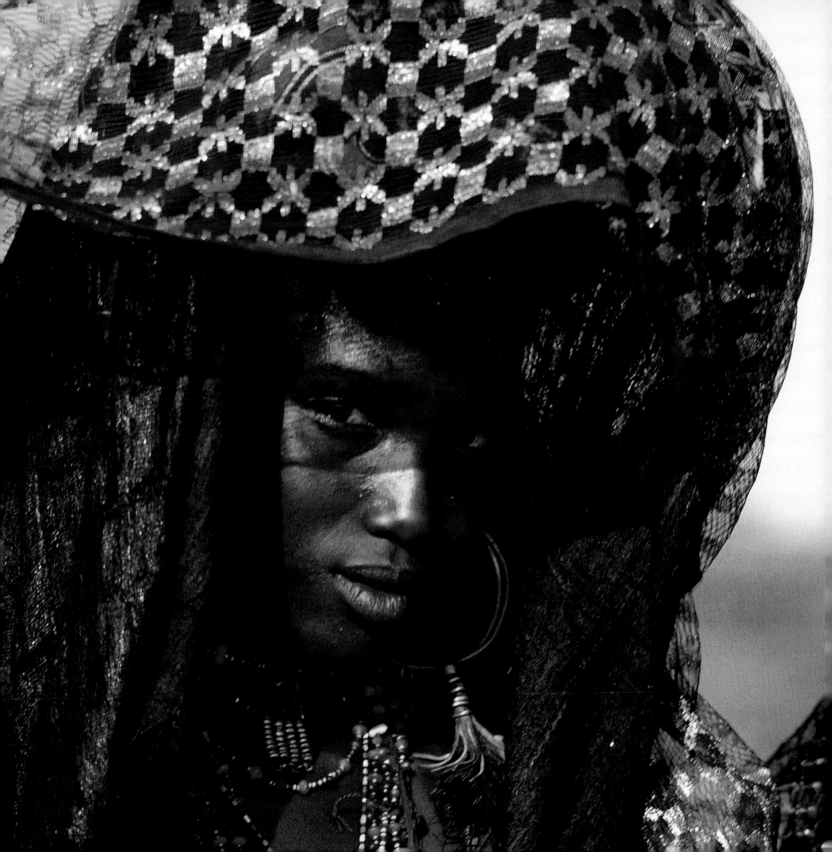

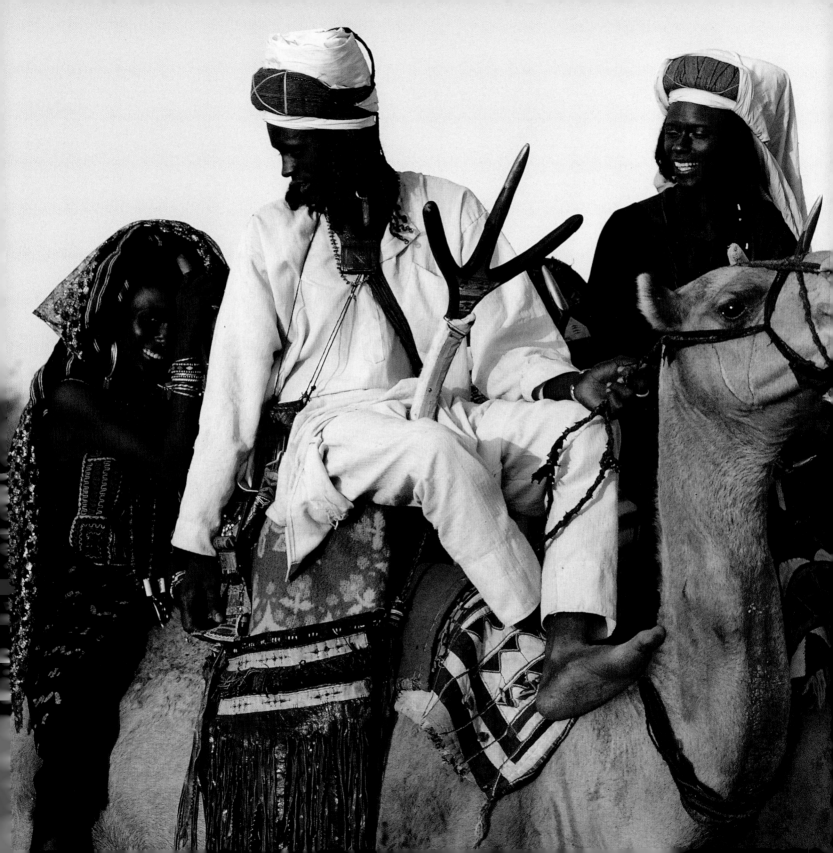

DURING COURTSHIP SEASON, WE WERE INTRIGUED TO SEE TWO MEN SEDUCING THE SAME GIRL. We learned that Wodaabe tradition allows male cousins of the same age the freedom not only to display affection toward each other, but also to become lovers of the same girl. If the girl decides to marry one of the cousins, the other will always be welcome in the camp of her husband, who will generously offer his wife for the night—but only with her consent. In this unique relationship between men no jealousy is permitted, and the normal Wodaabe tradition of reserve is lifted.

Another Wodaabe practice both intrigued and involved us. When a Wodaabe man is attracted to a woman, he will often wink at her. She is required to be modest and lower her eyes demurely. However, if she is interested, she will lower her eyes only part way, and he will then twitch the corner of his mouth to indicate a meeting place behind a bush. Before we understood the meaning of this practice, handsome Wodaabe men would wink at us and we would respond with delight—winking back two or three times. Eventually Nebi took us aside to tell us how forward our behavior was, and taught us the proper secret code of female eye response.

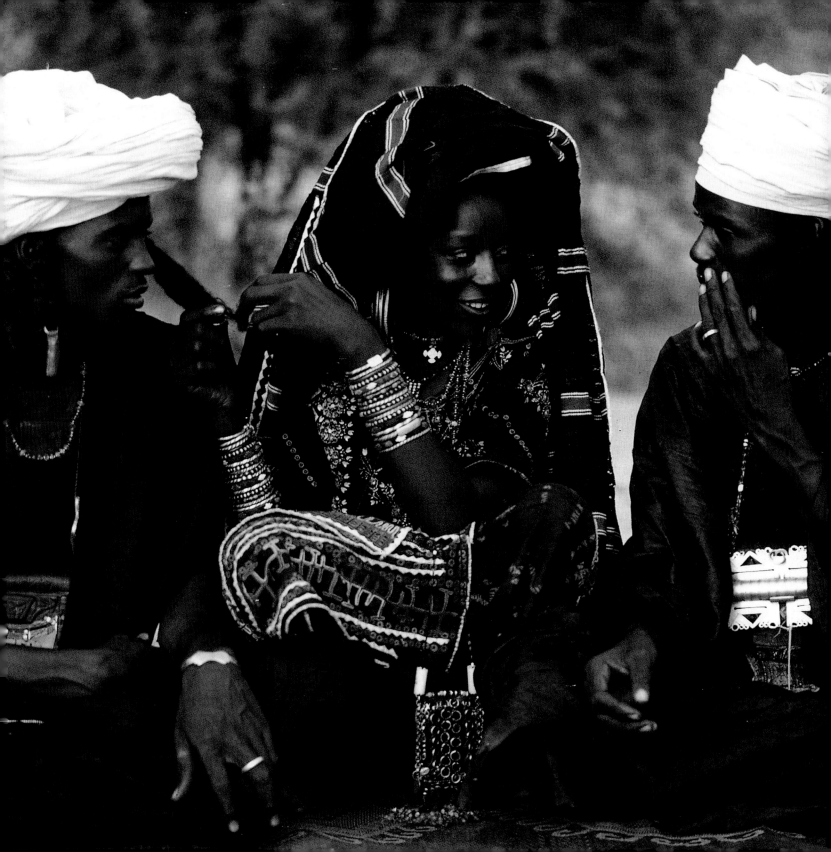

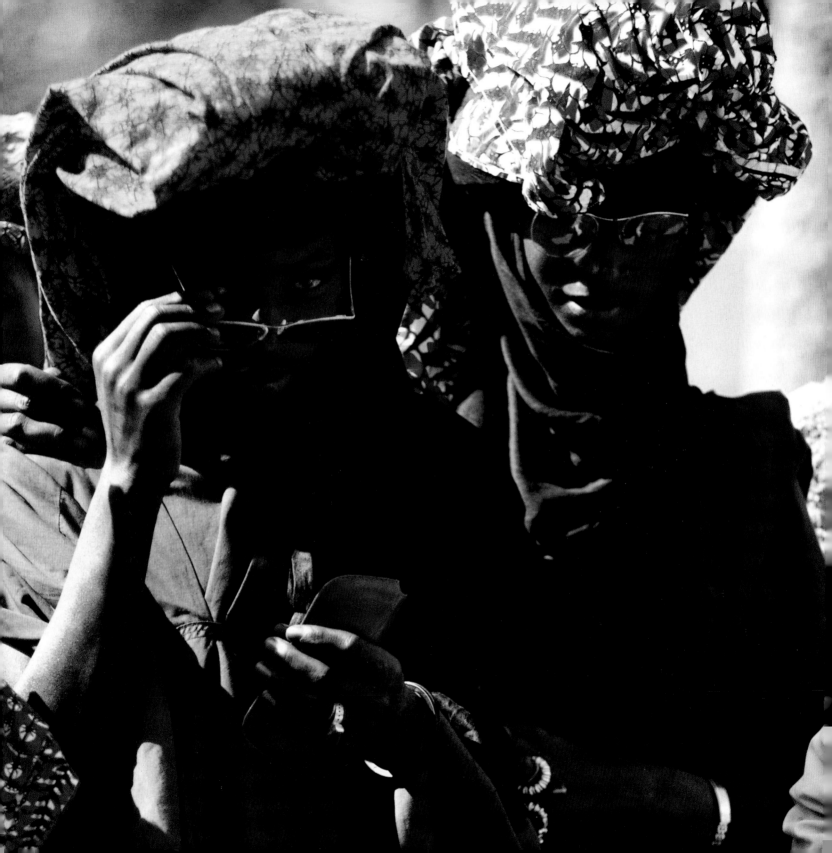

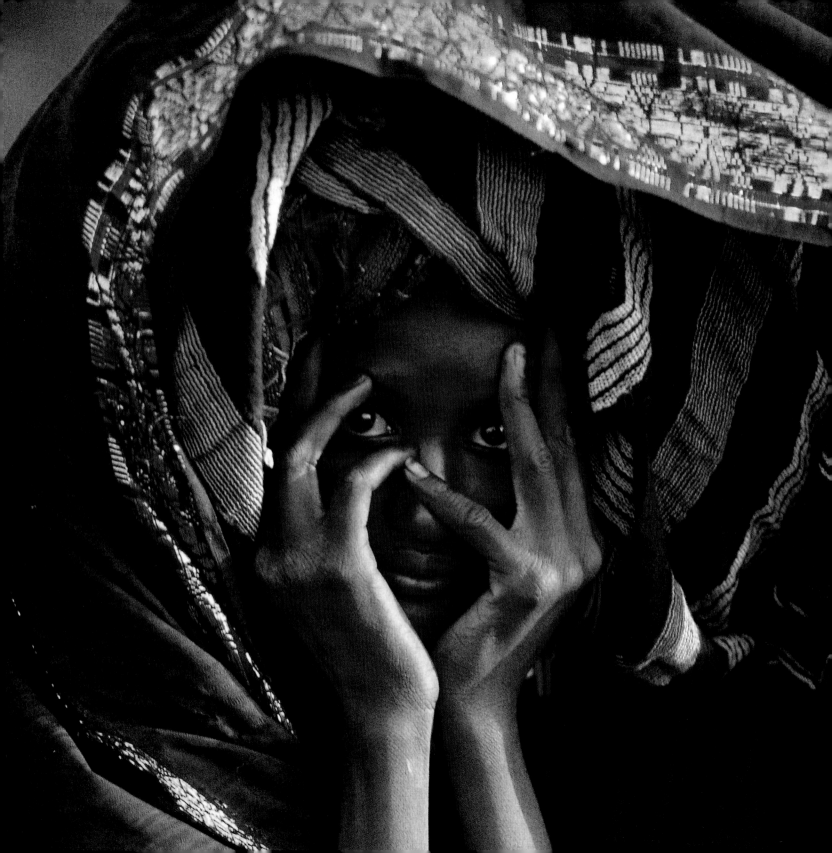

OUR FRIEND AMERIKAN INVITED US TO A KARO COURTSHIP DANCE ALONG THE OMO RIVER IS SOUTHWEST ETHIOPIA. Amid clouds of dust and highly explosive energy, we were given permission to photograph, but only on the condition that we first join in. Our ballroom dancing lessons of childhood had hardly prepared us for the following:

First, each girl was required to study the long semicircle of virile male dancers, all painted to attract the eye of the opposite sex and singing and clapping in a captivating way. Next, each girl ran toward the dancer of her choice, stopping just short of touching him and indicating her selection with a graceful wave of the hand. Then each man advanced toward the girl who had chosen him, giving the subtle intimation that he was seriously out to capture his prey—but all with a great sense of play.

Couples then formed and jumped provocatively in unison from side to side, with each man's hand lightly touching and guiding the bare back of his woman. At the climax of the dance, each man thrust his hips with vigour at his partner, attempting to catch her unawares. Gales of laughter ensued, especially when they watched us—the two unseasoned novices—perform this highly provocative dance. After an hour, with our newly acquired expertise in Karo courtship technique, we retreated to the rooftop of our Land Rover for "aerial" shots of the dance.

Preceding pages:

FULANI

MALI

Left: Seductive eyes are concealed by trendy mirrored sunglasses, which these two young men have purchased in market towns on their way home. Colorful cloths given to them by admiring females are piled on top of their turbans. The girls make sure that the patterns of the fabrics they give match the patterns of the dresses they will wear that evening.

Right: A young Fulani girl coyly peaks out from under layers of cloth.

KARO

ETHIOPIA

Painted to attract the eye of the opposite sex, a young couple enjoys the climax of the courtship dance.

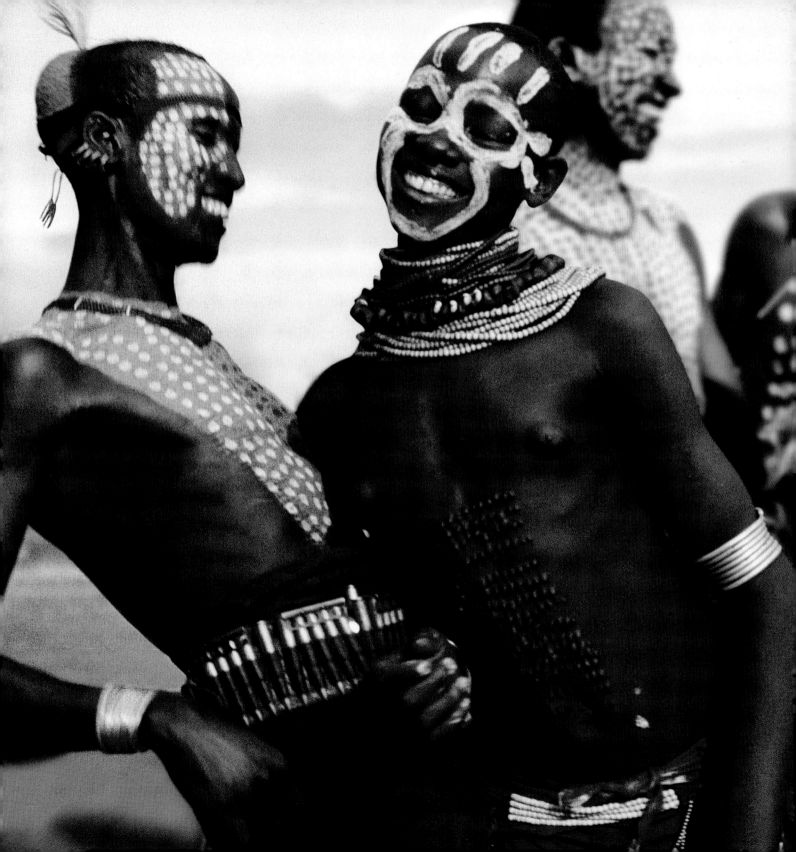

Sebera Seko, a Muslim bride from
the family of the Sultan of
Tadjourah, enhances her already
considerable beauty with some of
the most exotic gold jewelry found
in the Horn of Africa. Because of
her father's involvement in the
dhow sea trade, she is given
jewelry that comes from as far
away as Saudi Arabia, Yemen,
Pakistan, and India.

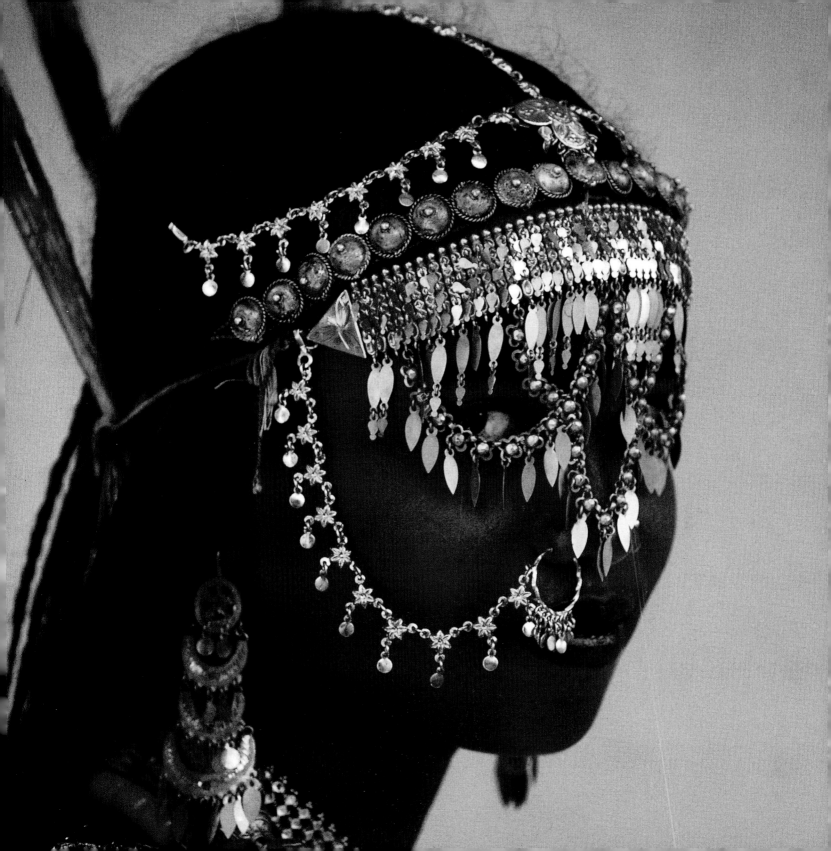

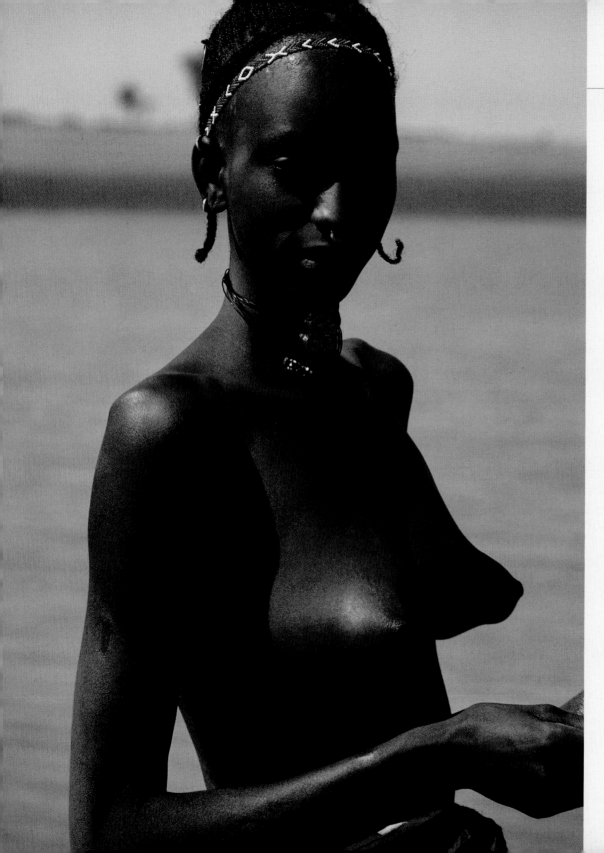

A young Fulani girl stands by the
Niger River after bathing.

SURMA

ETHIOPIA

Barchini, with his chiselled
features and long elegant body,
was one of the handsomest and
most seductive men we met in
Surmaland. After painting his
body with beautiful chalk
designs on the banks of the
Dama River, he would turn
around and gaze at us intensely,
seeking our approval. We were
so disarmed by his powerful
expression that we would
sometimes forget to press our
camera shutters.

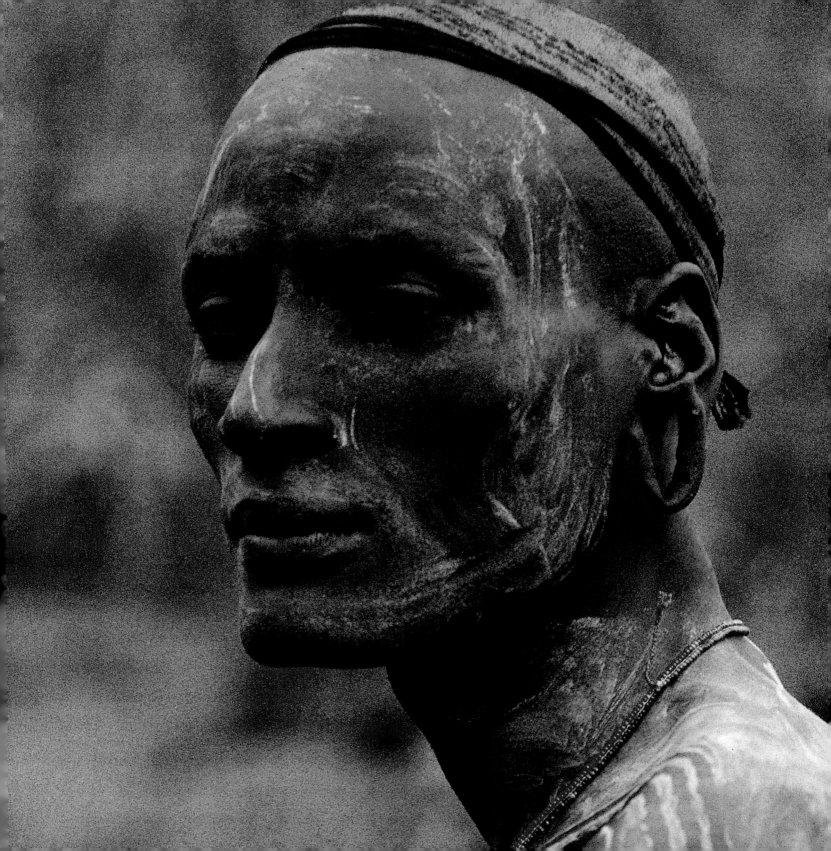

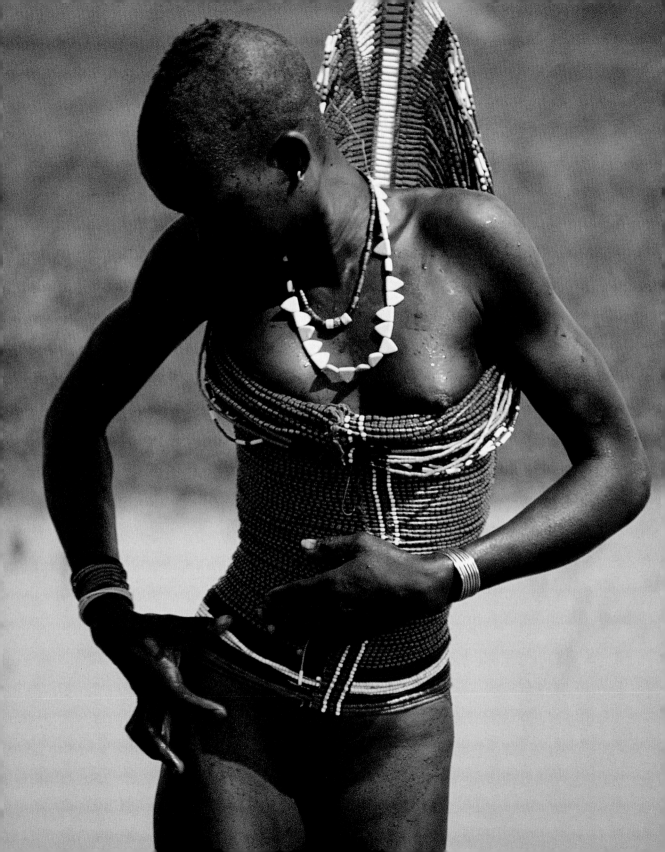

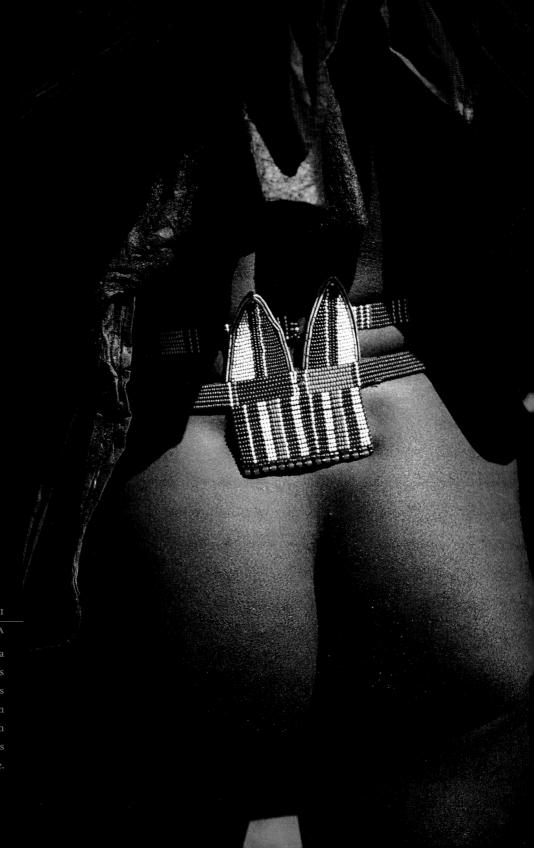

DINKA
SUDAN

Left: A girl whose family is rich in cattle wears a beaded corset, which is sewn tightly onto her body and worn until marriage. This corset communicates the important message of her availability. The height of the beaded projection at the back reveals the wealth of her family and her bride price. Due to the devastation of civil war in Sudan and the subsequent infiltration of Muslim values, the wearing of corsets may have become a tradition of the past.

MASAI
KENYA

Lontini, a warrior, wears a narrow beaded belt, which serves to carry the scabbard of his short sword. This belt is often embellished at the back with a beaded design fashioned by his girlfriend as a sign of love.

Unmarried girls wear alluring beaded bodices that both reveal and conceal their young bodies. The colors and design of the beadwork running down the front of the bodice indicate the number of cattle required by the girl's family as a bride price. The white cowry shells symbolize fertility.

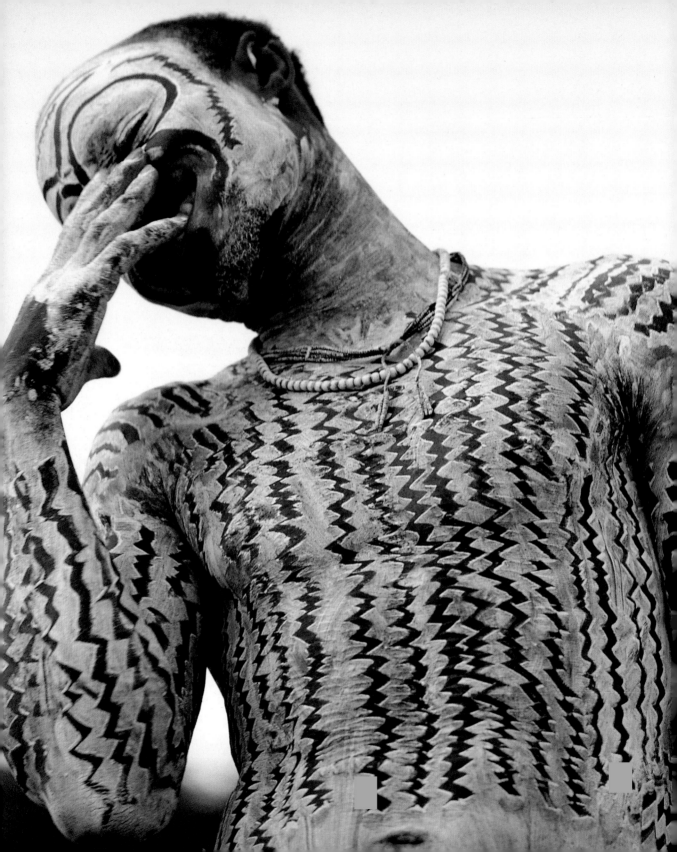

THE SAHEL HAD NOT SEEN RAIN FOR TEN MONTHS, and all living things struggled to survive. And then one day while we were out photographing the Tuareg, the rains came. As sheets of rain drenched us, we huddled under a grass mat and tried to keep our cameras dry. We were starting to feel totally frustrated—soaked to the skin, cold, and miserable—when we saw the children.

Every child in the area was out in the rain, dancing for joy. They leapt and splashed and hopped about, imitating the crickets that had suddenly appeared. We couldn't resist leaving our shelter and joining the children dancing and laughing in the rain.

Many times during our travels throughout Africa—especially among people who live in the harshest climates—we have seen how the simple joy of being serves as an antidote for hardship, and how laughter is a mechanism for coping with adversity.

It is hard to analyze this phenomenon, but we believe that the social structure of traditional African societies explains part of it. The extended family system ensures that no child lacks for love or someone to talk to and play with. As children grow up in the security of their extended family, they create games and toys with great inventiveness and learn to laugh no matter what the circumstances.

The capacity for joy learned as a child becomes part of an adult's personality and remains an invaluable asset through difficult times. We have found it wonderfully inspiring to see how the people we have met in Africa take joy in the simple things of everyday life and in each other.

KARO
ETHIOPIA

Courtship season brings great enjoyment and laughter as men paint their bodies to attract the opposite sex.

JOY OF BEING

Exuberant children with painted
face masks play creative games
imitating frogs, grasshoppers, and
crickets. As they leap, they sing,
"My mother, my apple, my fruit,"
expressing their love for their
mothers. Free to play into the night,
the children perform until the wee
hours of the morning, repeating
this chant with endless enthusiasm.
As the village slept, we lay in our
tents and listened to the children
singing deep in the forest.

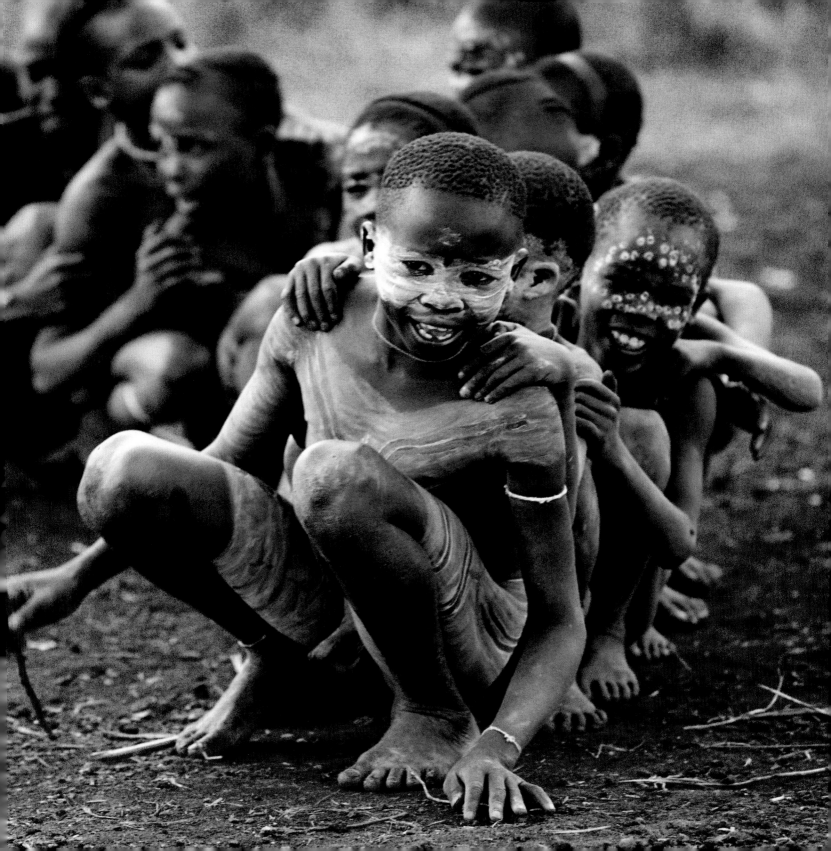

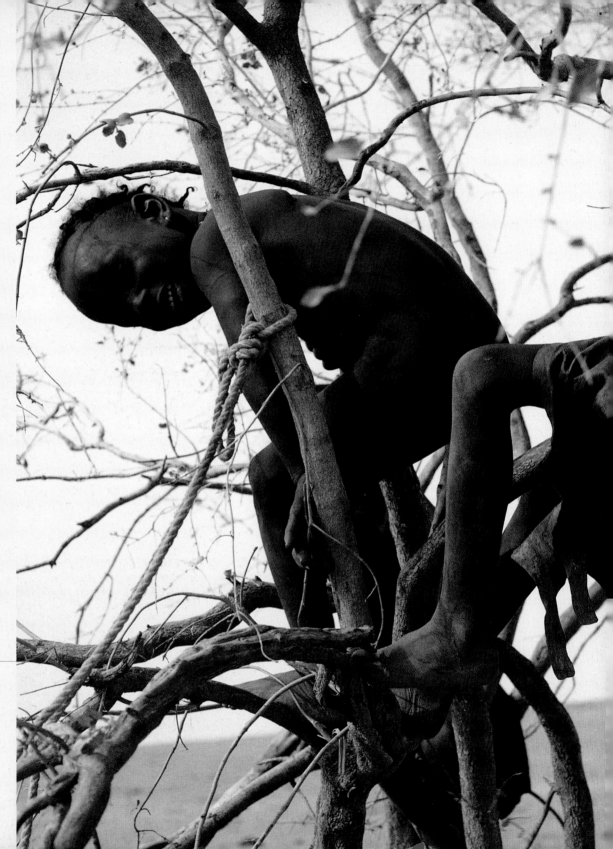

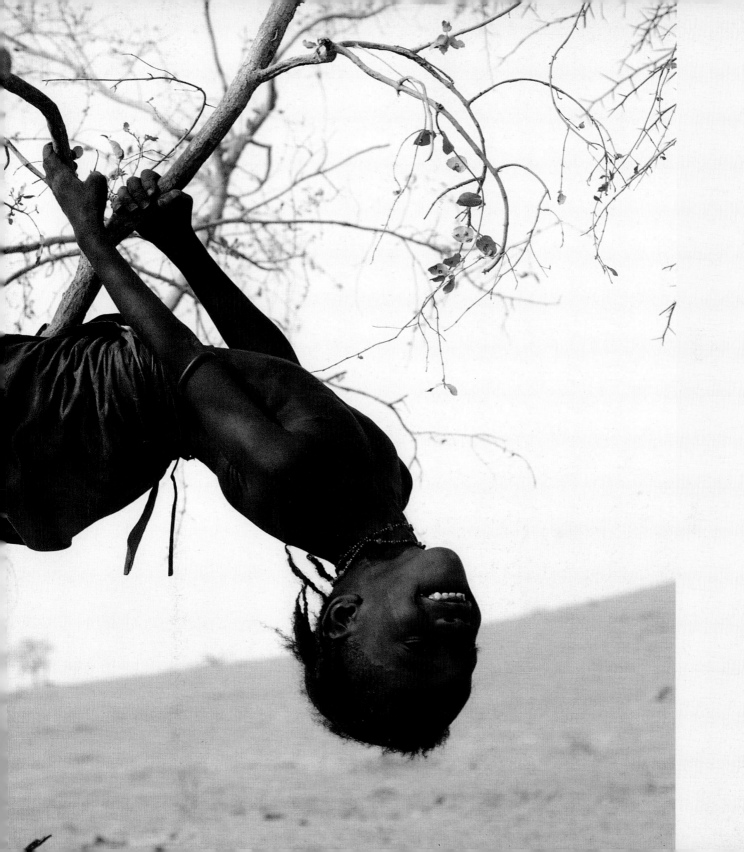

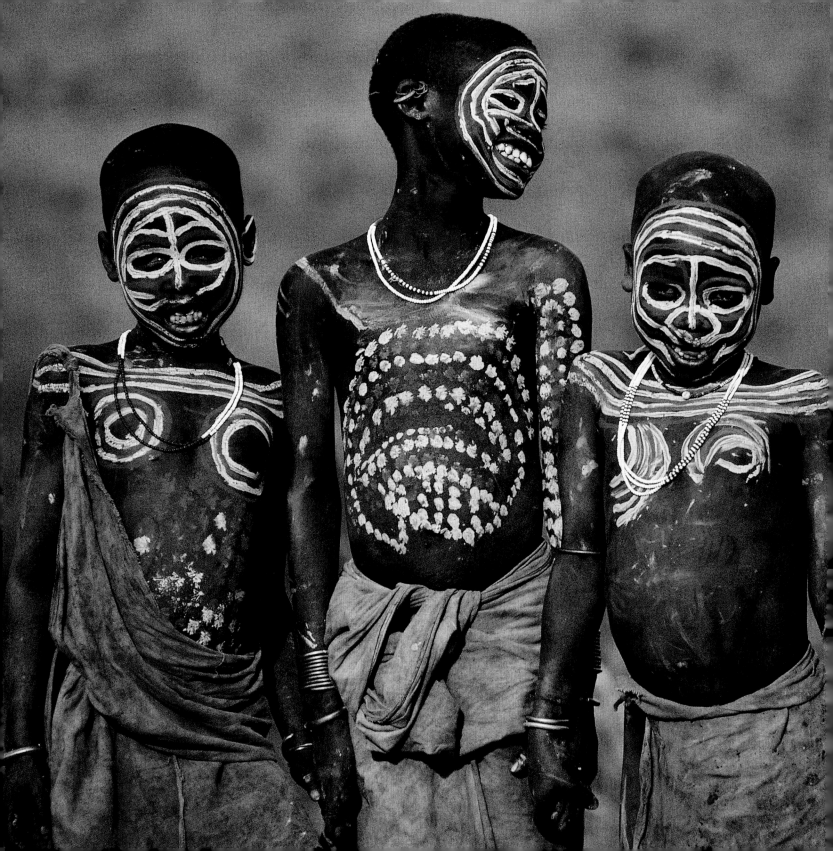

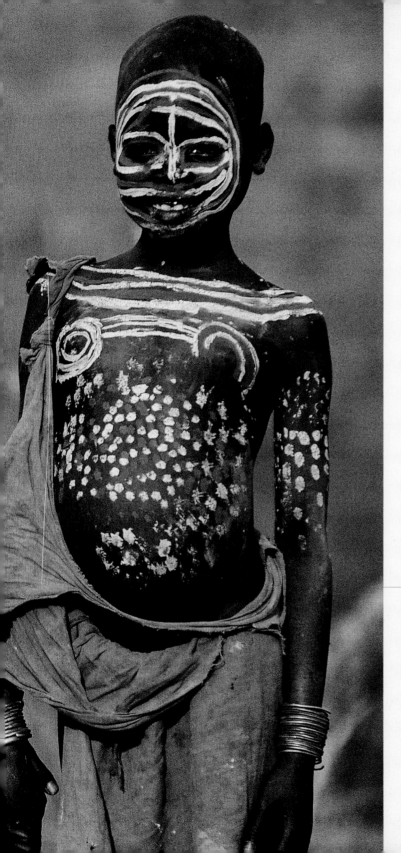

Transforming the body with paint
is a great source of fun for small
Surma children, like "dressing-up"
in the Western world. In this way,
they are learning to decorate them-
selves for courtship rituals later in
life. These little girls have painted
their faces with identical designs to
identify themselves as best friends.

The infectious exuberance of a
small girl captivated us while
photographing Surma children at
play. The pattern of dots freshly
painted on her face was made
with a hollow stick dipped into
chalk and ochre paints.

Following pages:

MASAI

KENYA

Oblivious to the heat of midday, a
Masai girl leaps with spontaneous
joy across the family compound
while entertaining her little sister.

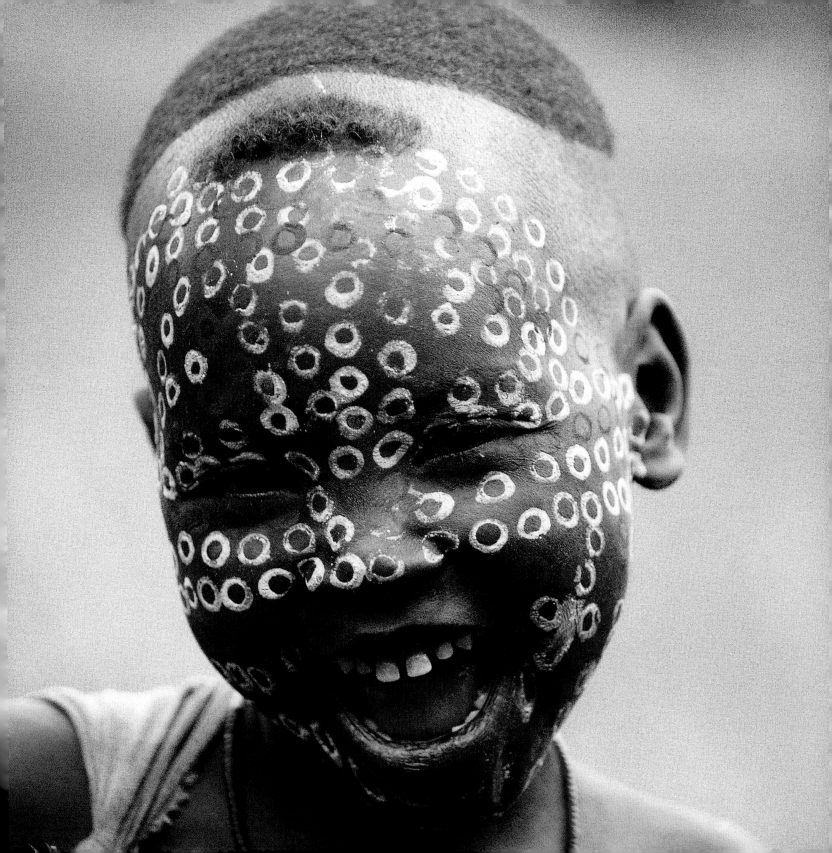

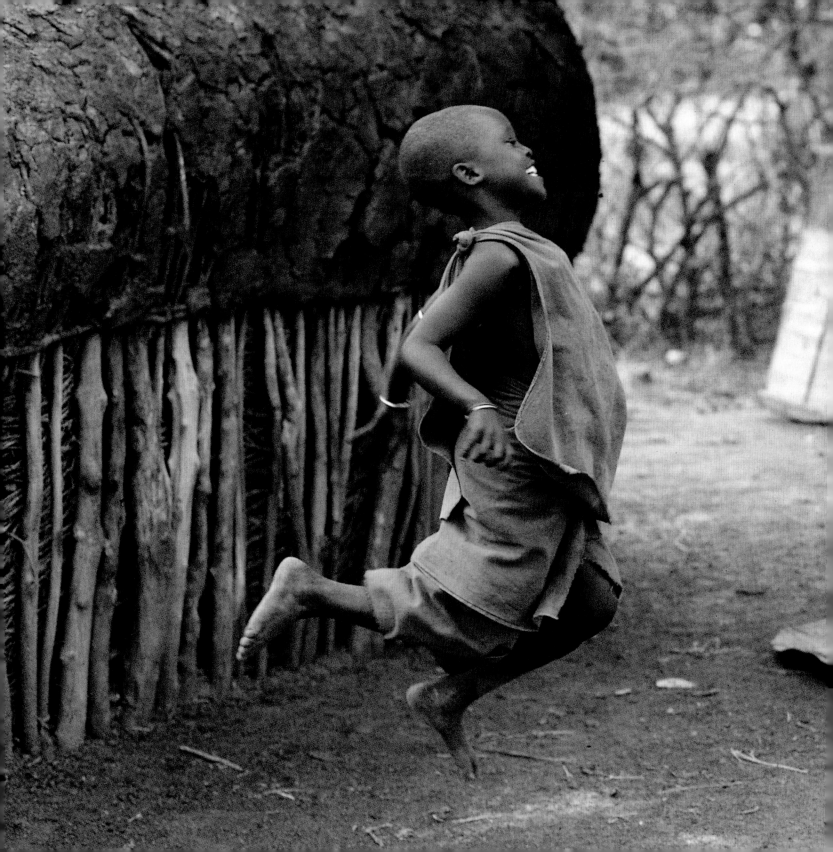

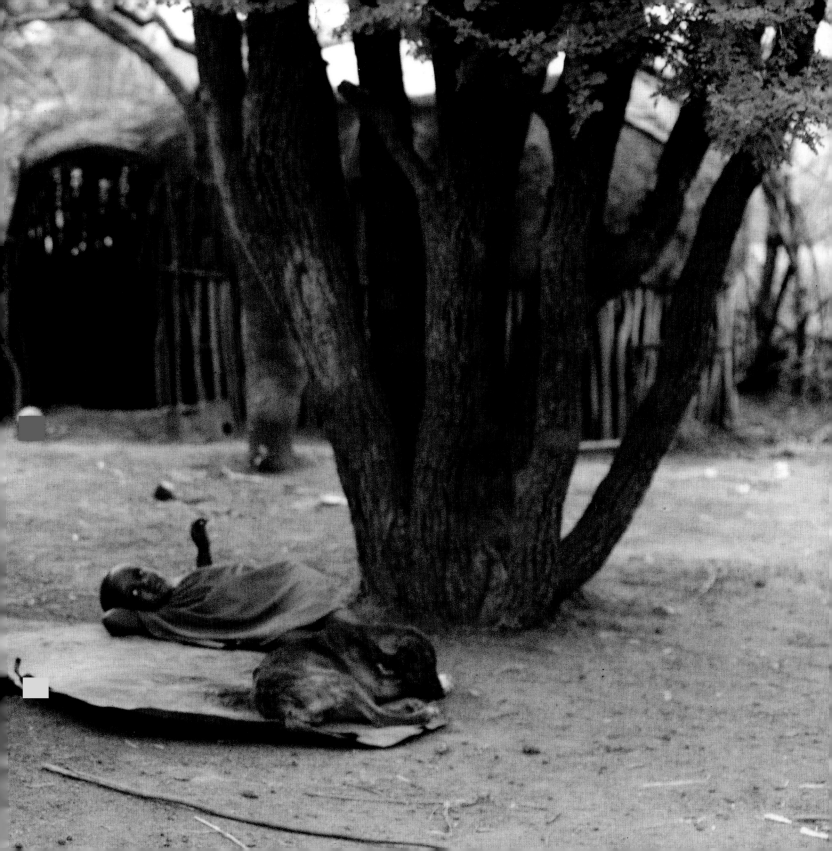

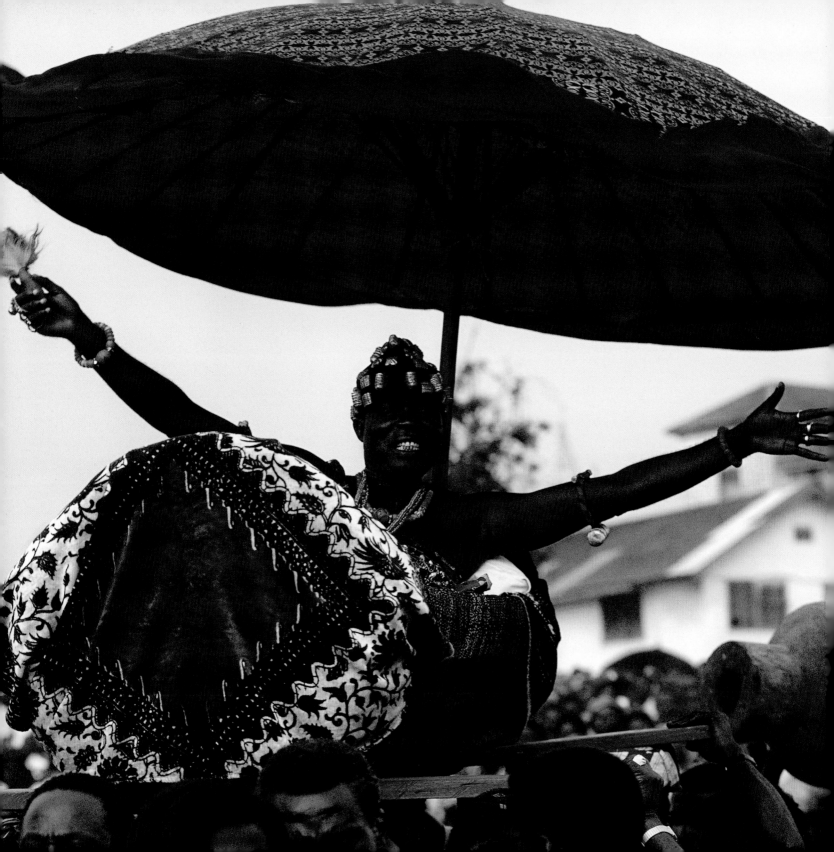

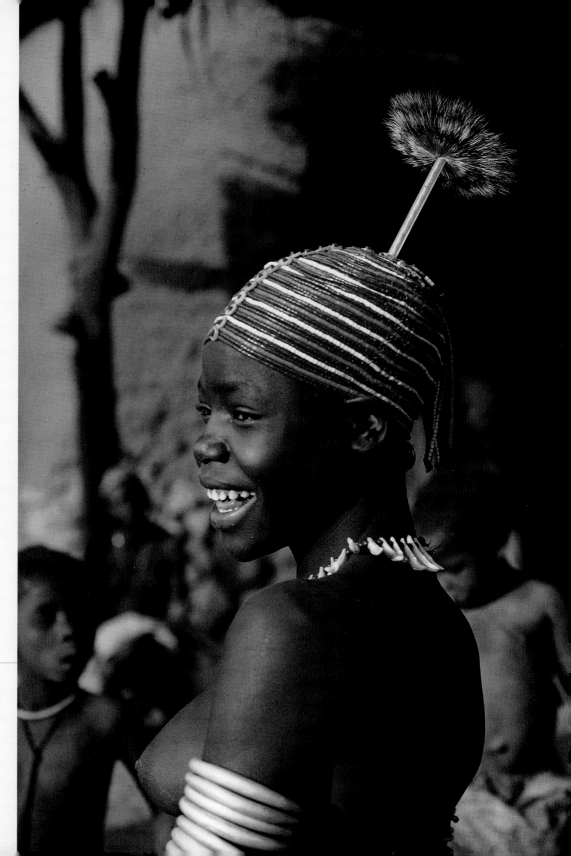

TANEKA
BENIN

Dressed in a headdress of white
feathers and red bamboo stalks, a
Taneka initiate displays his exhila-
ration in participating in the "dance
of force." To the accompaniment of
tam tam drums and iron bells, he
will dance through the night, right
up until the moment of his ritual
circumcision the next morning.
His ebullient mood helps
keep fear and anxiety at bay.

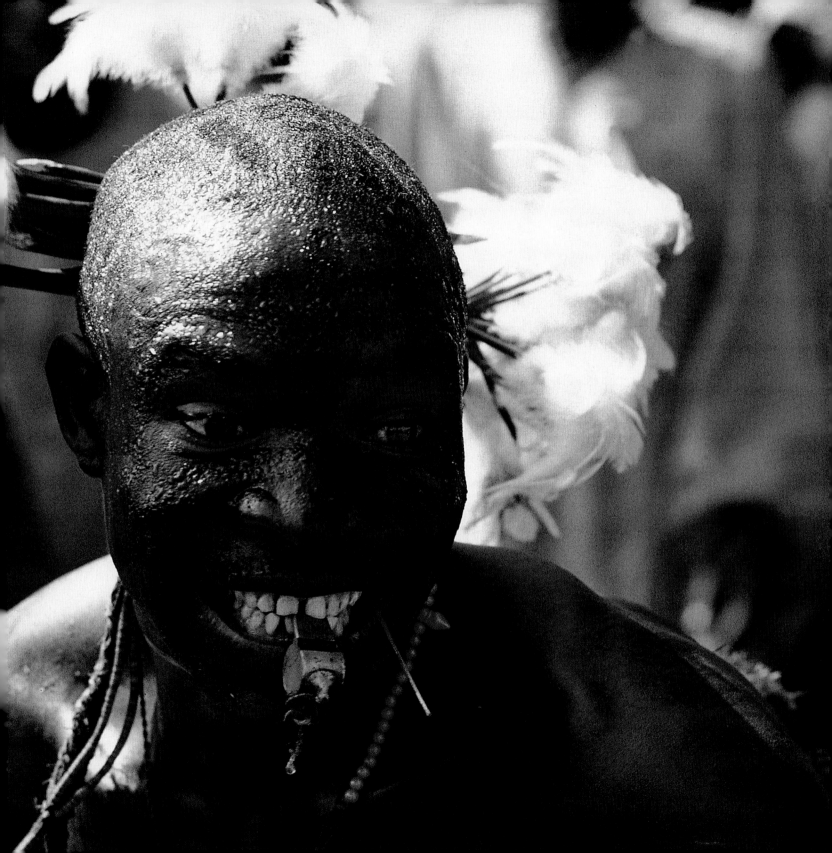

Dancing with gay abandon, a Bozo
woman gyrates to the rhythmic
clapping of a group of women
celebrating the baptism of a child.

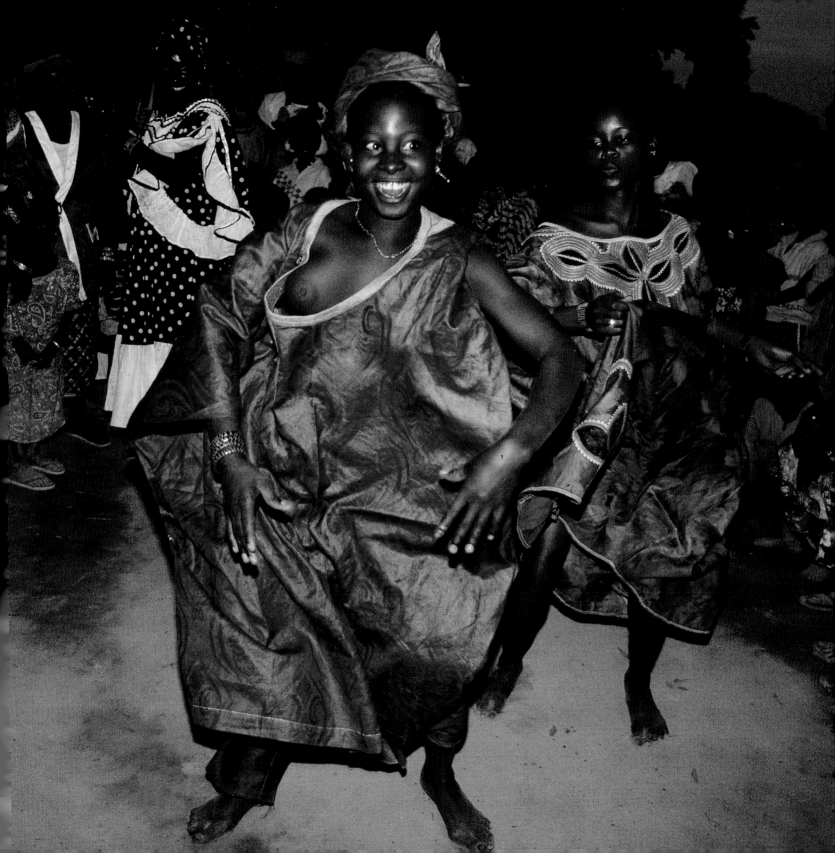

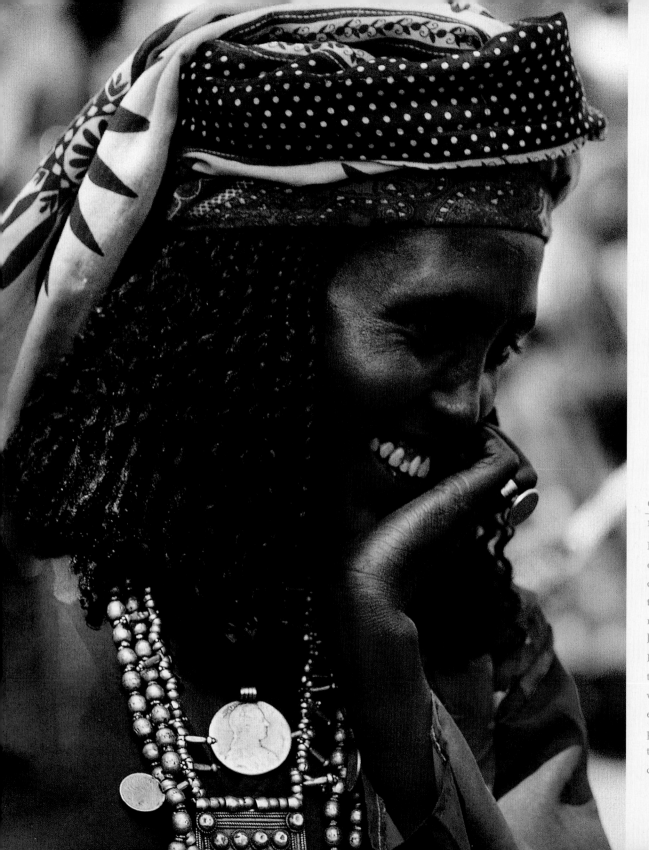

OROMO

ETHIOPIA

Left and right: A shy
expression of pleasure is
caught on the faces of
two Oromo women on
market day in the high-
land escarpment of
Ethiopia. Market day is
the time of the week
when friends meet,
exchange news, and
purchase such desirable
treasures as fine cotton
cloths and silver jewelry.

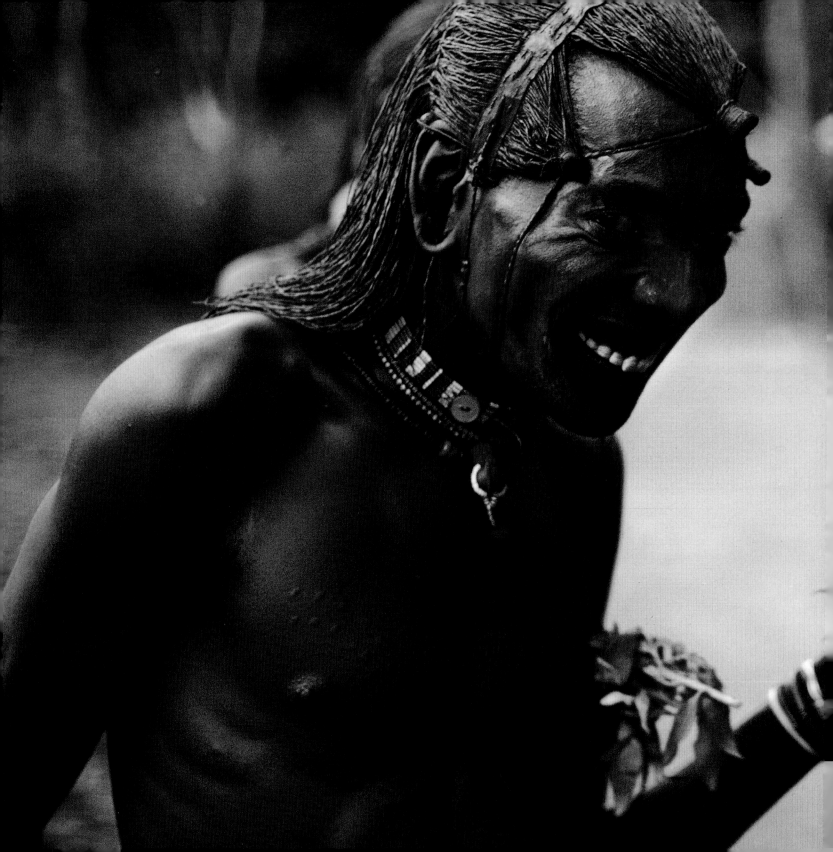

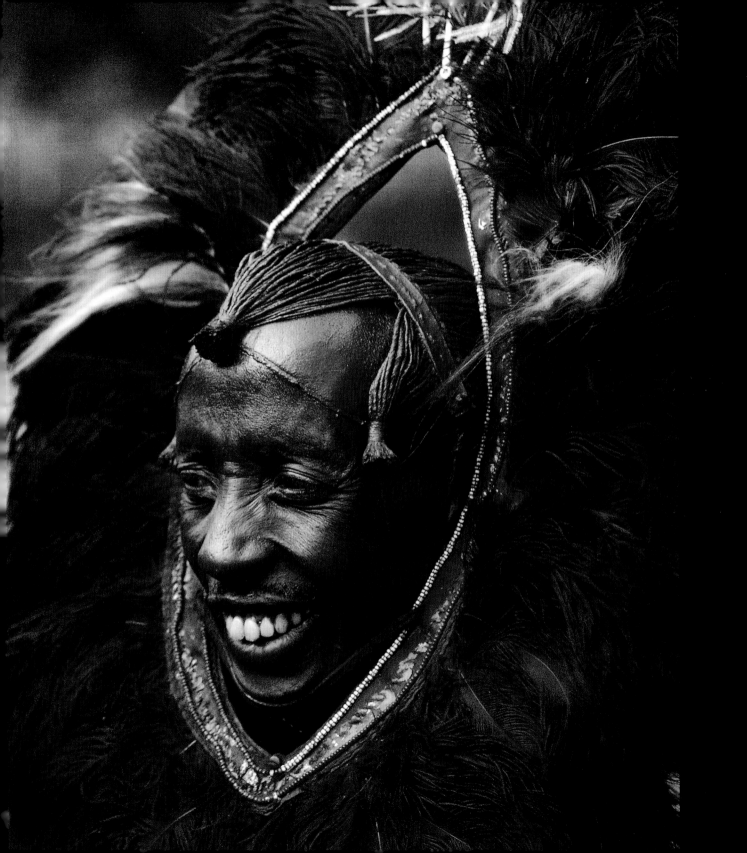

Preceding pages:

MASAI

KENYA

Two warriors express their delight
on hearing that we were not cir-
cumcised and therefore, according
to their code, available as compan-
ions and free to play. Through our
long lenses we were able to capture
their mischievous and seductive
glances, well-practiced during
warriorhood.

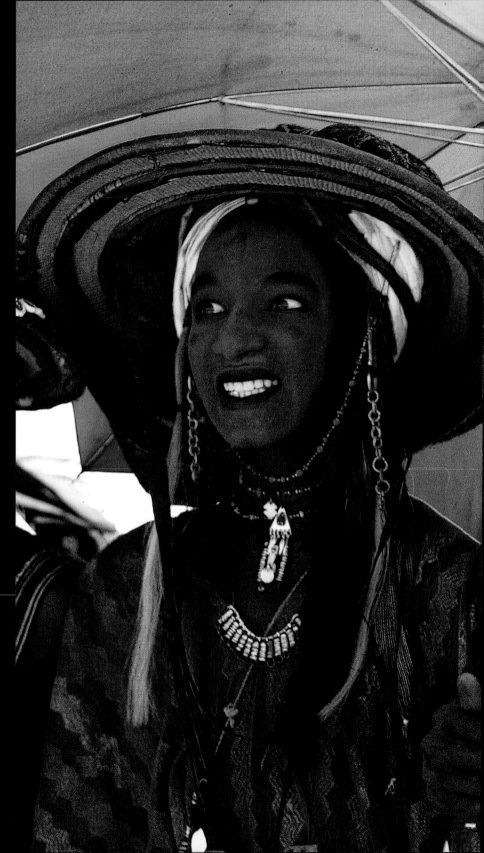

WODAABE

NIGER

The most joyful moment in a
Wodaabe man's life is when he is
chosen as the champion of the
annual Yaake charm dance. The
winner in the middle is showing off
his charisma by holding one eye
still and rolling the other from
side to side, making him more
irresistible to the female judges.

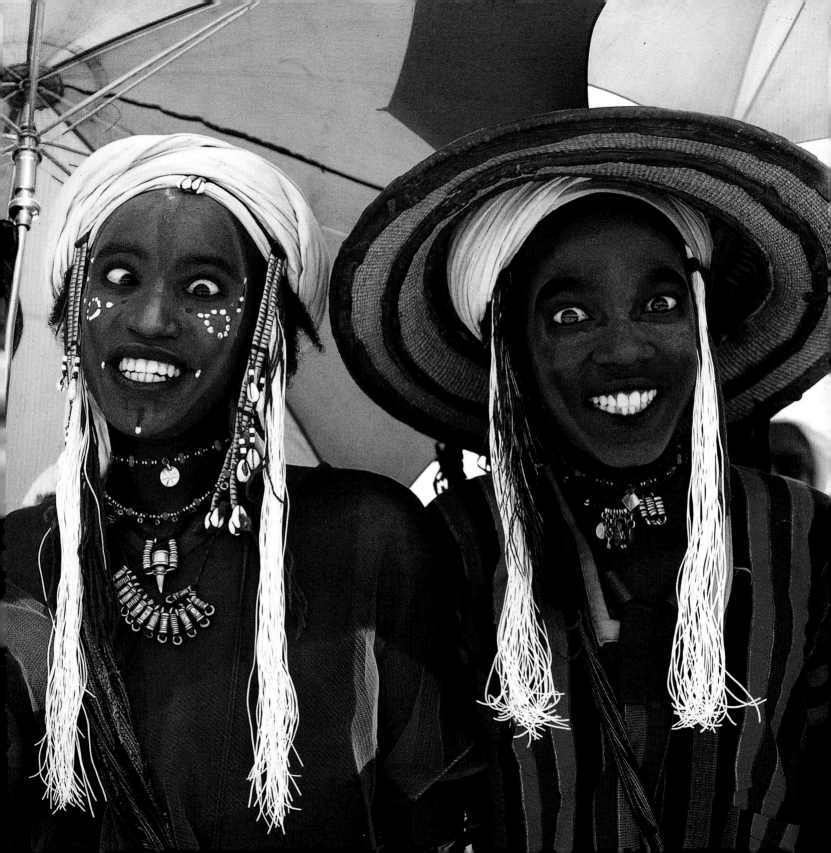

Two girls celebrate their
Outdooring ceremony in the final
stage of their three-week training
into womanhood. Dressed in
beautiful beads and finery, they are
on display for the approval of the
community, and are particularly
enjoying winning the hearts of
potential suitors. This is one day in
their lives when the girls are privi-
leged to wear their family's wealth
and show off with pride and excite-
ment their treasured Bodom beads.
Made of powdered glass, these
large yellow beads are worn in the
hair, and are highly prized for their
beauty and protective powers.
Our Krobo friends shared with us
the superstition that if you put a
Bodom bead in a glass of water and
place it at the entrance to an initi-
ate's bedroom, should a strange
man try to enter during the night,
the bead will bark like a dog.

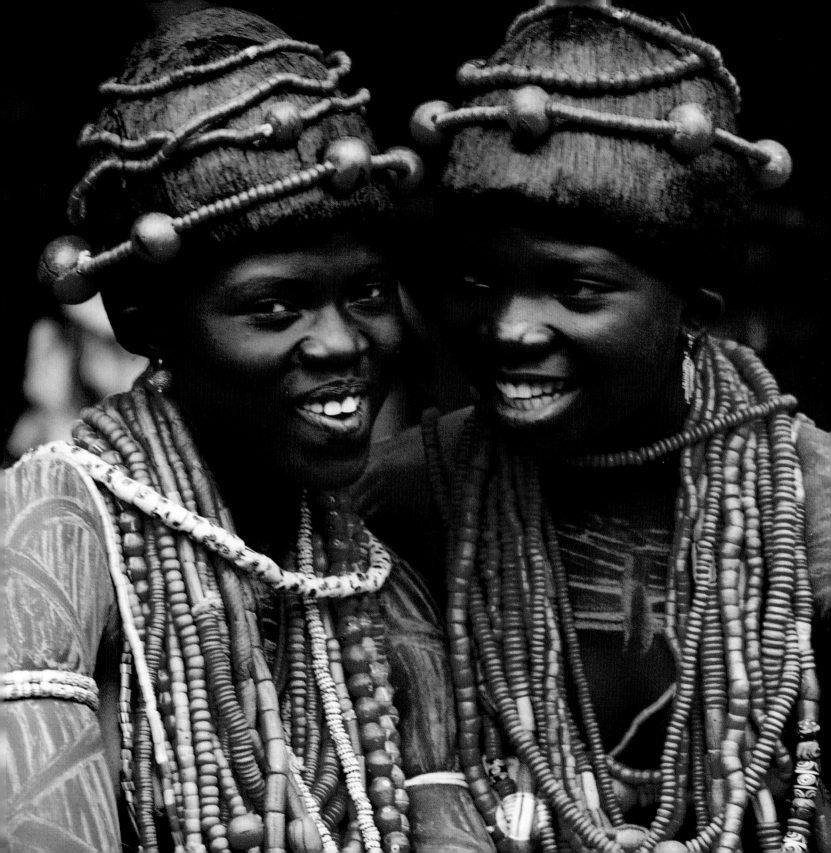

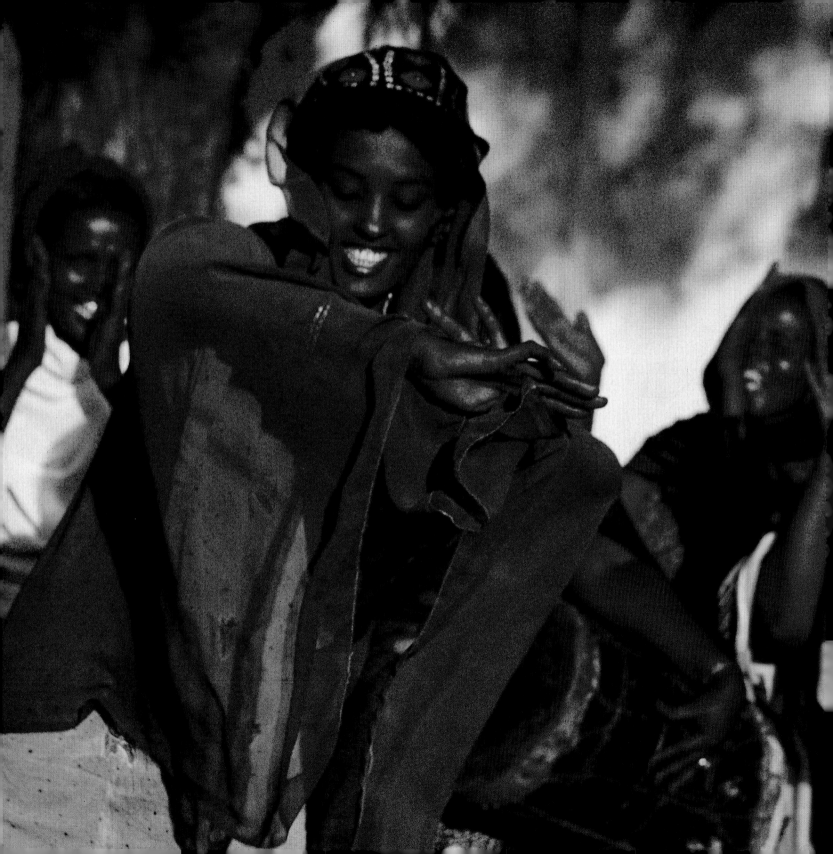

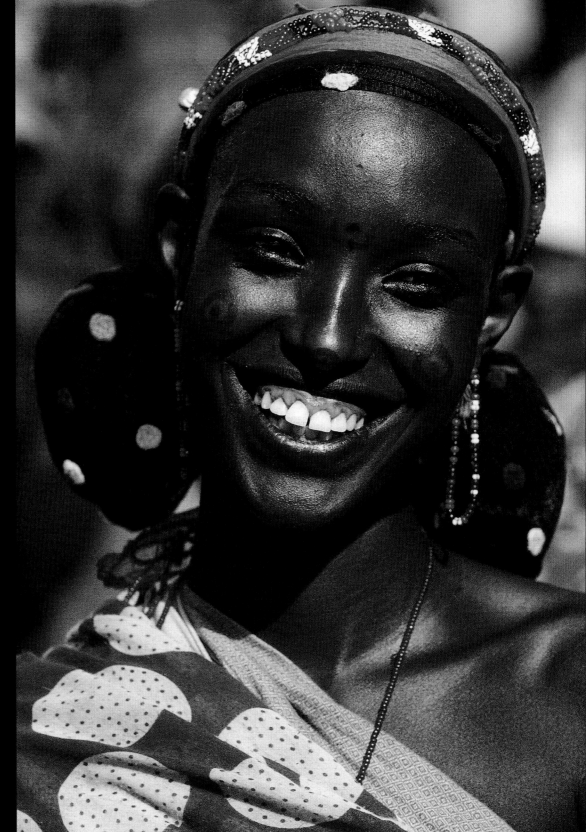

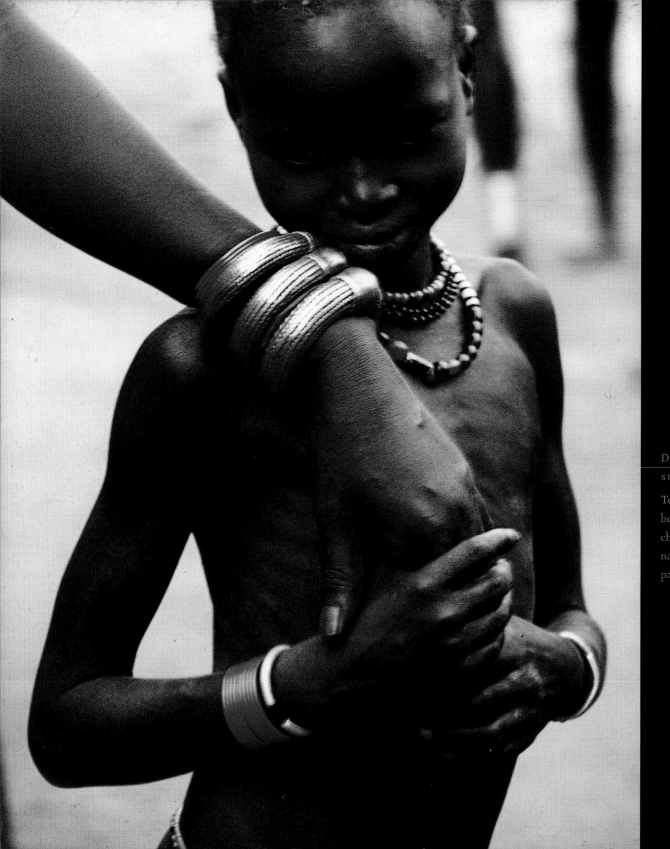

Tender touches
between a mother and
child reveal the gentle
nature of the Dinka
pastoralists.

AS WE WALKED TOWARD A RASHAIDA BEDOUIN CAMP IN THE ERITREAN DESERT, a group of women wearing silver embroidered veils met us. They took our hands in theirs, removed their delicate silver rings from their fingers, and placed them on ours as a gesture of welcome. Then, holding our hands, they led us to their desert camp.

One of the many pleasant surprises we experienced in our early days in Africa was the frequent and natural way Africans touched each other. Masai warriors preparing for a dance to celebrate their prowess in battle spent hours delicately braiding each other's hair and painting each other's faces. Dinka pastoralists in a remote desert camp, absorbed in watching a ceremony, leaned together with their arms draped around each other's shoulders. Two Oromo girls in a village market kissed each other tenderly on the lips in greeting. To this day, the African art of touching still delights and inspires us.

Touching in traditional African societies is much more than just a way of showing affection. In fact, it is often not about affection at all, but simply an elegant form of communicating in the most direct and deliberate way. For African people, touching is a natural outgrowth of the supportive relationships created by the extended family and age-grade system. Confidence in knowing that one is a valued and beloved member of a tightly knit community creates a trusting environment in which a wider and richer range of communication is possible. Emotional security encourages the physical freedom to express oneself without the inhibitions that prevail in the Western world. In Africa, we have learned that touching is a special language of its own.

ETHIOPIA

A baby girl tugs at the clay lip plate
inserted in her mother's lower lip.
We learned that the lip plate is
inserted just before marriage, and
its size indicates the number of
cattle required by a girl's parents for
her hand in marriage. This was one
of the largest lip plates we ever saw,
and we were amazed to see that
it was even larger in diameter
than the baby's head.

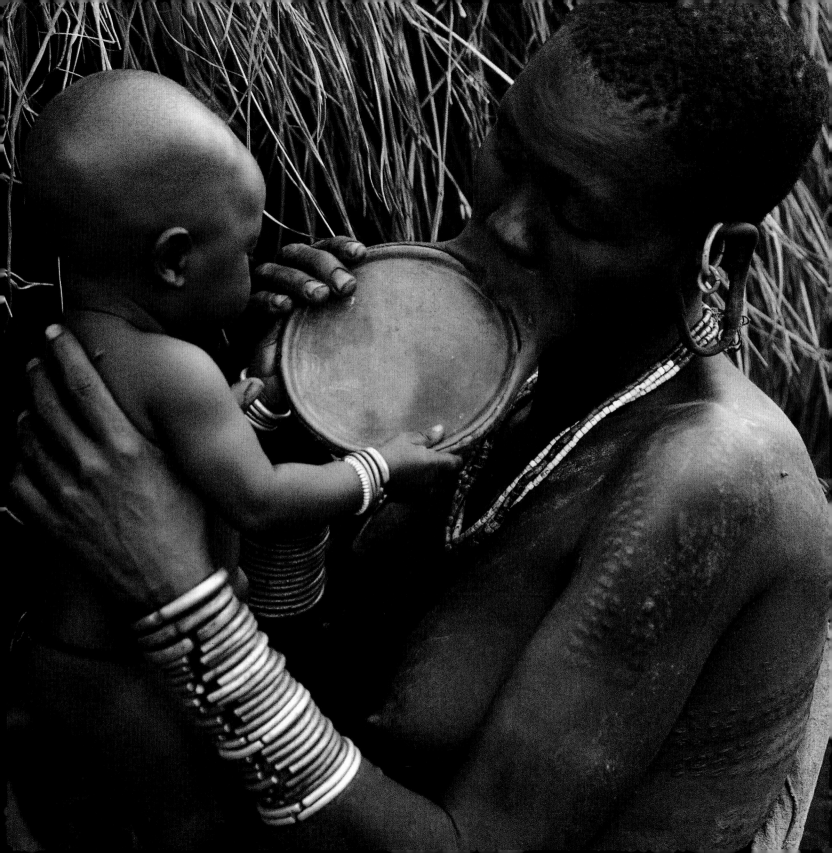

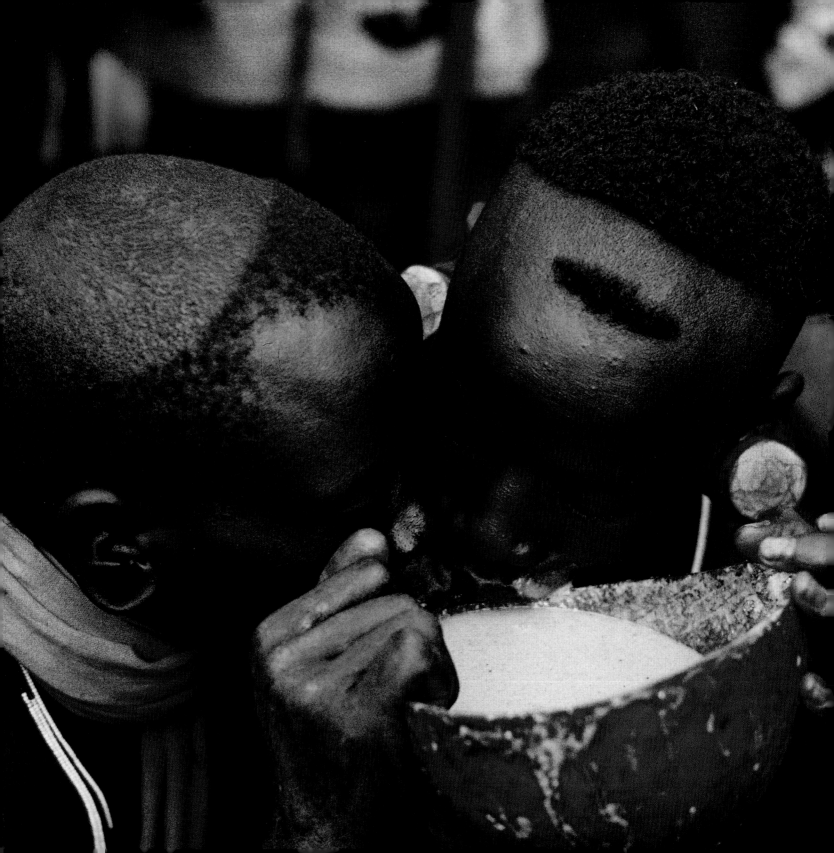

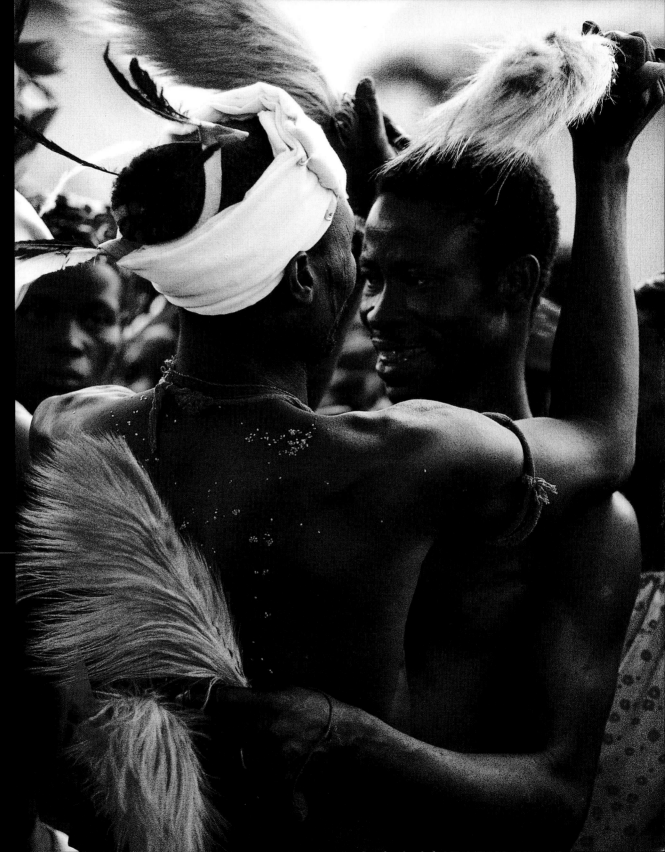

SURMA

ETHIOPIA

Two Surma age
mates drink millet
beer from a calabash
in the marketplace.
It is considered
taboo to eat or drink
on one's own, and
young men share
these activities as a
ritual of friendship.

TANEKA

BENIN

During male initia-
tion, an elder tests
the initiate's ability
to face the ordeal of
circumcision by
hugging him and
feeling his heartbeat.
If the initiate's heart
is racing, an herbal
draught is given to
calm him down.

ETHIOPIA

Two women greet each other
tenderly with kisses on the lips at
the Bati Market in the central high-
lands of Ethiopia. This form of
greeting is an acknowledgment of
close friendship among females in
this highly structured community.

Following pages:

MASAI

KENYA

Bonds of friendship formed during
their years together as warriors lie
behind the men's tenderness of
touch with each other. While apply-
ing ochre make-up to their recently
shaved heads, these age mates share
their transition into elderhood.

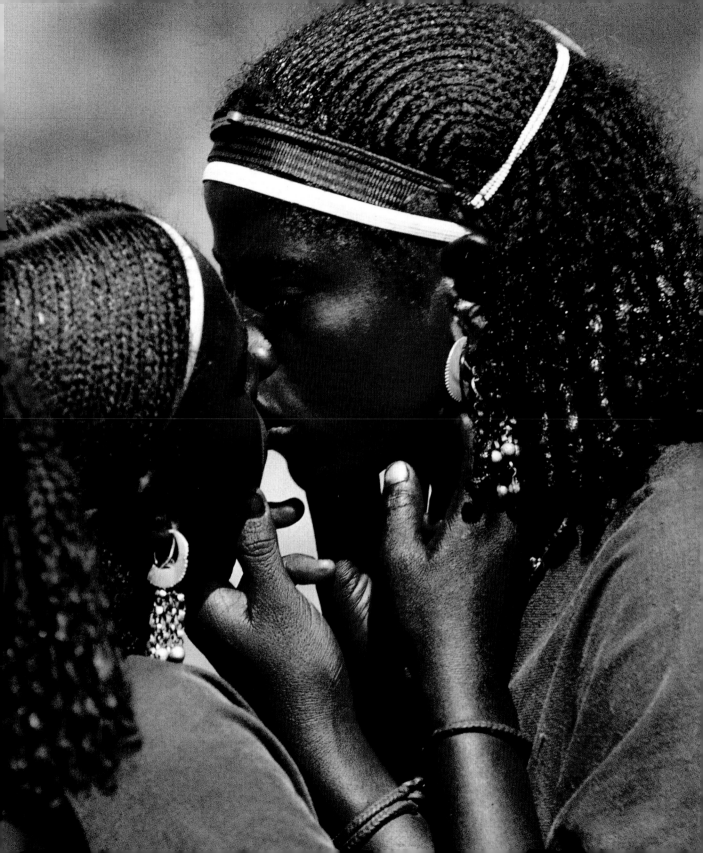

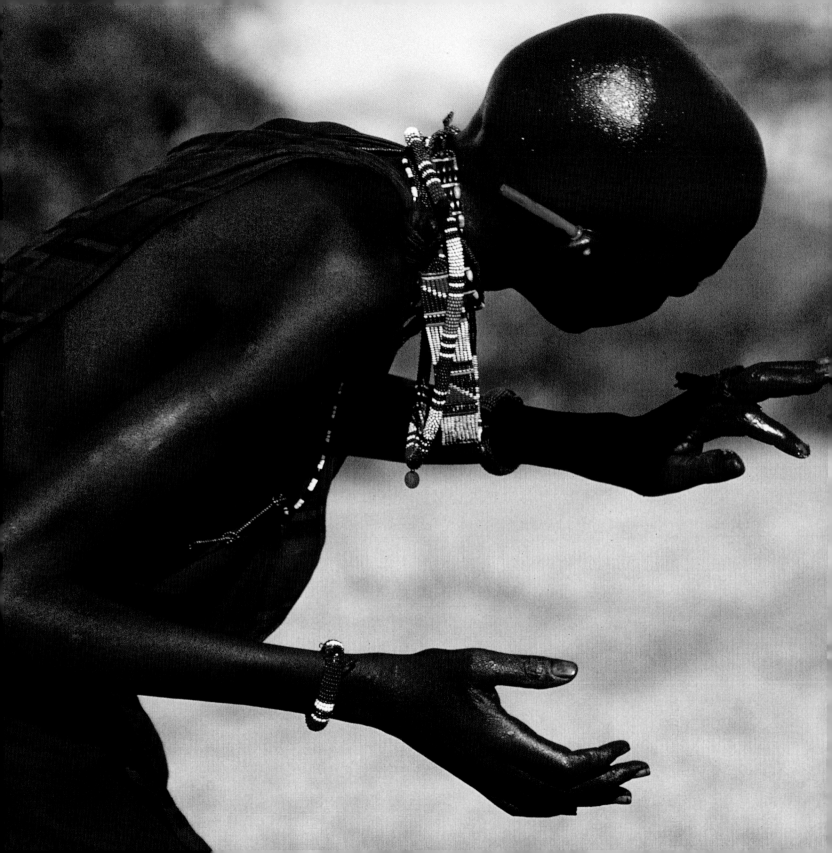

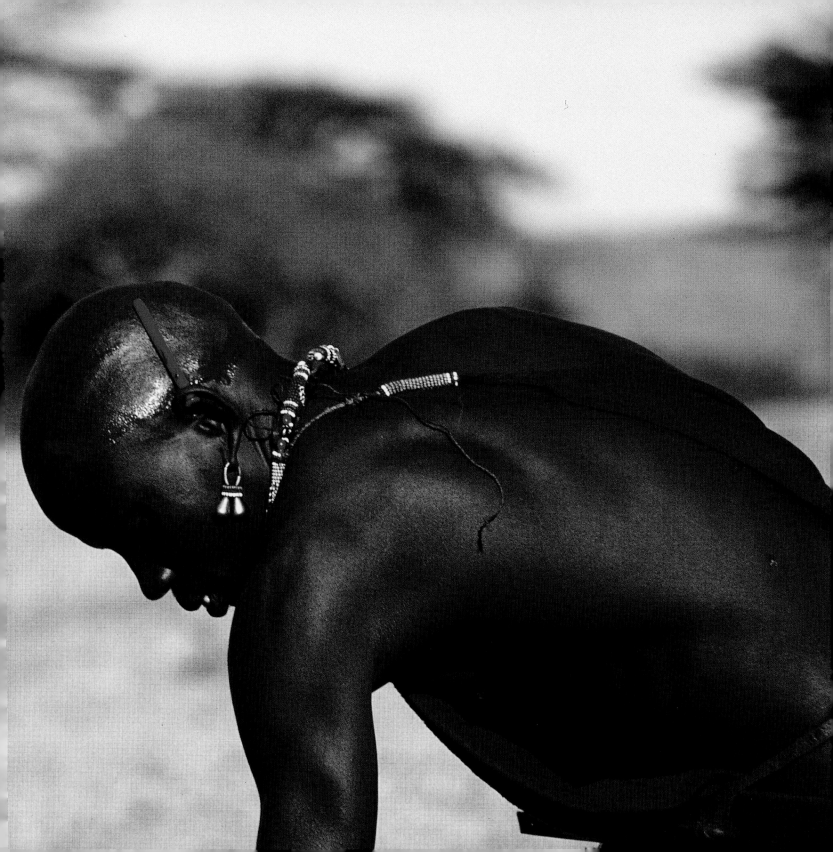

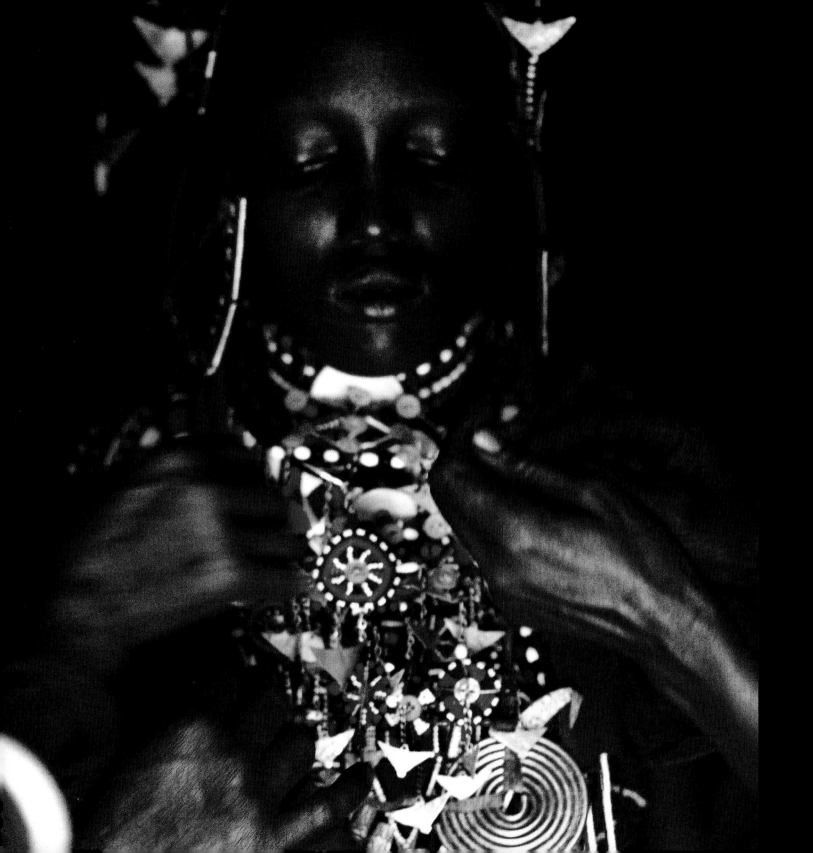

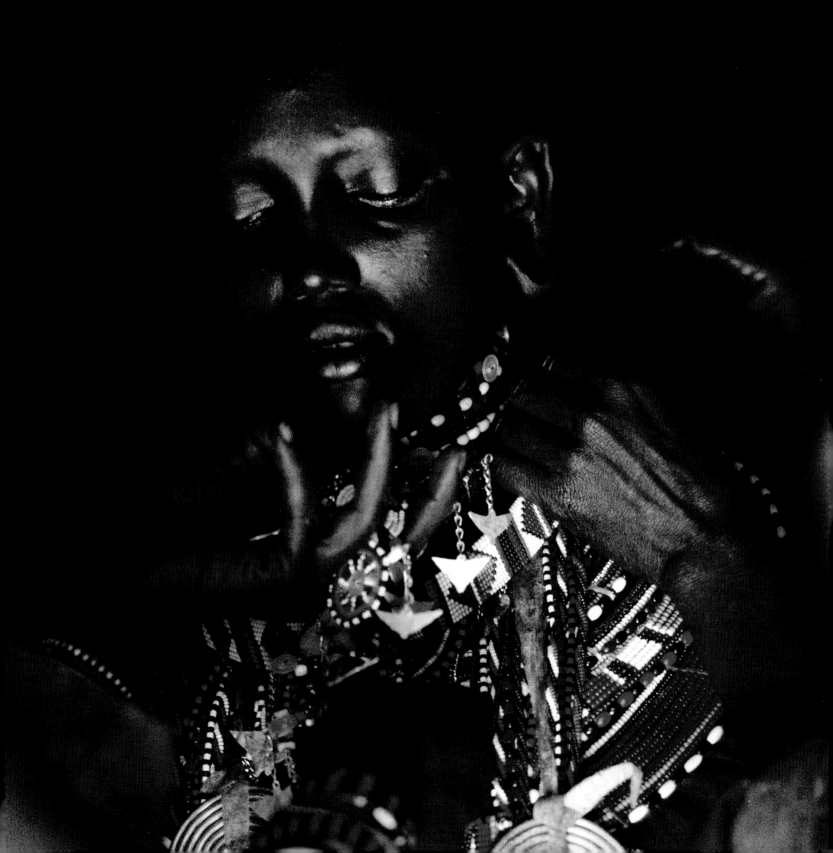

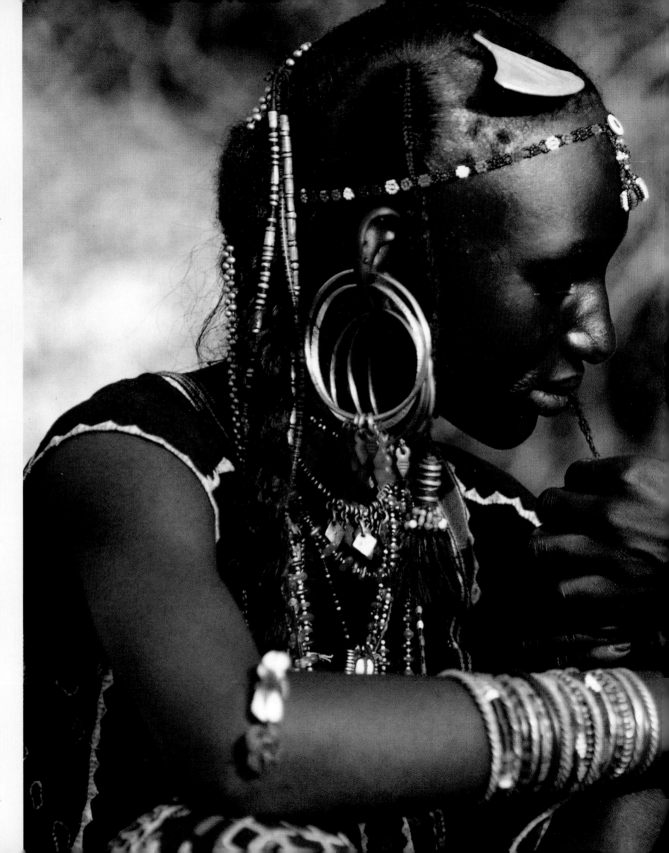

Preceding pages:

MASAI

KENYA

In the privacy of her
mother's hut, a young
bride is adorned with
layers of exquisite
jewelry on the day of her
marriage. Her mother
and female relatives
spend hours lavishing
attention on the young
bride, and their gentle
touch helps ease her
anxiety as she prepares
to leave her childhood
home and begin
a new life.

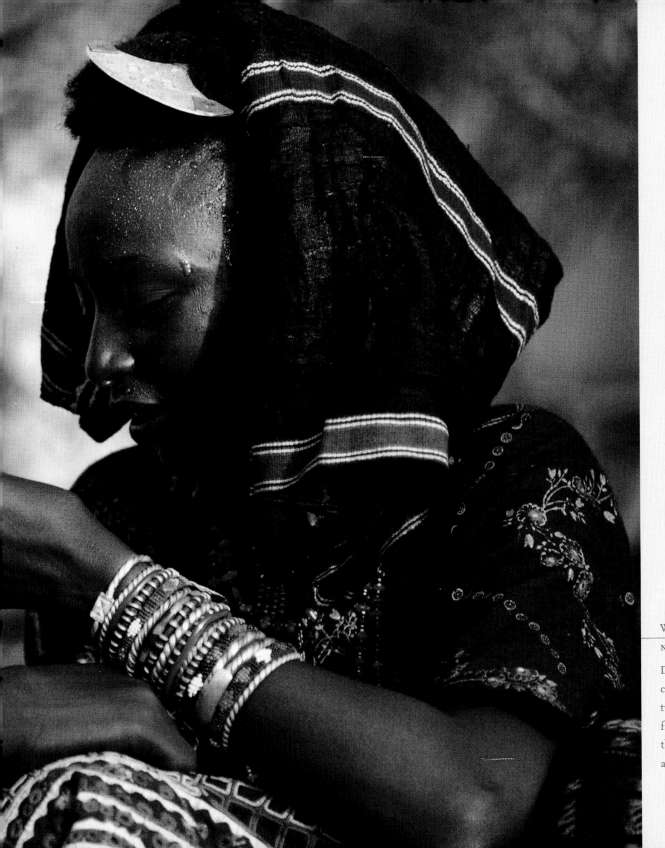

WODAABE

NIGER

During the Geerawol
courtship ceremony,
two young women put
finishing touches to
their delicate jewelry
and finely braided hair.

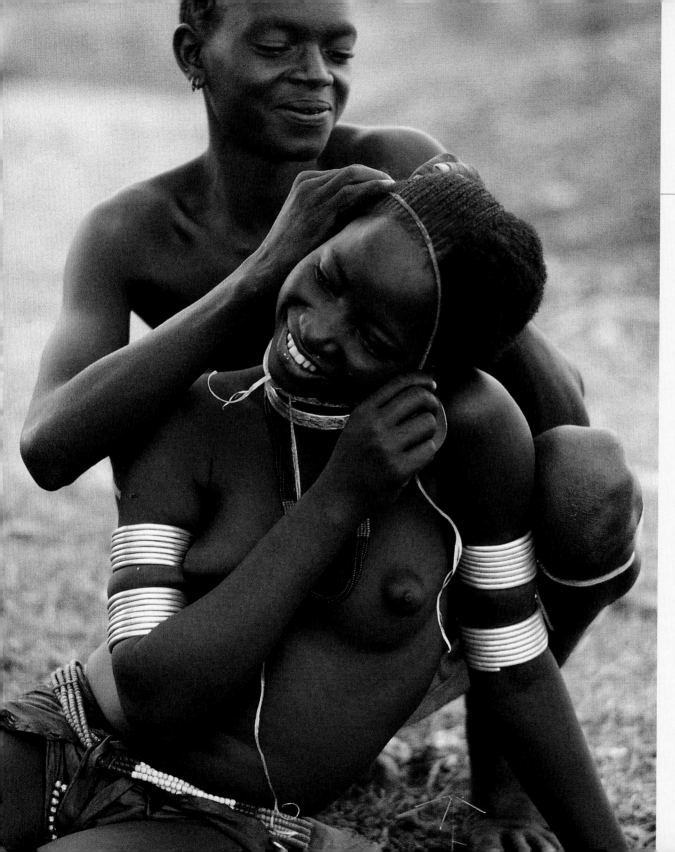

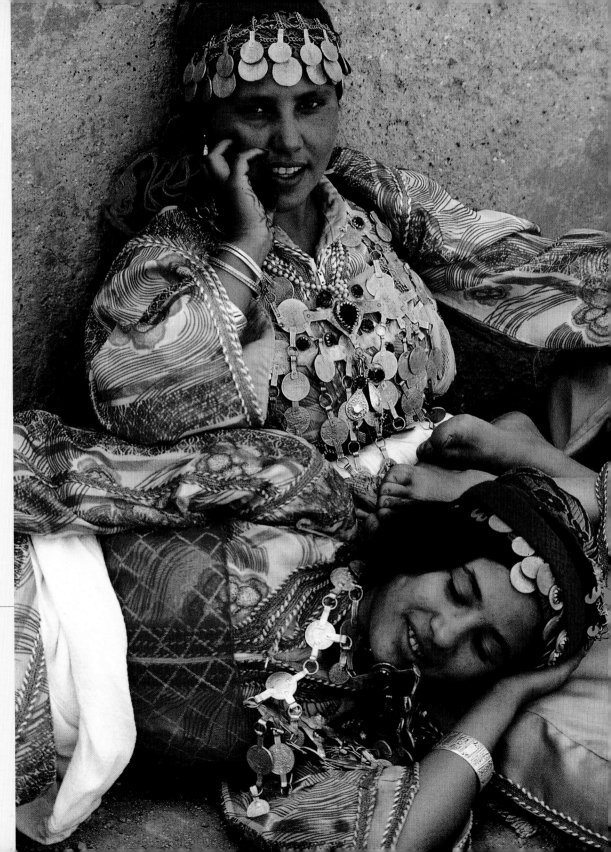

BERBER

MOROCCO

The relaxed body
posture of two girls at
the folk festival in the
High Atlas Mountains
is a typical expression
of friendship and
camaraderie between
Berber females.

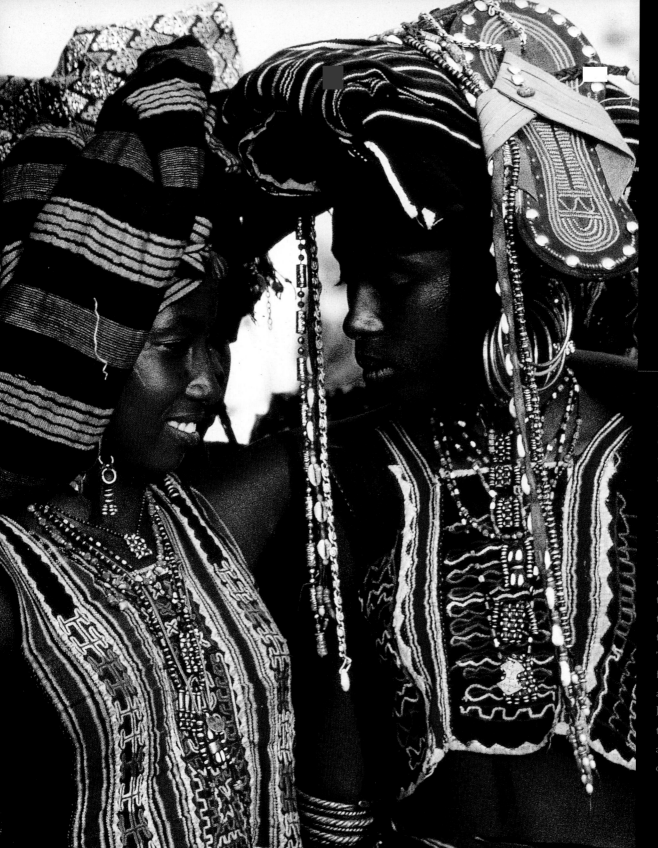

WODAABE

NIGER

A young girl draws her friend closer to secretly discuss the merits of the various male charm and beauty dancers.

RASHAIDA

ERITREA

Right: Two women exchange confidences through their veils at the marriage celebration of their friend. They have been veiled from the age of five, and are required by the law of purdah to cover their faces when they are in the presence of men.

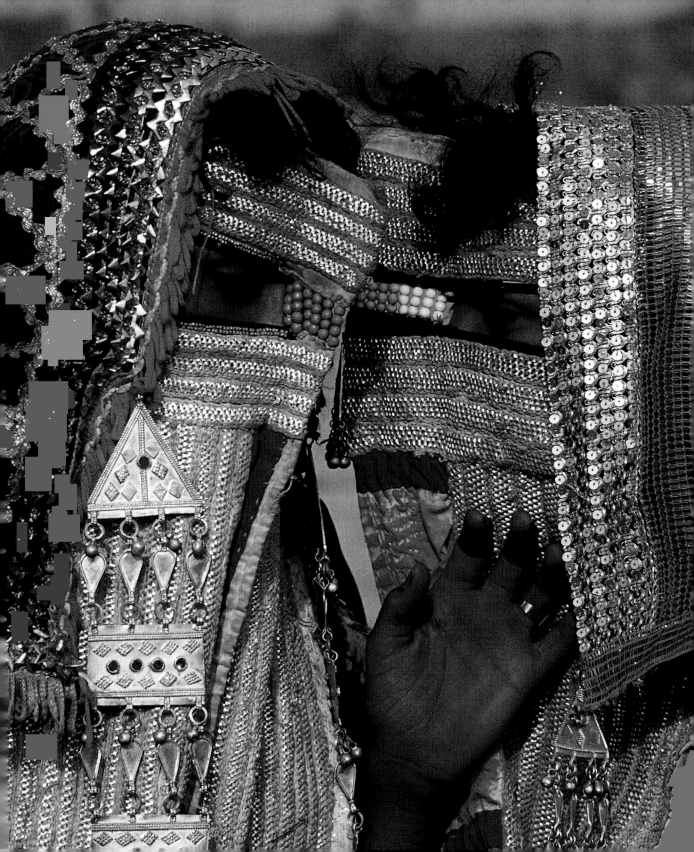

During the Gelede masquerade
festival, two masked dancers kiss to
portray the danger of uncontrolled
romantic passion. Beneath the
patterned blue cloth of the dancer
on the left is a large, carved
pregnant belly showing the results
of unbridled love. As the dancers
perform, the pregnant tummy
serves as a reminder to the young:
Pregnancy out of wedlock is taboo.

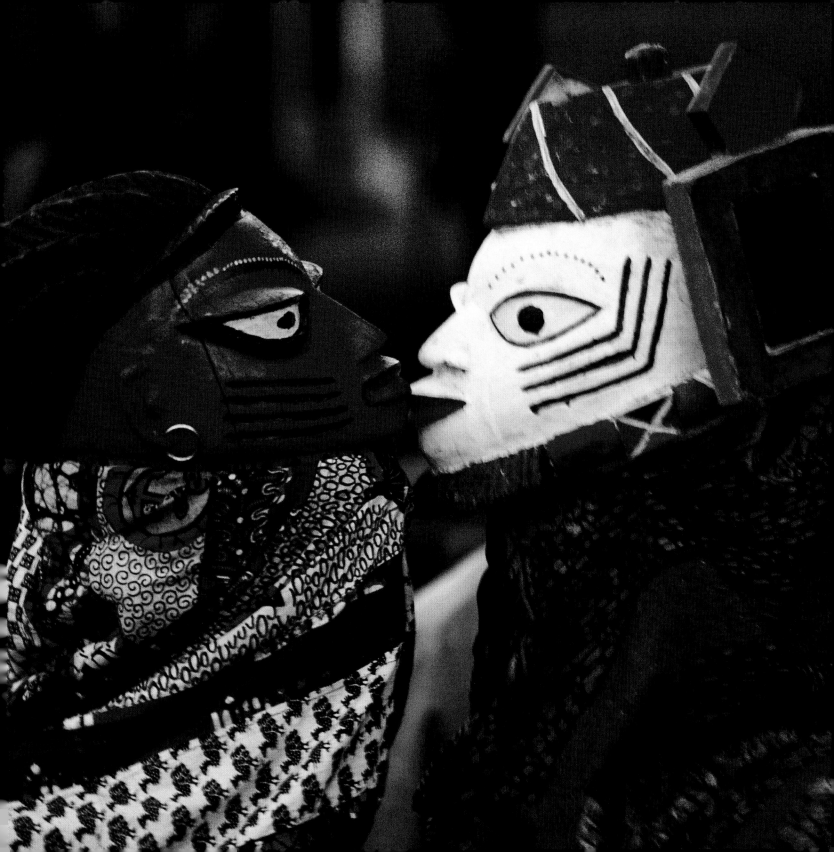

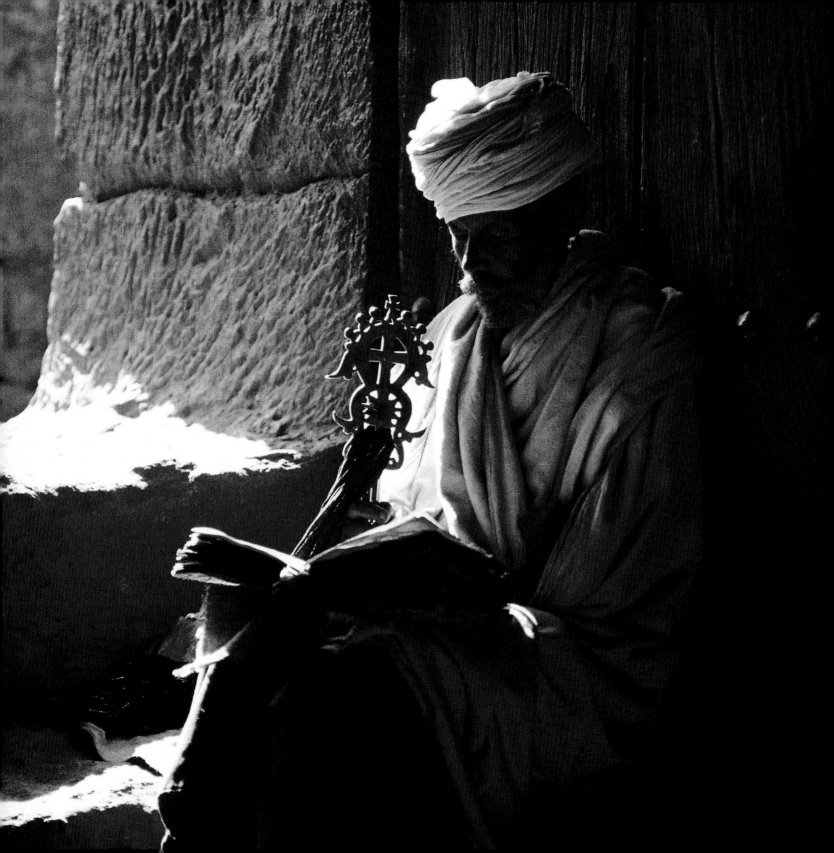

"YOU WESTERNERS CANNOT UNDERSTAND THE POWER OF SPIRITS, BECAUSE YOUR EARS ARE CLOSED TO THE DIN OF THE SPIRIT WORLD." So said our spiritual guide, West African shaman and teacher Malidoma Somé.

One of the most challenging aspects of our study of African traditional cultures has been to understand the role of religion and ritual in everyday life.

The spiritual journey of traditional Africa is a complex one, composed of many layers. There is the physical world that one experiences with the five senses. Then there is a remote realm where the creator god dwells. Somewhere between these two lies a shadow world, where the spiritual counterparts of all things on Earth—humans and animals, trees, rocks, and rivers—live in a parallel universe. Here in this shadow world, the spirits of all things past, present, and future play an active role in all aspects of daily life.

This belief in an interactive spirit world has been called animism, and animism influences many aspects of traditional African religious life. Enriching the traditions of spirituality on the African continent is the added layering of other ancient religions, such as Judaism, Islam, and Christianity. Although all of these religions arrived in Africa centuries ago, and millions of Africans today practice a heartfelt devotion to them, it is a rare convert who does not still feel the influence of animism to some degree in his or her daily life. African traditional religion still influences every aspect of life, and for many Africans today, it brings profound meaning and inspiration to their lives.

AMHARA
ETHIOPIA

Priest Yitabarak reads peacefully from the Kidan, the New Testament, in the early morning light at St. Gabriel church in Lalibela.

INNER JOURNEYS

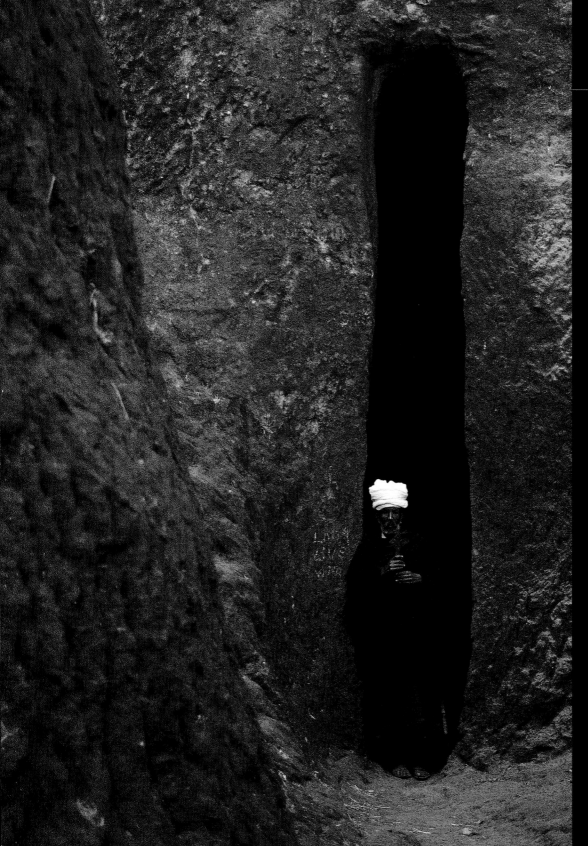

Priest Yitabarak stands at the
entrance to one of the many
chiselled pathways that join the
12th-century rock-hewn churches of
Lalibela. Christianity found shelter
in this mountain stronghold, where
religious practices went literally
underground for protection against
Islamic invasion.

A pilgrim reads from the Psalms
of David—the most popular
prayer book among the Christian
Orthodox of Ethiopia. His wooden
cross is a reminder of the cross
on which Jesus was crucified, and
his staff symbolizes the staff with
which Moses struck rock in the
wilderness to provide water for
the children of Israel.

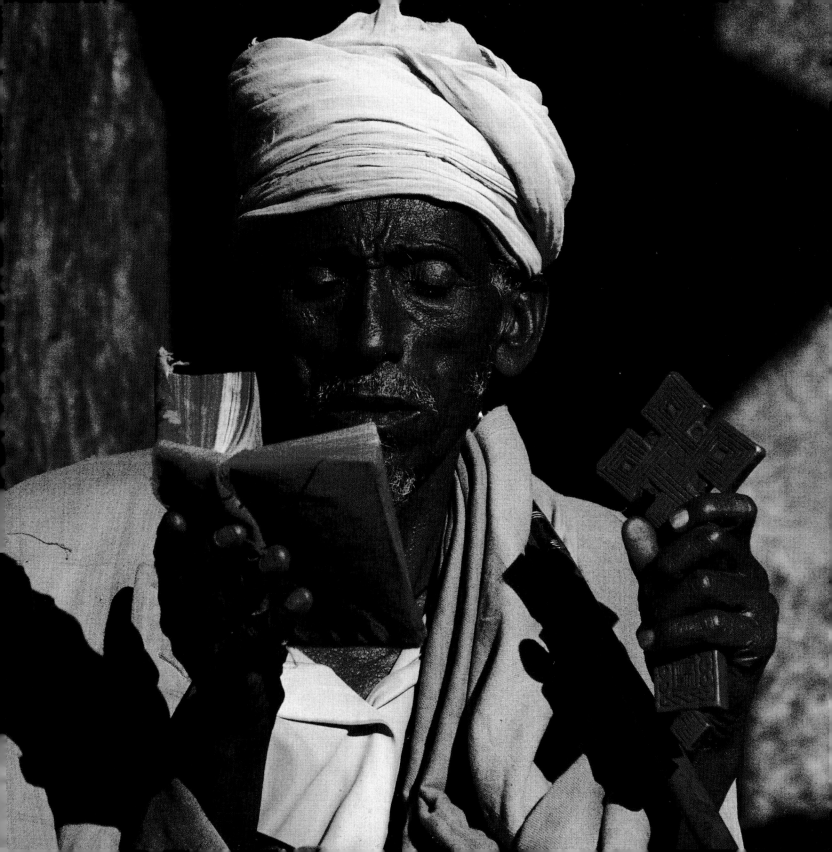

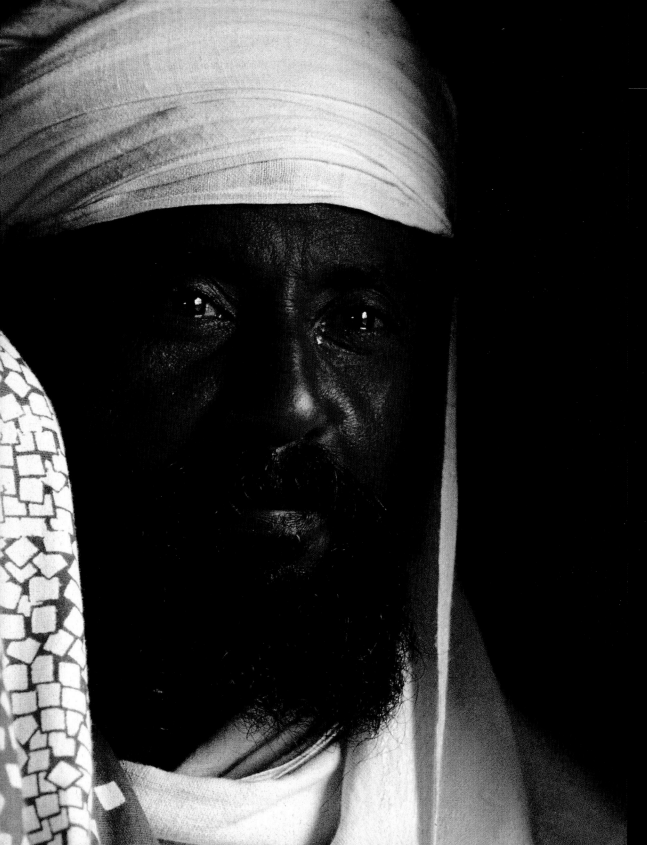

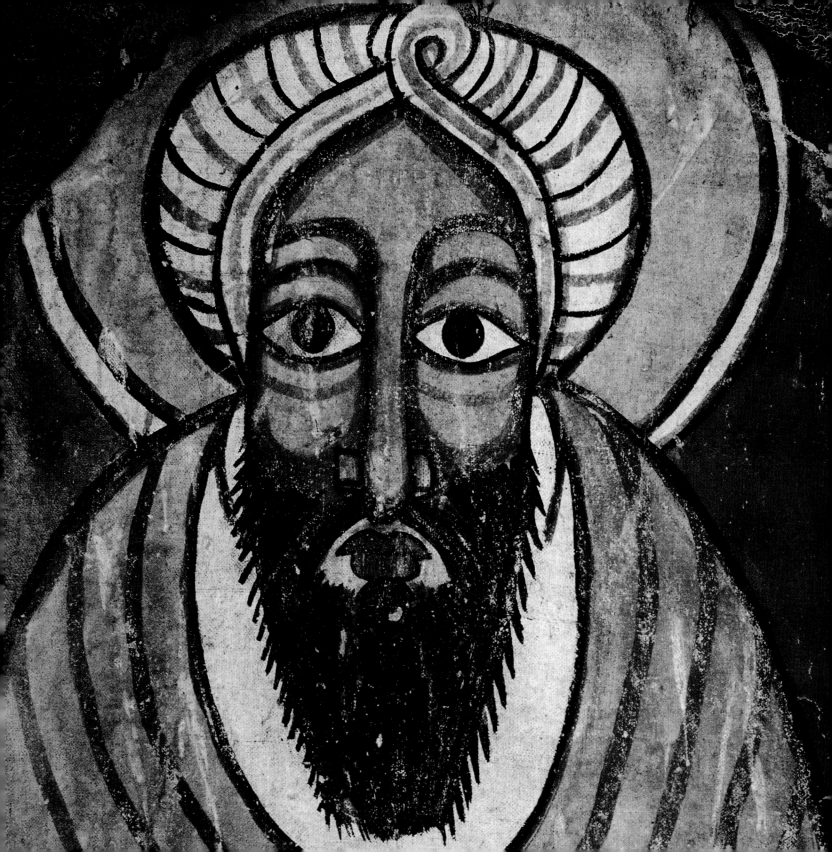

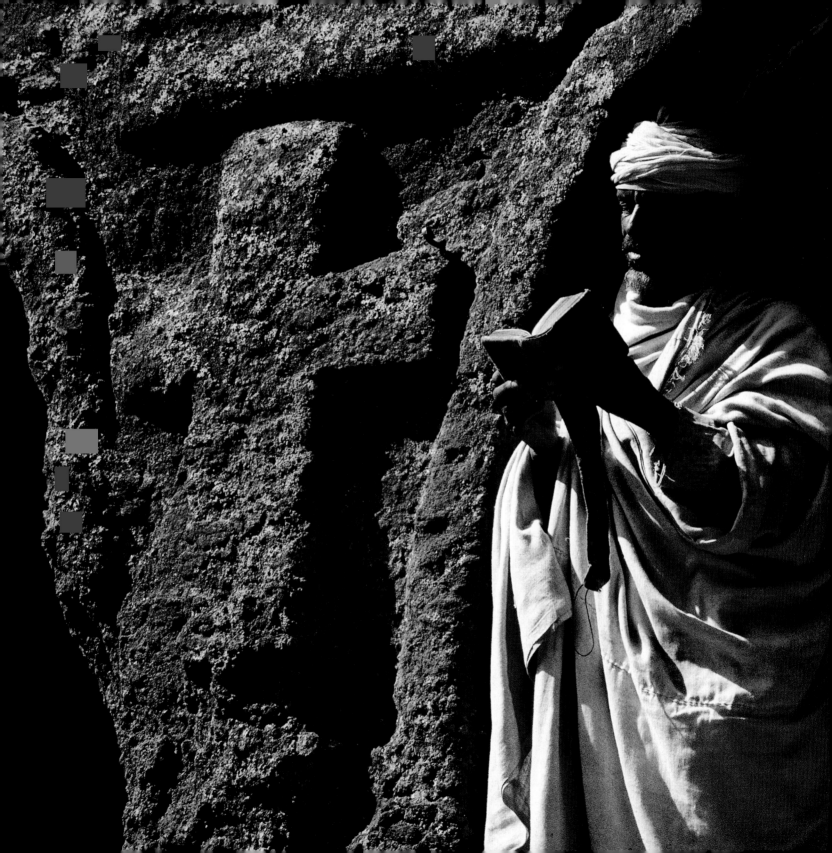

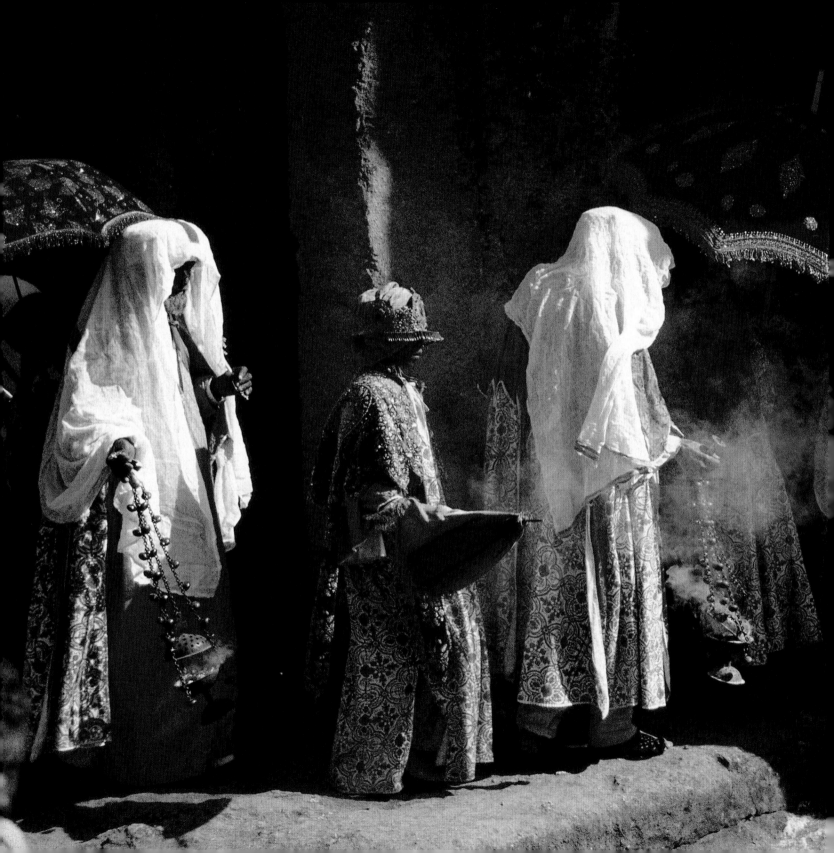

Preceding pages:

AMHARA
ETHIOPIA

A pilgrim reads the Psalms
of David outside Geneta
Mariam Church. The 13
rock-hewn churches of
Lalibela are renowned for
their carved window designs
and incised walls patterned
with arches and crucifixes.
An architectural feat
inspired by Christianity,
Lalibela is believed by many
to be the 8th wonder of
the world.

AMHARA
ETHIOPIA

Genna (Christmas) falls on
January 7, according to the
Ethiopian Julian calendar,
and is one of the most
important celebrations of
the Orthodox Church.

"AT SIX IN THE MORNING ON CHRISTMAS DAY,

pilgrims gather in the sunken courtyard of Beta Mariam. Priests and deacons parade around the church, wearing soft brocade robes, shaded by velvet umbrellas, and swinging censors filled with frankincense and myrrh. They encircle the church and join other priests from neighboring churches, moving counterclockwise around the upper wall of Beta Mariam. Stopping at intervals to sway back and forth to the sound of sistra and drums, the priests chant down to the worshippers below, who call their responses back. Their exchange symbolizes the union of heaven and Earth and the dialogue between God and man. Genna in Lalibela was a moving spiritual journey we will never forget."

An excerpt from our diary describing Christmas morning at Beta Mariam Church in Lalibela on January 7, 1985.

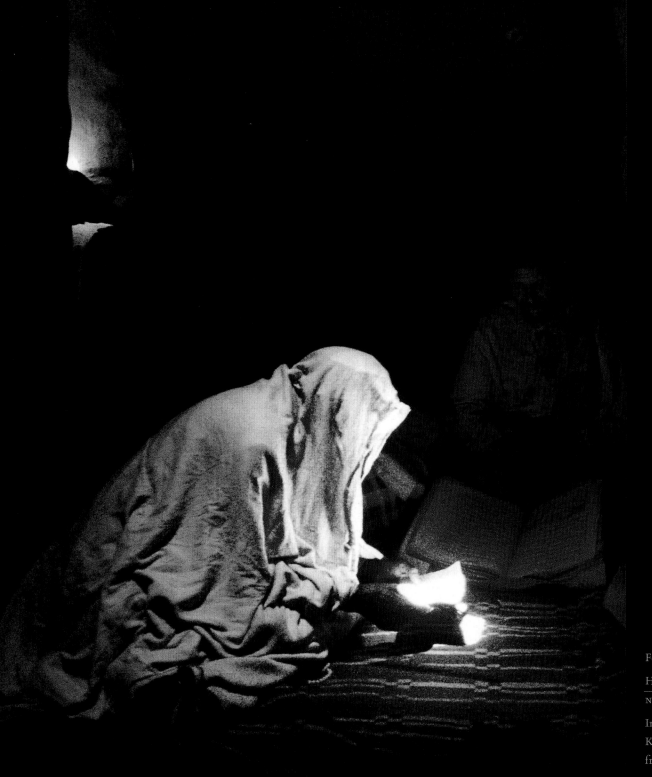

Following pages:

In a deep trance, healer
Katjambia chants in
front of the sacred fire.

Oromo

ETHIOPIA

Left and right: In the ancient mosque built by Sheikh Hussein himself, sheikhs, imams, and hajjis sit in the inner sanctum reciting passages from the Koran. The pages of their books are illuminated by narrow shafts of light that pass through openings in the ceiling of the mosque. Twice a year, up to 50,000 pilgrims come from as far as 600 miles away to celebrate the death of Sheikh Hussein and the birth of the prophet Muhammed.

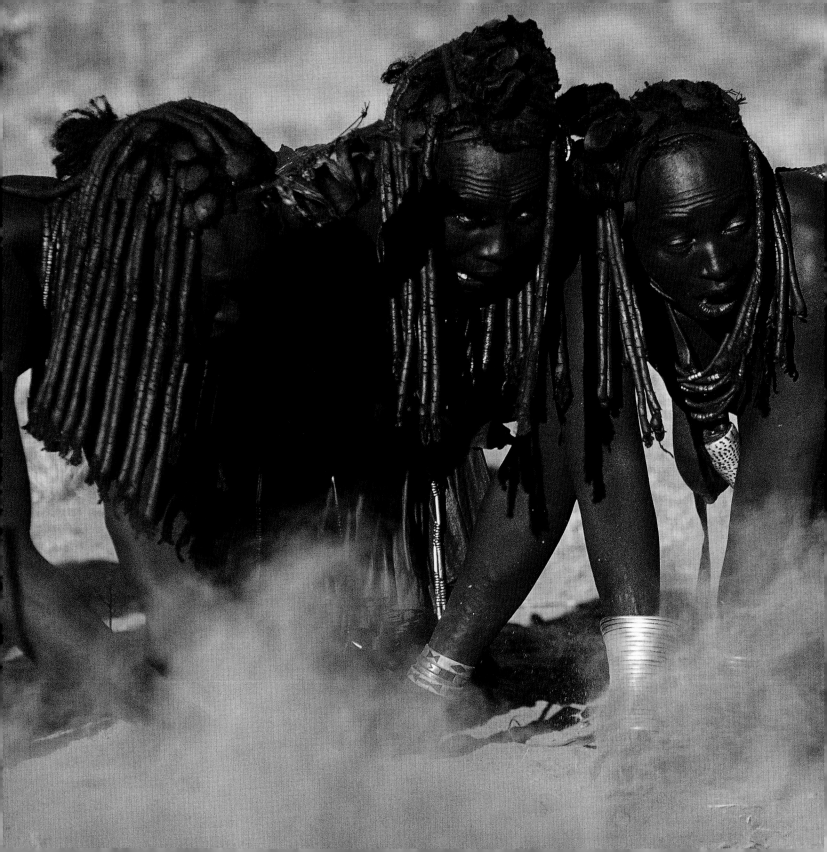

IN NAMIBIA, WE WERE HONORED TO TRAVEL WITH

KATJAMBIA, a six-foot-two-inch, highly intelligent woman who was the most renowned healer among the Himba people. For two weeks, we walked with her in the semiarid pasturelands of Kaokoland as she visited people in need. She explained to us that the Himba believe all sickness is brought about either by a curse carried by a black bird from Angola or by a premature calling coming from the ancestor world.

One of the most remarkable things we have ever witnessed in Africa occurred during this journey with Katjambia. One day we came across three women possessed by the spirit of a lion sent to them by their deceased husband—who had been killed by a lion and was believed to be calling them to join him in the afterworld. Growling and snarling, they crawled around on the ground on all fours, their knees cut and bleeding.

Shaking her healing rattle, Katjambia managed to identify the curse, exorcise it from the bodies of the women, and absorb it into her own body. But it was too strong for her to expel. She indicated that she wanted to return to the sacred fire in her own compound—a fire containing the powers of three generations of ancestors. For six hours we watched Katjambia (possessed by the lion spirit), sway and chant in strange tongues in front of the fire, praying to the ancestors for help. Then suddenly, at two in the morning, a shaft of light flashed from her head and disappeared into the darkness. Her body started to relax and she silently lay down. To our amazement, we may have captured on film the exact moment when the lion spirit left her body.

Himba

Namibia

Three women are possessed
by the lion spirit.

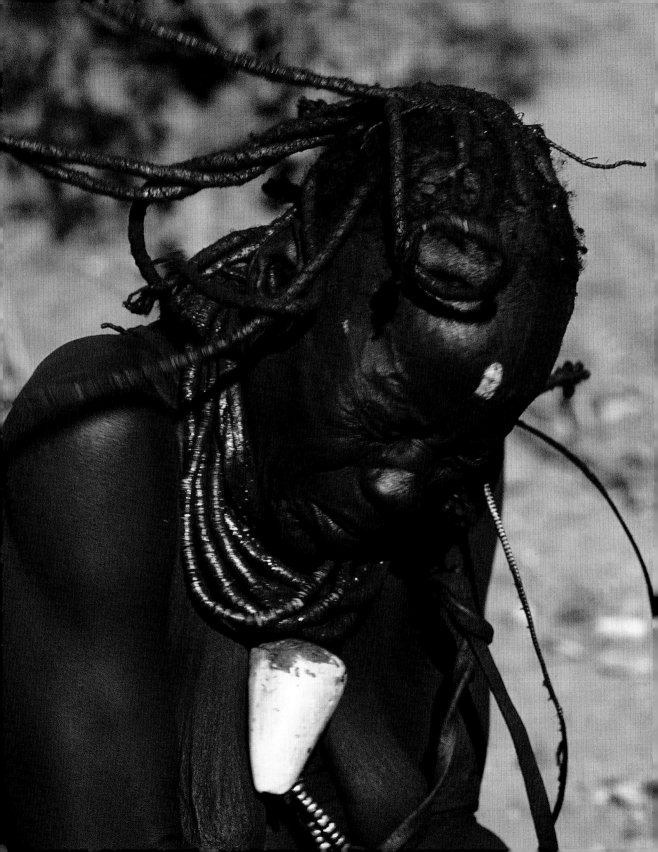

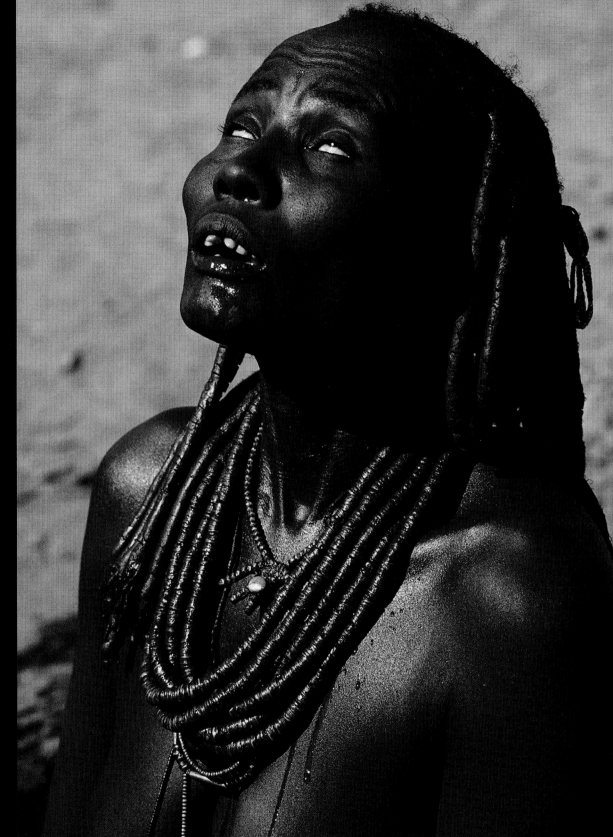

HIMBA

NAMIBIA

Left: An elderly woman suffers from chest pains and internal bleeding. Katjambia shakes a calabash rattle to agitate and identify the curse inside her. In a frenzied state, the woman expels the curse from her body and Katjambia absorbs it into her own.

Right: Possessed by the curse, Katjambia enters a trance state. Using her powers of healing she frees herself of the curse, and within 20 minutes her body relaxes.

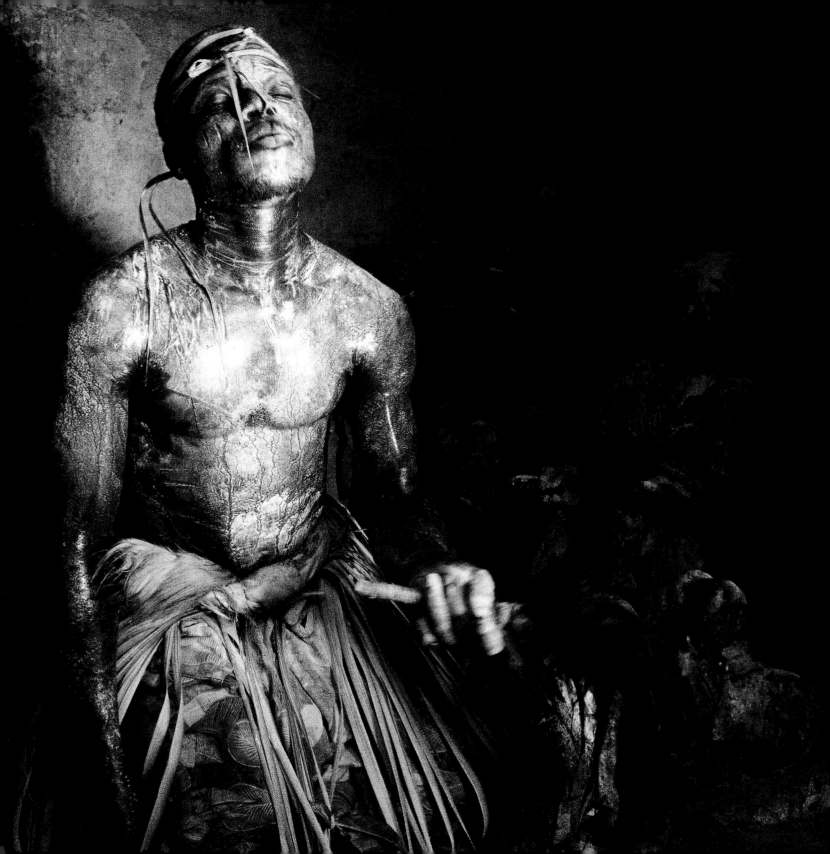

Preceding pages:

Ewe

TOGO

Two fetish dieties in the Voodoo healing hospital in Seko: Agbakpan (left) deals with problems of male virility, and Gabara (right) cures female lovesickness.

IN THE WORLD OF VOODOO THERE ARE THOUSANDS OF DEITIES, some embodied in sculptural figures, and others in amorphous mounds of earth. In the Voodoo healing hospital in Seko, one of the most powerful centers of healing in west Africa, we visited many shrines containing deities who dealt with every conceivable form of illness—often those beyond the reach of Western medicine.

In one of the shrines (preceding pages) we saw a guardian in a semitrance watching over a clay healing god covered in white kaolin powder. The deity, Agbakpan, whose erect penis symbolizes new life, is consulted by men with problems of virility and fertility. Gabara specializes in lovesickness and broken hearts and is popular with females in distress. Offerings of cigarettes, gin, kola nuts, and perfume are given to the deities to release their powers and facilitate the healing process.

We watched Tata, the fetish priest, put a cigarette in Gabara's mouth in order to excite her and release her healing powers. He then backed toward the wall, and under a shaft of light closed his eyes and fell into a trancelike state. He was channeling Gabara's spirit so as to receive instructions from her to give to a female patient who had come to consult him. A long silence passed as he journeyed within, then suddenly opened his eyes and spoke in a completely normal voice. He handed the girl the lit cigarette from Gabara's mouth and requested a sacrificial offering of a chicken. He also gave her special dietary restrictions, which she acknowledged gratefully—understanding that it would release her from the jealousy she had been suffering since her husband took a second wife.

Ewe

TOGO

Priest Tata channels the power of a diety at the Voodoo healing hospital in Togo.

IN AUGUST 1995 WE WERE HONORED TO BE TWO OF ONLY SIX PHOTOGRAPHERS FROM THE OUTSIDE WORLD invited to the anniversary of the Ashanti king's reign, an event attended by 70,000 people.

As photographers we had learned how important it is to arrive well before a ceremony to get to know our subjects and to learn about the rituals that lie ahead. To our surprise, we were the only outsiders to arrive early enough to witness the extraordinary gathering of fetish priests for a day of rituals that took place one week before the anniversary celebration. Hundreds of priests and priestesses from 18 districts of Ashanti land were gathering at the Manhyia Palace in Kumasi to give blessings for the royal ceremony scheduled for the following week. We had never imagined such a turnout, nor the underlying importance the power of the spirit world held for the Ashanti kingdom and the king, who was brought up as a Christian and trained as a barrister at Oxford University.

We photographed fetish healers calling on the spirits of the Tano River to protect the king and community from evil powers causing harm. We recorded the chief fetish priest slaughtering a sheep and pouring a libation to pacify the gods before the grand occasion began. The Atanafo priest (right) covered himself in kaolin powder—considered to be food for the spirits and used to elicit his deity's power.

The palace grounds were alive with spirit energy from the "other world," and we knew that this fetish display would lead to a successful 25th Jubilee—just as it was believed to have brought the Ashanti major successes in war over the kingdom's 300-year history.

ASHANTI
GHANA

An Atanafo fetish priest
in possession elicits the
diety's power to protect the
Ashanti king.

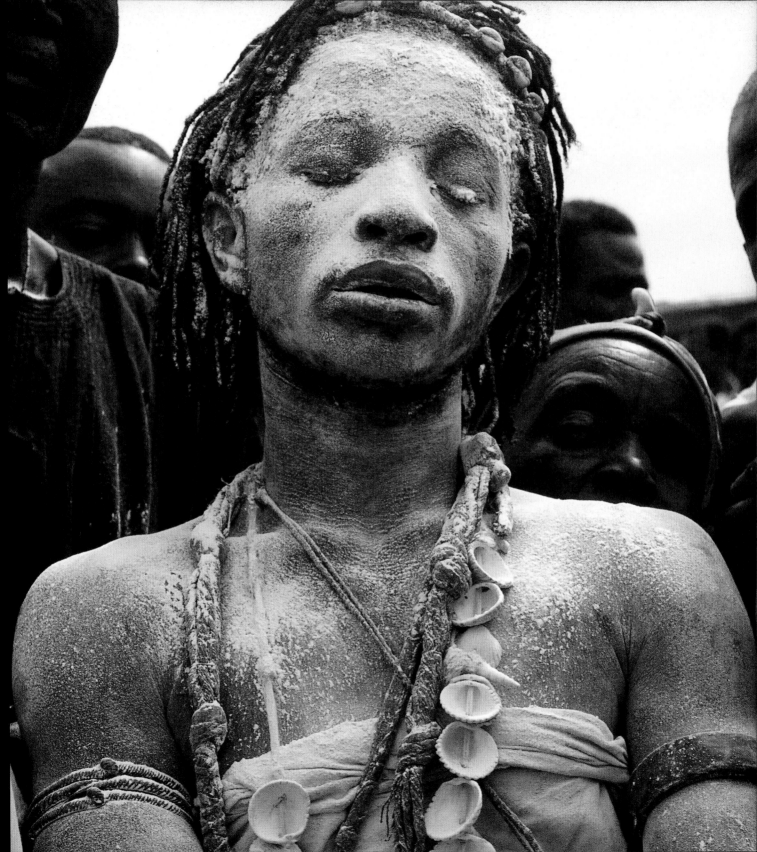

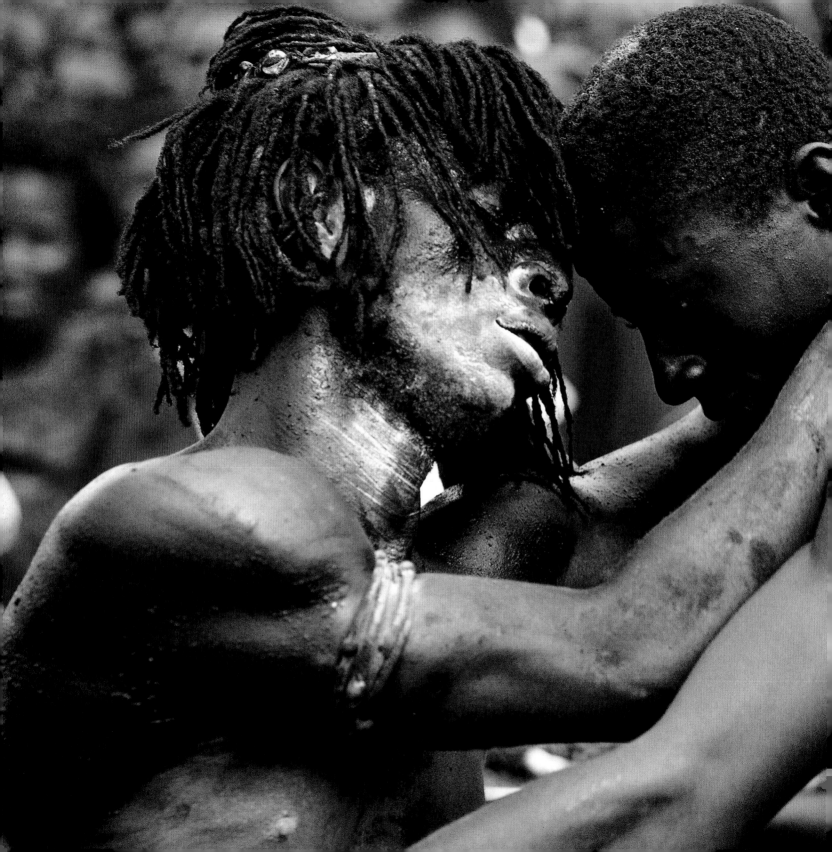

GHANA

A Sumbrafo priest covered
black charcoal and red clay
into a state of possession,
he is quickly able to comm
with his god. Exhausted by
performing many feats, he
supported by a devotee dur
the king's fetish display.

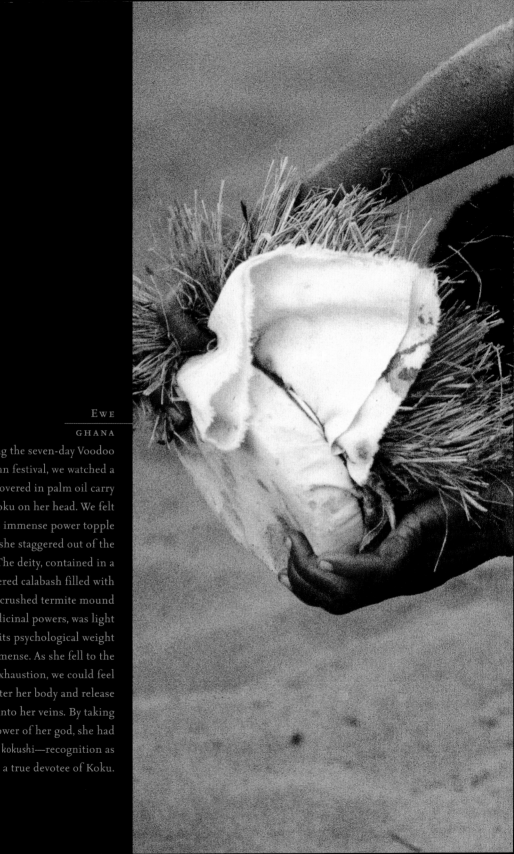

During the seven-day Voodoo
Kokuzahn festival, we watched a
woman covered in palm oil carry
the deity Koku on her head. We felt
the god's immense power topple
her body as she staggered out of the
shrine. The deity, contained in a
grass-covered calabash filled with
the soil of a crushed termite mound
holding medicinal powers, was light
to carry but its psychological weight
was immense. As she fell to the
ground in exhaustion, we could feel
the deity enter her body and release
its force into her veins. By taking
on the power of her god, she had
achieved *kokushi*—recognition as
a true devotee of Koku.

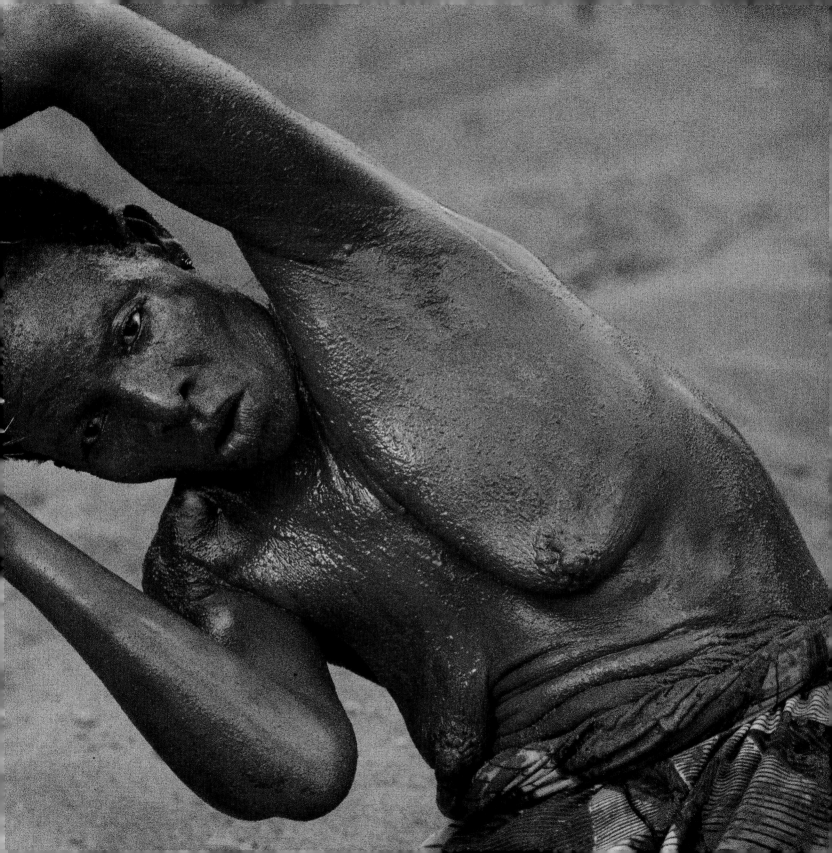

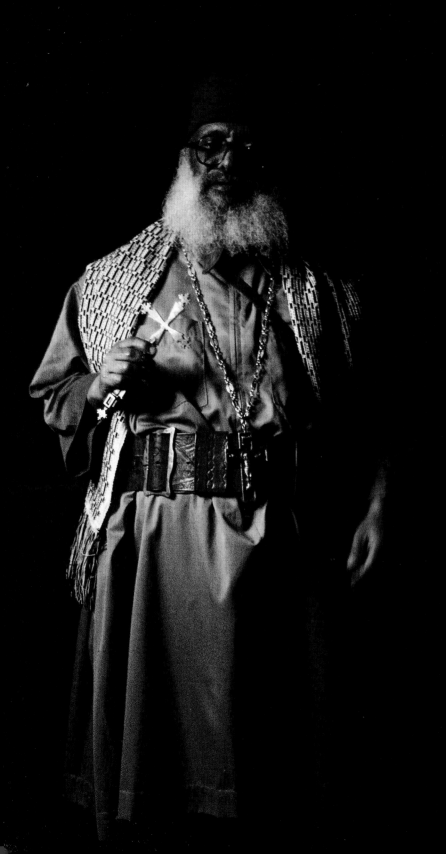

IT SEEMED LIKE A NORMAL CHRISTIAN CHURCH SERVICE, except that the white-bearded priest giving the service wore a fez-like cap and Wellington boots under his khaki gown. Aba Wolde Tensaie Gizaw cut his sermon short to make time for the healing baptism—the exorcism of demons that everybody eagerly awaited each week.

That morning we watched Aba Wolde treat a young woman possessed by the Zar spirit. His assistants placed the woman on a bench in front of him, holding her tightly by her arms and legs. She contorted violently in an effort to break free and cried out, "The Zar is eating my spine and cutting the power of my legs." Aba Wolde carefully aimed a hose at her solar plexus and placed his cross over her third eye (both believed to be centers for Satan). He sprayed her forcefully with cold water—believed to be the vehicle of exorcism—and prayed on her behalf. She writhed in agony, crying out in resistance. The spirit was unwilling to leave her. Gradually her body relaxed, and the Zar departed, leaving her at peace.

Priest Aba Wolde, descended from a 12th-century saint and healer, treats many thousands of people for both physical and mental ailments. He told us modestly that his powers were not inherited, but rather were a gift from God.

AMHARA
ETHIOPIA

Right and left: Priest Aba Wolde
treats a young woman
possessed by the Zar spirit.

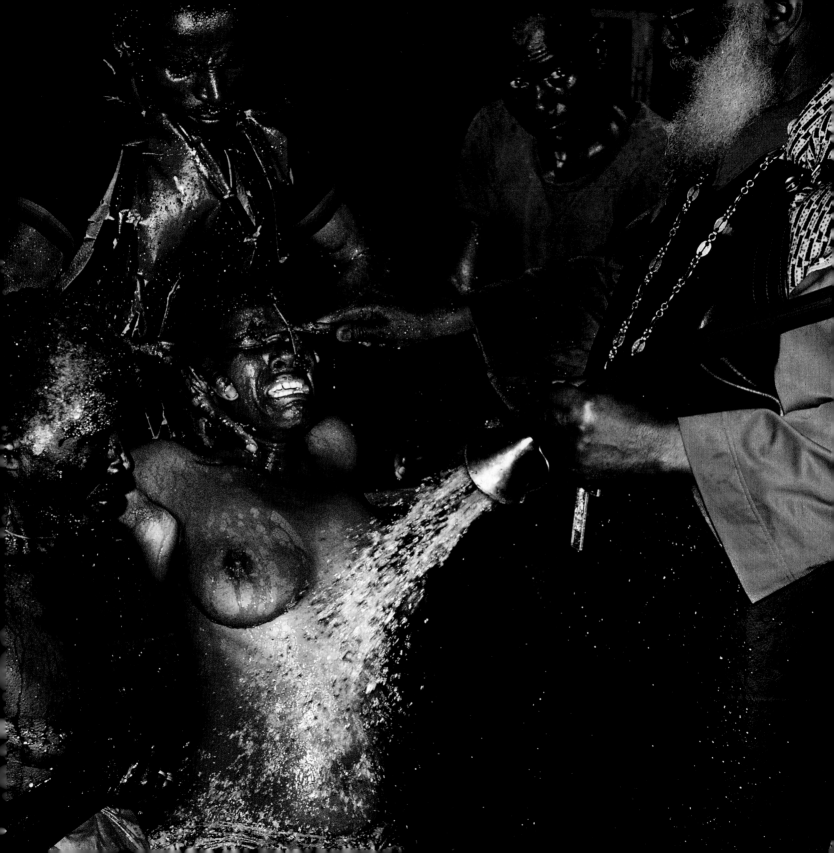

A Voodoo devotee surrenders
himself to the spirit of his personal
deity. His eyes roll upward and his
pupils disappear, leaving only the
whites. Depending on which
direction the eyes roll, observers
can tell what spirit has possessed
him. This man, with his eyes rolled
toward the sky, is possessed by
Hebioso—the thunder god.

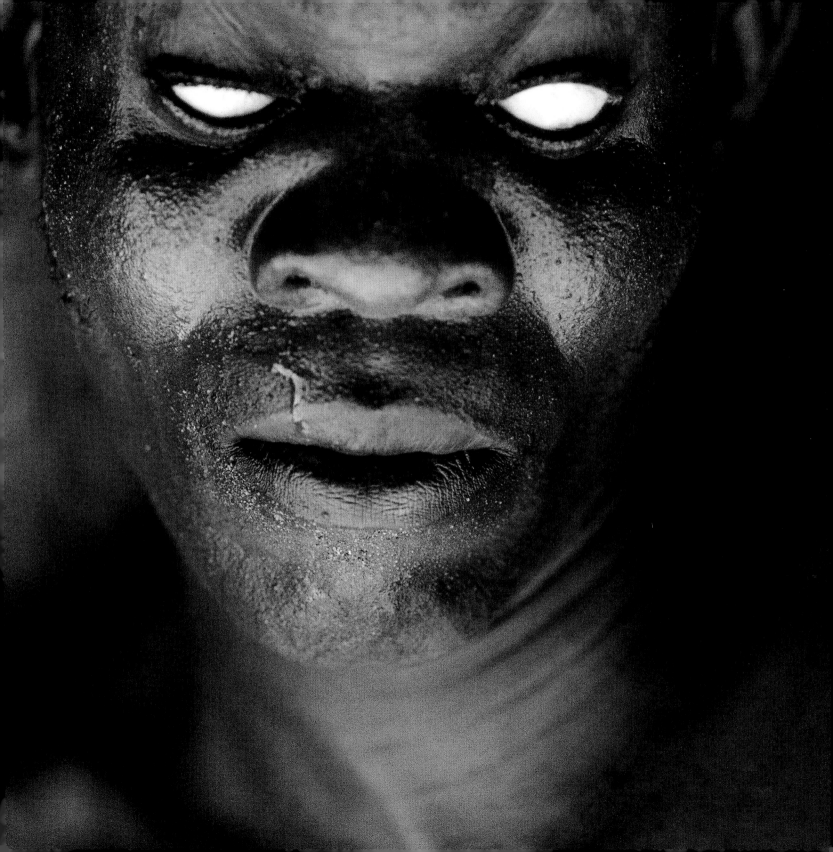

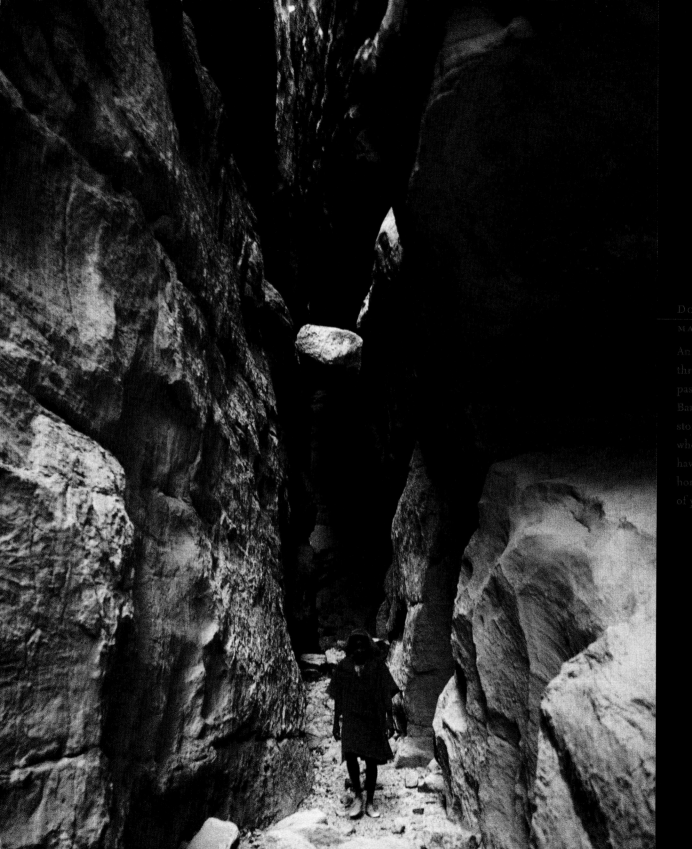

WE LEARNED OUR FIRST LESSON ABOUT THE CLOSE RELATIONSHIP BETWEEN AFRICAN PEOPLE AND THEIR ENVIRONMENT when our vehicle broke down at an oasis in Niger. Repairs would take days, and we might miss an important Wodaabe ceremony. We locked the vehicle and traveled on camels with a group of passing Wodaabe nomads.

We took with us only our cameras and a small bag of necessities, leaving our "creature comforts" behind. For the next six weeks we slept on camel-hide mats, drank only a calabash gourd of camel milk per day, and learned just how little we required to survive. Everything the Wodaabe possessed was created from natural materials, and each item was essential to their survival.

Since the beginning of time, Africa's people have been shaped and defined by their environment, and they in turn have fashioned natural elements into shelter, clothing and adornment. Wood and grass make shelters and vessels, but are also the materials used to fashion the ritual masks and costumes that bridge the physical and the spirit worlds. White chalk makes an excellent paint, but is also regarded as food for the spirits. Ochre has ritual significance throughout Africa, but when mixed with animal fat it is a valuable skin moisturizer and provides insulation on cold desert nights. The use of natural elements in all aspects of traditional life is testimony to the profound way that nature shapes the existence and empowers the creativity of African people.

SHAPED BY THE EARTH
EMPOWERED BY NATURE

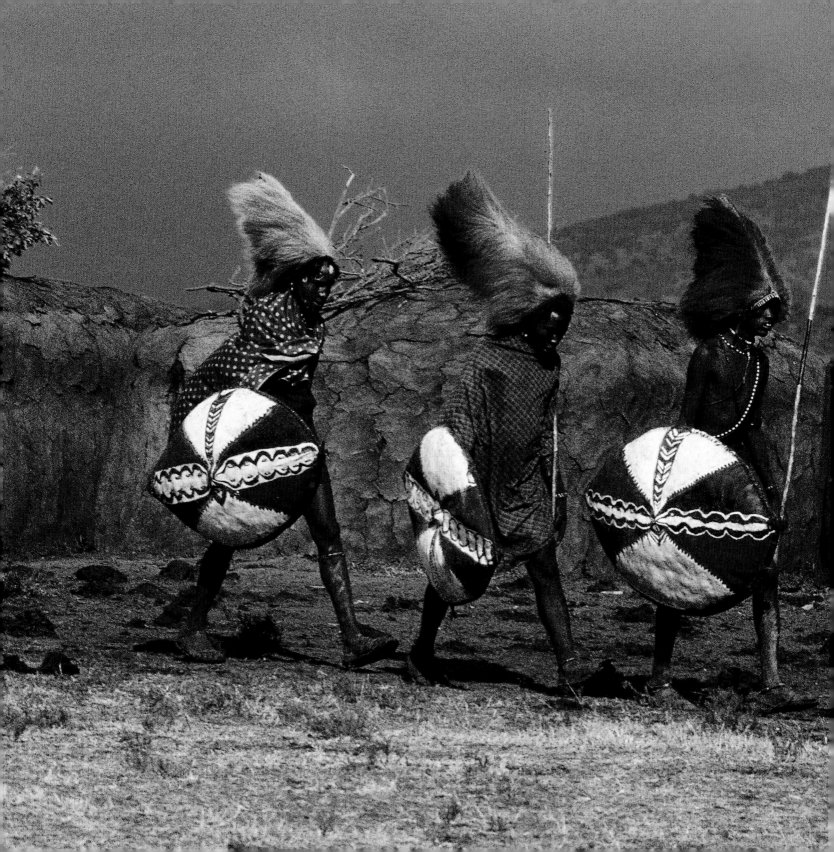

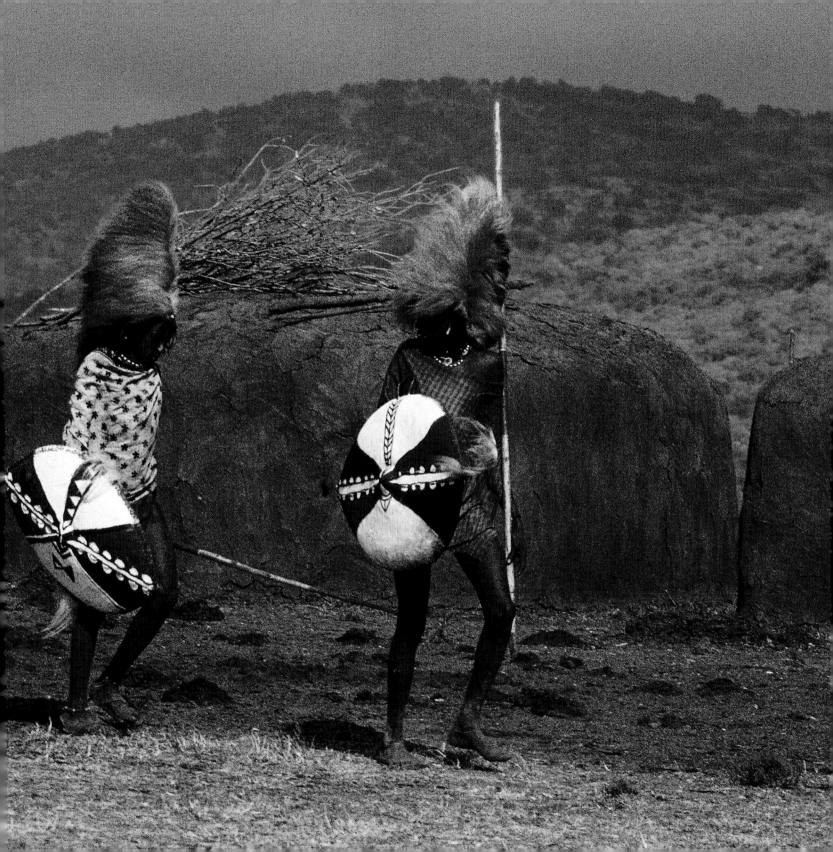

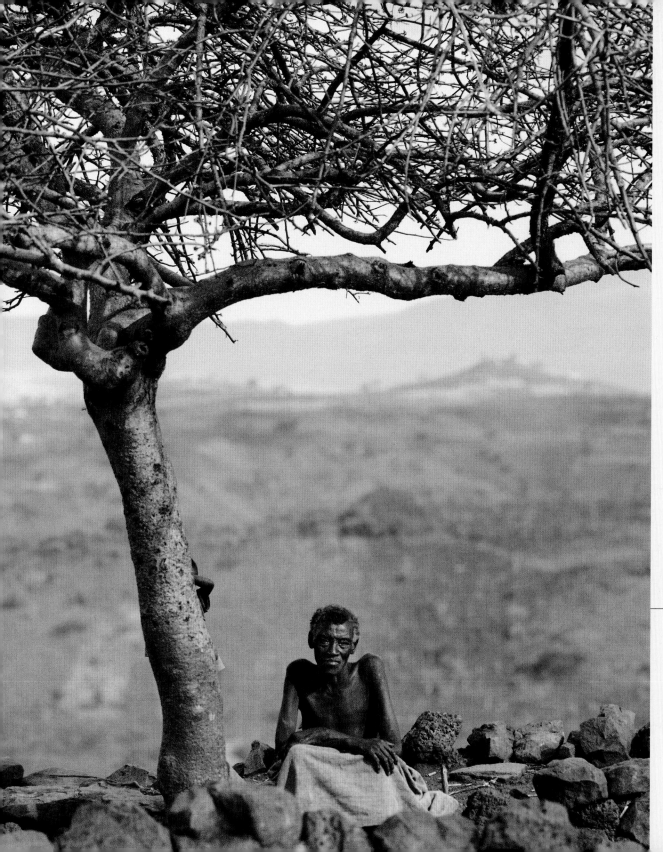

Preceding pages:

MASAI

KENYA

A line of warriors marches past ceremonial huts made of cow dung and mud. The men carry shields made of buffalo hides and wear headdresses made of lion manes, thus identifying themselves with the power of the animal kingdom.

KONSO

ETHIOPIA

Right and left: Using gnarled roots and branches, the Konso build their houses on stony mountain terrains, leaving the better land to be terraced and cultivated.

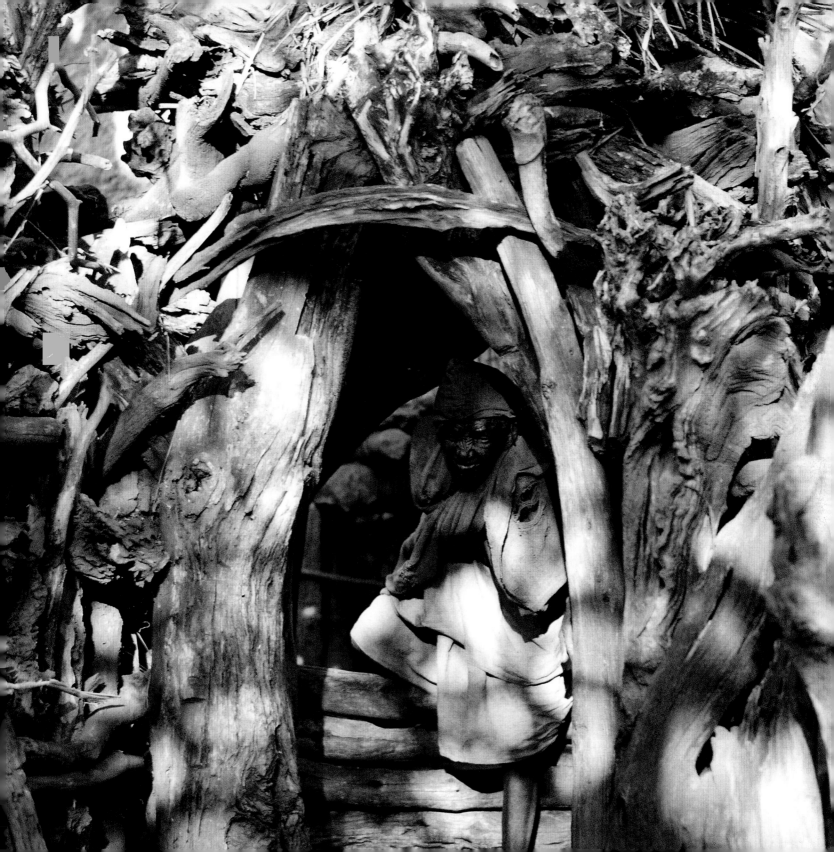

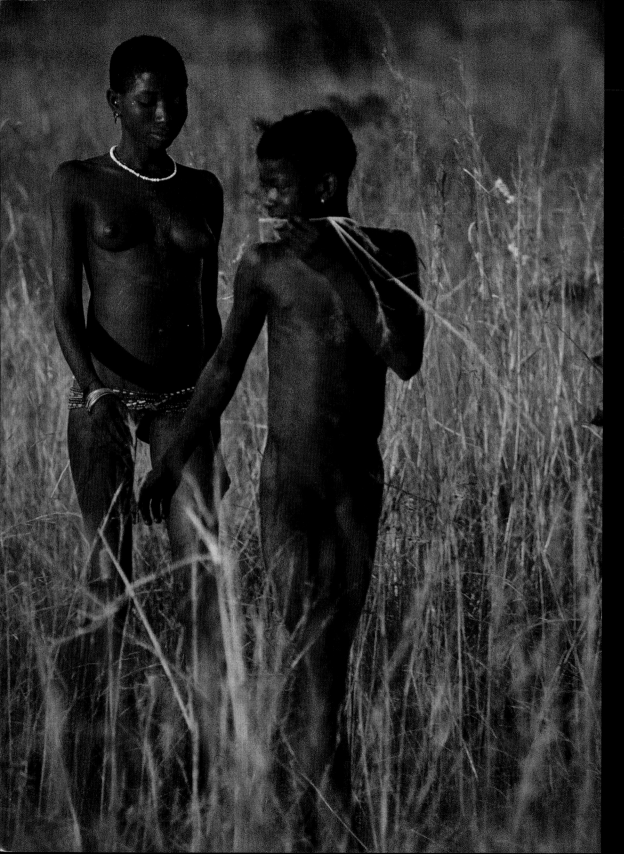

An initiate leads his sister
through the long grass to the
sacred mountain, where he
will undergo circumcision. The
initiate is painted with black
spots of charcoal to transform
him so that the knife will not
recognize him.

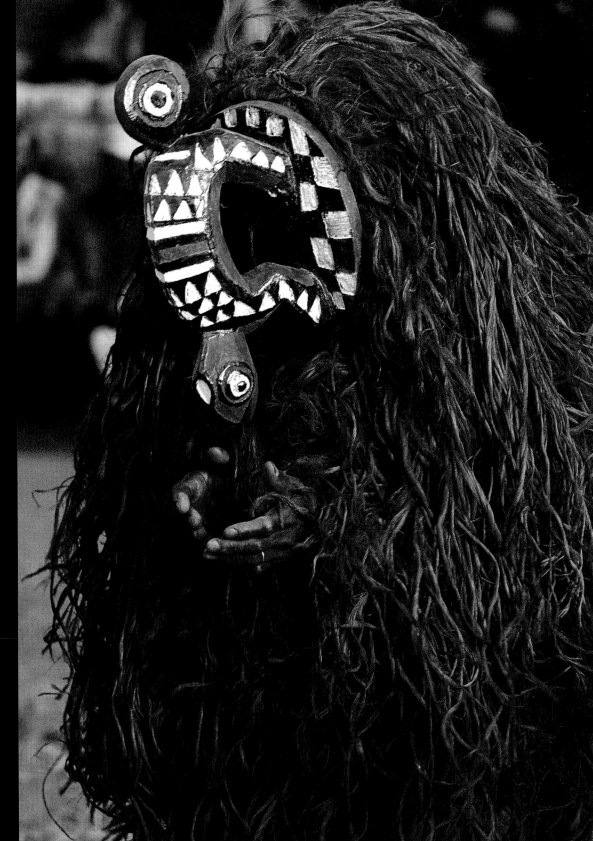

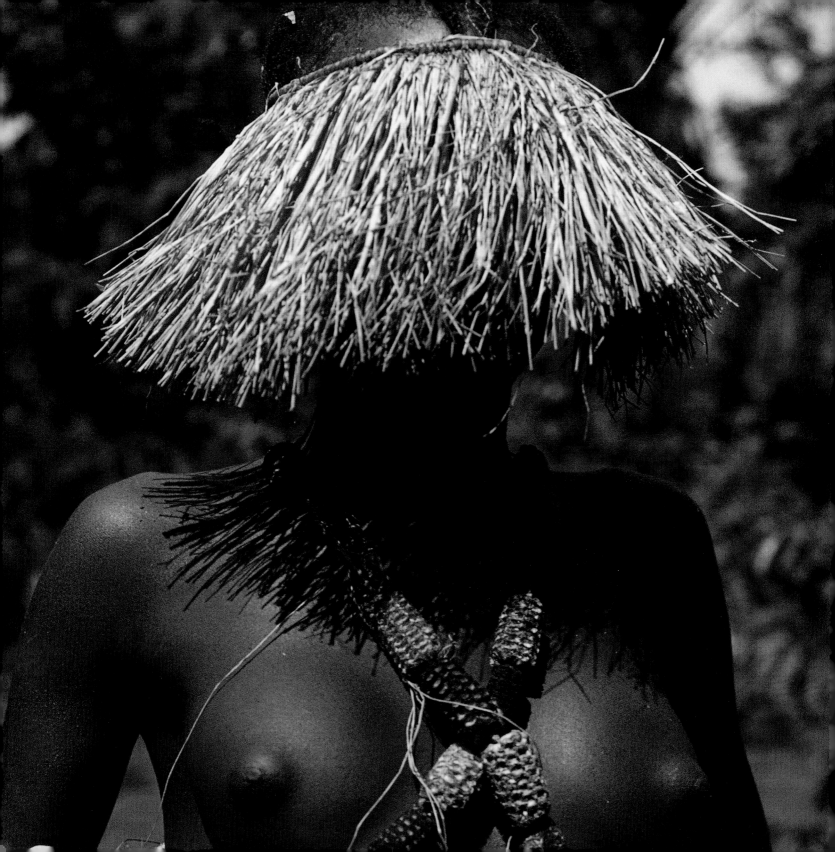

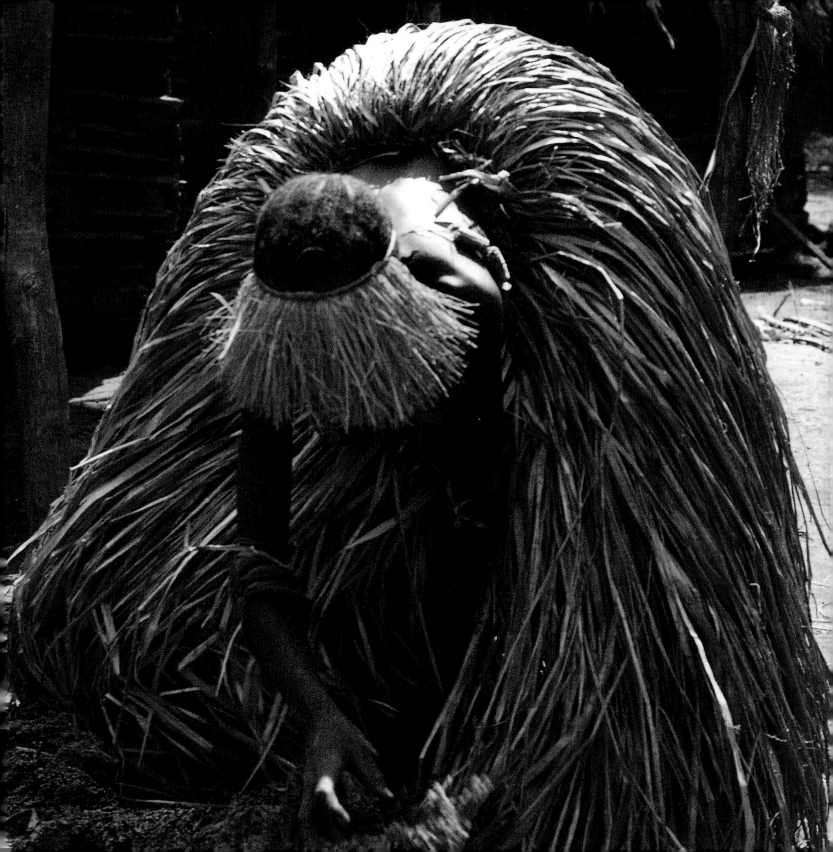

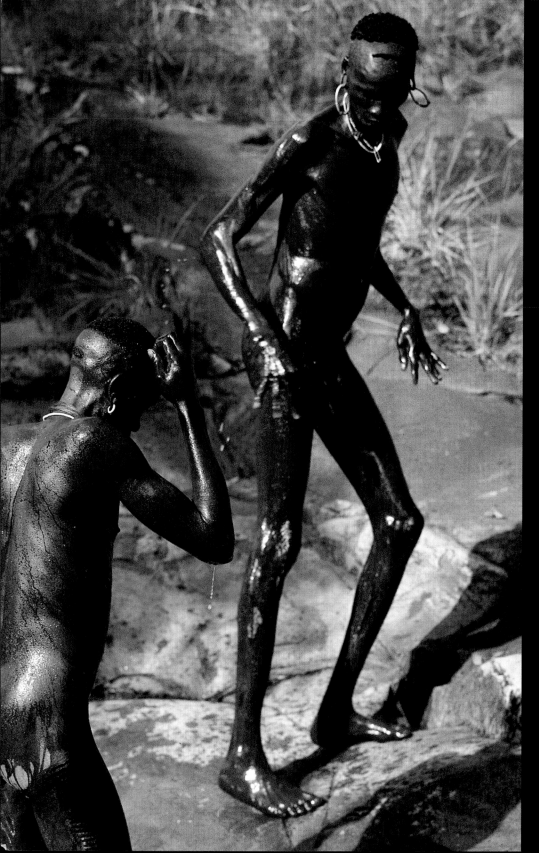

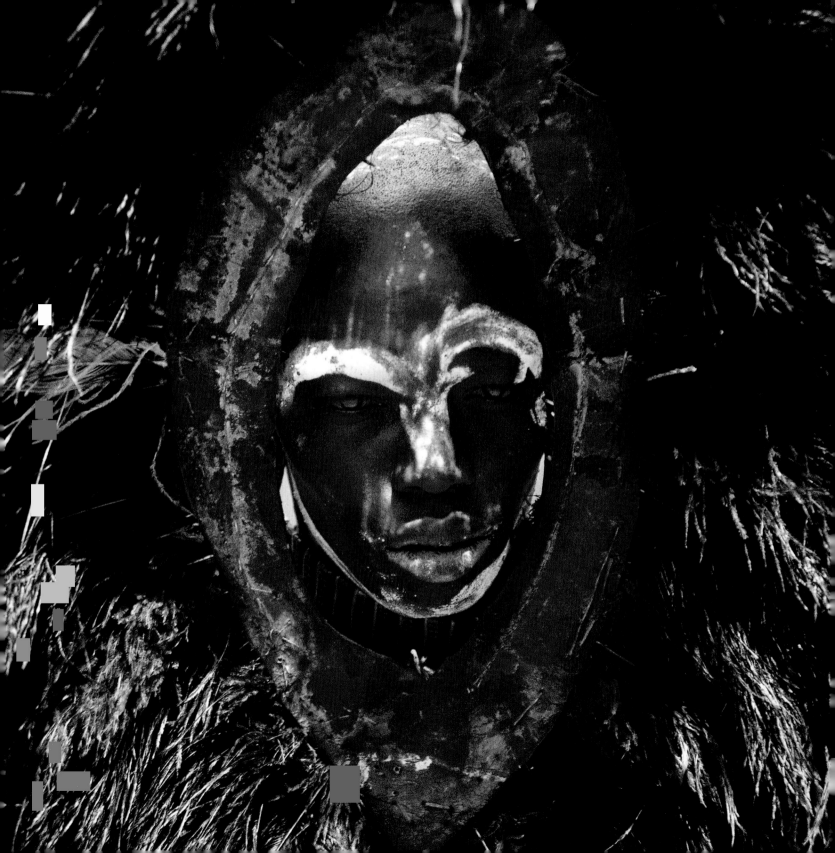

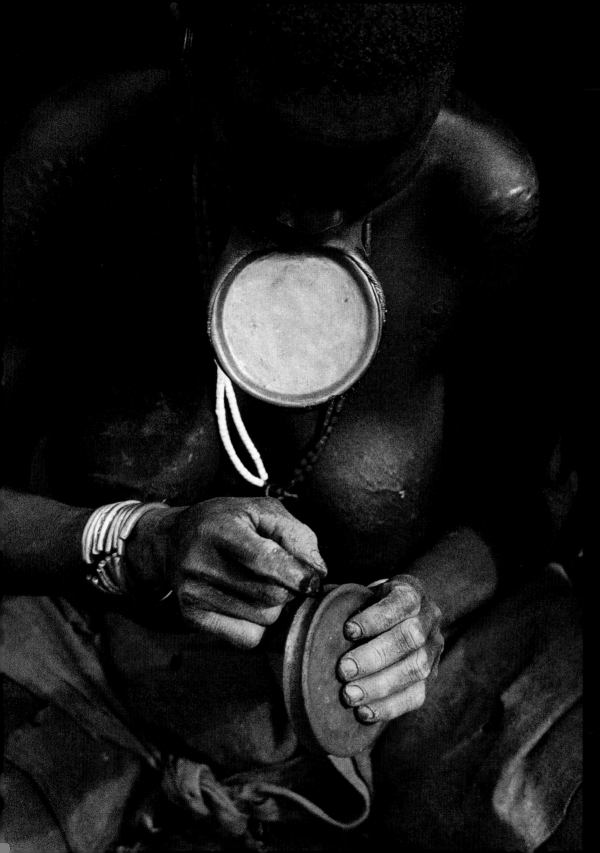

SURMA

ETHIOPIA

Using locally dug clay, a woman
fashions a lip plate, defining the
groove for her stretched lower lip,
which will hold the plate in place.

SURMA

ETHIOPIA

Nabongay shapes a large clay
pot for storing water and
borday (an alcoholic millet brew).
She uses circular coils of clay,
pressed one into the other, to
build the form.

Following pages:

HIMBA AND KARO

ETHIOPIA

One of the most popular
cosmetics used in Africa is red
ochre powder ground from rocks
with high iron content. For the
Himba of Namibia (left) and the
Karo in Ethiopia (right), an ochre-
and-animal-fat mixture perfumed
with herbs nourishes the skin,
protects it from heat and cold,
and adds dramatic coloring to the
distinguished and stylized hair-
styles of young men and women.

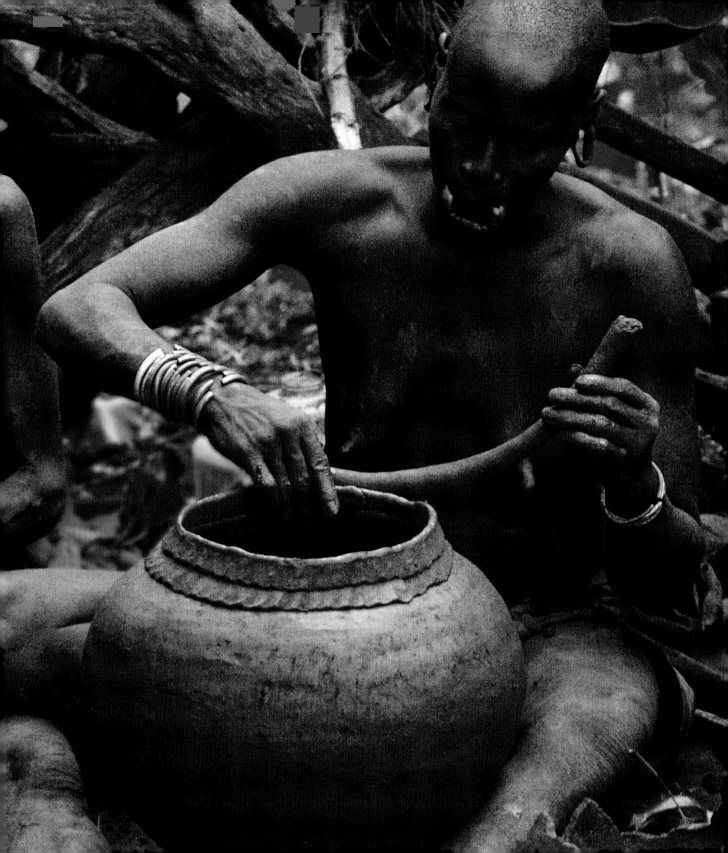

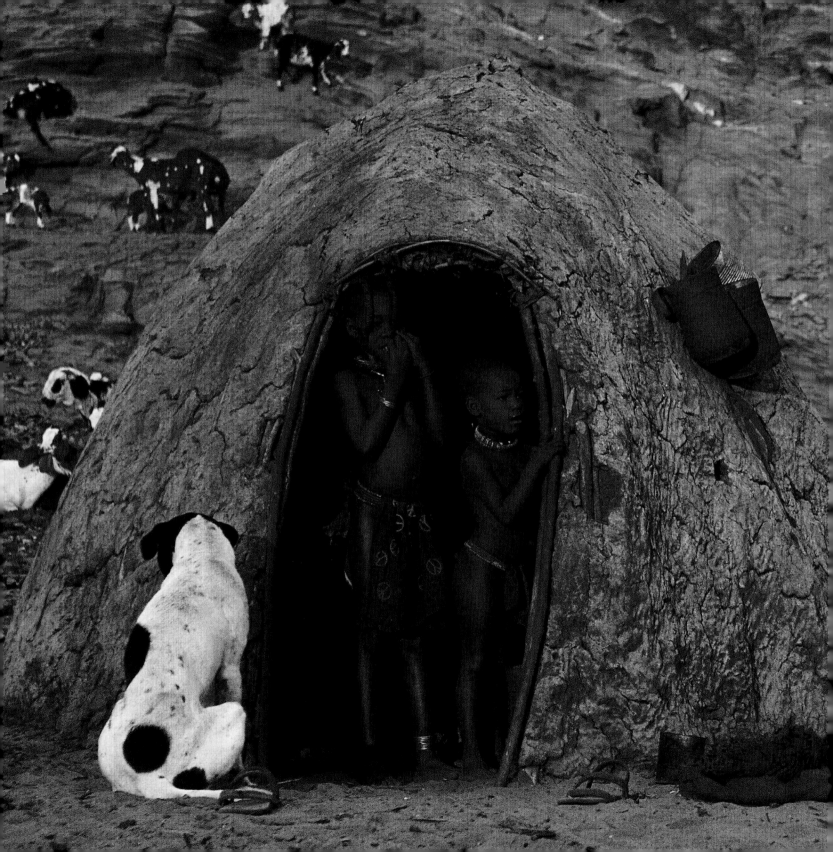

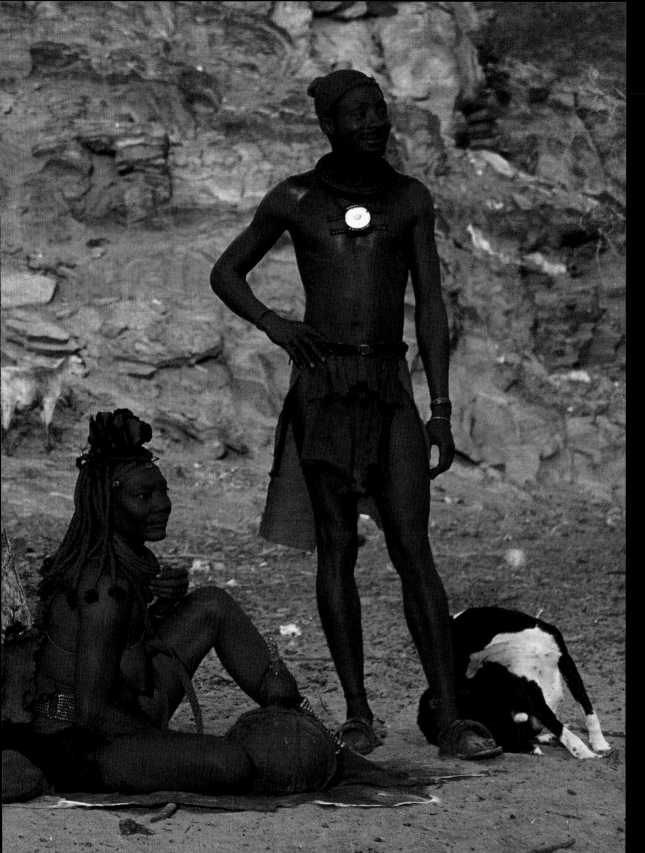

HIMBA
NAMIBIA
Once the great cattle
breeders of the continent,
the Himba rely heavily on
their animals for survival.
Their huts are constructed
of branches packed with
plaster made from cattle
dung and clay. Cattle skins
provide mats to sleep on and
skirts for women and chil-
dren, and milk is the main
staple of the Himba diet

Matjirwapi wears the Ekori wedding
headdress, a stylish piece of female
adornment made from cowhide
and goatskin that goes back as
many generations as the Himba can
remember. At the front, the soft
skin rolls forward to prevent the
young bride from looking back as
she leaves her family. The hide at
the back is fashioned into the shape
of cow ears, showing the close
relationship she has with her
beloved cattle. Iron and copper
beads, locally mined and crafted, are
designed into the headdress to
indicate her family's wealth.

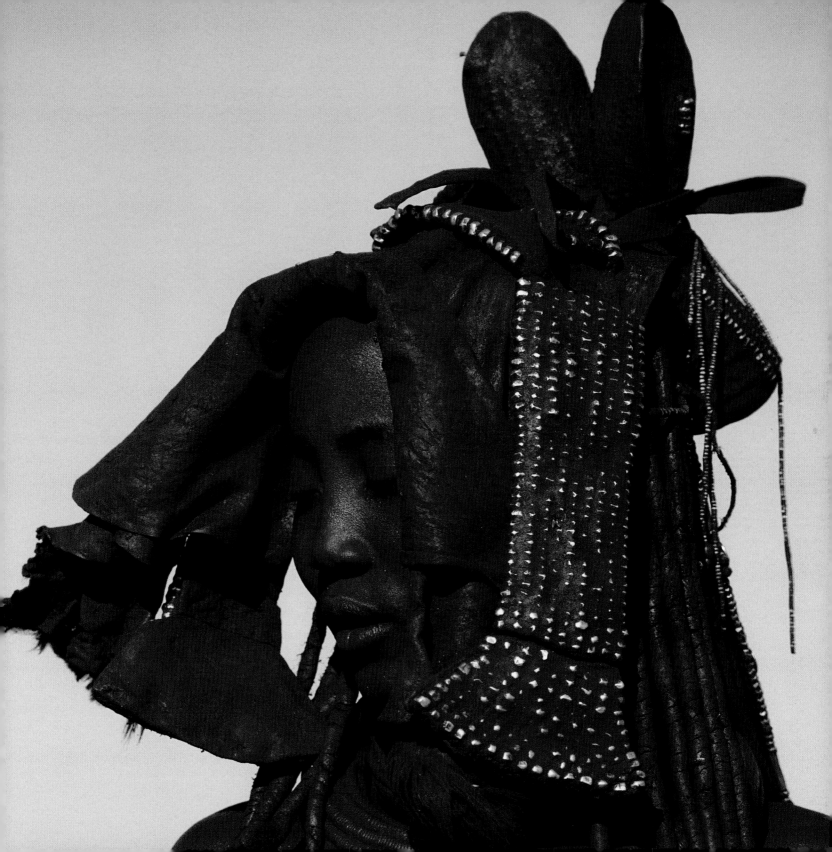

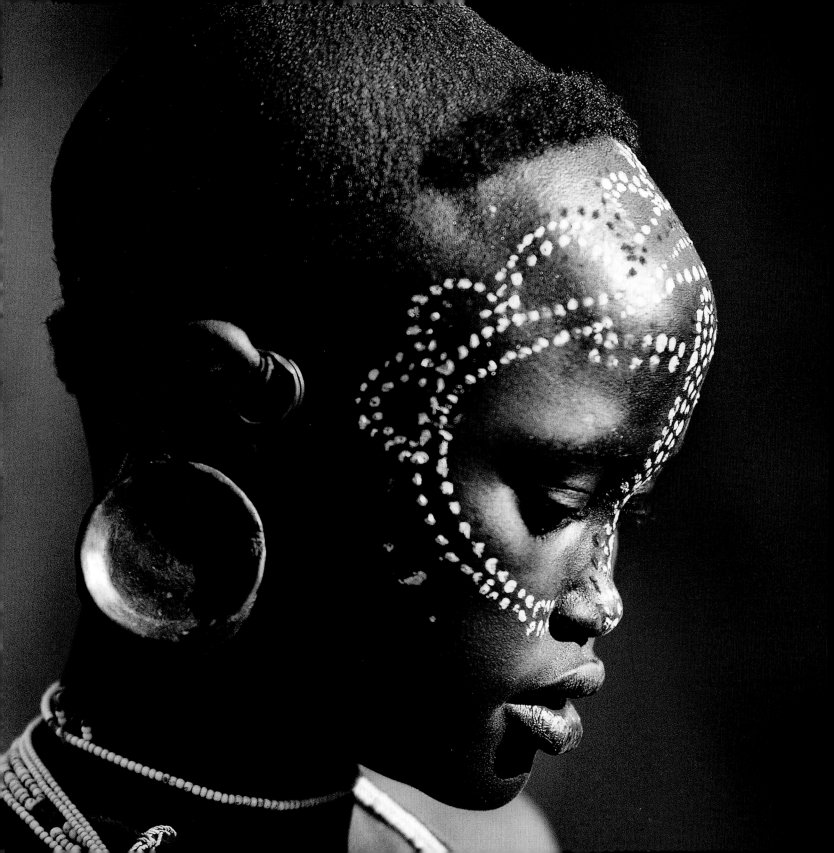

SOMETIMES OUR WESTERN SENSE OF MODESTY ABOUT NUDITY HAS INHIBITED OUR PHOTOGRAPHIC WORK in remote corners of Africa. On our first expedition to the Surma of southwest Ethiopia, we photographed the marvelous body painting perfected by the Surma as a ritual art form. All around us stood naked men, absorbed in the enthusiasm of their creativity.

As one can see from our photographs, the Surma paint every inch of their bodies, but out of shyness and sensitivity for what we imagined might be a delicate matter, we avoided taking pictures of certain areas of their anatomy. To our surprise, some of the Surma men challenged us: "Why aren't you photographing us the way we are?" they asked. They then proceeded to come forward so that our cameras could capture the painted designs on every part of their bodies.

Among many of the most traditional African cultures a healthy body is a gift to be celebrated without shyness or shame. These cultures use the human body both as a vehicle of artistic expression and as a way to send messages and announce status. They regard the human body as the best possible canvas, to be lovingly decorated with patterns formed with paint, tattoos, and tiny raised scars. To see these patterns of beauty and expression, displayed with such boundless flair and creativity, is to witness a special alchemy—as if the elements of the earth were made animate. To see African patterned bodies celebrating the rituals of life is to witness one of the world's oldest and most beautiful art forms.

SURMA
ETHIOPIA

A lacy pattern of delicate dots decorates the face of a young Surma girl. Her clay earplug enhances her beauty.

PATTERNS OF BEAUTY

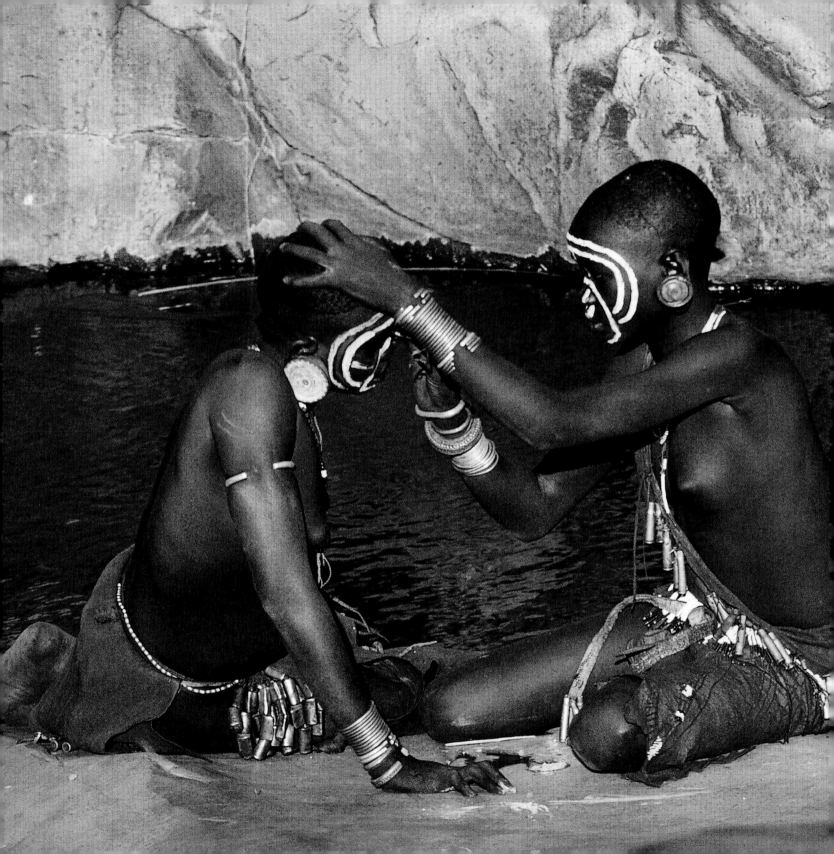

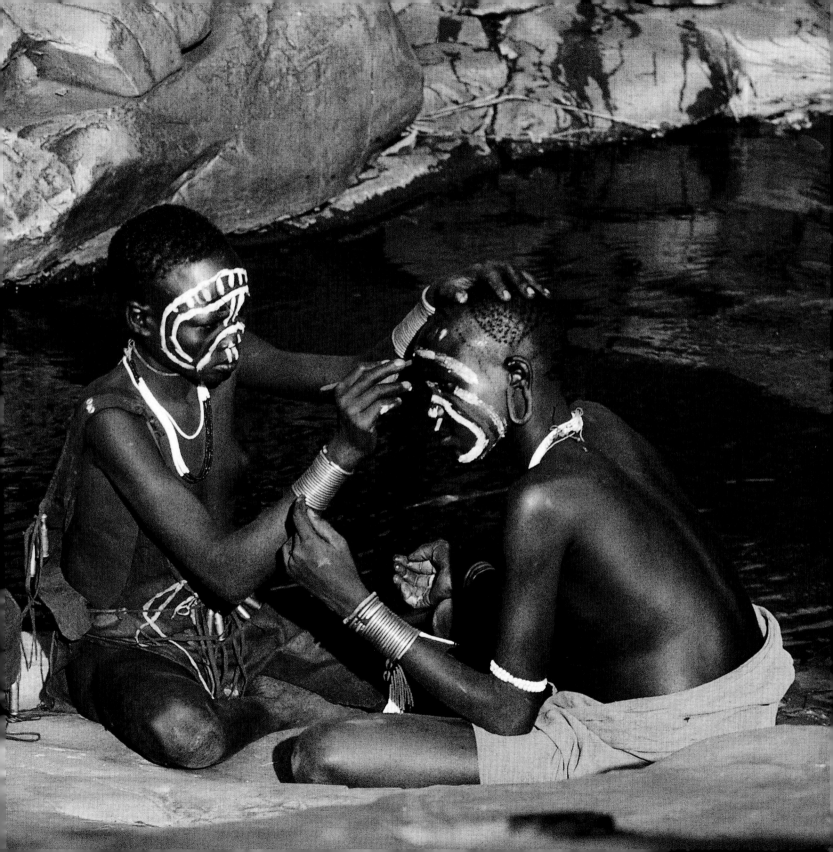

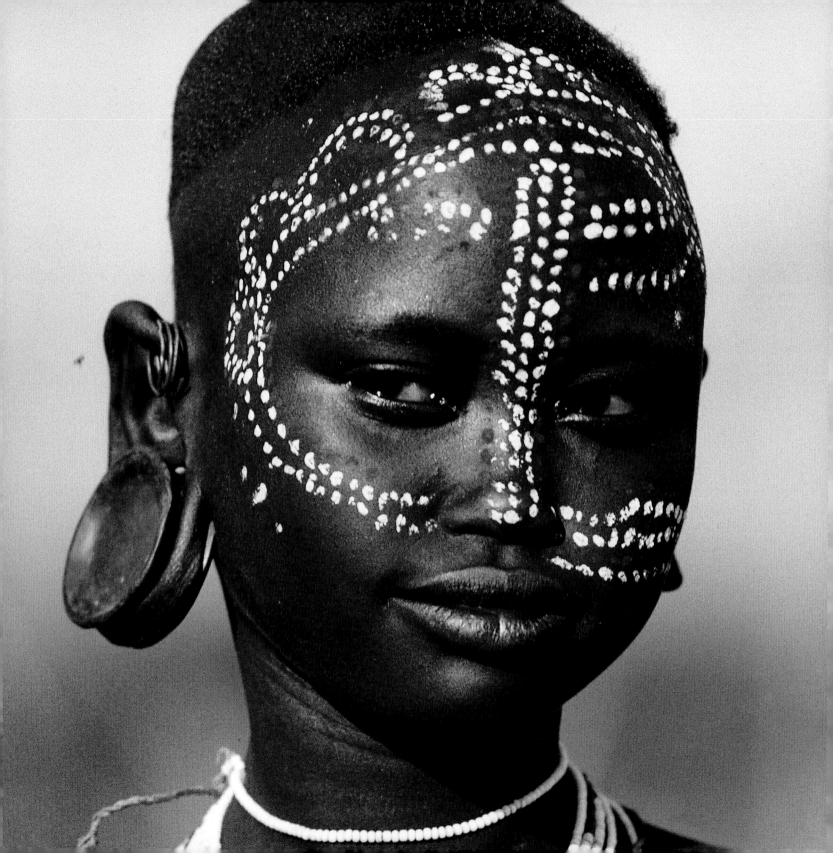

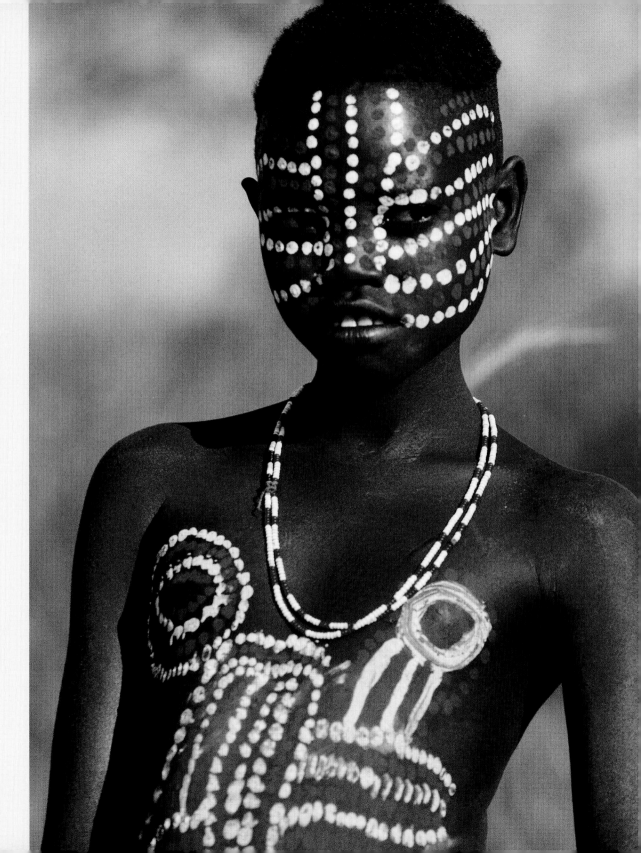

Preceding pages:

Surma
—————
ETHIOPIA

Young girls paint their
faces and bodies with a
mixture of chalk and
water from the riverbank,
highlighting their designs
with red ochre paint made
from pulverized rock con-
taining iron. Their inno-
vative face and body
patterns are designed to
attract the opposite sex.

Surma
—————
ETHIOPIA

Left and right: Two young
girls decorate their bodies
with a pattern of dots
inspired by the spotted
guinea fowl. In anticipa-
tion of maturity, one
encircles her breasts with
white chalk designs.

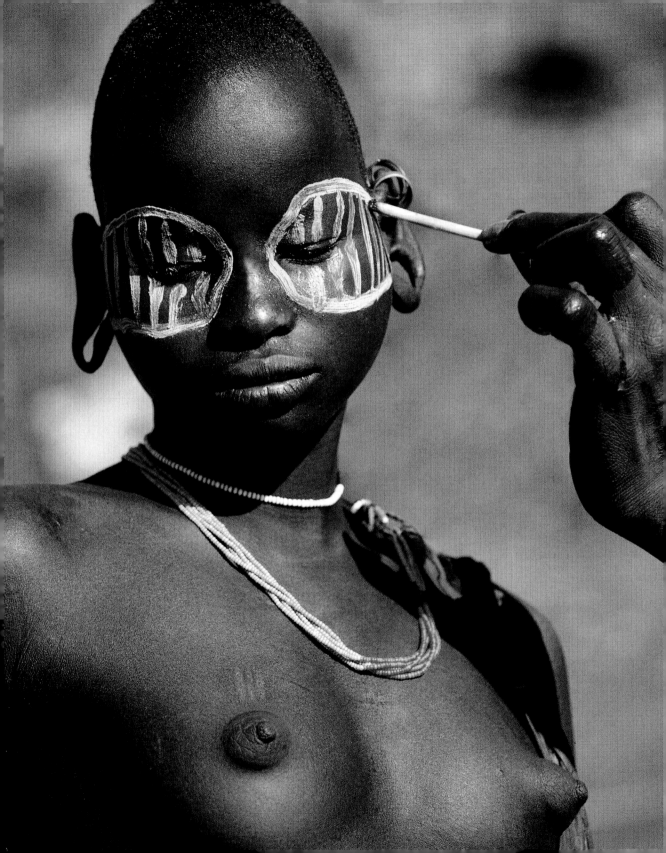

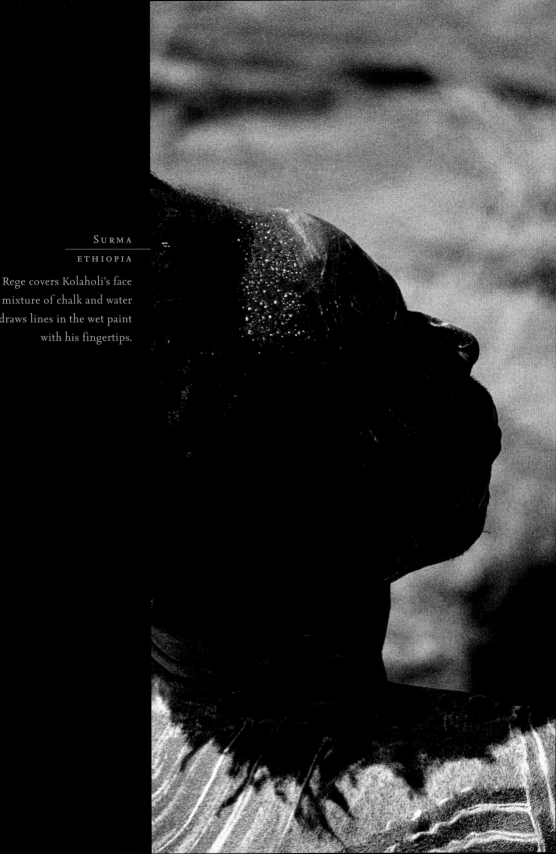

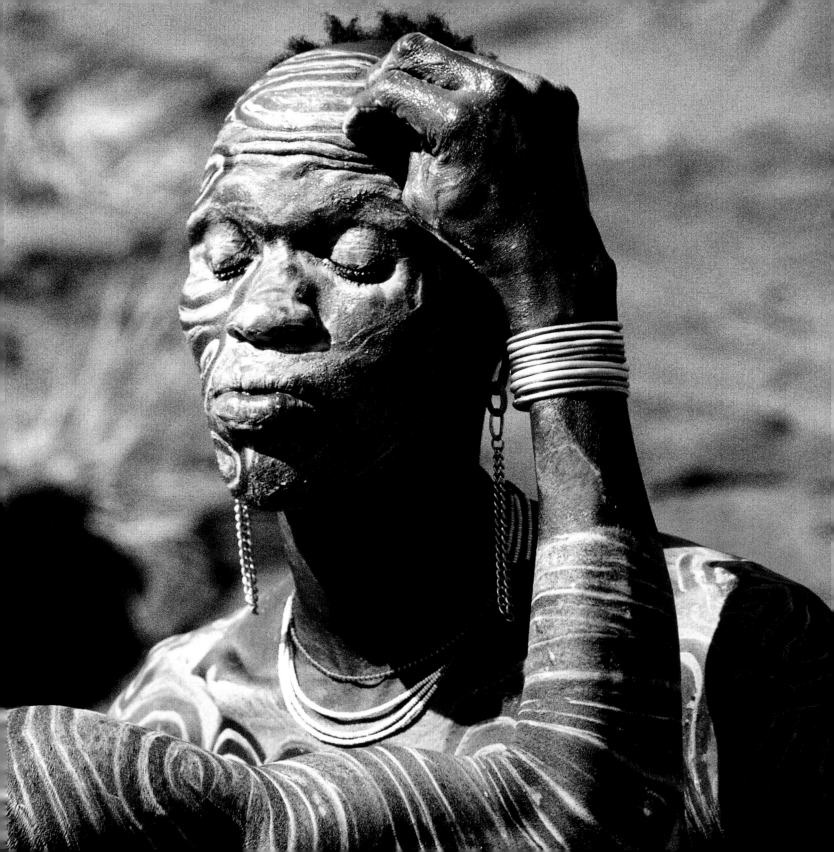

EARLY IN THE MORNING MURADIT ARRIVED AT OUR TENT TO ANNOUNCE THAT THE SURMA WERE READY TO PAINT THEIR BODIES. With a feeling of excitement, we all headed down to the Dama River. Muradit began by washing his naked body in the ice-cold water. Next he scraped chalk from the riverbank and mixed it with water to form a thick paste, which he slathered over his body. His friend Ole Rege began drawing intricate linear designs on Muradit's chest, using his wet fingertips to expose the dark skin beneath. The balletic process of Surma body painting reminded us of Zen calligraphy: You do not lift your brush until you have finished your painting; from start to finish, the process is one continuous flow.

Each day the Surma would return with new designs. They were so spontaneous—painting for pleasure, using the body as canvas, oblivious to the impermanence of each day's work of art.

Unbeknownst to us the Surma were always wondering why, when they were so comfortable with their naked bodies, we were so shy about nudity and constantly covered ourselves up with T-shirts and camera jackets. We found out about this in the most extraordinary manner.

When the day came to leave Surmaland, we asked Muradit what we could give the Surma as a thank you for their wonderful hospitality. After a moment of reflection, he announced, "We would all like to see your breasts!" We were quite taken aback, but realized that this was a fair request as Surma women went bare-breasted, men often nude, and we were completely covered up, hiding unimaginable and mysterious secrets!

We invited Muradit into our hut, took a deep breath, and, to the count of three, lifted our T-shirts for five long seconds. His eyes widened with amazement and his mouth dropped open. He raced outside to tell the 300 villagers pulsating with curiosity what he had seen. Muradit stood on a tree stump and delivered an 11-minute speech. Our guide, Zewge, translated his words. One of us had round voluptuous breasts and was clearly a married woman with many children and absolutely taboo. The other had small upright pointy nubile breasts and was clearly available to everyone! At this point, Zewge hurriedly packed up our mule train and spirited us over the mountains to safety.

SURMA

ETHIOPIA

Muradit's painted face patterns enhance his mischievous mood.

Following pages:
SURMA

ETHIOPIA

Details of body painting

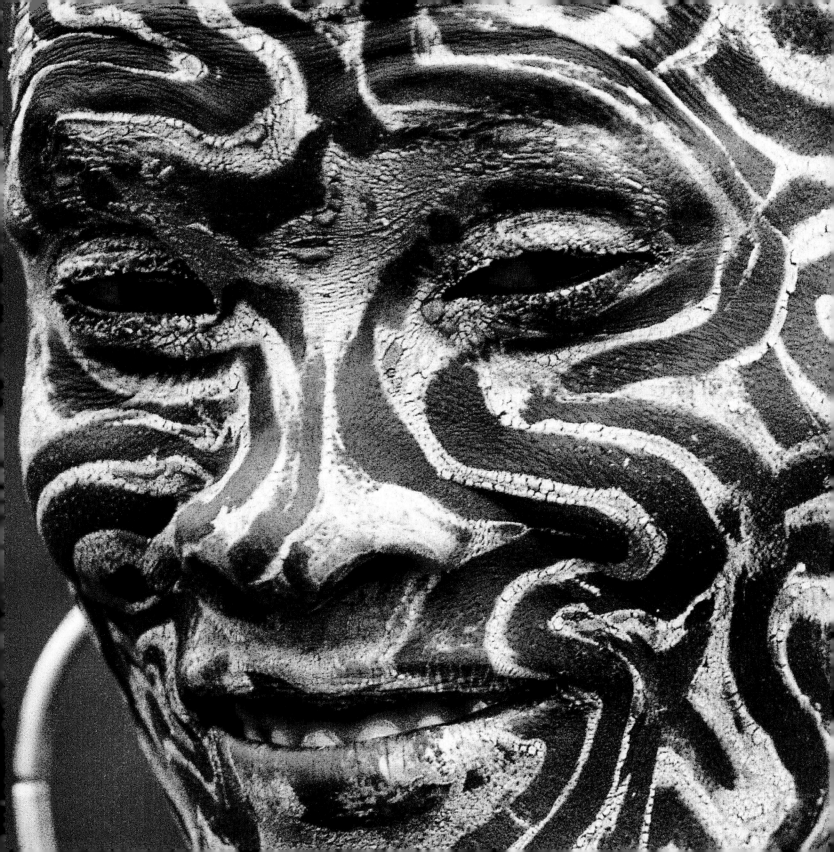

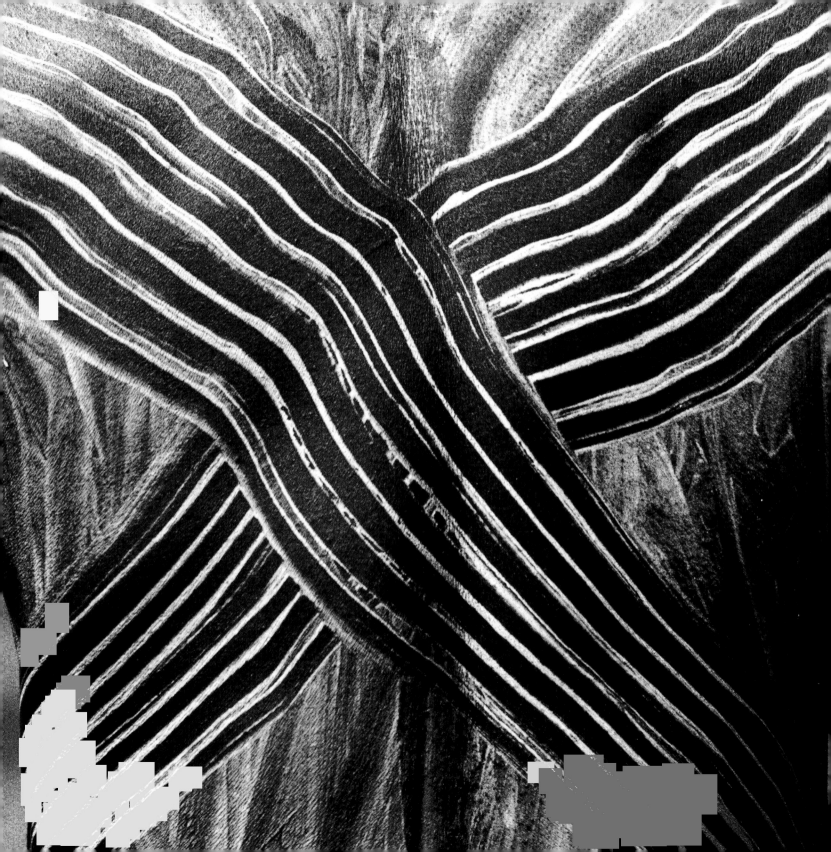

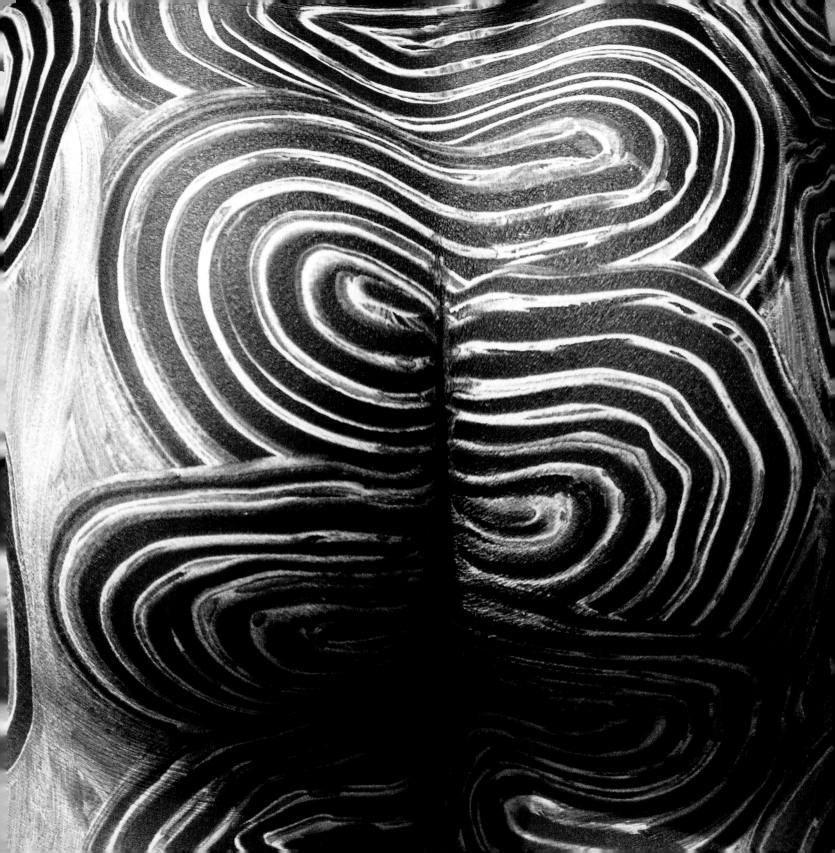

OLINYA EXPLAINED TO US THAT AT THE TIME OF HER MARRIAGE HER MOTHER HAD PIERCED HER LOWER LIP WITH A THORN to begin the six-month process of stretching it to accommodate a large clay or wooden lip plate. The size of her lip plate would indicate the number of cattle required by her family for her hand in marriage. Her parents wanted to insert a lip plate large enough to bring in 50 head of cattle. Few Surma men were interested in marrying a woman without a lip plate. We had read in early books on African culture that in some areas the tradition of lip plates came about during the era of the slave trade: If a woman was unappealing to a slaver, she would not be taken from her home. In other areas, the lip plate was believed to seal an important orifice of the body to prevent evil spirits from entering. Our Surma friends, however, had not heard these interpretations and could not believe them to be true. They related the wearing of the lip plate solely to the acquiring of a bride price.

SURMA

ETHIOPIA

A married Surma woman wears a clay lip plate decorated with incised cow-horn designs along its border. During her youth, her ears were stretched to accommodate a smaller earplug. Note the delicate shaved designs of her eyebrows.

Following pages:

DINKA

SUDAN

Left: A scarified pattern of cow-horn designs decorates the temples of a Dinka woman. Cuts are first made with a knife, and ash is rubbed into the open wound to create the raised texture.

WODAABE

NIGER

Right: Intricate tattoos of delicate blue lines identify this woman as Wodaabe. After small cuts are made with a razor blade, charcoal is rubbed in under the skin, resulting in finely raised designs.

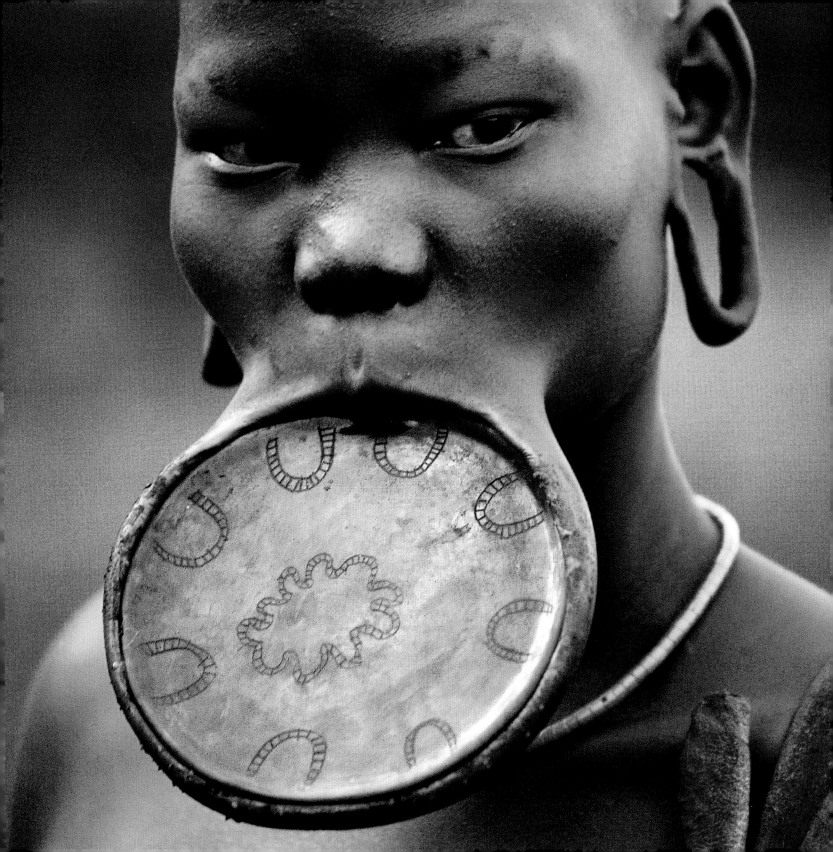

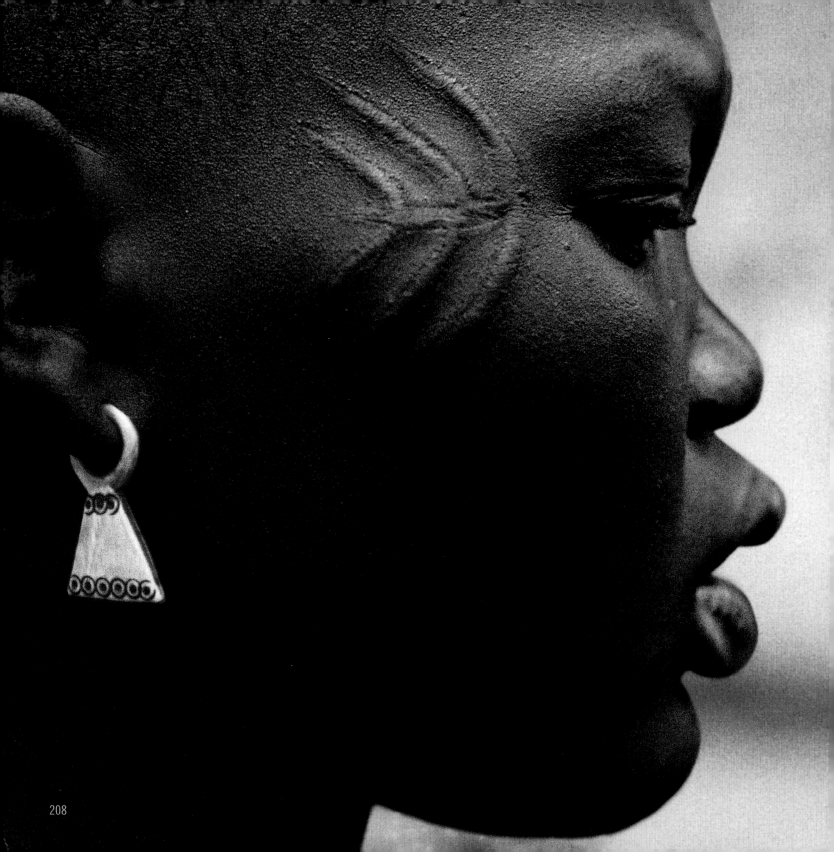

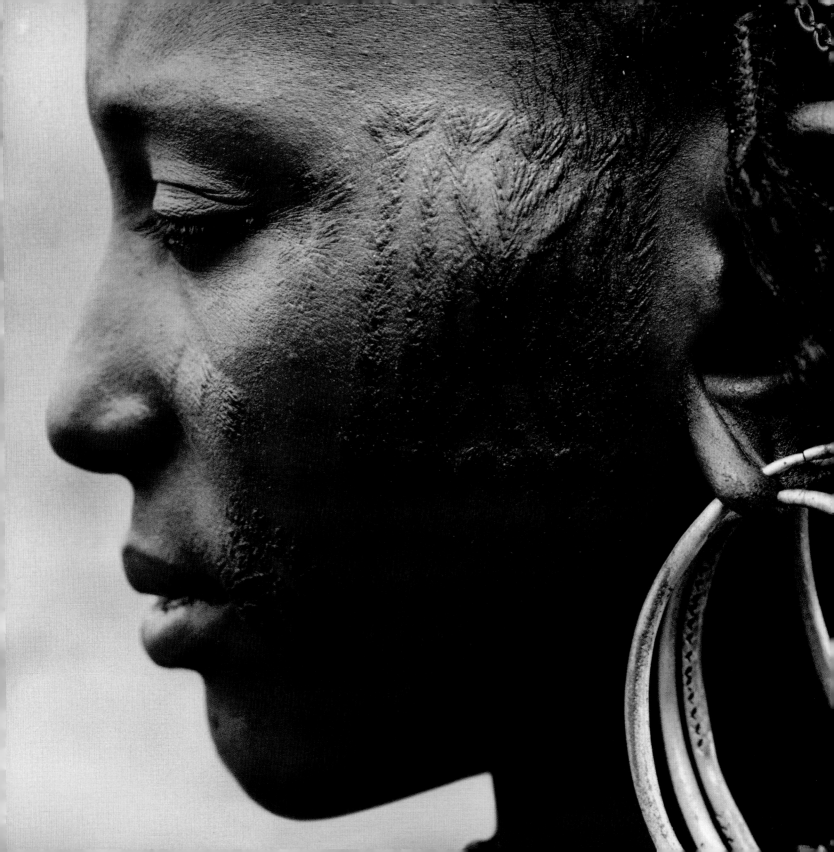

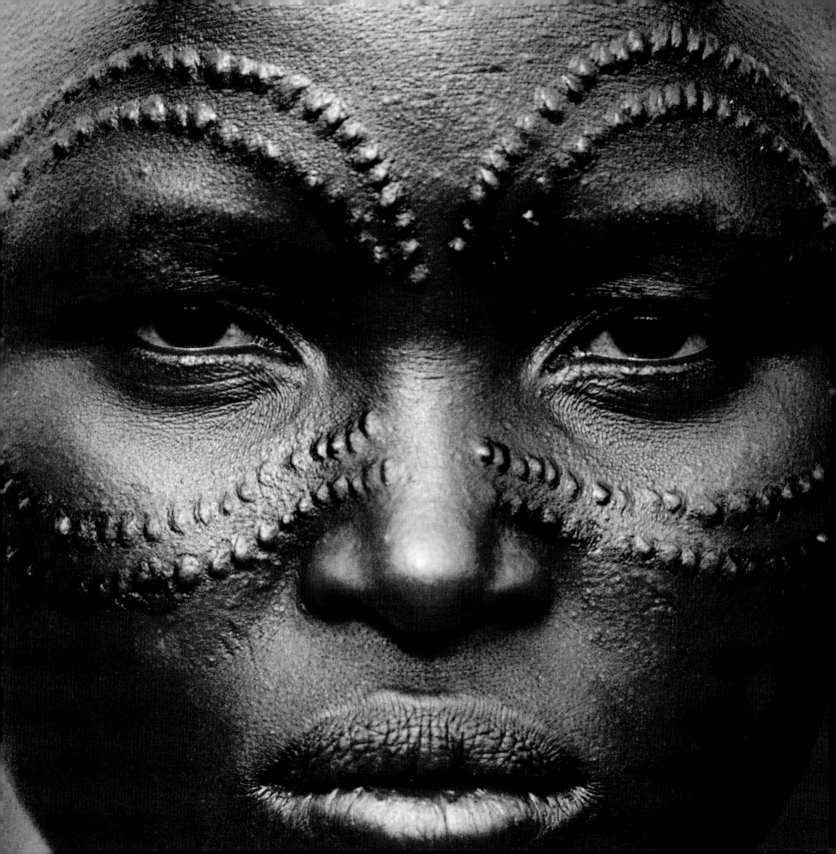

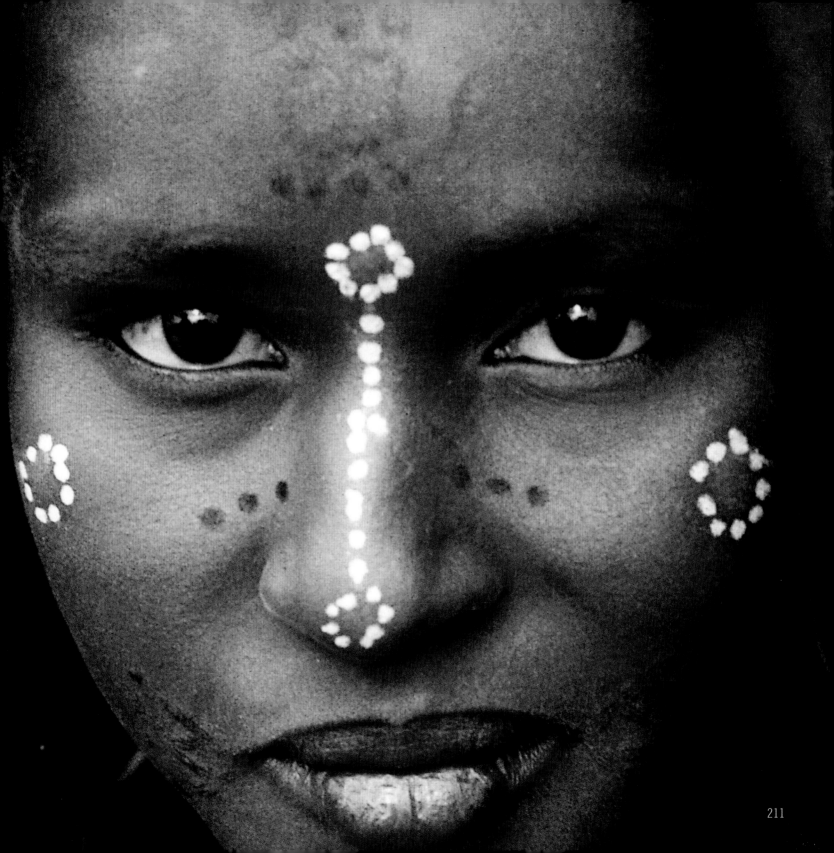

Preceding pages:

Barabaig
TANZANIA

Left: Parallel lines of raised dots encircling her eyes identify this Barabaig woman.

Wodaabe
NIGER

Right: A combination of tattoos and face paint announce that this girl is Wodaabe.

Following pages:

Karo
ETHIOPIA

Left: A young woman scarifes her stomach to beautify herself. Our Karo male friends told us that the skin texture of a scarified belly holds great sensual appeal.

Nuer
SUDAN

Right: The parallel lines of scarification on the forehead of this man identify him as a Nuer. The dotted patterns on his cheeks and chin are designed to enhance his good looks.

Swahili
KENYA

Henna designs decorate the hands, arms, and feet of a Swahili woman. She must remain concealed in black veils and long robes in public, and these are the only parts of her body that may be seen. Henna dye is made from a powdered leaf mixed with water and the juice of unripe limes. The designs are drawn with a fine twig; five to six applications are made to ensure the henna does not fade too soon. The process takes up to 12 hours to complete. In modern times a black synthetic dye is used to enhance the elaborate designs.

In order to publish this photo, we promised that we would never reveal the name of this girl, nor show more than her beautifully patterned hands and feet, so as to protect her family from community disapproval.

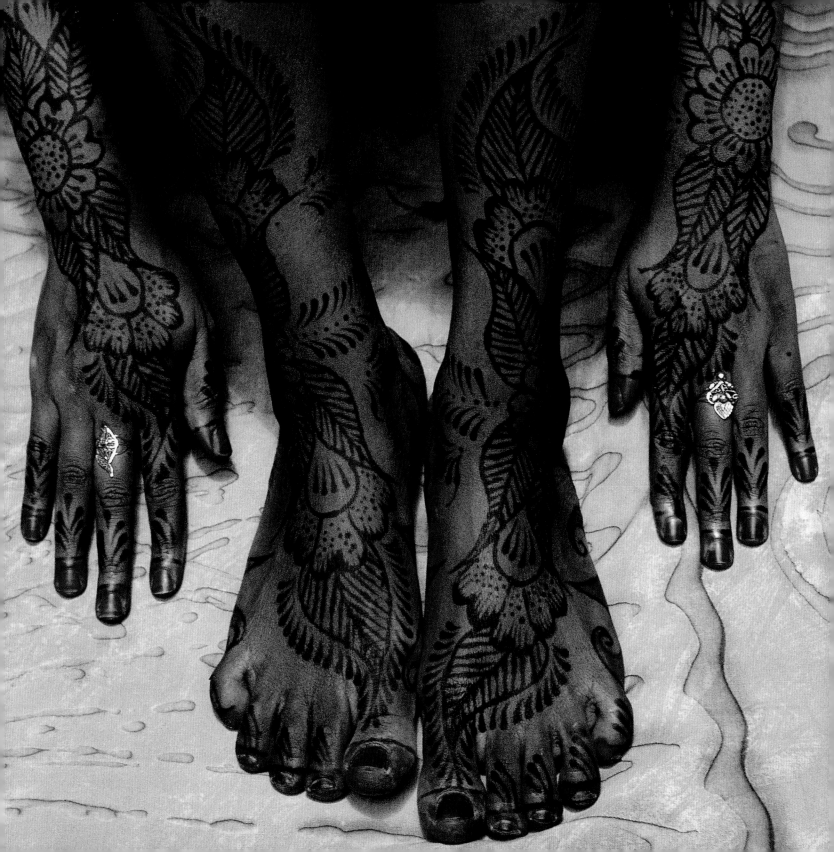

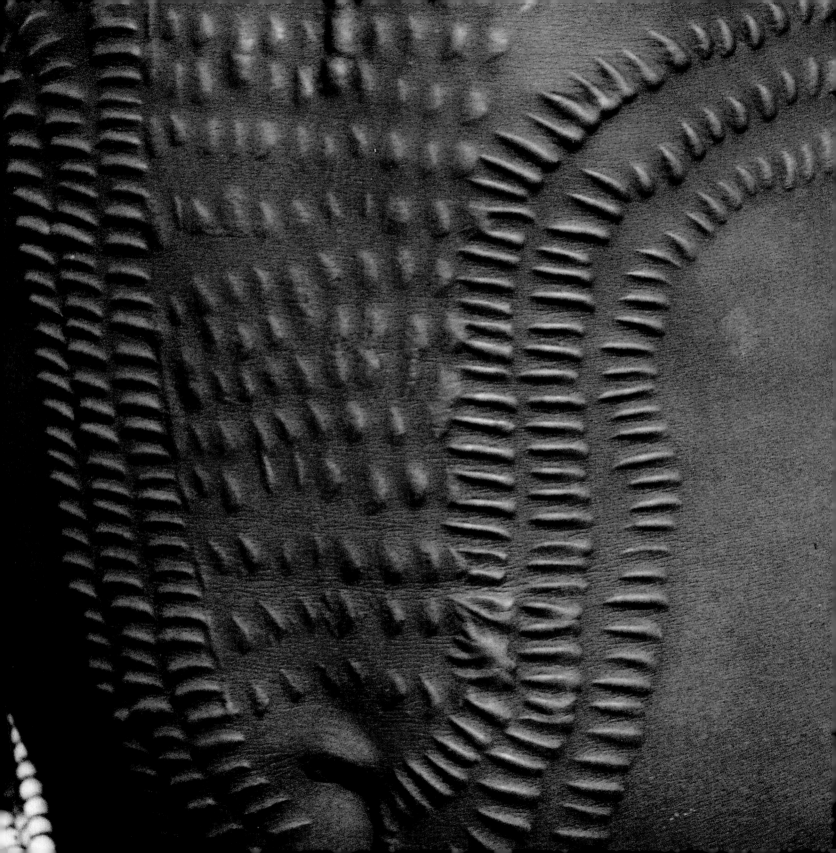

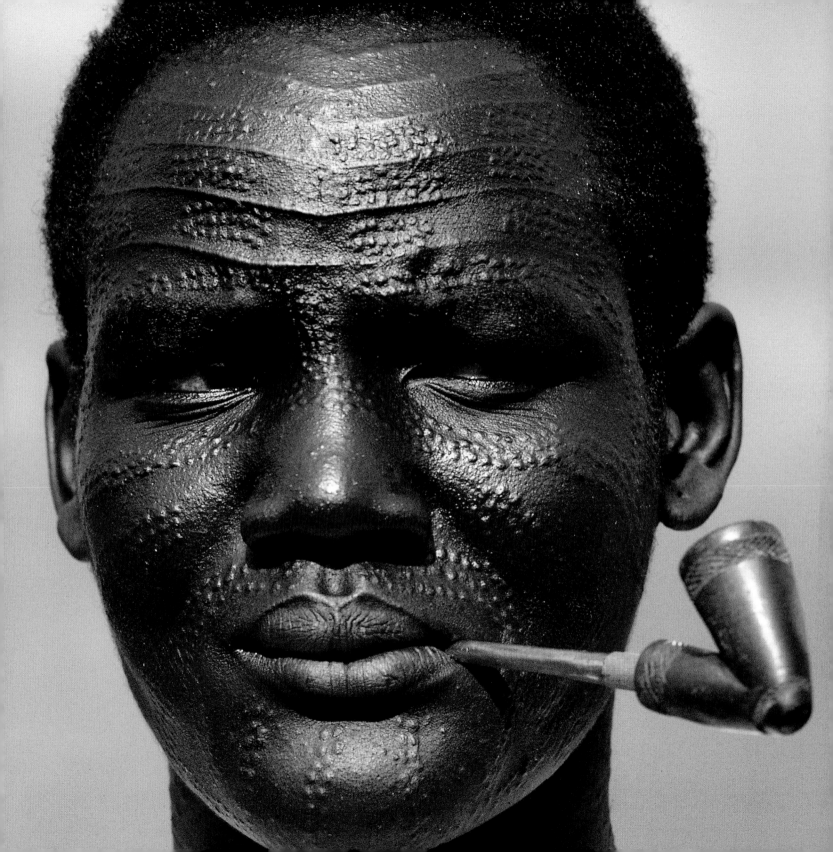

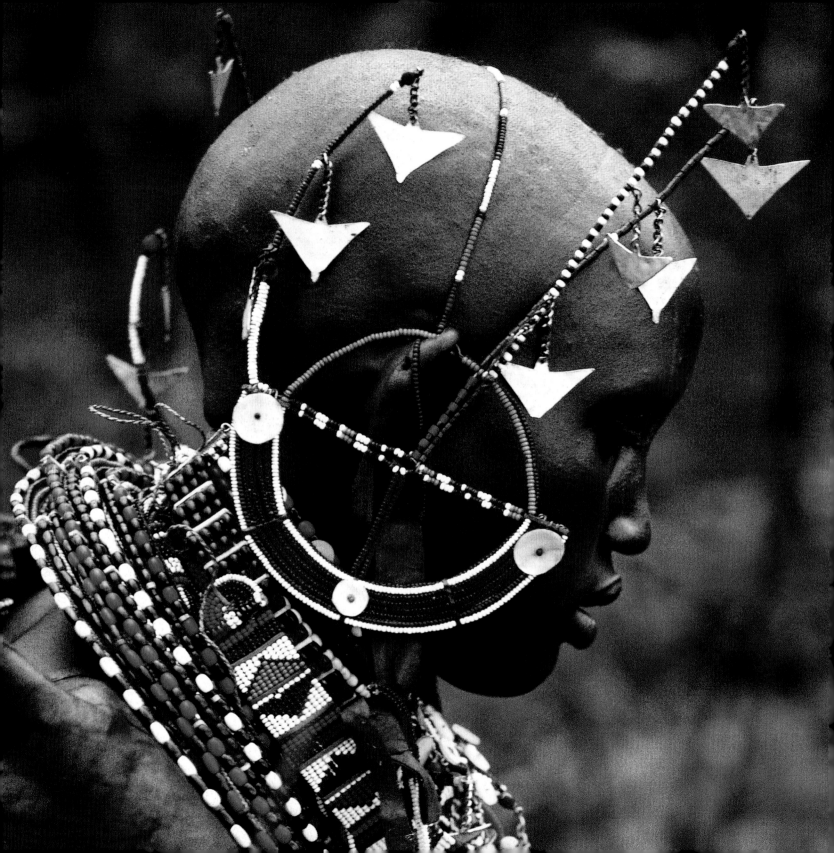

OF ALL THE AFRICAN LANGUAGES WE KNOW, THE MOST EXCITING FOR US TO LEARN HAS BEEN THE LANGUAGE OF JEWELRY AND ADORNMENT. It has a vocabulary that conveys information, proclaims status, and expresses feelings, moods, and intentions. The language of jewelry and adornment has rules of usage, definitions, nuances, and limitations that are specific to each culture and play a role in every aspect of daily life.

Archaeological records, including burial sites and rock art, tell us that jewelry has been important to African cultures for a very long time. The oldest art on Earth was found in southern Africa—a small rock of red ochre with lines incised in a chevron pattern made about 70,000 years ago—and it isn't hard to imagine that the first jewelry must have been created from the same artistic impulse.

It is not often spoken of in this context, but we feel that the "cradle of humanity" could also be called the cradle of creativity, especially when one considers not only the historical heritage, but also the incredible variety of African adornment. From the simple but striking cowry-shell necklaces worn by Hamar girls in Ethiopia, to the elaborate beaded wedding crowns of the Masai in Kenya and Tanzania, African adornment displays dazzling artistry and inventiveness. We have photographed beautiful pieces fashioned from every imaginable material, from objects other people have thrown away to precious metals and gems. Africans' ancient love affair with adornment embraces any material—from solid gold to plastic pipes—that enhances their beauty and allows full expression of their artistic style.

MASAI

KENYA

On her marriage day, Nosiani wears beaded earrings made from mobile wire extensions decorated with buttons and triangular pendants that imitate birds in flight.

CRADLE OF CREATIVITY

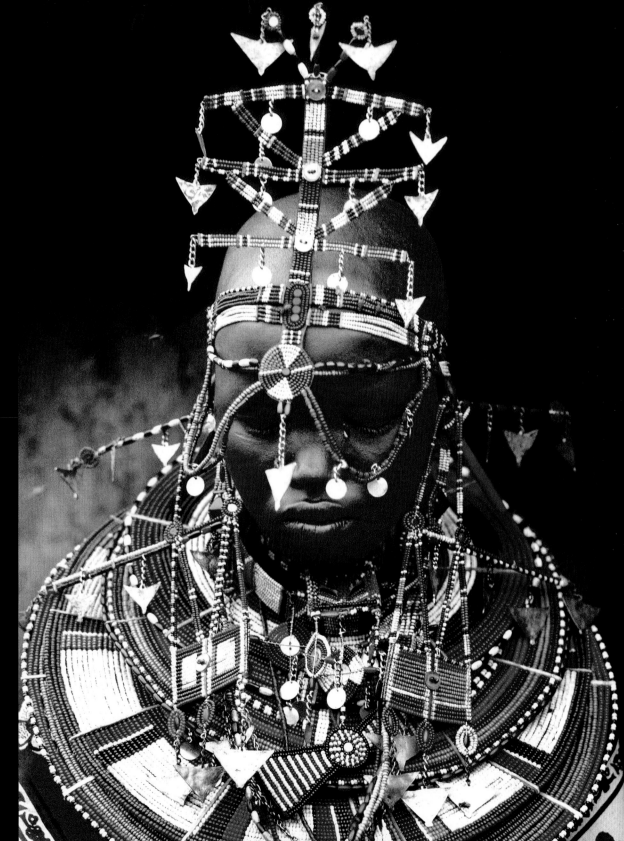

A 16-year-old bride from Kitilikini wears a magnificent collection of beaded collar necklaces and mobile head pendants designed to follow and enhance the movements of her body. The tear in her eye reflects her sadness upon leaving home. According to Masai tradition, as she leaves her family compound her mother tells her, "You must not look back or you will turn to stone." This will give her strength to leave her parents and follow her husband to a new home.

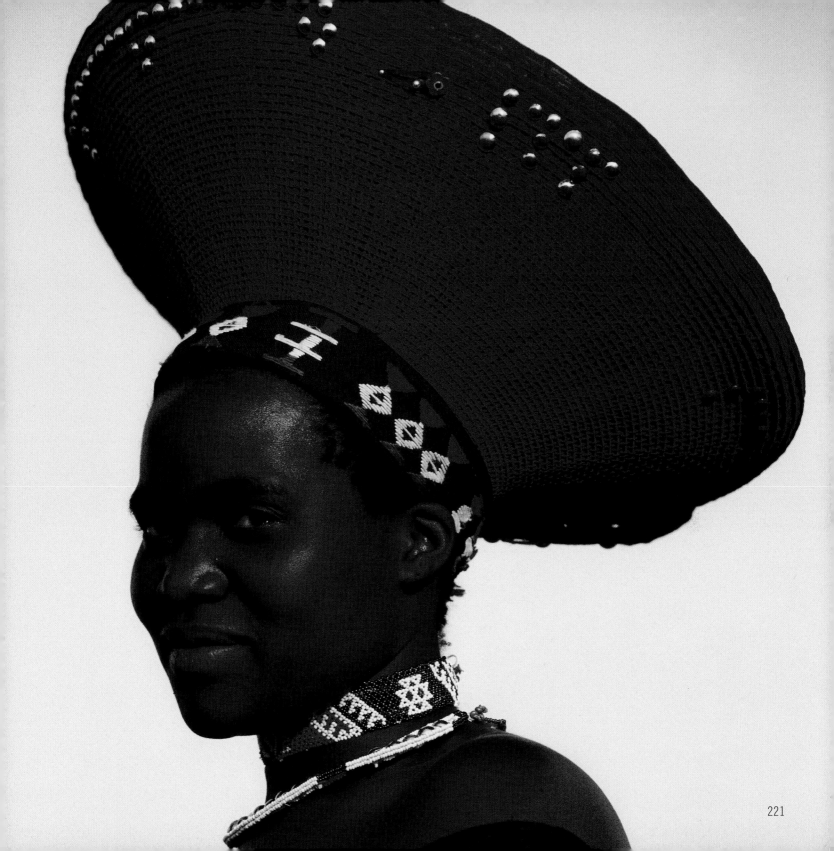

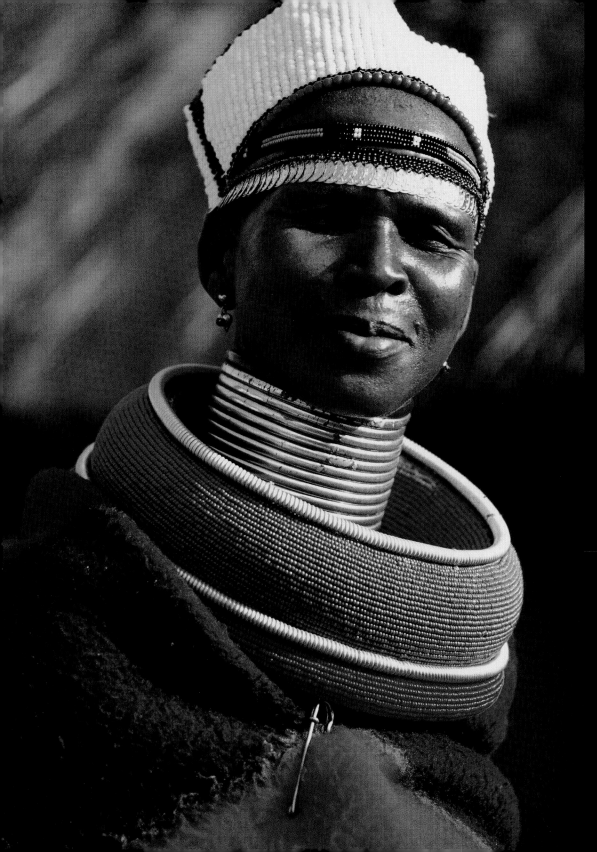

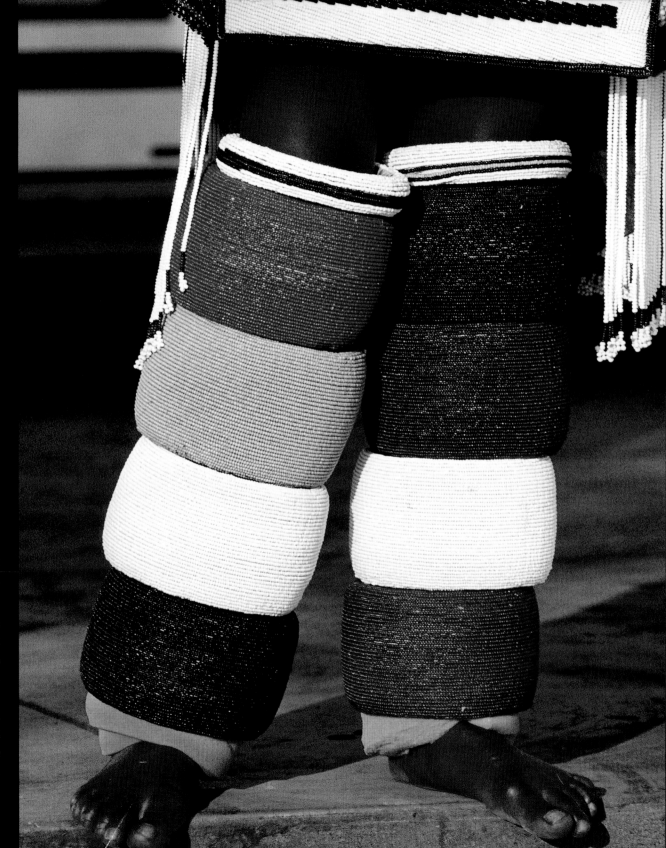

NDEBELE
SOUTH AFRICA

To indicate her availability for marriage, a girl wears large beaded leg hoops believed to emulate the voluptuous rolls of body fat that are considered a mark of health and beauty among the Ndebele.

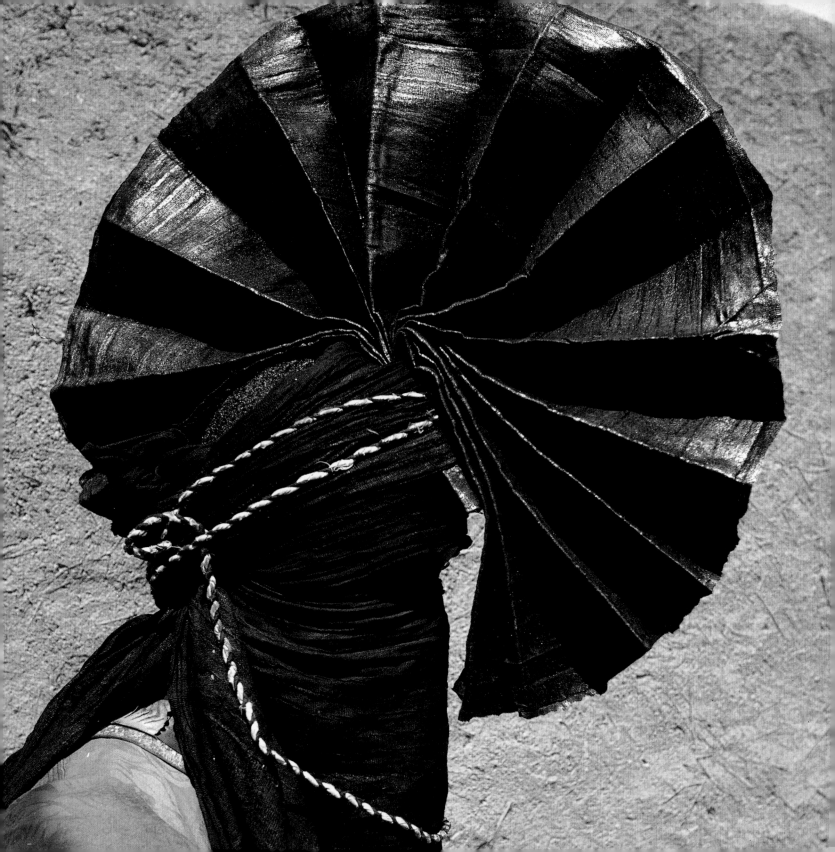

THE HIGHER THE SOCIAL STANDING OF A TUAREG, THE MORE CARE HE WILL TAKE TO COVER HIS FACE. He will make certain that he does not reveal the tip of his nose, and will wrap a veil so high around his face that his eyes cannot be seen. We attended the festival of Bianou in the ancient town of Agadez, situated on the southern edge of the Sahara Desert. Two groups of Tuareg celebrants dressed as warriors charged through town commemorating those who fought in the holy wars in Mecca in the early days of Islam. The warriors wore two pieces of cloth beaten with indigo dye to give a lustrous sheen. The first piece of indigo cloth was wrapped around the head as a turban, and the second was folded into a pleated crest to stand like a coxcomb, creating an effect similar to the rise and fall of the crest of a male bird performing a mating display.

TUAREG

NIGER

A Bianou celebrant wears a traditional pleated headdress fashioned from hand-beaten indigo fabric.

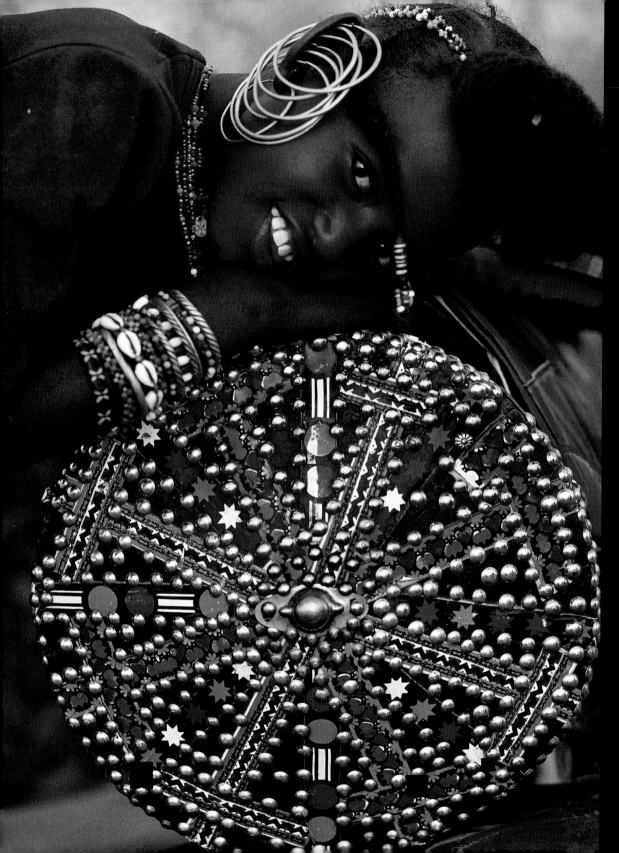

A young girl decorates her
round wooden bedposts with
metal thumbtacks and colorful
plastic cutouts found in the
marketplace. The Wodaabe are
renowned for their unique
ways of incorporating found
objects from the outside world
into their traditional style.

RASHAIDA
ERITREA

From the age of five a
Rashaida girl wears a veil,
removing it only in the
privacy of her family's tent.
At the time of marriage, her
mother gives her the
elaborate veil seen in this
photograph. The veil is
stitched with silver thread
and decorated with sequins,
gold bric-a-brac, and
silver pendants.

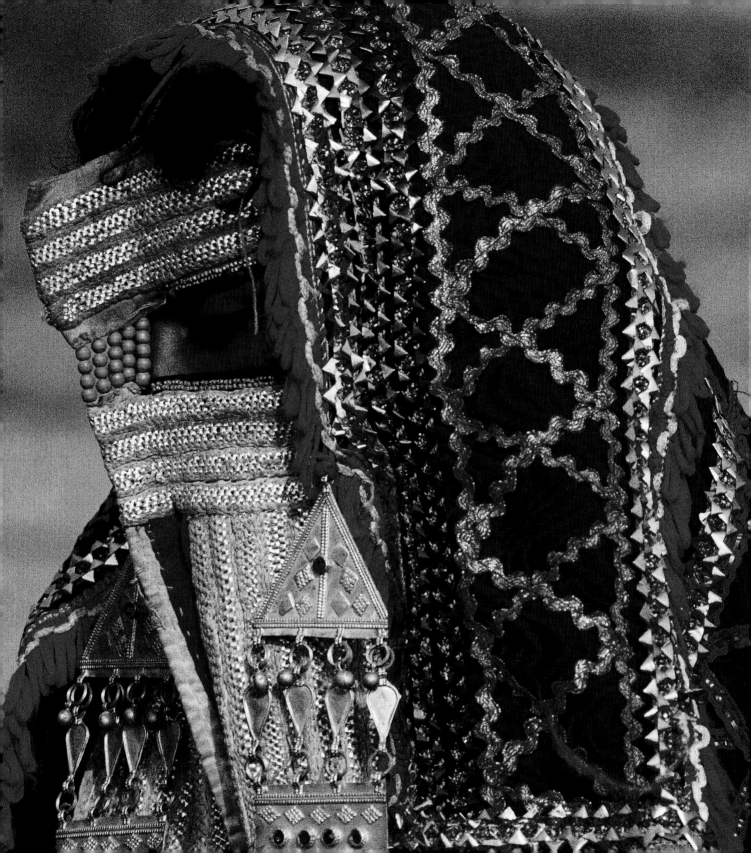

"AS WE WALKED TOWARDS THE VILLAGE, WE COULD HEAR THE RESONANCE OF IRON BELLS, enhancing the rhythmic singing of dancers. Women in a seemingly mesmerized state advanced towards us in single file, taking tiny steps that gave the impression that they were dreaming. They wore intricate headdresses styled to resemble the crests of birds, and they carried dance sticks topped with stylized beaded dolls.

We were intrigued to learn that Bassari women pass through six different stages in life, and as they mature their beadwork grows more elaborate. Bassari women celebrate not only beauty but more importantly maturity and wisdom. The Ohamana dance performed by the woman in this photo marks the arrival of 35-year-old women into a new age set. We were touched by the importance of the ritual in the lives of older women and noticed how much the women enjoyed being admired and looked up to at this stage of life. The woman photographed here was very proud of her plastic hair bow, found in the marketplace, and we were impressed by her very creative attention to detail."

An extract from a page in our journal, December 1995.

BASSARI

SENEGAL

A 35-year-old woman wears the
traditional hair adornment of the
Ohamana age-passage ceremony.

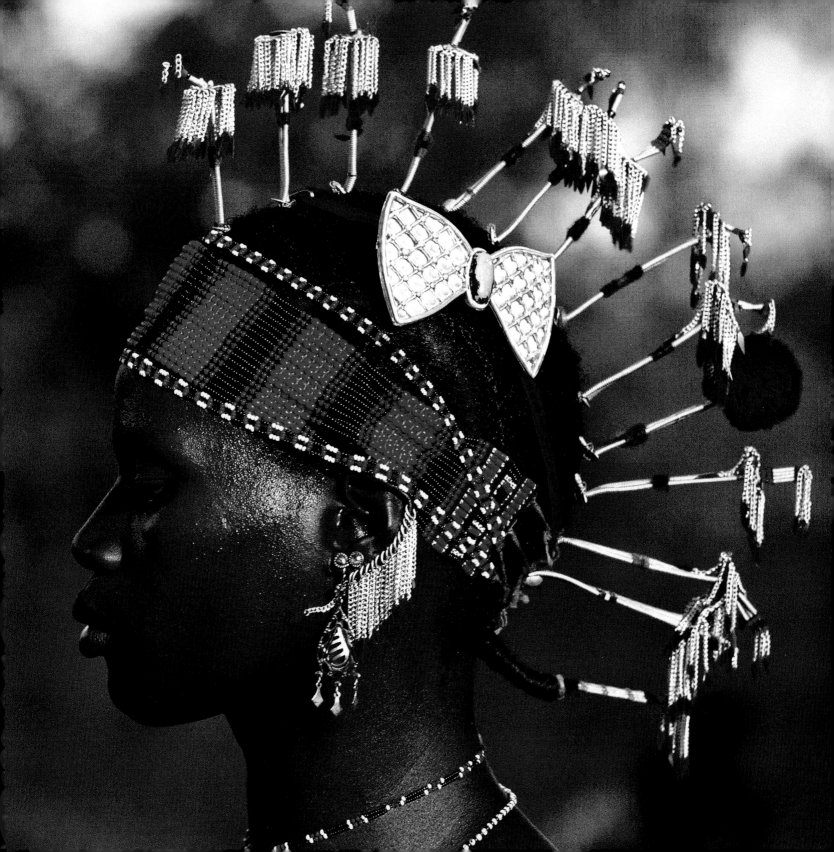

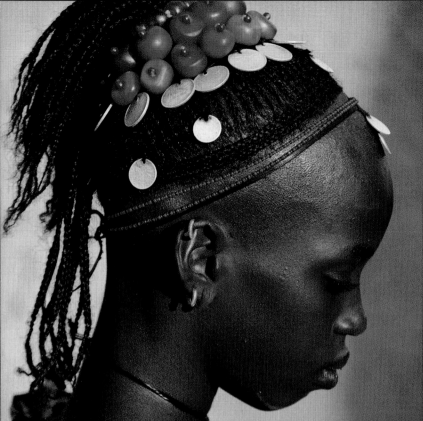

FULANI
MALI

All images: Pastoral women from the savanna grasslands of west Africa lavish great attention on their hairstyles. They grease, part, pad, and support their hair in an amazing variety of forms. Once styled, it is decorated with precious metals, colorful beads, and buttons reflecting the woman's origin and status in life.

BELLA
BURKINA FASO

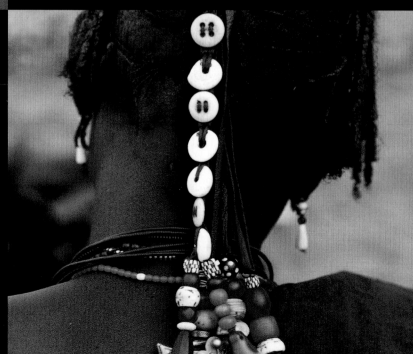

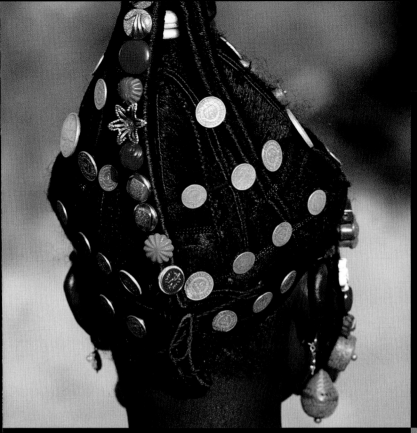

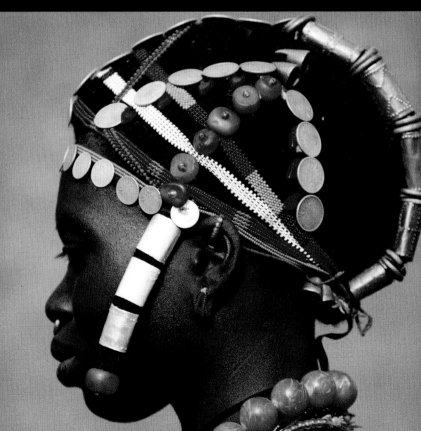

"IN DJENNÉ, A SISTER TOWN TO TIMBUKTU ON THE RIVER NIGER,
WE WALKED THROUGH NARROW PASSAGEWAYS leading into the central
courtyard that served as the marketplace of the town. Fulani women wrapped in soft, col-
orful, diaphanous cloths moved from stall to stall, their large sculpted earrings catching
the sunlight beneath the awnings of the vendors selling their wares.

We befriended Alisa Djallo (right), a kind gentle lady who invited us to spend time in
the privacy of her home to get to know one another. Later in the day, she allowed us to take
her portrait wearing her beautiful gold earrings. She explained that these had been given
to her on her wedding day, and because she was the oldest daughter in the family, she would
keep them permanently. She would, however, lend them to her sisters for their wedding cel-
ebrations, after which they would be returned to her."

An excerpt from our journal, December 1994.

FULANI

MALI

Alisa Djallo wears magnificent
22-carat hand-beaten gold earrings
received on her wedding day.

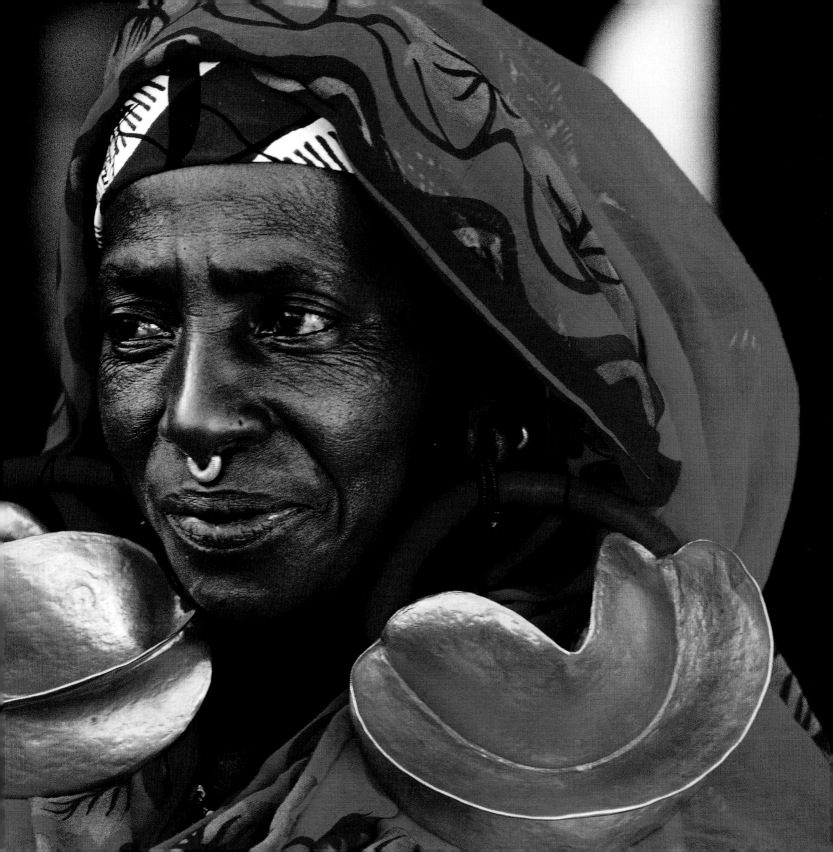

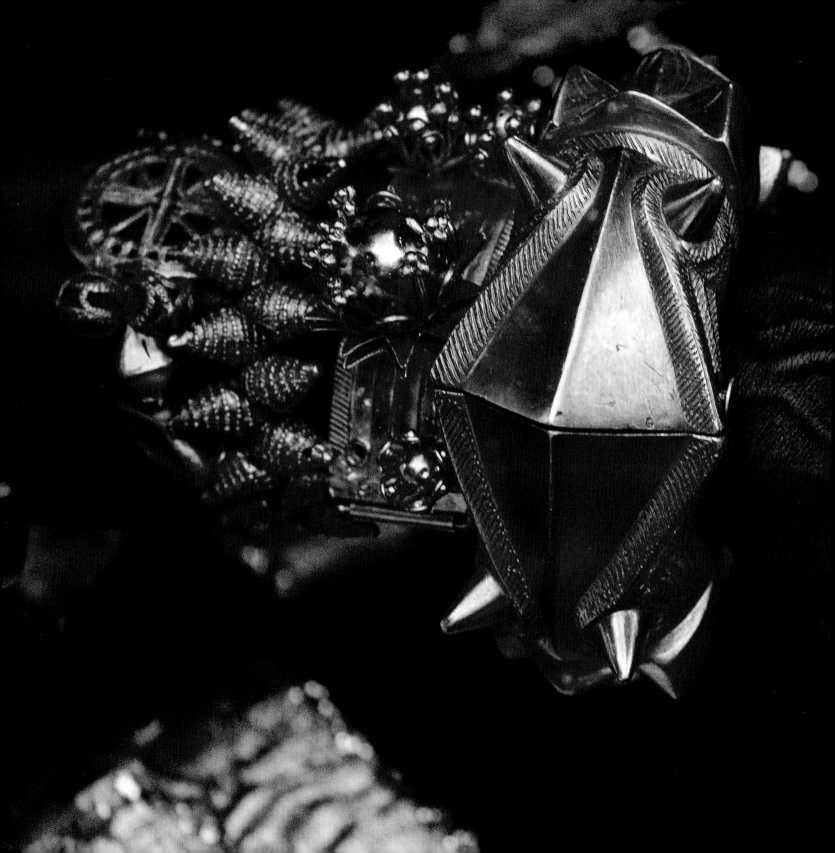

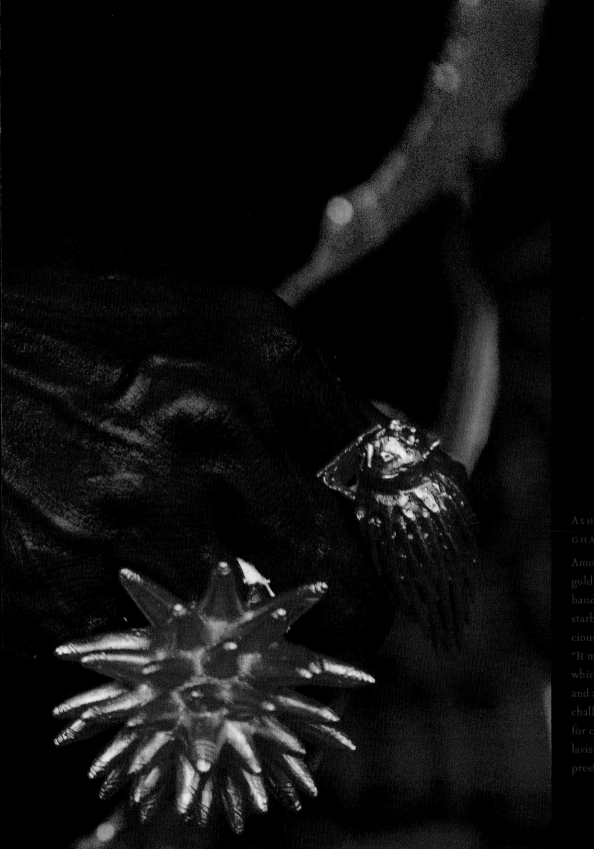

Among the impressive display of
gold jewelry worn on the arm and
hand of an important chief is a
starburst ring, named after a deli-
cious fruit. It reflects the proverb
"It may not speak, but it breathes,"
which refers to a leader who is calm
and able to exert authority when
challenged. Gold has been mined
for centuries in Ghana and is worn
lavishly to display wealth and
prestige on important occasions.

We met Uda Geykul, a young
Barabaig girl, at the Bungeda cere-
mony, a ritual funeral held for
a man considered a "perfect elder."
She had come to honor the passing
of a great man, and would dance
with her age mates each day. Uda's
father was a wealthy man, and he
helped her acquire the beautiful
jewelry that she wore to the funeral.
Her brass-tooled necklace and
spiral rings were purchased from
the local blacksmith—who also
cleverly sliced a plastic water pipe
into multiple bracelets in imitation
of the ivory bracelets of the past.

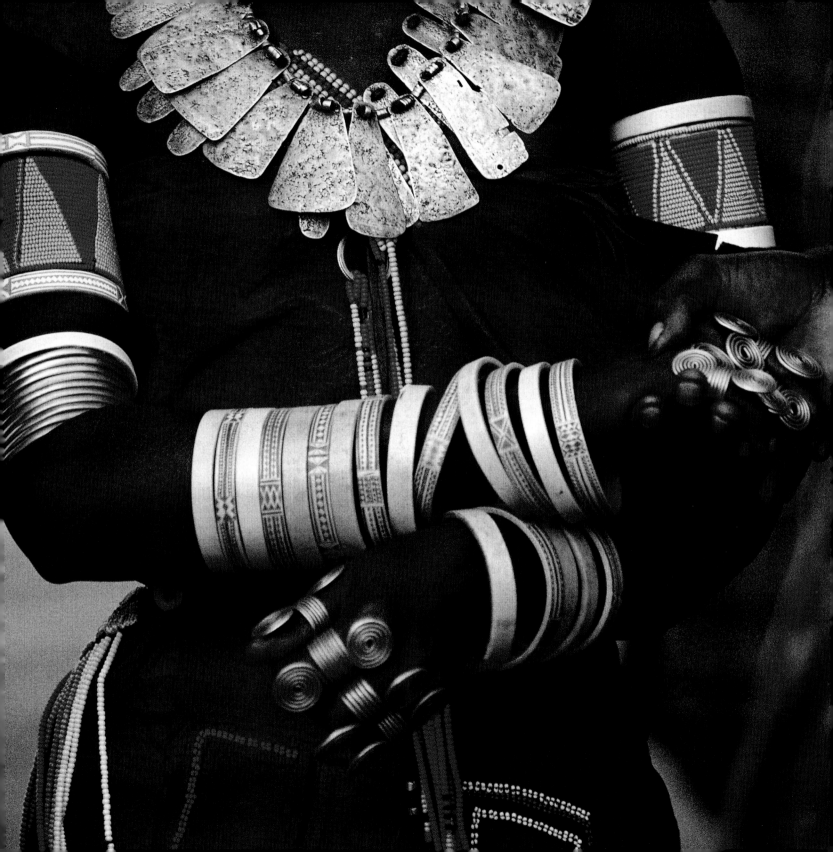

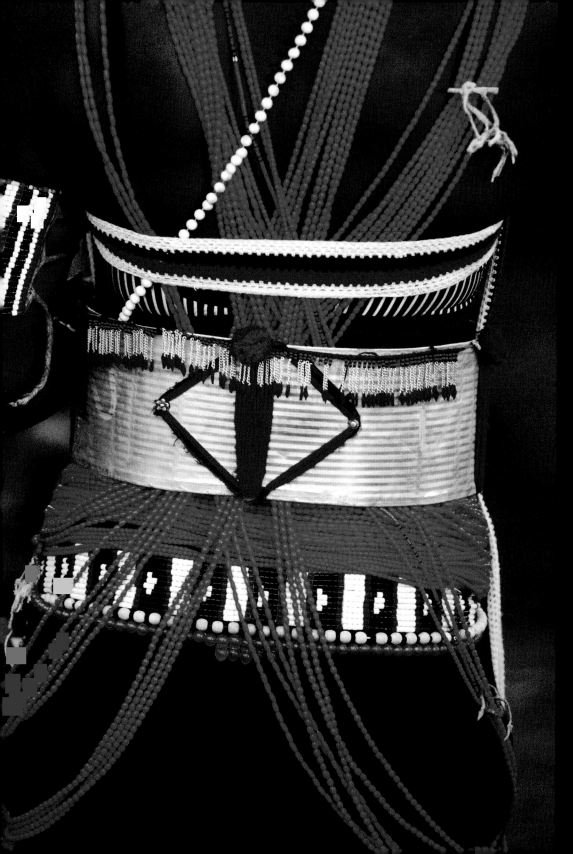

BASSARI
SENEGAL

Left and right: Strands of beads,
worn crisscrossing the shoulders,
and tight corsets made of
aluminum accentuate the physiques
of the guardians of the Bassari
male initiates at their
coming-of-age ceremony.

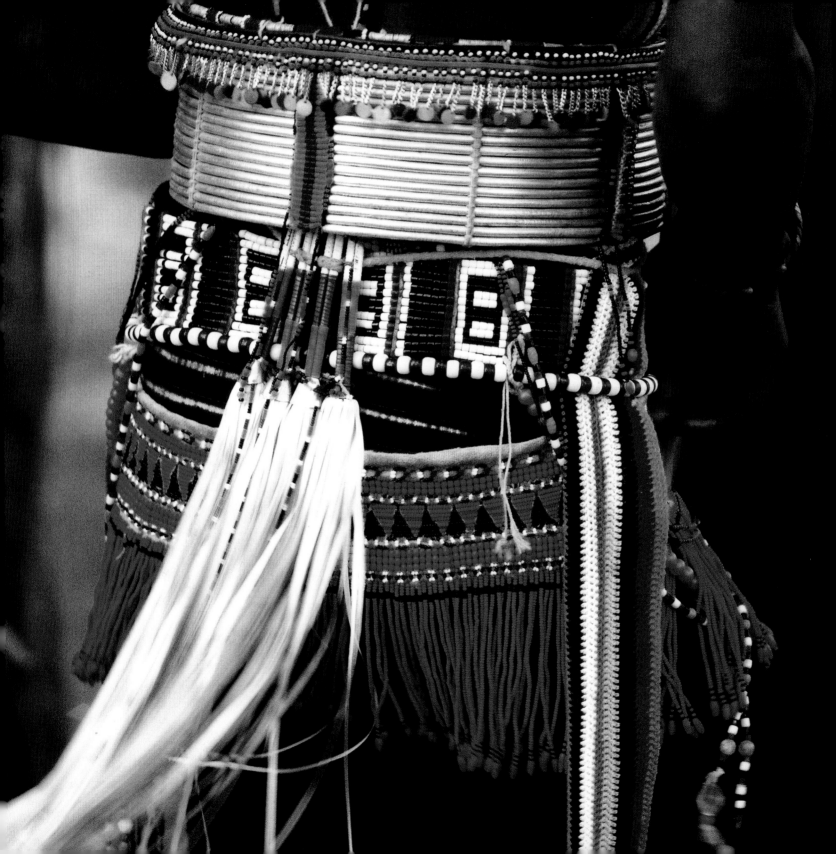

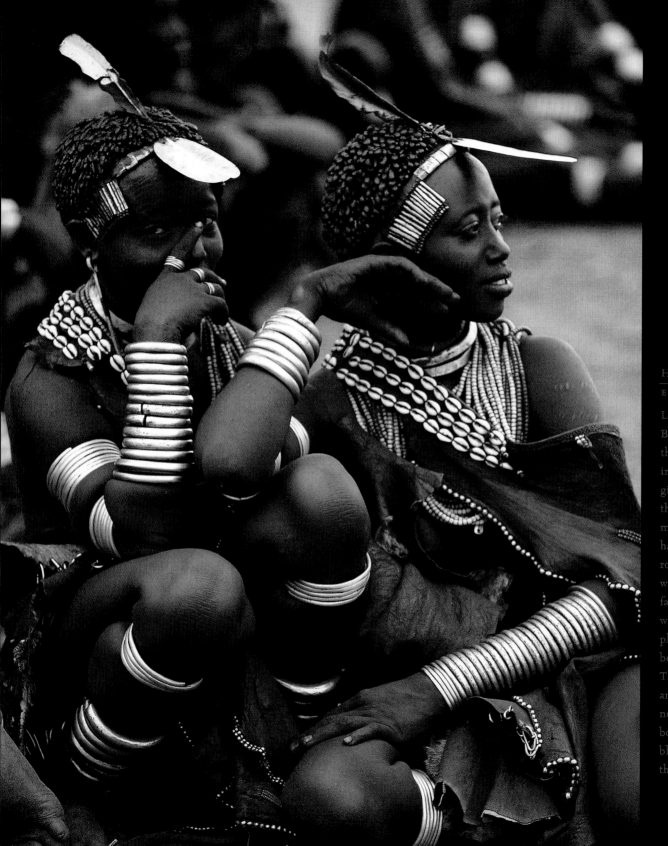

HAMAR

ETHIOPIA

Left and right:
Beautifully attired in
their beaded skins and
iron jewelry, Hamar
girls gather to celebrate
the Jumping of the Bull
male initiation. Their
hair is styled into small
round pellets covered
with ochre and perfumed
fat, and accentuated
with a large aluminum
plaque resembling the
beak of a spoonbill.
Their iron neck torques
and armlets are perma-
nently fixed onto their
bodies by the local
blacksmith to proclaim
their marital status.

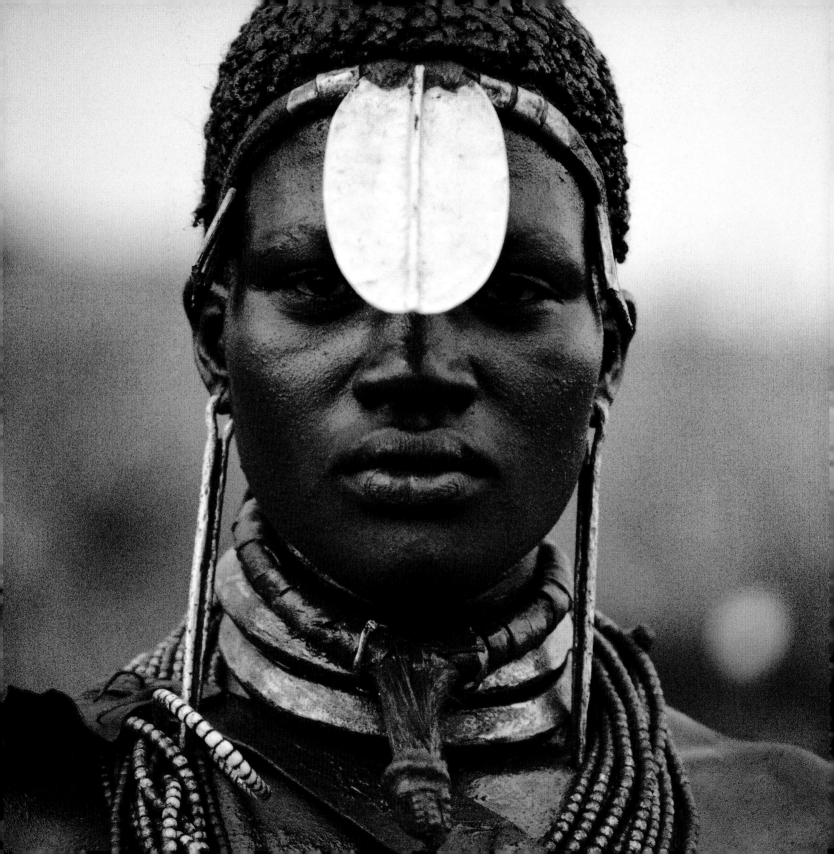

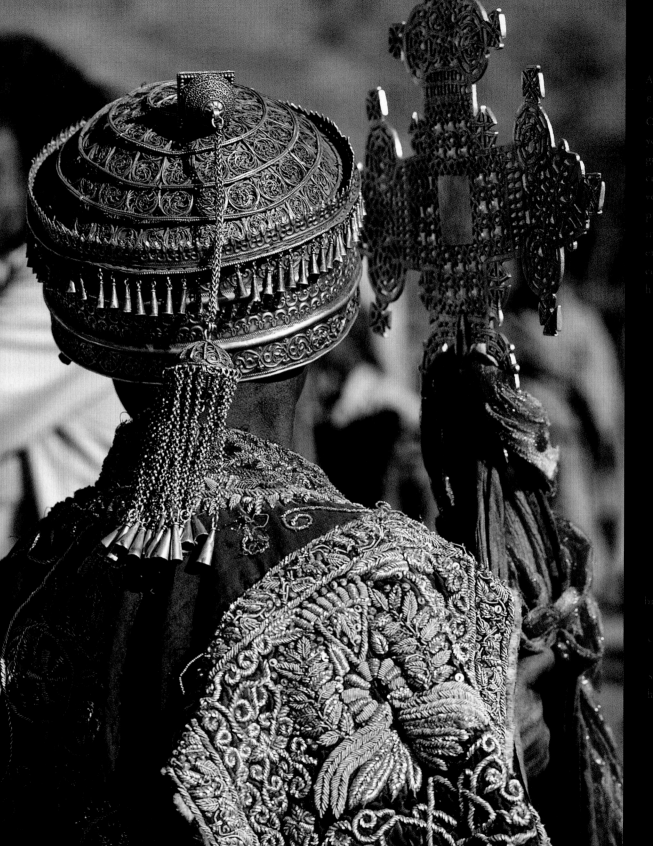

AMHARA
ETHIOPIA

Celebrating Christmas, a
young deacon wears a
gold-and-silver filigree
crown and an embroidered
velvet cape. He carries a
processional cross whose
interlaced design is
emblematic of the 12th-
century capital, Lalibela,
his hometown.

RASHAIDA
ERITREA

On her wedding day, a
bride wears an elaborately
embroidered veil that
covers her nose and fore-
head, leaving only two
slits edged with black for
her eyes to peep through.
According to the code
of Islam, her smile
must never be revealed
to strangers.

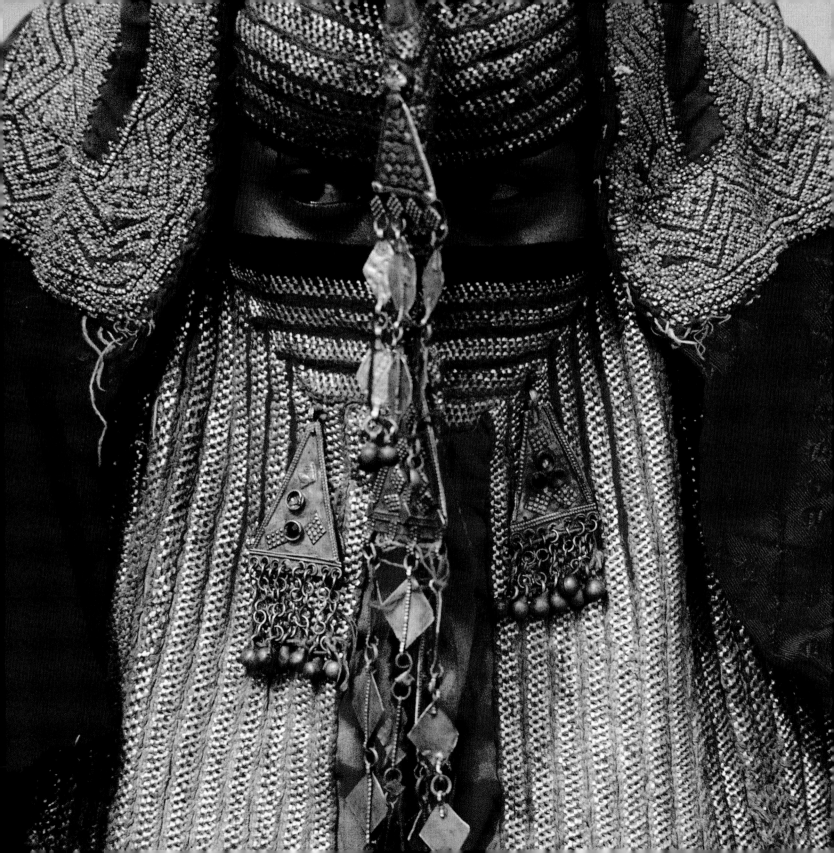

IN A SMALL VILLAGE CALLED DABOU IN SOUTHERN IVORY COAST, WE WERE INVITED INTO A MODEST BANCO HOUSE TO MEET ANGBADZ, who was preparing for the ritual celebration of her husband's wealth. We watched her being dressed by her relatives in bark-fiber cloths and magnificent gold jewelry. The gold beads in her necklace were crafted by the ancient lost-wax technique—still practiced by the Adioukrou today—and her hair was adorned with finely molded gold animal talismans. We learned that these golden ornaments had been given to her by her husband at marriage. This however, was not the end of his husbandly duties; he was required by tradition to present her with gold jewelry for the rest of their married life. After the finishing touches of gold-dust makeup were put onto her face, Angbadz's husband proudly led his wife out into the center of the village and sat her on a small throne, so that all could admire her great beauty and his significant financial achievement. We were thrilled to photograph one of the most extravagant and beautiful feminine decorations we had yet seen in Africa.

ADIOUKROU

IVORY COAST

An Adioukrou queen mother is bedecked in gold jewelry.

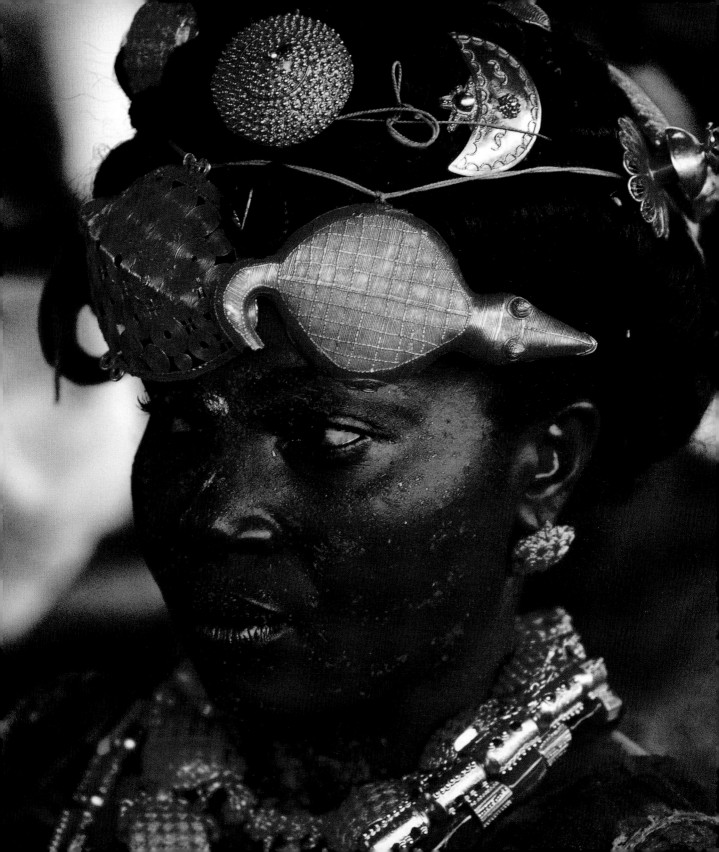

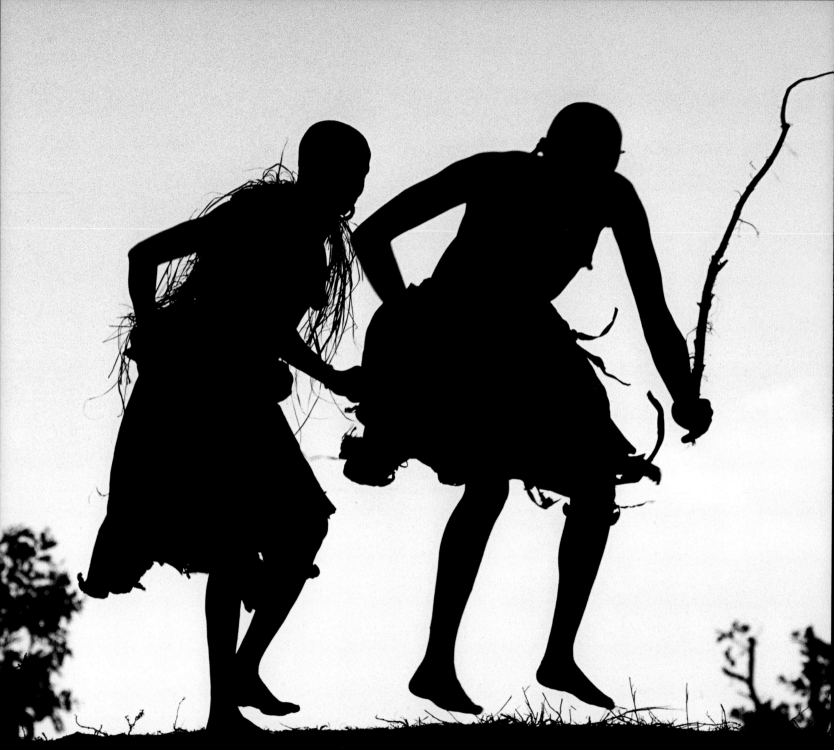

IN THE RUGGED MOUNTAINS OF SOUTHWEST ETHIOPIA, we photographed Surma pastoralists performing a ceremonial dance whose color, music, and choreography would be admired on any stage in the world.

What we marveled at that day, and hundreds of other times, was the African genius for dance and music. Surma music, like so much other African traditional music, requires no conductor, no scores or libretto, only voices singing, hands clapping, and, occasionally, simple stringed instruments, rattles, and thumb pianos. Across the continent, music is a part of every activity—from the cultivation songs of Tanzania to the singing wells of Ethiopia to the lullabies of the Sahara Desert. The magic of music and dance transcends the hardships of existence, rejoices in the miracle of survival, and celebrates the passages of life.

Most African dances are born of traditions centuries old, and many are based on rhythms from nature. A Pokot rain dance represents the cadence of raindrops falling on the ground. A Himba initiation dance imitates the birds and animals that share the Himba's desert world. A Kassena hunting dance simulates the actual hunt; a dancer crawls on all fours wearing the hide and horns of the prey, while dancers impersonating hunters surround the animal and perform a wild, stylized capture.

African rhythm is the resonance created when the soul of a continent connects with the spirit of a people. The basis of all African dances is a rhythmic impulse that surges from deep within the land and flows directly into African hands and feet and voices.

SURMA

ETHIOPIA

Two Surma women dance in a frenzy, expressing their grief over the passing of a close female relative.

RHYTHM FROM WITHIN

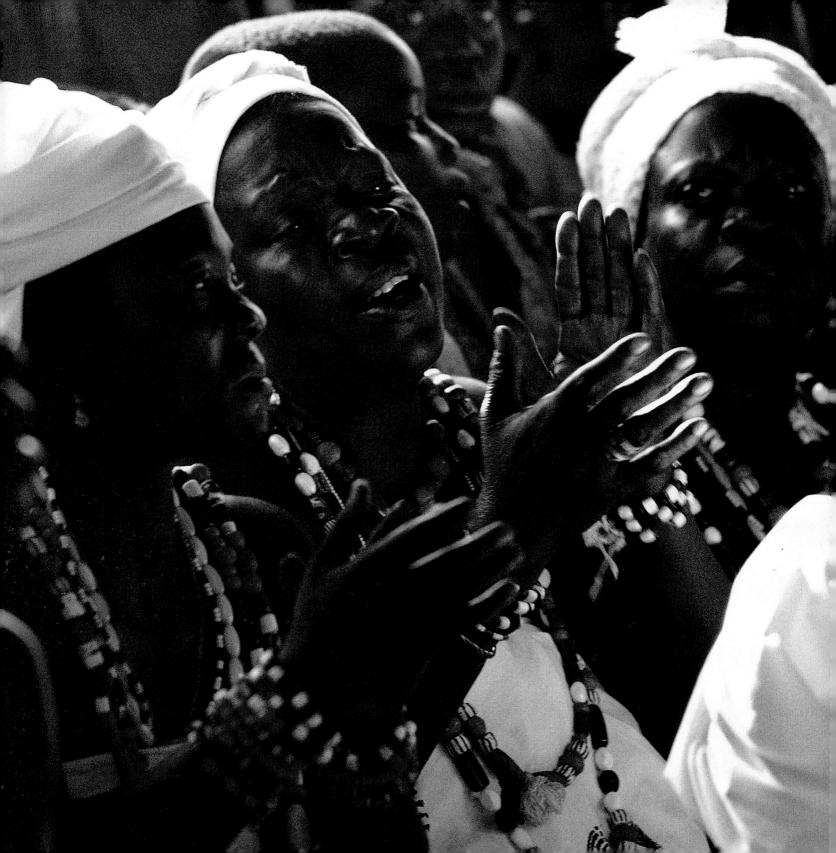

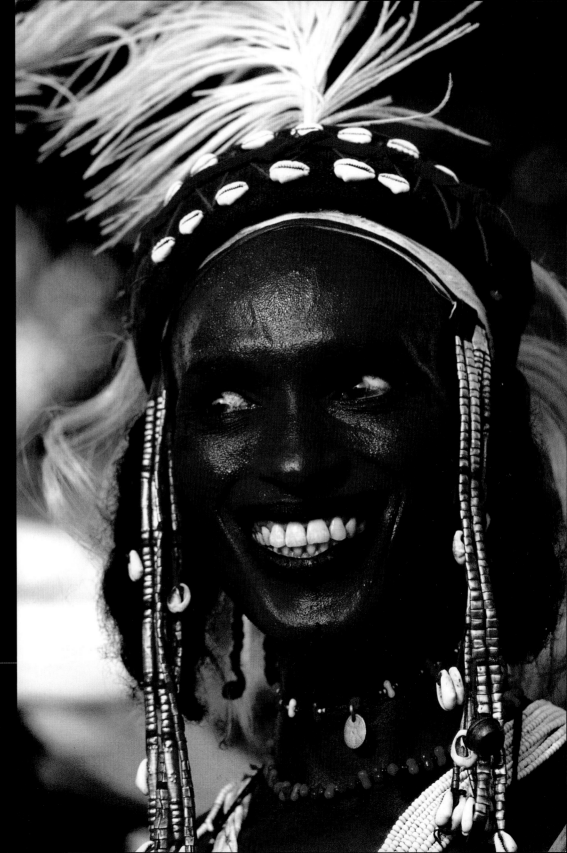

GA
TOGO

Voodoo priestesses perform a haunting, rhythmic chant to welcome a new priestess emerging from the sacred forest where she has been in training for six months.

WODAABE
NIGER

A Wodaabe male finalist in the "dance of beauty" accentuates his facial movements with a display of bright eyes and sparkling teeth for the benefit of his female judges.

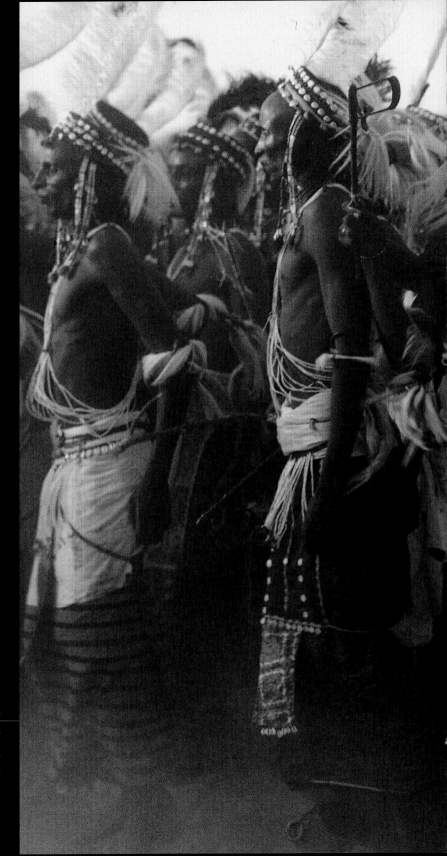

THE GEEREWOL IS ONE OF THE MOST BEAUTIFUL AND POETIC DANCES WE HAVE EVER SEEN IN AFRICA. Male contestants form long lines, facing up to 500 female judges, in a competition for physical beauty.

Side by side they present themselves, wearing ochre makeup on their faces, tight wraps around their hips, bindings around their knees, and strings of white beads criss-crossed on their bare chests. The dance alternates between quiet, quasi-religious passages and frenzied jumping and stomping designed to show off the physical strength and stamina of the men.

Punctuating these warlike passages are haunting chants, during which the men sink down with their knees bent, gracefully swing their arms forward, and turn their heads to display their broad smiles and the whiteness of their eyes and teeth.

At the close of the dance, three unmarried girls chosen for their beauty are bought out to serve as judges. Each girl advances slowly toward the dancer of her choice, and with a graceful swing of her arm, indicates her favorite.

WODAABE
NIGER

The climax of the Geerewol dance,
in which men compete for beauty.

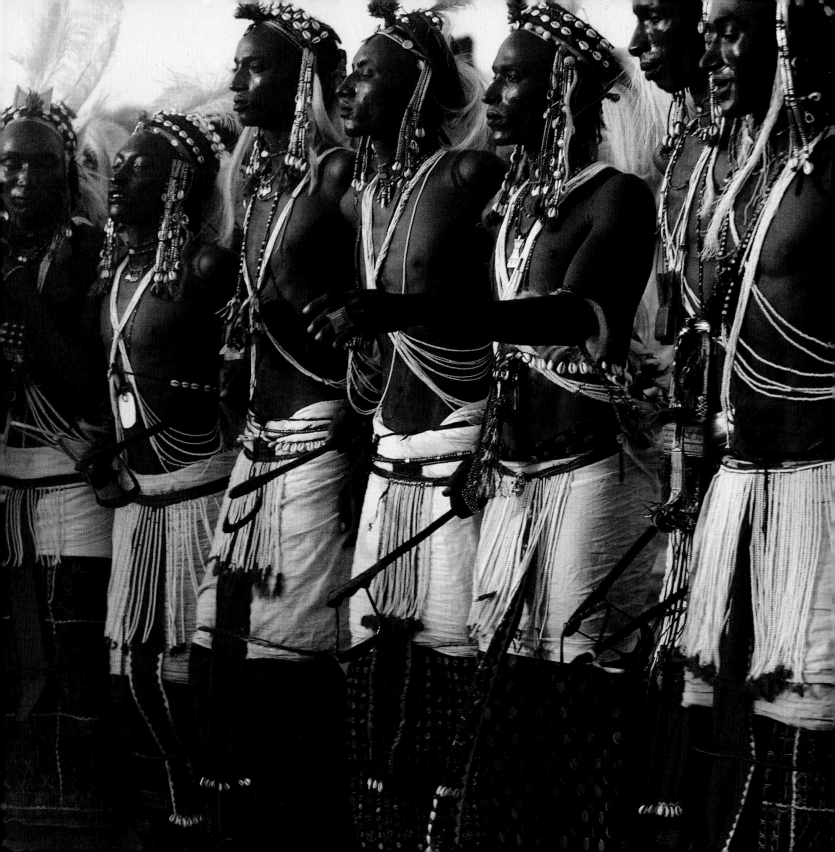

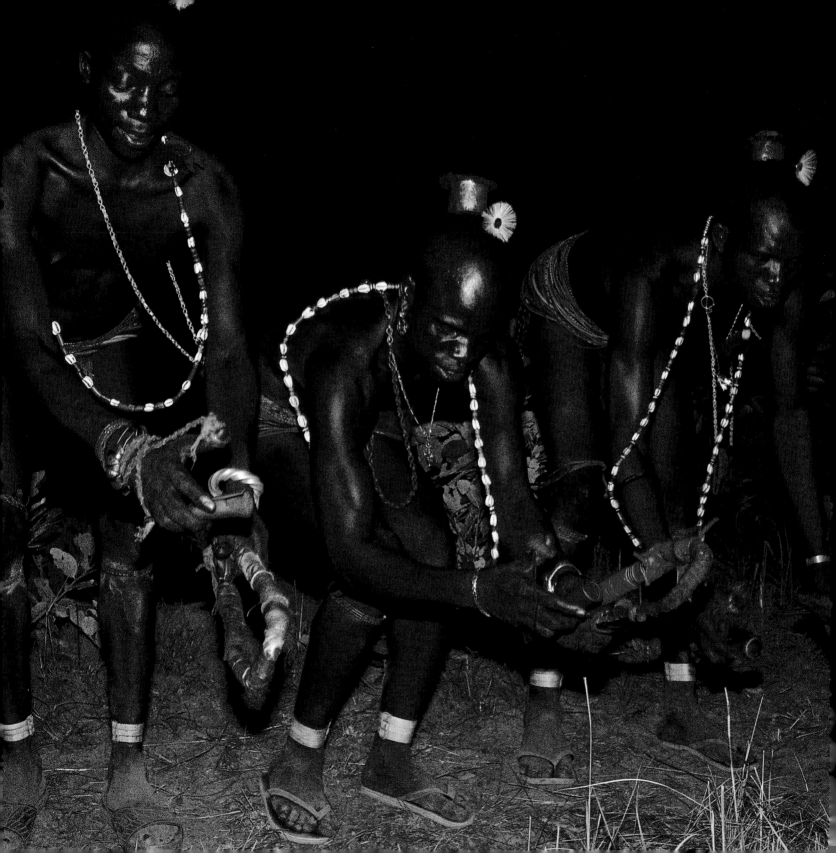

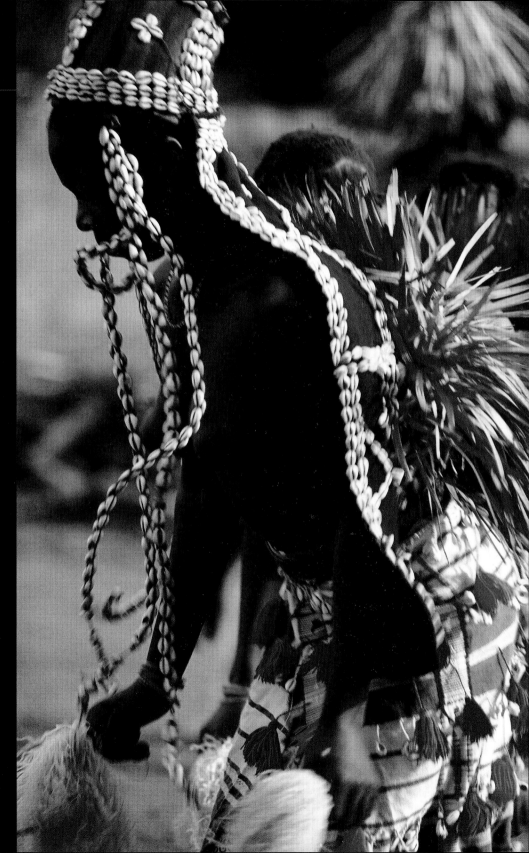

Female initiates of the secret Poro
Society perform the Ngoron dance
at their initiation ceremony.
Festooned with strings of cowry
shells symbolizing femininity, and
wearing large grass pompoms on
their backs, the girls dance to
celebrate their newfound maturity.
The steps, both subtle and
complex, can take up to
six months to master.

TANEKA

BENIN

A special group of guardians,
responsible for male initiates await-
ing circumcision, act as travelling
entertainers during the eight-month
period preceding the circumcision
ceremony. They constantly devise
new ways to amuse their audiences.
Late one night we heard the jingling
sounds of metal castanets and
found outside our tents a line of
Taneka guardians performing a
mesmerizing syncopated line dance.

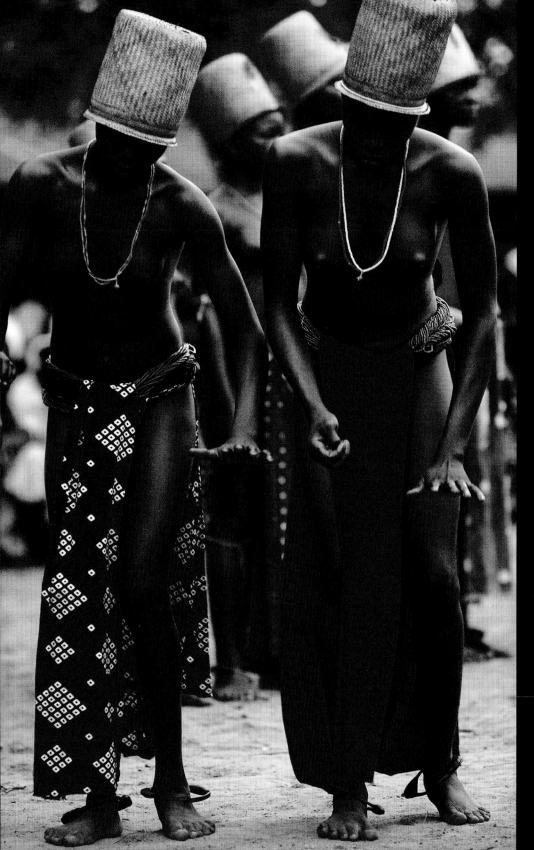

Two female initiates perform
the Klama dance at their
Outdooring ceremony.

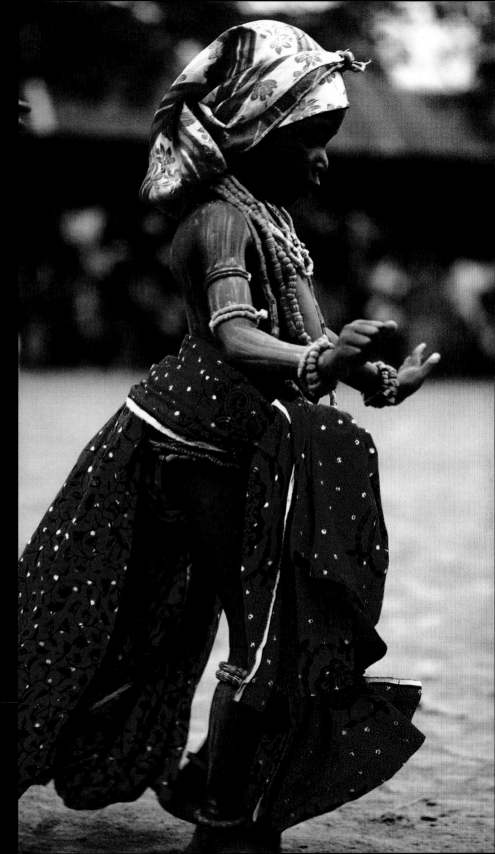

WITH SMALL RHYTHMIC STEPS and eyes cast downward, a small Krobo girl masters the graceful movements of the Klama dance at the annual Outdooring ceremony of female initiates.

Each girl practices the different movements of the dance over three weeks of training, in preparation for graduation into womanhood. The quiet elegance of the dance reveals the beauty of the dancer to family, friends, and above all potential suitors attending the ceremony. Often a suitor will approach a girl's family after the event to make an offer of marriage.

In recent times, because of pressure from the Christian church to curb "animist" ritual, and to reduce the considerable costs of putting a girl through initiation, many mothers initiate all their daughters simultaneously. This often means that the ages of the initiates vary greatly, the youngest being perhaps only six years old—like the girl in this photograph.

KROBO

GHANA

A young girl imitates the movements of the Klama dance performed by the older initiates.

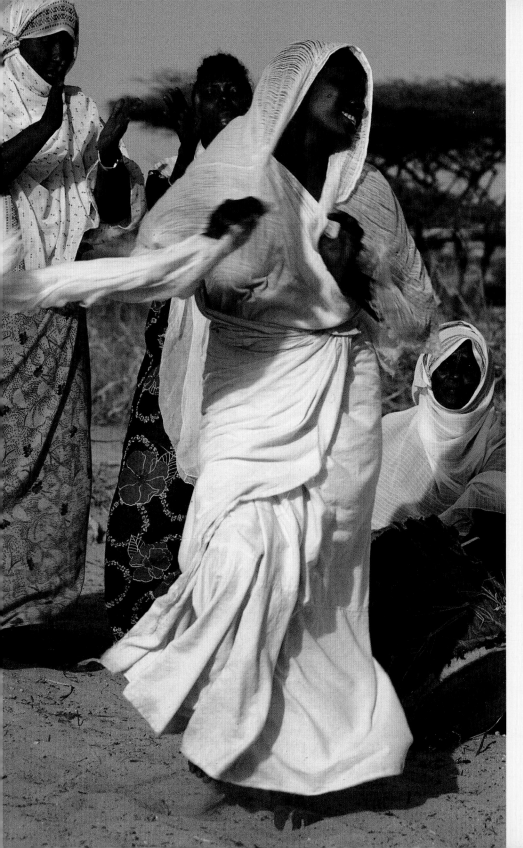

SOMALI
SOMALIA

Left and right: Billowing robes and vigorous hand clapping intensify the swirling movements of Somali dancers celebrating the end of the dry season.

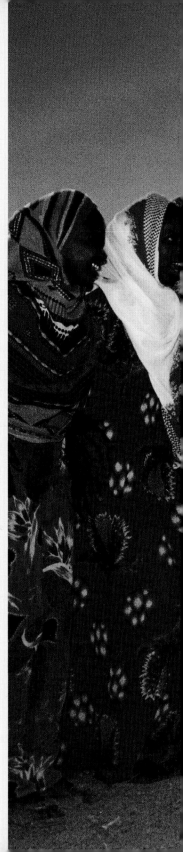

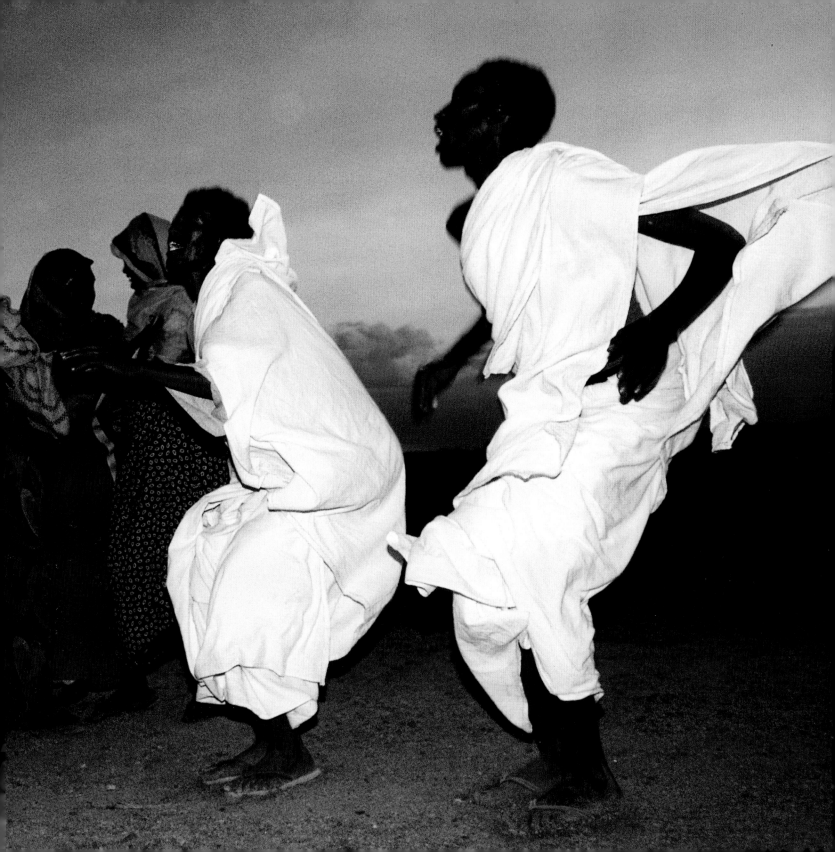

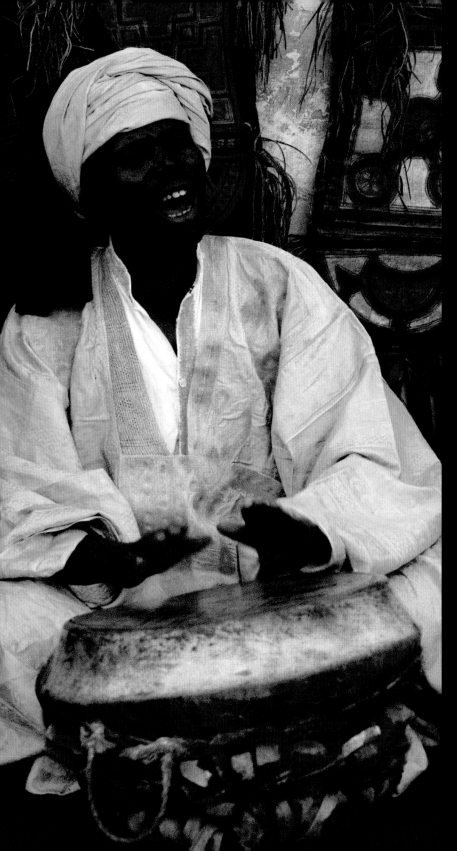

Left and right: To the rhythmic
accompaniment of drums, a Guedra
dancer performs a ritual dance of
love. At the climax of the dance she
removes her veil, and her long
strands of beautifully decorated
hair swing wildly from side to side,
emphasizing the sinuous and erotic
movements of her body.

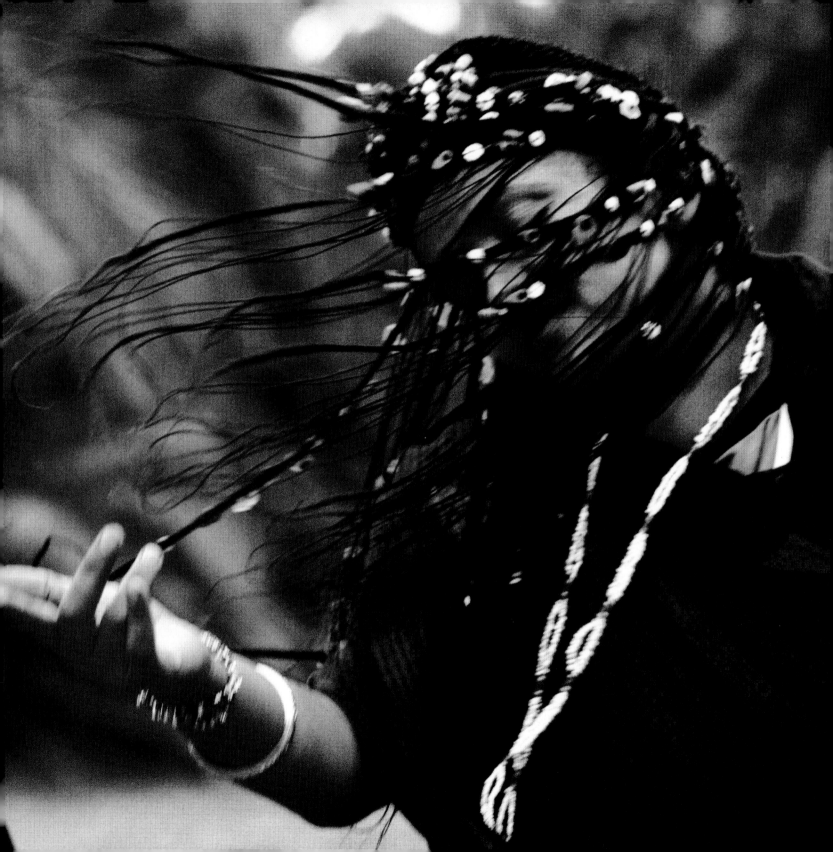

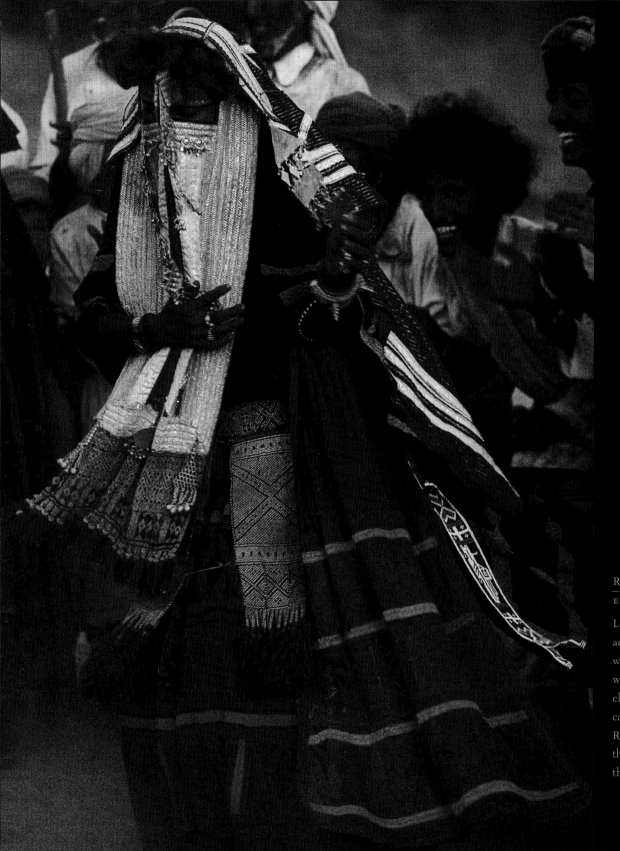

RASHAIDA
ERITREA

Left and right: Surrounded by admiring men, veiled Rashaida women dance at a desert wedding, twirling in circles and clapping their hands rhythmically. The men cry out, "Rashaida Rashaida," affirming with pride their ethnic identity and inspiring the women to greater fervor.

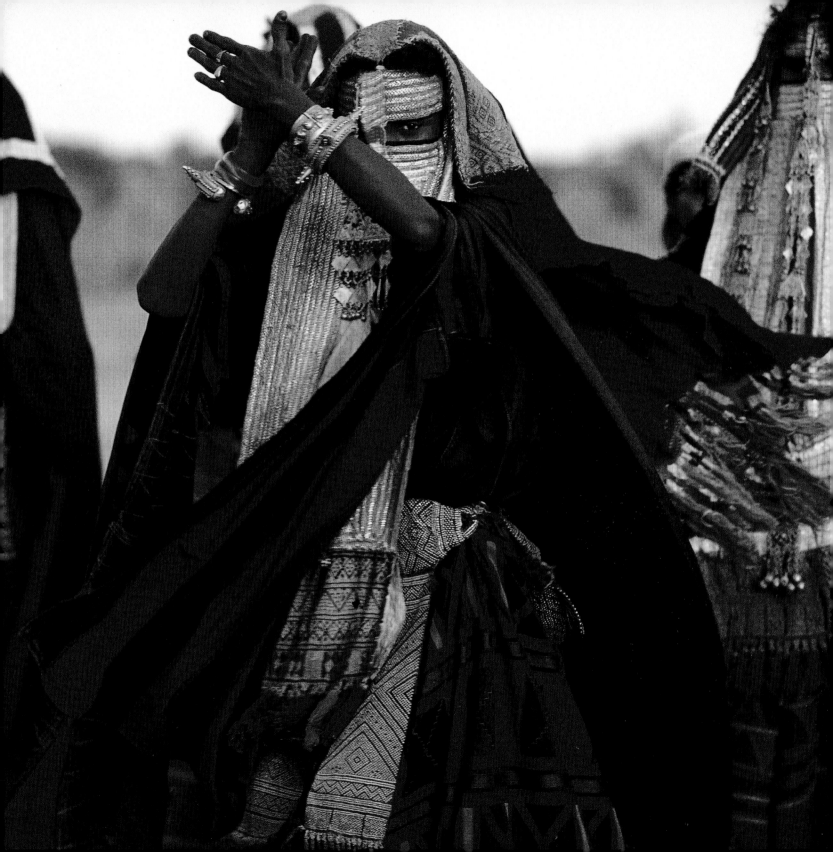

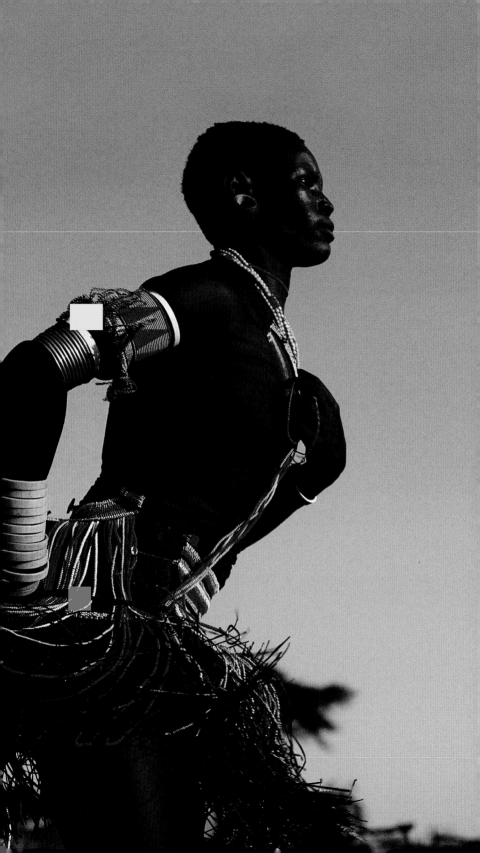

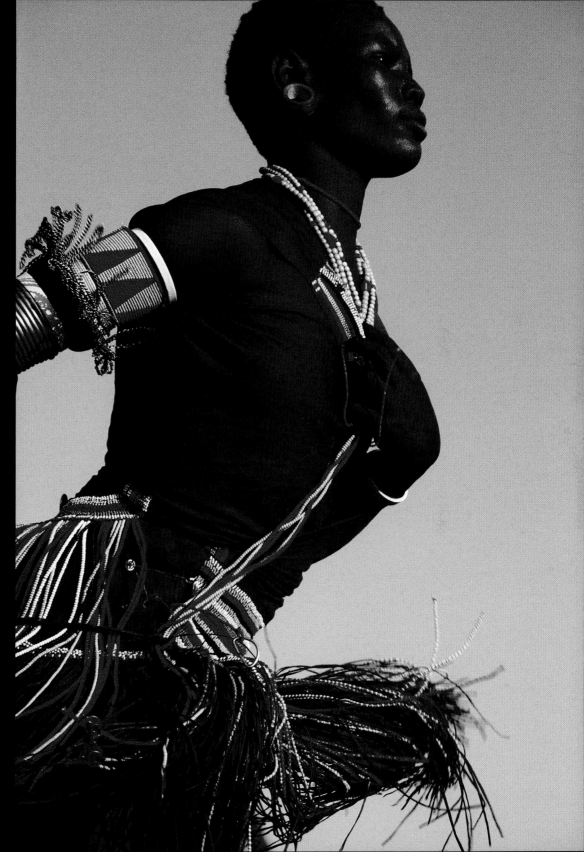

BARABAIG
TANZANIA

Left and right: The courtship dance of the Barabaig has been likened to the mating dance of the crowned crane (a bird found in Barabaig country). The male and female bird stand facing one another, open their wings slightly, then bend their knees and jump into the air. Their mating dance may last for several hours. To our delight, we found the similarities between the dances of the crowned crane and the Barabaig to be true and enchanting.

The special dances of the
guardians of Taneka initiates are
meant to parody the idiosyncrasies
of modern life. Wearing pointy hats
made from a collage of photographs,
blowing metal police whistles, and
frantically waving fly whisks, the
dancers ease the tensions among
the villagers whose young men
will undergo the most serious
transition in their lives.

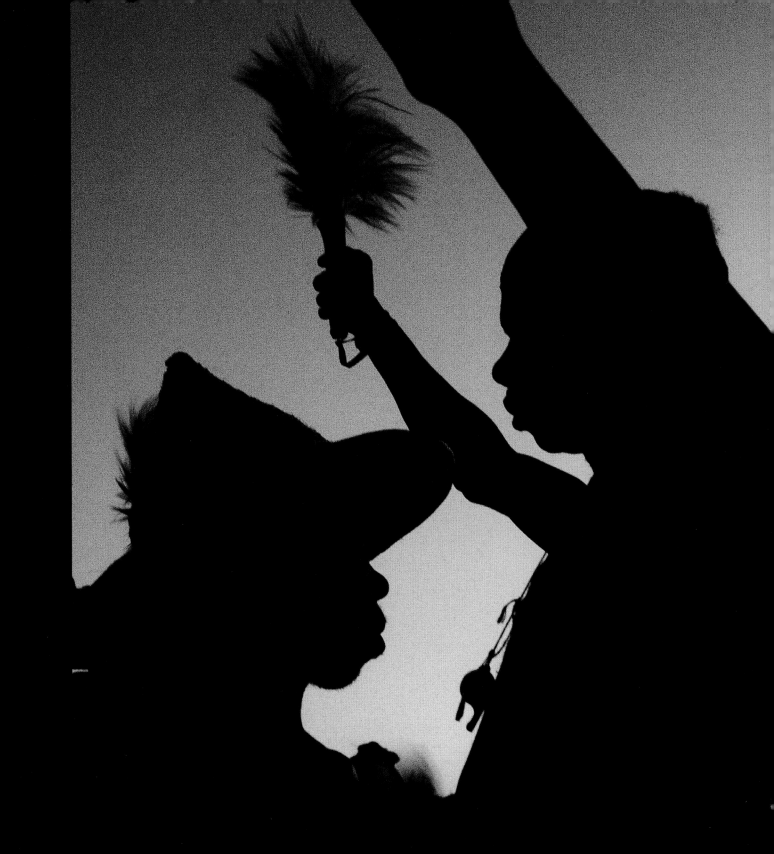

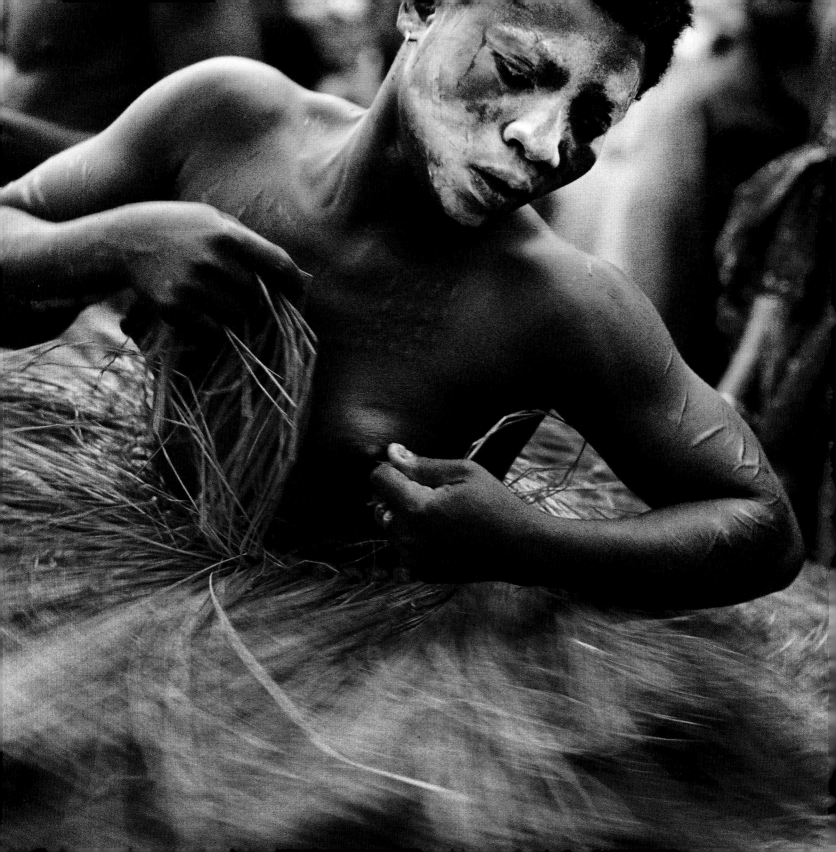

OUT IN THE DARKNESS, WE HEARD A PULSING DRUMBEAT THAT DREW US TOWARD IT AS IF WE WERE HYPNOTIZED. On a remote beach near the border of Togo and Ghana, we came upon a ceremony being performed by followers of the Voodoo god Koku. Followers of Koku believe that their god has a specific drumbeat that is his signature.

Through the frenetic beating of drums and the performance of whirling dances, the power of Koku enters into the dancers' bodies, and they become the god. To demonstrate their power, dancers put hot knives on their tongues without burning themselves, and draw knife blades across their skin without making wounds.

The Kokuzahn rituals are an extreme example of a phenomenon we have seen in various guises throughout Africa: the use of pulsing, hypnotic rhythm to heighten the collective power of a group, age-grade, or society, and create a powerful sense of unity among its members.

We have seen Masai warriors in Kenya prepare themselves to face a charging lion, Himba healers in Namibia cast out evil spirits and cure illnesses, and Dogon masked dancers in Mali chase the spirits of the dead from the corporeal world back to the spirit world, all using the power of pulsing chants, dance, and drumming.

By invoking the pulse of their ancient homeland, African traditional cultures are able to transform normal individuals, with all their human frailties, into a focused and united group, a society that is greater, more powerful, and more transcendent than any individual.

Ewe
GHANA
As the Kokuzahn Voodoo festival reaches its frenzied climax, a female devotee spins faster and faster to the rhythms of the Voodoo drums.

PULSE OF AN ANCIENT LAND

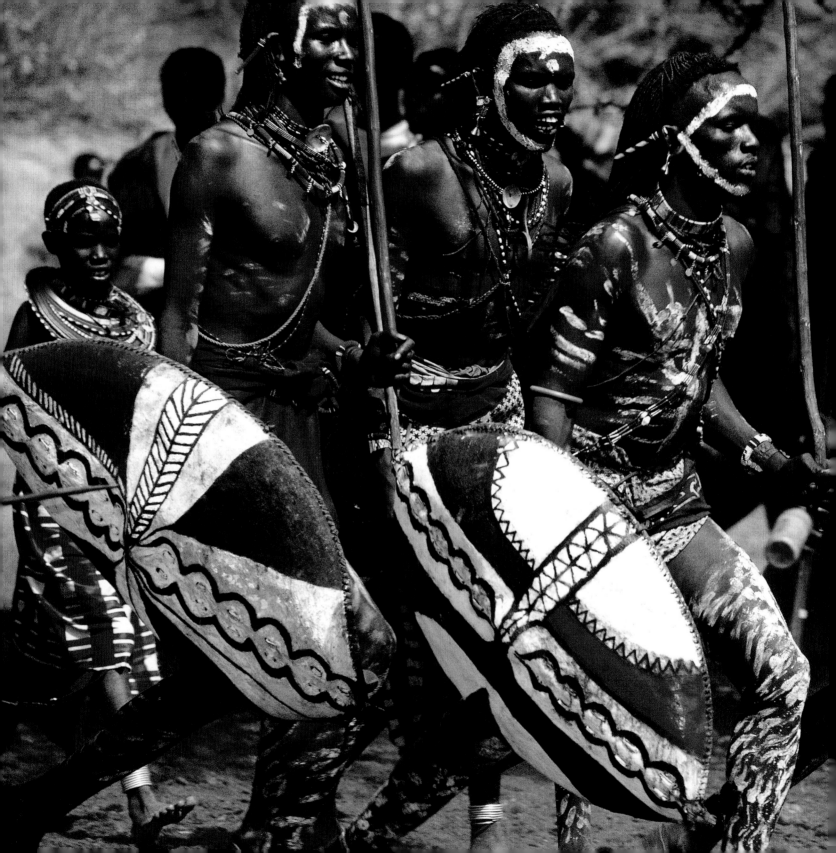

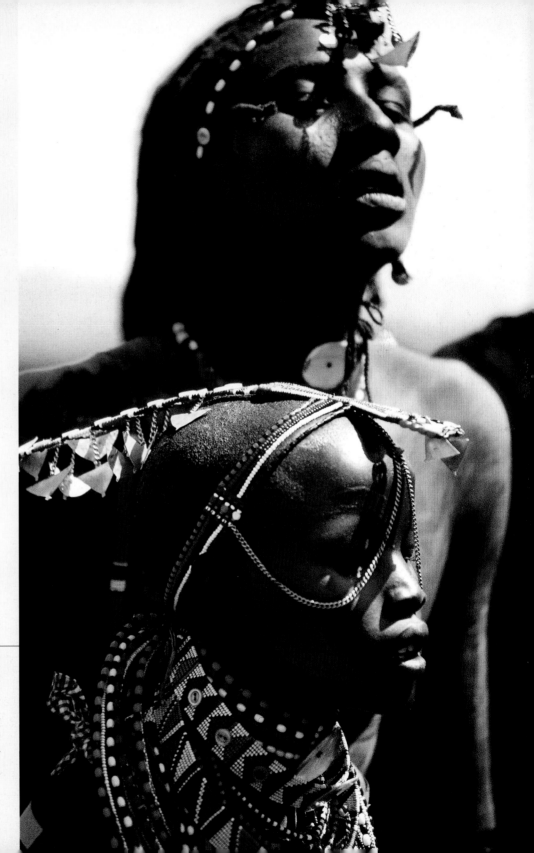

MASAI

KENYA

Building momentum, warriors
charge about the manyatta carrying
their buffalo-hide shields decorated
with symbols of achievement
during warriorhood. Their hot,
fiery temperaments and collective
energy give them formidable power
in cattle raids, lion hunts, and
intertribal warfare.

MASAI

KENYA

A warrior and his young girlfriend
are transported by the guttural
chants of their age mates, which
extol the bravery of warriors who
have distinguished themselves by
killing a lion with their spears.

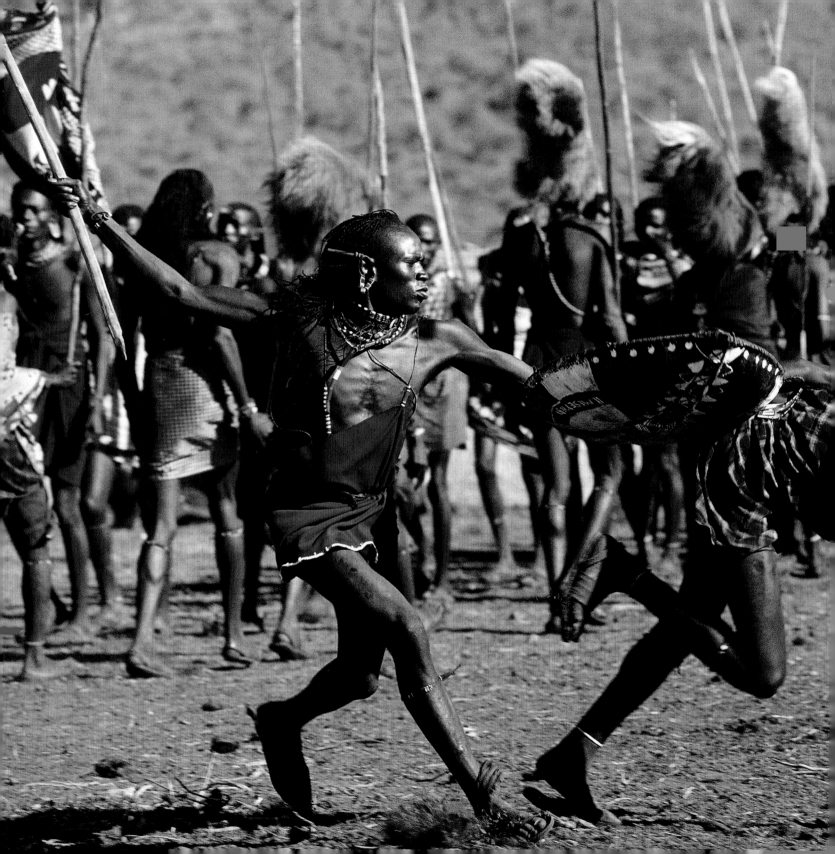

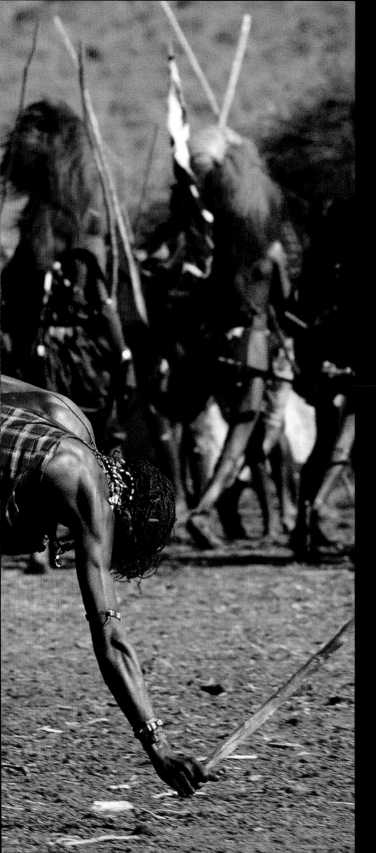

MASAI
KENYA

When warriors assemble in large
numbers, whether for ceremonies,
cattle raids, or lion hunts, they
often become consumed with
emotion and enter into an altered
state called *emboshona*. We watched
a warrior tremble from head to toe,
foam at the mouth, and take off at
breakneck speed, then collapse
onto the ground, his body rigid and
quivering. His friend raced after
him, attempting to catch him
before he hurt himself. Our Masai
friends told us that if a warrior
undergoing emboshona can be
forced onto the ground in a seated
position, and a 12-year-old girl
placed on his lap, he will quickly
return to normalcy in a very
calm and gentle way.

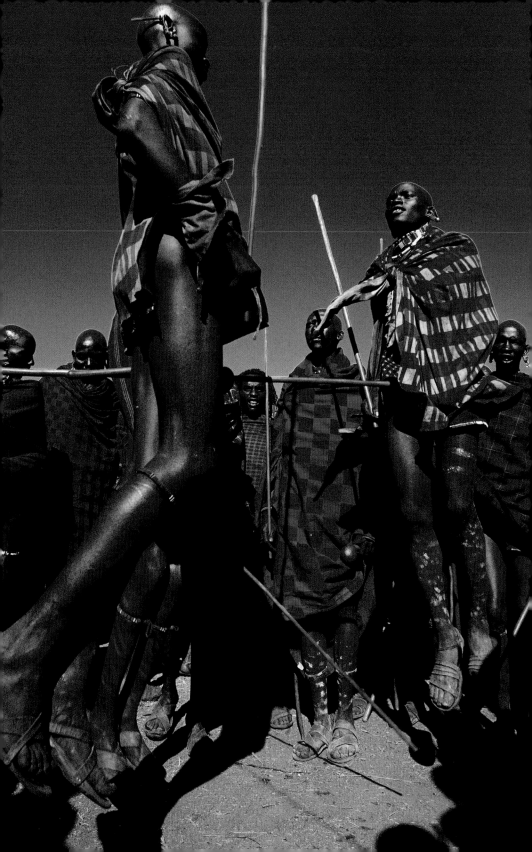

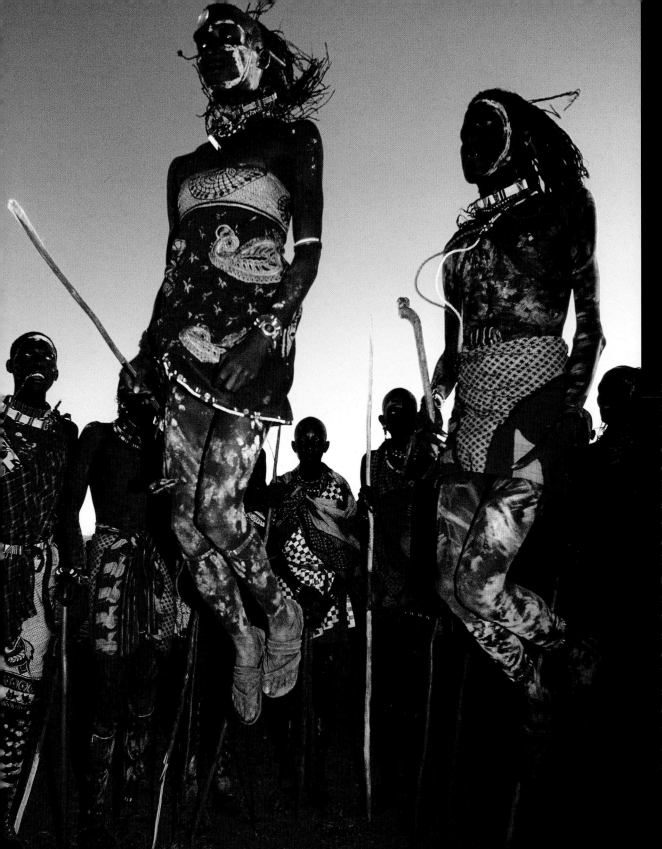

In the final celebration
of their passage into
elderhood, warriors
launch themselves into
a leaping dance in
which they seem to
defy gravity. At the
height of each leap
(sometimes as high as
four feet) they shimmy
their shoulders to the
rhythmic chanting
of their age mates.
Upon landing, the war-
riors flick their long
ochred hair against
the cheeks of their
special girlfriends
standing nearby.

273

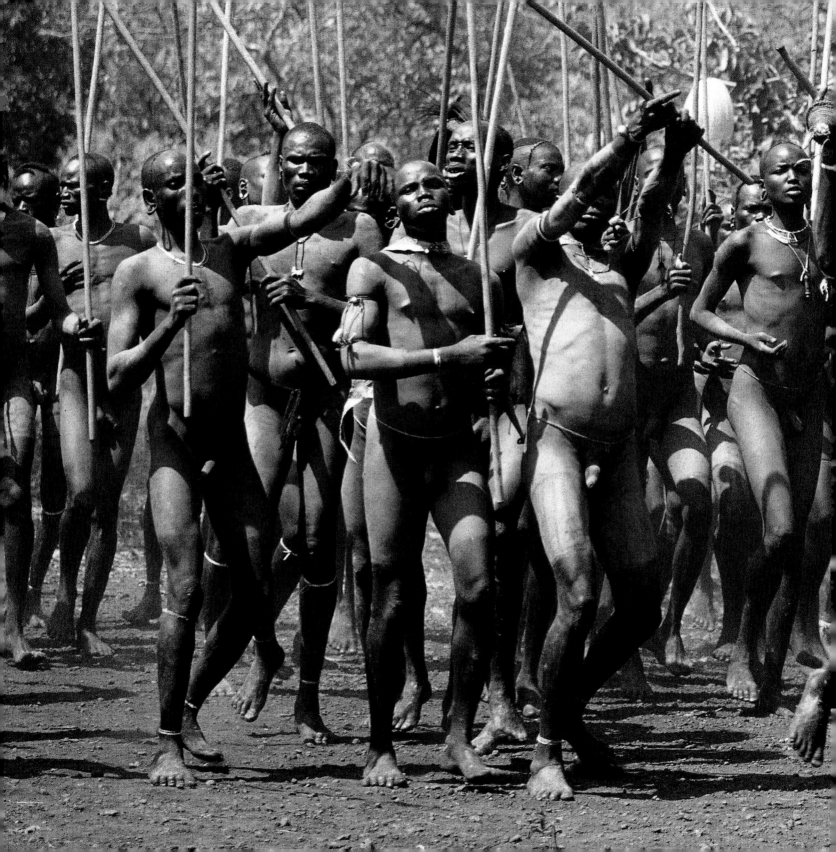

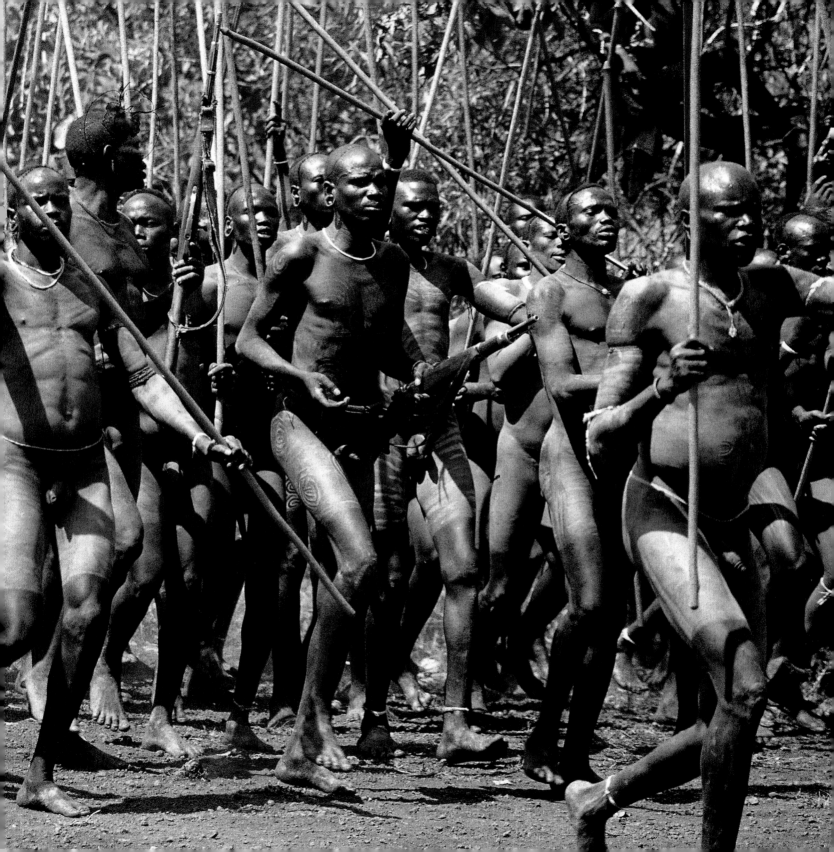

Preceding pages:

SURMA

ETHIOPIA

A group of stick fighters, holding
their Donga sticks high in the air
and chanting in frenzied rhythms,
approach their opponents at a
clearing in the forest where the
fights will take place.

KARO

ETHIOPIA

An impassioned courtship
dance is held after harvest
along the Omo River.

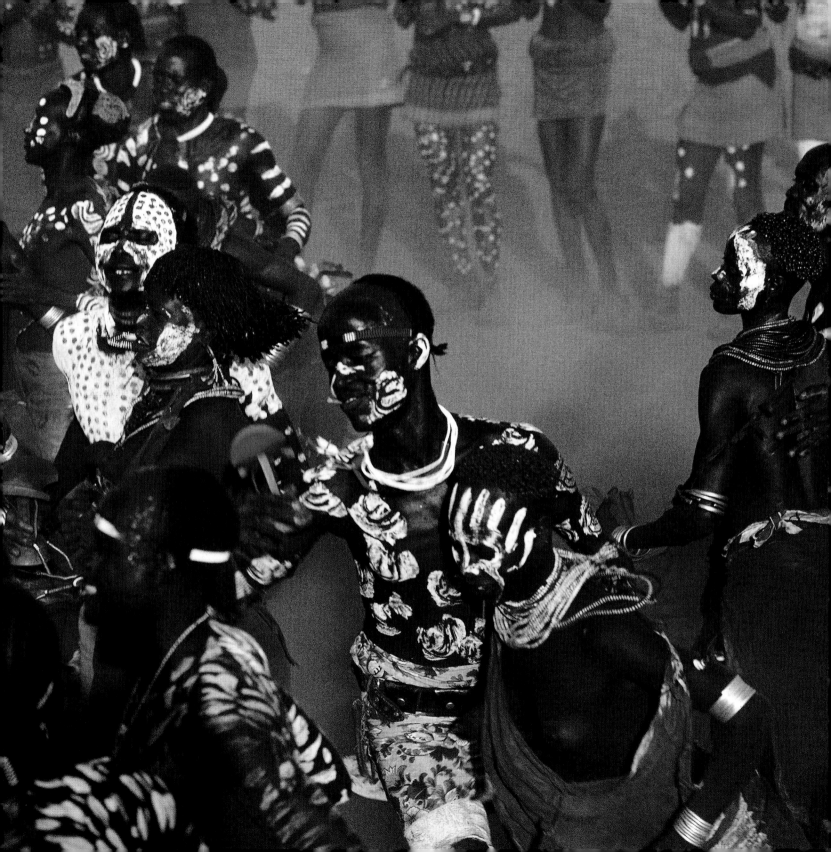

ETHIOPIA

At the climax of a courtship dance,
a couple jumps in unison from side
to side. Suddenly the man thrusts
his hips at his partner, catching her
off guard and increasing the
seriousness of their sexual play.

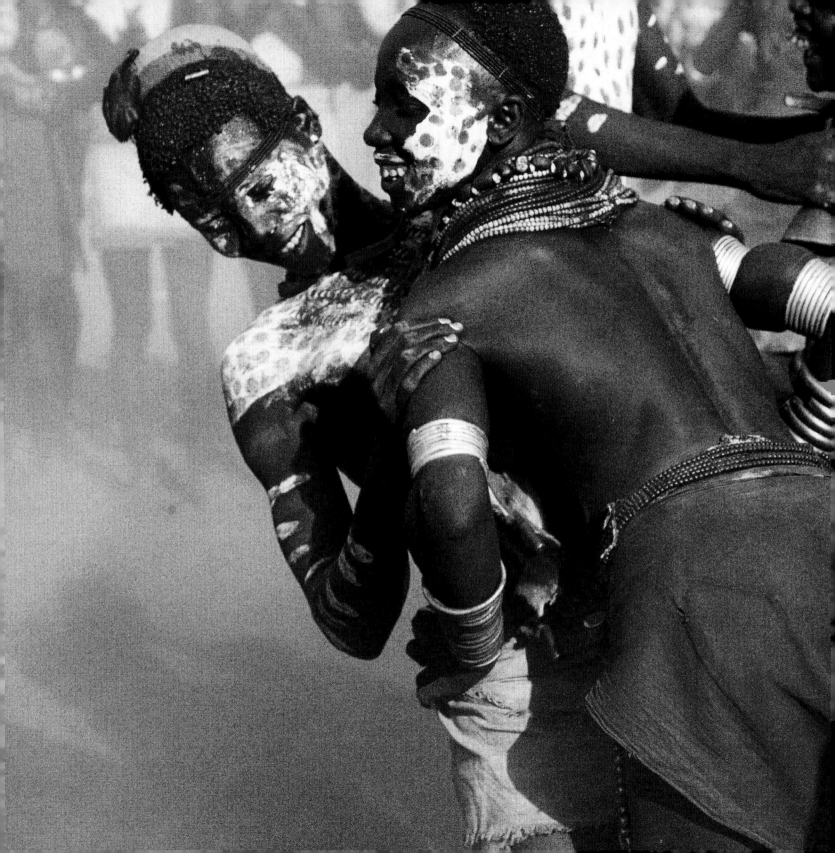

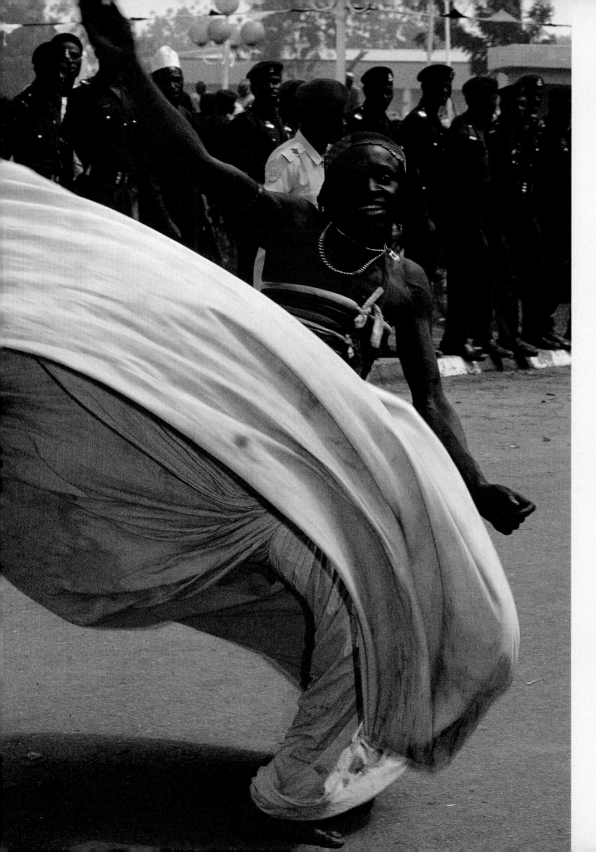

HAUSA

NIGERIA

Left and right: Wearing billowing
pantaloons and covered with
protective leather talismans, Hausa
dancers called Gardi whirl along
the processional route of the Sallah
ceremony to clear a path for the
emir. Resembling small hurricanes,
the dancers leap and spin round
and round, gathering momentum
as they whirl past the crowds.
Their voluminous pants fill
with air and puff out like
balloons as they perform.

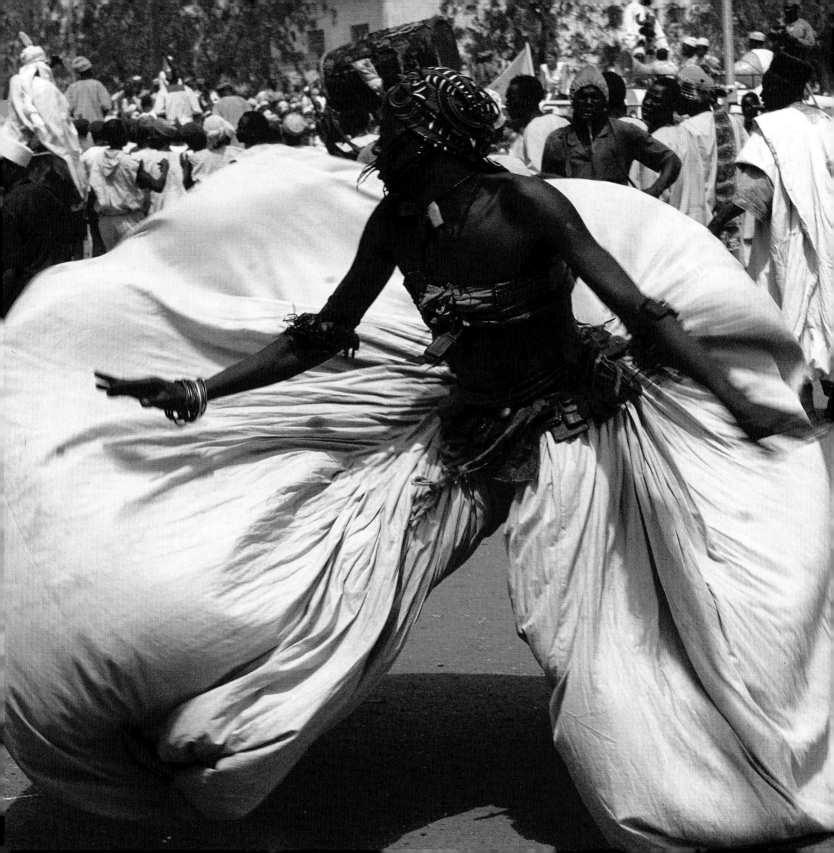

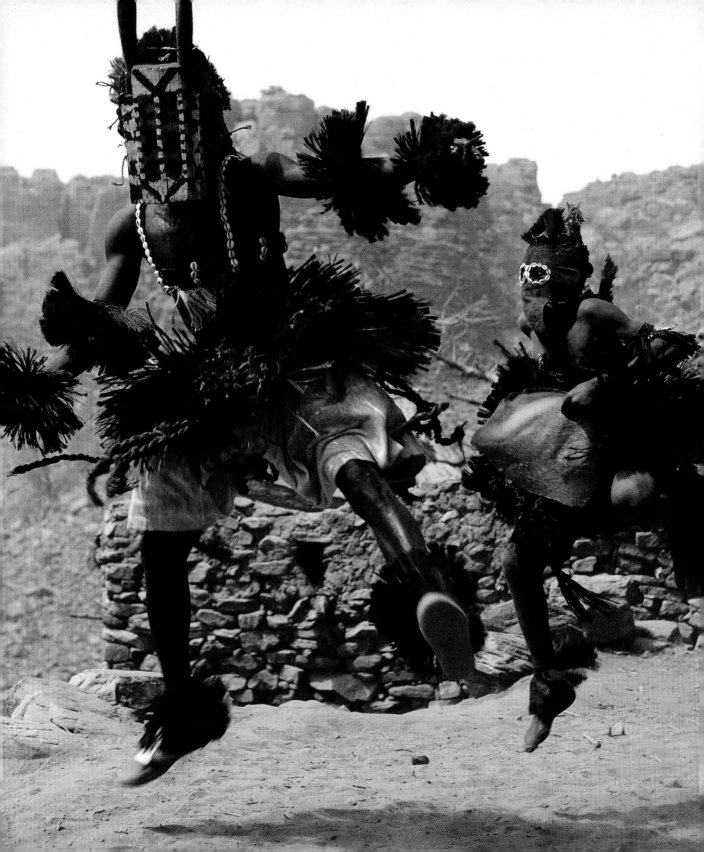

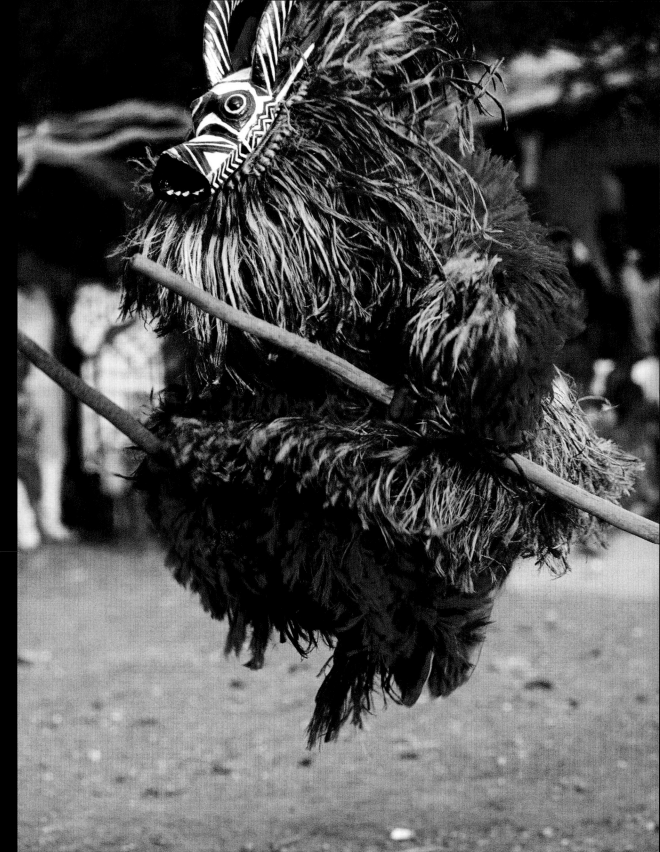

Dogon

MALI

Left: During the Dama
ceremony masked
dancers, mimicking
animals from the bush
and symbolizing every-
thing that is wild and
beyond the control of
man, burst into the
village to chase away
any lingering spirits of
the deceased and send
them to rest in the
ancestor world.

Bobo

BURKINA FASO

Leaping with
explosive energy, a
masked antelope
dancer bounds
through the village
during a ritual
purification of the
community, held prior
to both the planting
and harvesting
of crops.

WE WERE TOUCHED BY THE JOYFULNESS AND FREE SPIRIT OF OUR HIMBA FRIENDS, and were captivated by their absence of boundaries. Their dancing seemed to be a vehicle leading into another world—whether it was the world of nature spirits, the world of seduction, or the world of exorcism and healing.

When our friend and spiritual guide, Malidoma Somé, told us Africans can always hear the din of the spirit world, but that our ears are closed, we reflected that we in the West put up boundaries to our consciousness, preventing us from experiencing the many fascinating worlds accessed by our African friends. What if we were to let go?

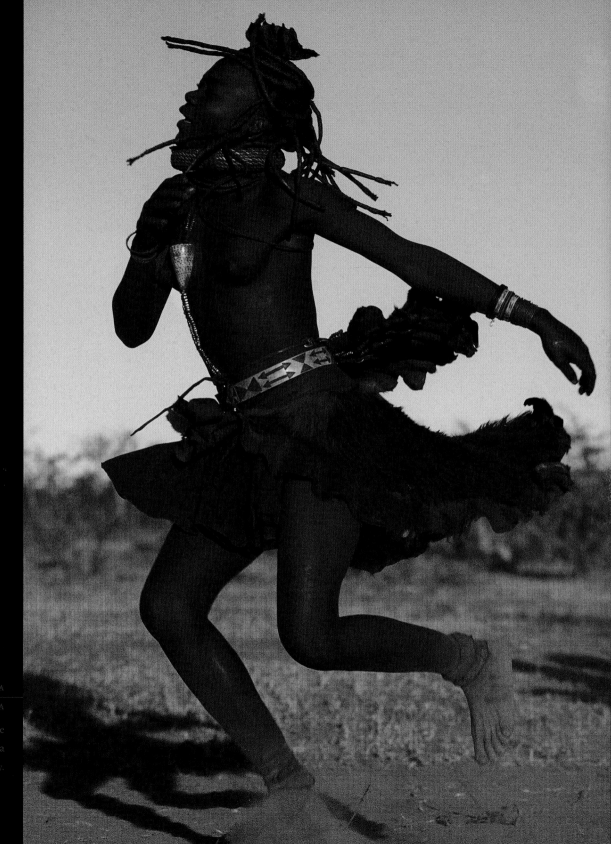

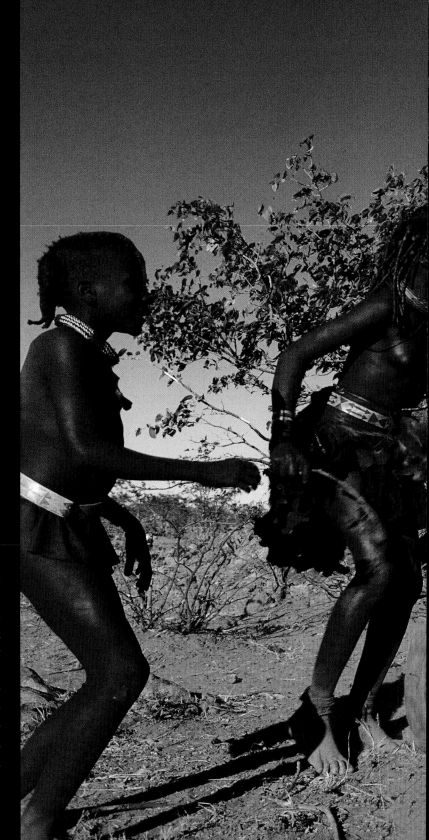

In a dancing game that starts as
an imitation of birds, Himba
women become possessed and
seem to become the birds, making
wild cackling sounds, flapping their
arms, and leaping off the ground.
Their close connection with the
spirit world enables them to move
back and forth between the
two worlds, with no boundaries
to their consciousness.

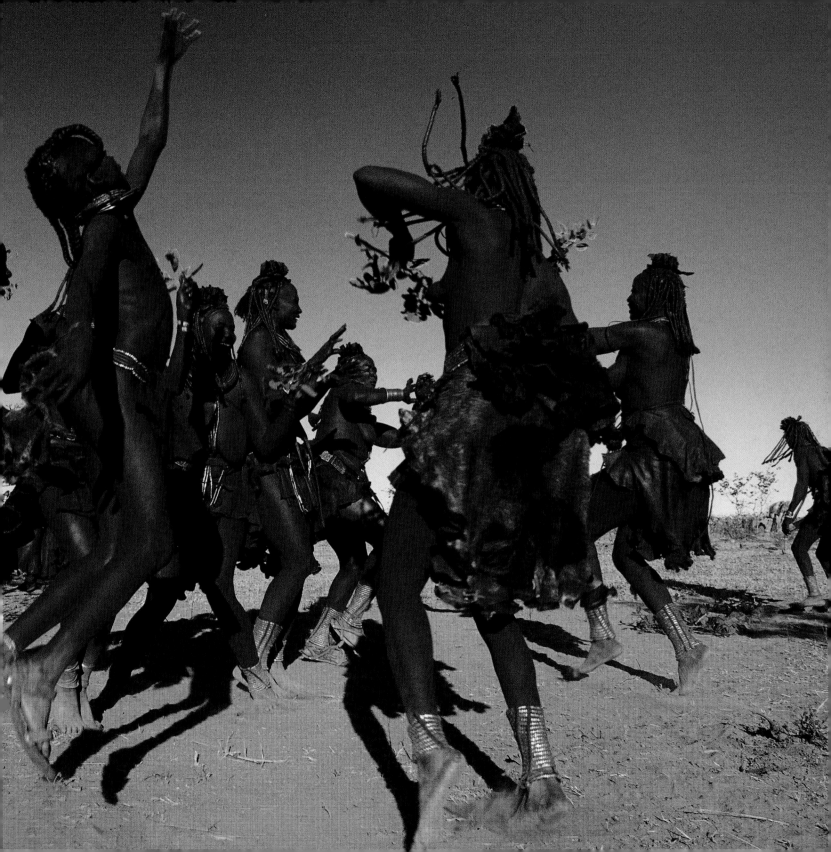

Wodaabe
Niger

On the final night of the Geerewol courtship celebration, Wodaabe men dance until dawn, bathed in the glow of an enormous fire. For both the dancers and the audience, the performance is hypnotic. The men alternate between quasi-religious chanting, accompanied by slow-motion movements, and warlike stomping, accentuated by the rhythmic jingle of metal ankle pods. Elegant long white plumes attached to the crown of each dancer seem to float over the men's heads into the night.

At sunrise the winners of the beauty dance are selected, reaping only intangible rewards: increased pride, the admiration of other men, the ardor of women, and the bonding of the lineage.

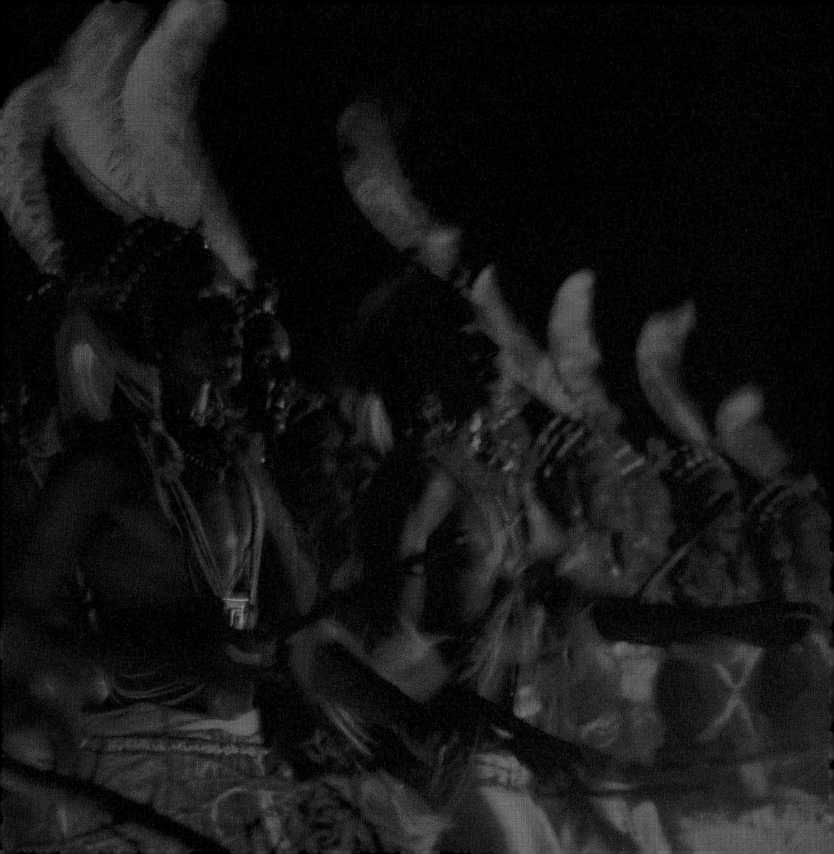

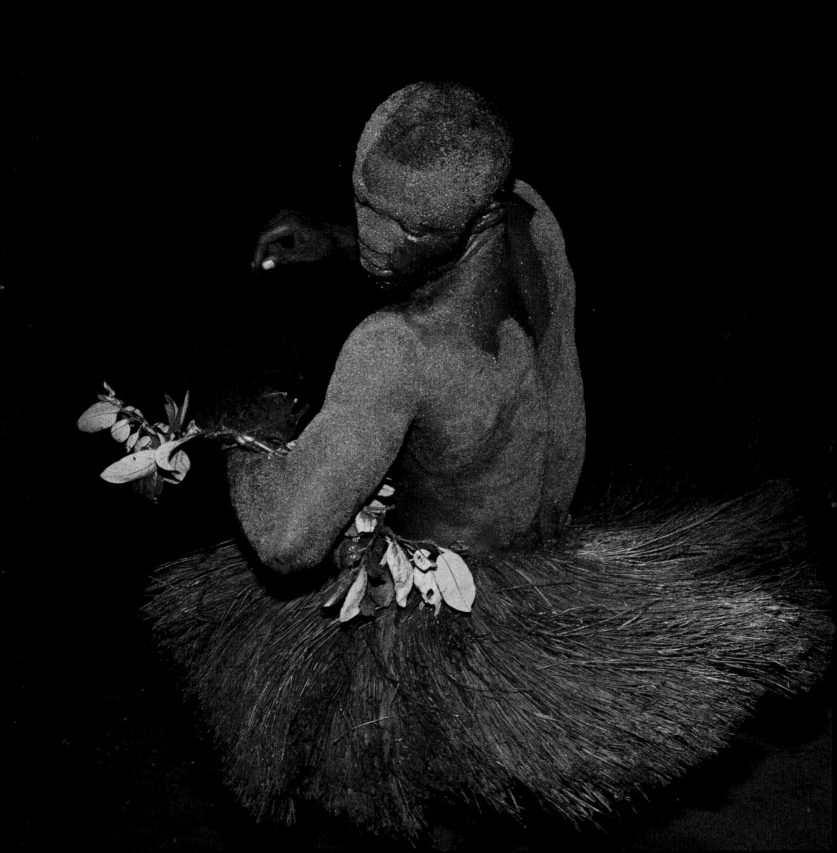

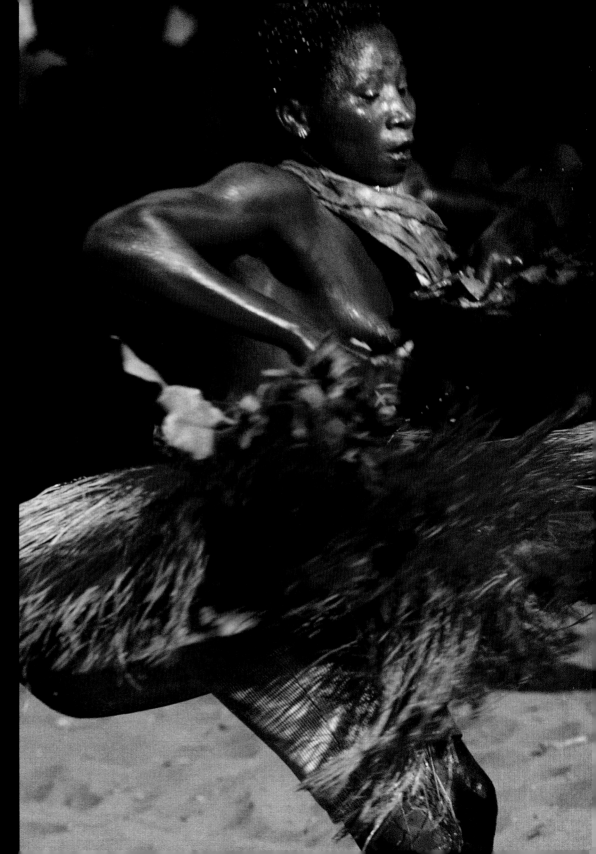

EWE
───
GHANA

Left and right: A male and a
female Voodoo dancer spin into
an intense state of possession,
driven by the pulsating drumbeat
associated with their deity. In
these altered states they exhibit
strength and endurance beyond
normal capacity, and are oblivious
to what they are doing and who
they are. As they spin faster and
faster, they are protected from
harm by wearing fiber skirts made
from the Alatsi tree.

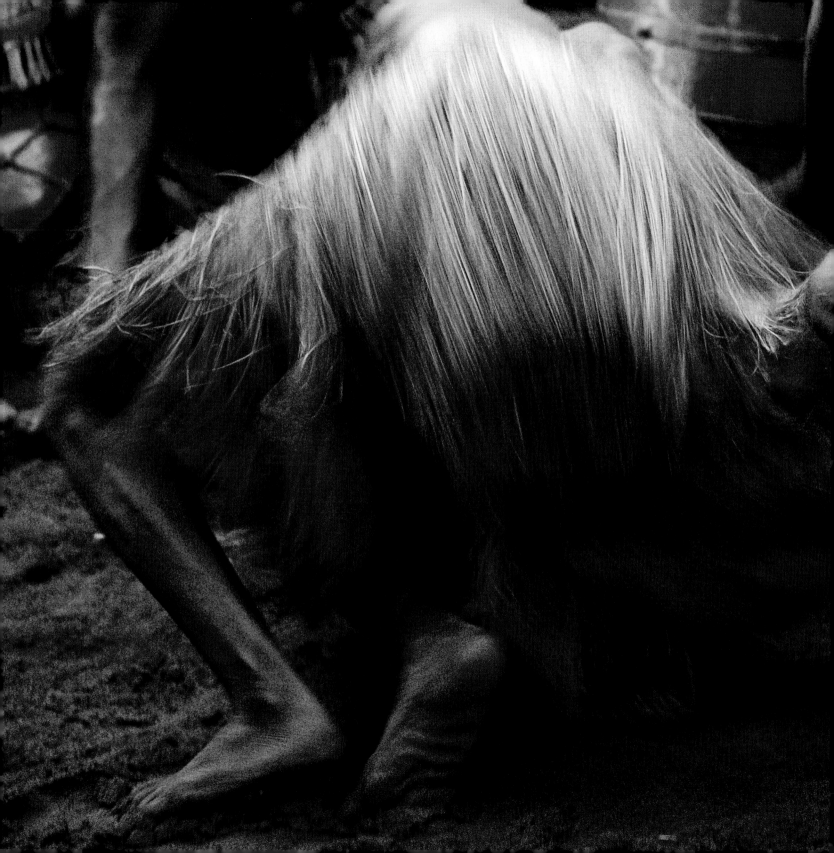

At the climax of the Kokuzahn
festival, Voodoo dancers surrender
their bodies to the power of the
deity and collapse on the ground
in a state of total abandon.

The high priest of Koku explained
to us that in this heightened state
the dancers achieve oneness with
their god, and that consciousness
of this affords one of the most
acute sensations of happiness that
human beings can experience.

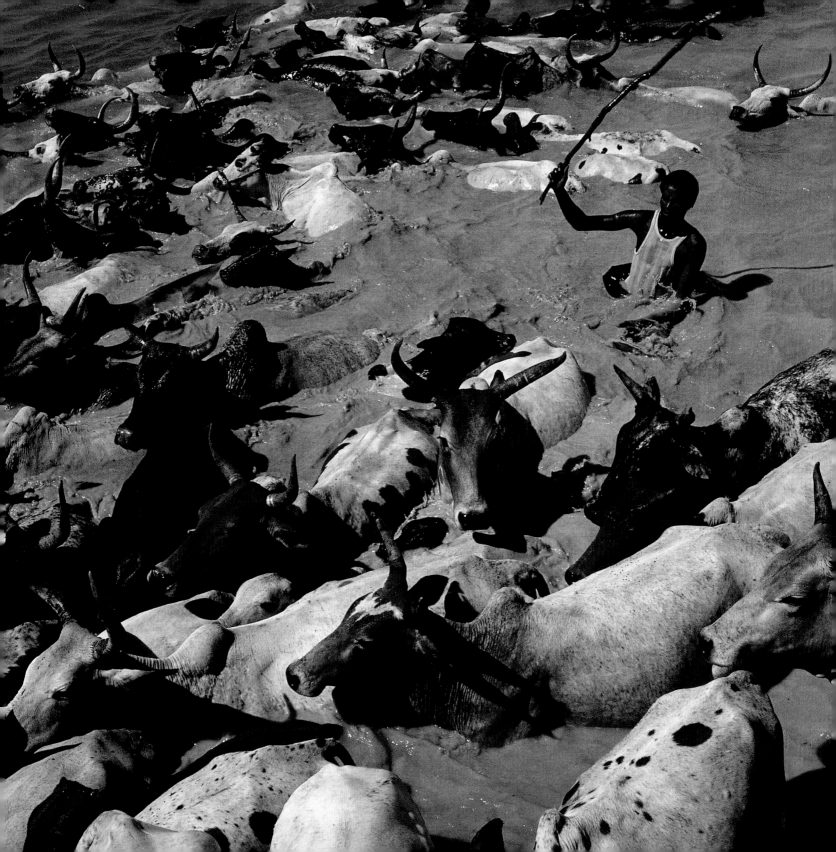

ALL AROUND US ON THE HILLS OF LASTA IN NORTHERN ETHIOPIA, WE SAW STARVING CHILDREN DIGGING IN THE GROUND, gathering grass seeds to feed their parents. On the steps of the ancient rock-hewn church of Lalibela, famished pilgrims collapsed on their way to celebrate the Ethiopian Orthodox Christmas and Epiphany. In the season of new life of January 1984, thousands were struggling to survive.

We had come to Ethiopia to do what we could in the face of a devastating famine, but what we witnessed in 1984 is only one of many challenges that have taught us much about the tenacity of African cultures and the power of the individual to endure.

On any given day, somewhere in the immensity of the African continent, people are enduring hardships caused either by the cycles of nature or the hand of man, or a combination of the two. Long dry seasons, extreme temperatures, and difficult terrains make survival a monumental challenge.

African traditional cultures make a ritual of endurance and resilience, and teach their young people that their ability to rise above life's hardships will determine their success as individuals and define their identity as a culture. By undergoing such tests as Taneka male initiation, in which a man undergoes circumcision at 28 years old; Masai female circumcision, in which a young girl faces clitoridectomy in order to marry and bear children; and Surma stick fights, in which men perform dangerous combats to win wives, young people learn that endurance is an essential virtue and part of the inheritance handed down from their ancestors.

FULANI
MALI

In their unending search for pasture, Fulani herders force thousands of head of cattle across the fast-flowing waters of the Niger River to the swampy grasslands of the interior delta.

CAPACITY TO ENDURE

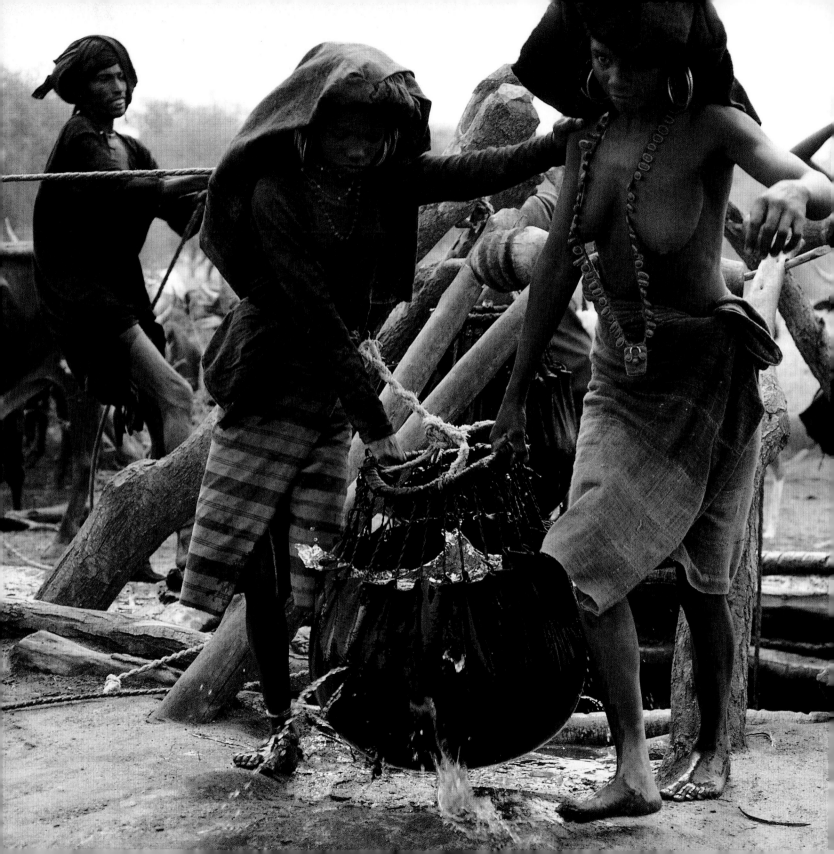

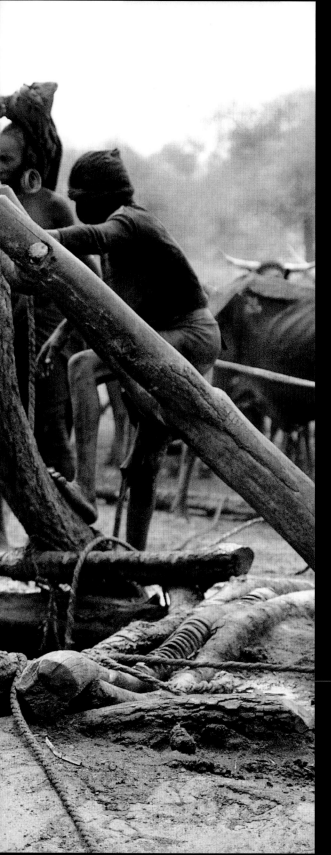

FOR NINE MONTHS OF THE YEAR NOT A DROP OF RAIN FALLS.

Wodaabe families struggle to survive in the inhospitable Sahel of Niger. Every other day they bring their thirsty cattle to the well. There they spend hours hauling heavy leather buckets up from a depth of 60 feet. Tua and Hassana help carry the buckets to water troughs surrounding the well. We felt their exhaustion and the immensity of the struggle just to stay alive.

After a five-month stay with the Wodaabe, we gathered the elders together to ask what we could do to help with their plight. What could we give them that would not depend on us for its maintenance, nor complicate their already challenging lives?

After much discussion, they asked us for assistance with the digging of new wells. Each well would take three months to complete. The process would start with a diviner who, with his divination rod, would explore the ten-mile north/south axis where water was known to exist deep underground. A Hausa family of well-digging specialists, with expertise in shoring up the sandy walls of a well, would then need to be brought in. We could not afford to lose time digging without assurance of reaching the water source.

We decided to contribute a portion of the royalties from our books and to give a series of fund-raising lectures on the Wodaabe in order to realize the wish of the elders. Within a year, we were able to dig two wells and repair a third for the Wodaabe, helping to ease their struggle during the dry season. In our small way, we were able to thank them for their generosity in sharing their traditions with us.

WODAABE

NIGER

Tua and Hassana haul a heavy
leather bucket of water from the
well to the trough, where the
animals wait to slake their thirst.

297

DURING THE DRY SEASON, WODAABE FAMILIES MIGRATE EVERY FEW DAYS, carrying all of their possessions on the back of pack oxen and donkeys. In search of pasture and water, they travel in the heat of the day, often for many miles.

Magogo, carrying her baby on her back and a calabash of milk on her head, leads the pack ox bearing her most prized belongings—bundles of decorated calabashes, one stacked inside the other and well-wrapped against the elements. These calabashes are never used, and are put on display once a year at the Worso celebration of births and marriages. They symbolize a woman's wealth and are considered her most precious treasures. She must carry them with her, packing and unpacking them with each migration, throughout her entire life.

We followed the Wodaabe for many months—on foot or donkey, or in our yellow Suzuki jeep, which was no longer than the biggest bull (a requirement of the Wodaabe). Whenever our energy flagged, our friend Mokao would look us in the eye and gently remind us "She who can't bear the smoke will never get to the fire"—words of wisdom we have never forgotten.

WODAABE

NIGER

Magogo leads her pack ox on a three-hour migration in search of pasture and water.

298

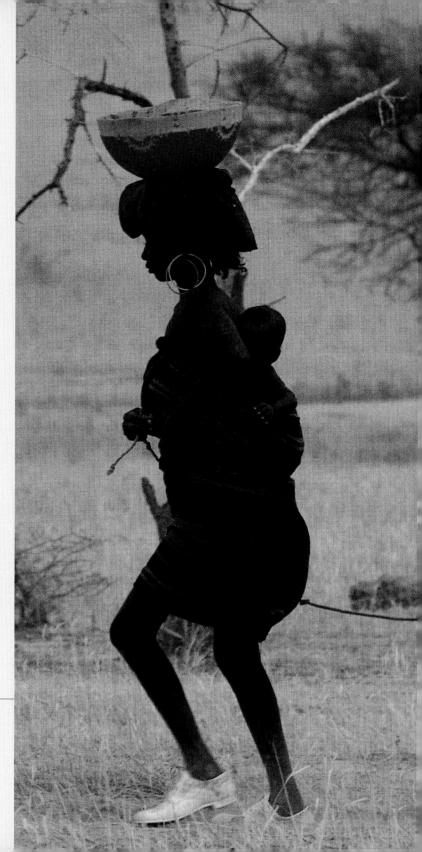

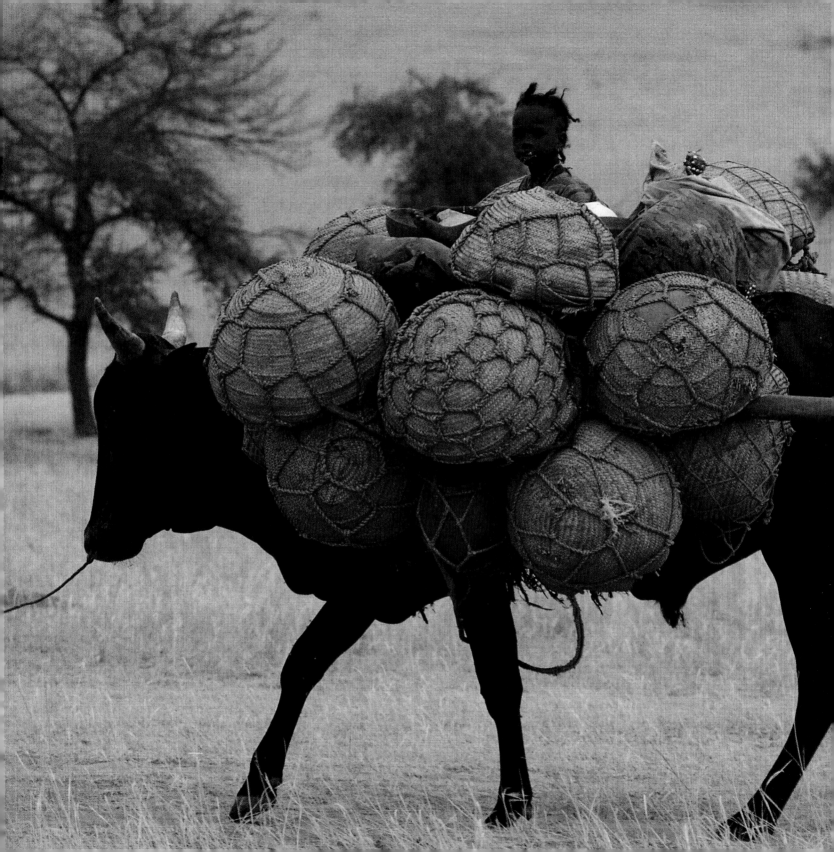

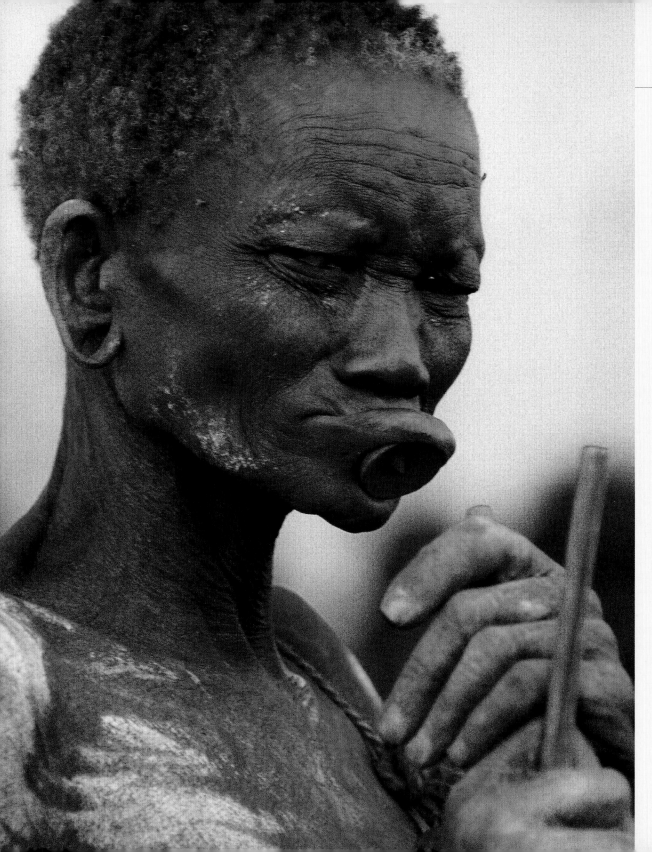

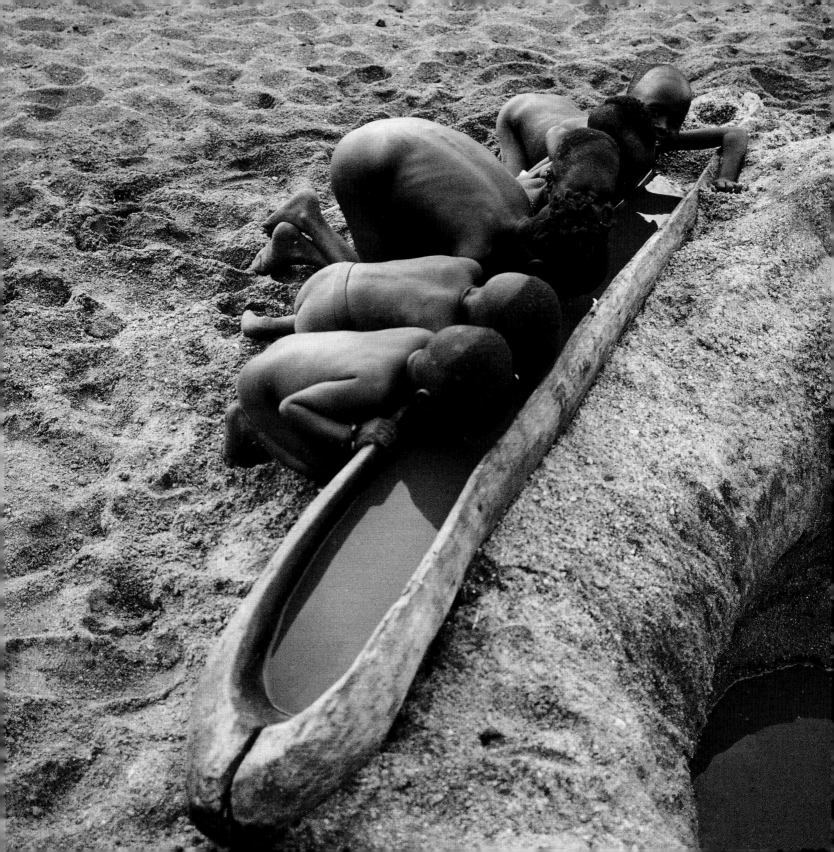

ETHIOPIA

A Konso woman carries a heavy
load of branches, which she will
use to build her home. Konso
agriculturalists are known to be so
hardworking, managing to make
things grow against all odds in
their rocky mountainous terrain,
that when an impossible task faces
an individual, Ethiopians say
as encouragement, "You must
work like a Konso."

A Surma woman, wearing her lip
plate in the presence of men,
carries her husband's old Lee
Enfield rifle. The Bumi, traditional
cattle-raiding enemies of the
Surma, have been involved in the
civil war in southern Sudan and are
now armed with Kalashnikov rifles.
They have returned to raid the
cattle of the Surma, using their
rifles rather than traditional spears.
This has forced the Surma to sell
cattle in order to acquire firearms
to defend their families and
protect their herds. The Surma
fear for their survival.

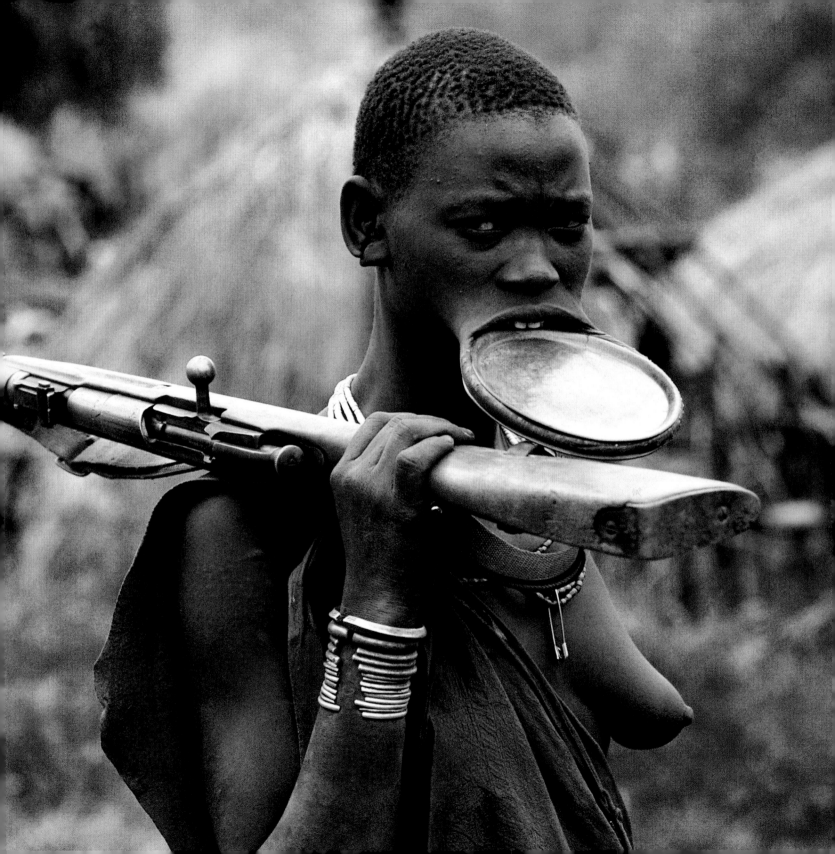

WE CROUCHED IN THE DARKNESS OF A MASAI HUT, DISTANCED BY OUR LONG CAMERA LENSES, experiencing the agony of a 14-year-old girl undergoing her circumcision, whereby she would become a woman eligible for marriage. Each time she cried out our chests tightened with the horror of her ordeal.

We understood that for Masai, ritual clitoridectomy legitimizes a girl's entry into womanhood and allows her to marry and bear children with the blessing of tradition. However, we could not help but imagine replacing this important rite of passage with a gentler ritual that would be more in spirit with the caring and loving nature of the Masai.

The operation was extremely difficult to photograph and forced us to reflect on what might be the most sensitive way to effect change without disturbing traditional values. But we felt it important to view this ritual through the eyes of the Masai themselves.

Since recording this ceremony we have met a number of Masai women who are bravely speaking out against this centuries-old practice. They express the belief that change should come from within, rather than be imposed by the outside world, which is so often disrespectful of their valued traditions. The Masai view this ritual as a way of preventing a girl from being ostracized from her cultural tradition. A solution must be found that effects change, yet accommodates and respects the Masai point of view.

MASAI
KENYA

A 14-year-old girl undergoes
her ritual clitoridectomy.

307

OUR TANEKA MALE FRIENDS UNDERGO CIRCUMCISION, A CHALLENGING ORDEAL FOR ANY ADULT MAN, when they are between 20 and 30 years old. This ritual tests their courage in the face of physical trauma, provides training for a new role in society, and bonds them to their peer group.

Preceding the operation, which will take place on the sacred mountain, the village elders bring out four symbolic circumcision knives honed to a peak of sharpness by the blacksmith. Each initiate symbolically selects the knife he wishes to be used for his circumcision and tests its sharpness against his neck, confronting the pain he will endure. If he undergoes the operation without crying out he will be considered a man.

TANEKA

BENIN

An initiate tests a symbolic ritual knife in preparation for his circumcision.

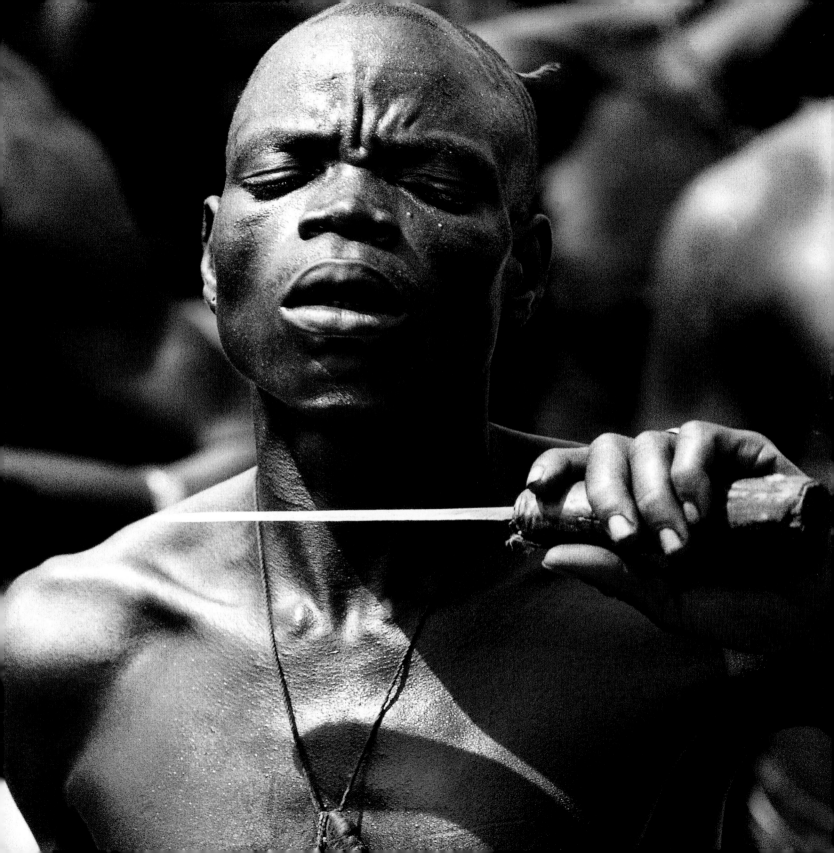

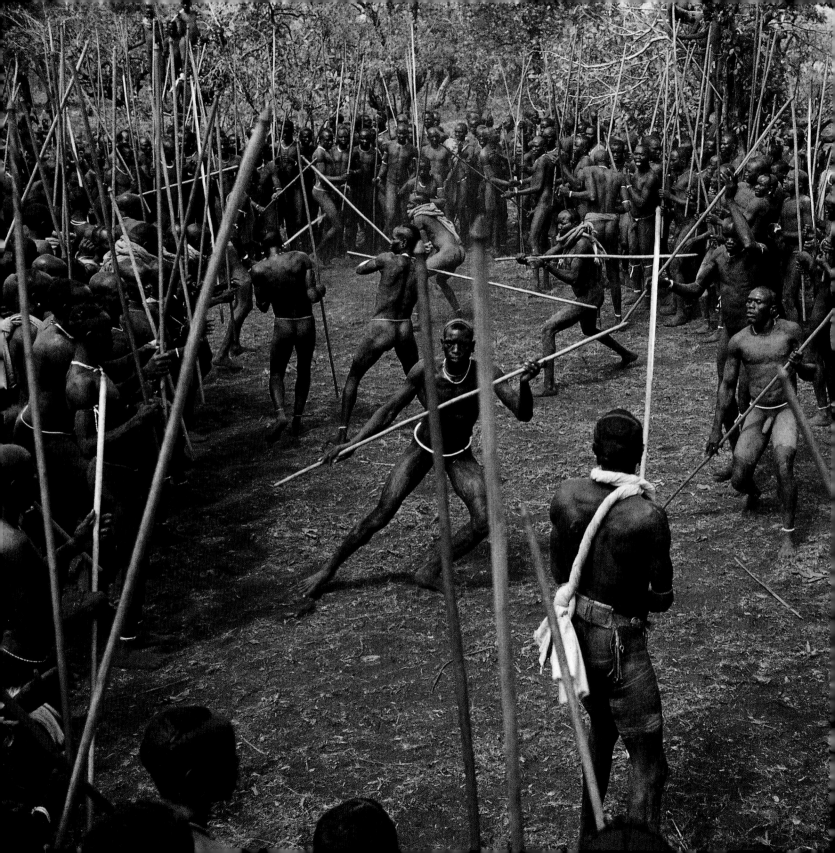

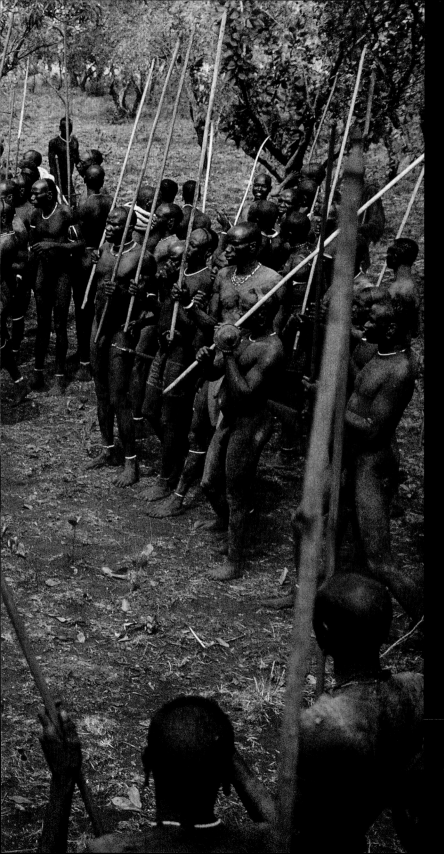

WE WALKED FOR 30 MILES to record this stick fight in a remote corner of southwest Ethiopia. More than 700 men had gathered together for one of the most violent sports on the continent— the Donga stick fight—designed to settle personal vendettas, prove masculinity, and above all, win wives.

The 50 or more men who participate in each tournament represent different villages. The contestants fight in heats, with the winners going on to the next round until the competition narrows to the finalists. The winner of the last bout wins the entire contest.

There are no rules to the game except that a man must not kill his opponent. If he does, he and his family will be banished for life from the village.

The Donga is fought with eight-foot wooden poles carved into a phallus at the tip. Because the fights are so wild, our Surma friends would lift us up into nearby trees so we could photograph in safety, without risk of decapitation!

Our friend Chinoi (renowned for winning 63 out of 67 stick fights in his lifetime) won the Donga fight. Women viewed his many scars as medals of honor. Chinoi was ceremonially lifted onto a platform of poles and presented to a select group of beautiful young girls awaiting him on the sideline. These girls had decided among themselves which one would choose Chinoi as her husband.

Surma
ETHIOPIA
Donga men compete in
the fierce stick fight.

311

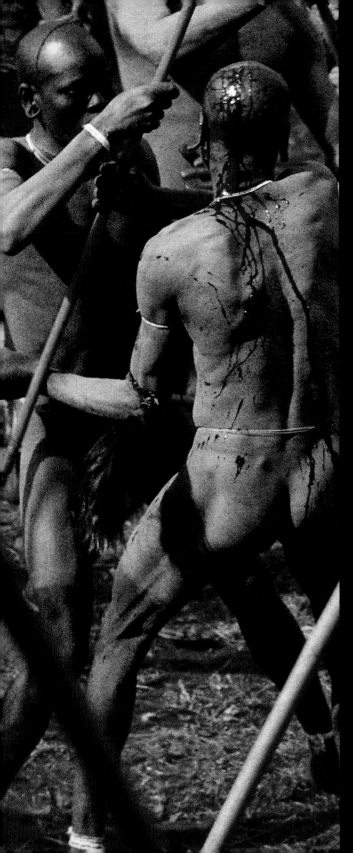

Left and right: Although the
contestants of the Donga stick fight
are swathed in layers of protective
cotton wadding, the spectators, who
are unprotected, often become so
frenzied that they break into spon-
taneous duelling. The fighter at left
received an accidental blow that
opened his scalp.

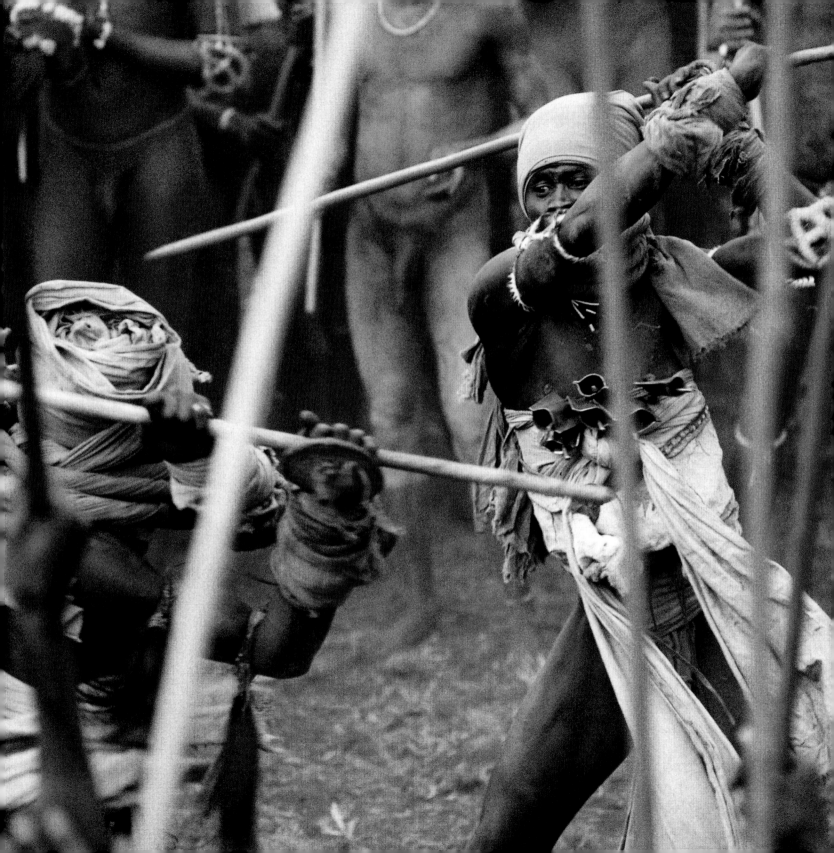

At funeral ceremonies, Surma
women transform the guns of their
menfolk from weapons of
protection to symbols of respect for
the departed. After men have fired
their guns repeatedly (the higher
the status of the deceased, the more
gunshots fired), the women dance
with these guns in a frenzy of grief.
In the gesture of lifting the guns
over their heads, they are reflecting
both their ability to survive the
threat of their enemies, and their
reverence for the deceased.

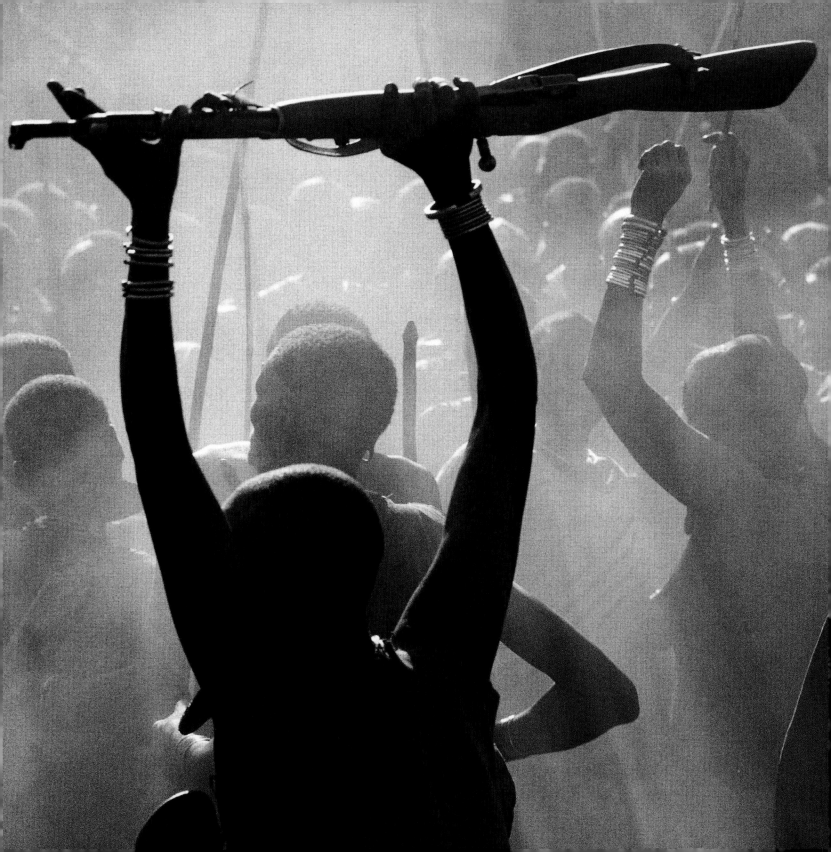

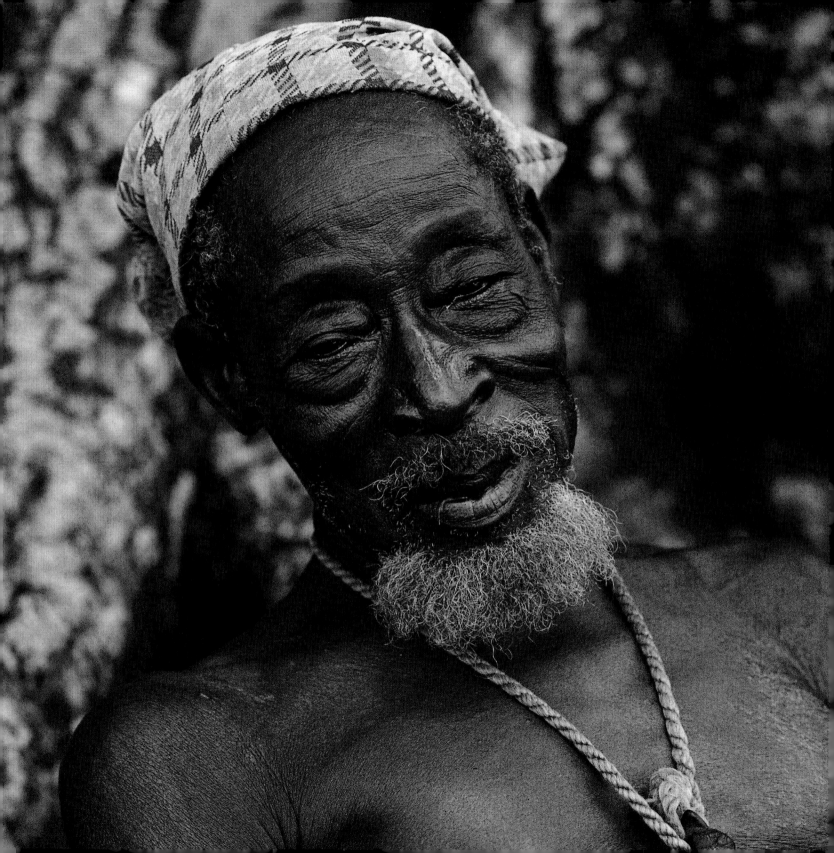

IF THERE IS ONE AFRICAN CULTURAL TRAIT WE WISH THE WESTERN WORLD WOULD EMULATE, IT IS THE REVERENCE SHOWN TOWARDS ELDERS, along with the importance given them as teachers, role models, and guides. Some of the most cherished memories from our travels are of occasions when we observed the love, care, and respect Africans displayed toward older people.

As experts on their culture's history—its genealogy, folktales, and other oral traditions—elders provide an essential link between the experiences of past generations and the challenges of the present one. The wisdom that comes with age honors a culture's past while helping forge its vision for the future.

An African elder once told us this story: "Before I was born, I lived in my mother's belly and I was very secure and happy there. I had everything I could possibly want. Then one day I was pushed through a doorway into a strange world of noise and confusion. I was angry at first, but soon learned to love being a child. But no sooner was I enjoying myself and perfectly happy to stay a child forever, than I was pushed through another doorway into a strange world where I had responsibilities, and wives, and work. But I loved my family, and I would have been happy to stay that way forever, but the years passed, and I was shoved through another door and became an elder, and now I have arrived at the end of that life also. You ask me if I am afraid of what happens next and I tell you: 'I have learned to understand that what is before me is just another doorway, and I am ready.'"

KASSENA

GHANA

The village soothsayer contacts the spirit world for guidance so as to give advice on community issues and personal needs.

WISDOM OF AGE

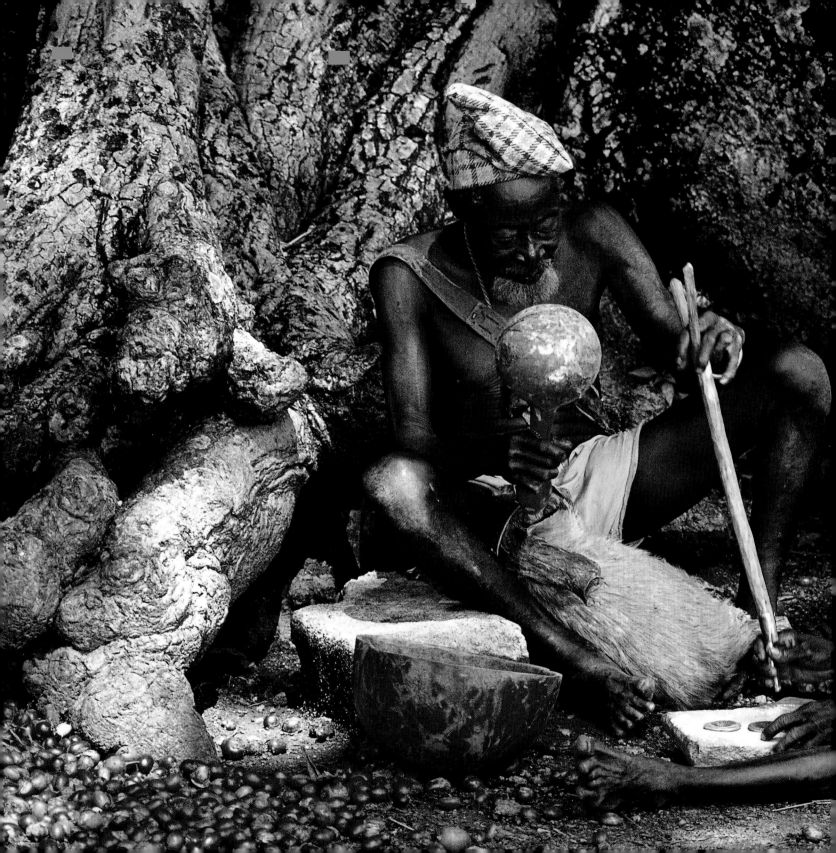

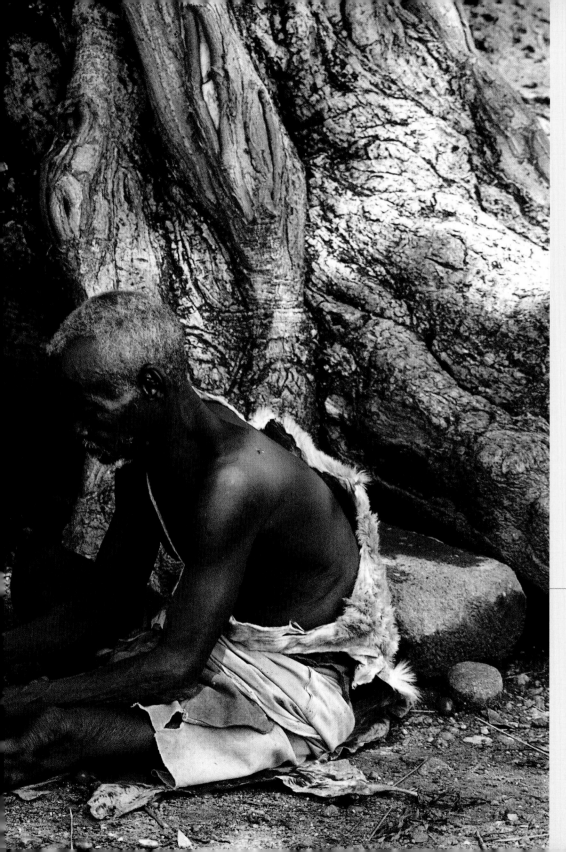

KASSENA
GHANA

Before a Kassena hunt, Apetaga, the village soothsayer, must be consulted. Using his traditional instruments of divination, he communicates with the nature spirits on behalf of the hunter to determine which day would be the most propitious to begin the hunt, and which animals to pursue.

319

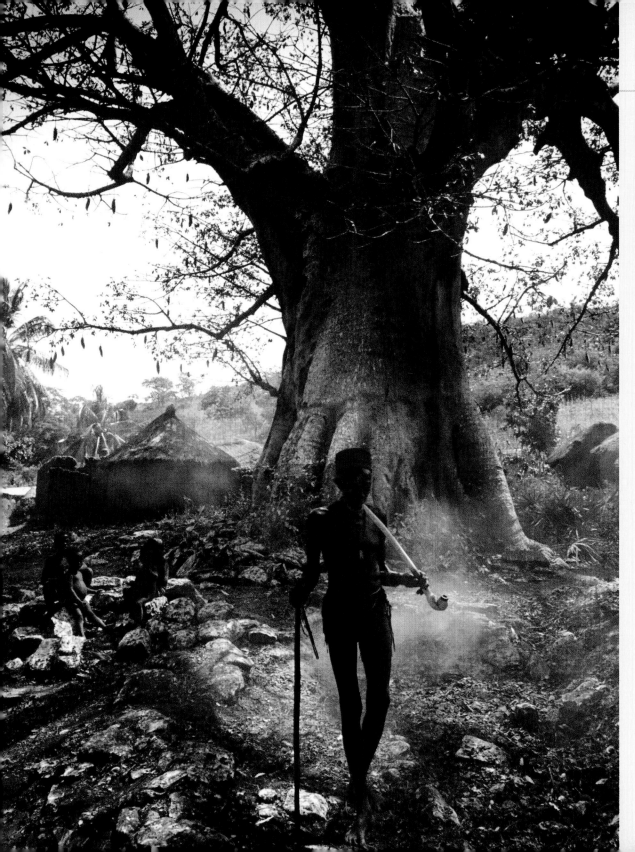

Namari Godogo, smoking his long wooden pipe, and wearing a hippo-tooth pendant carrying fetish power, is believed to have the ability to make rain. The authority of this renowned 90-year-old fetish chief and healer extends from his village, Taneka Koko, all the way to Karhum.

DINKA

SUDAN

A Dinka elder's pallid body, caked in ash, and his great height earned him the name "ghostly giant" from early explorers into Sudan. Wise in the ways of cattle husbandry, he is one of the oldest herders in the cattle camp and is consulted on important issues of survival during the long dry season.

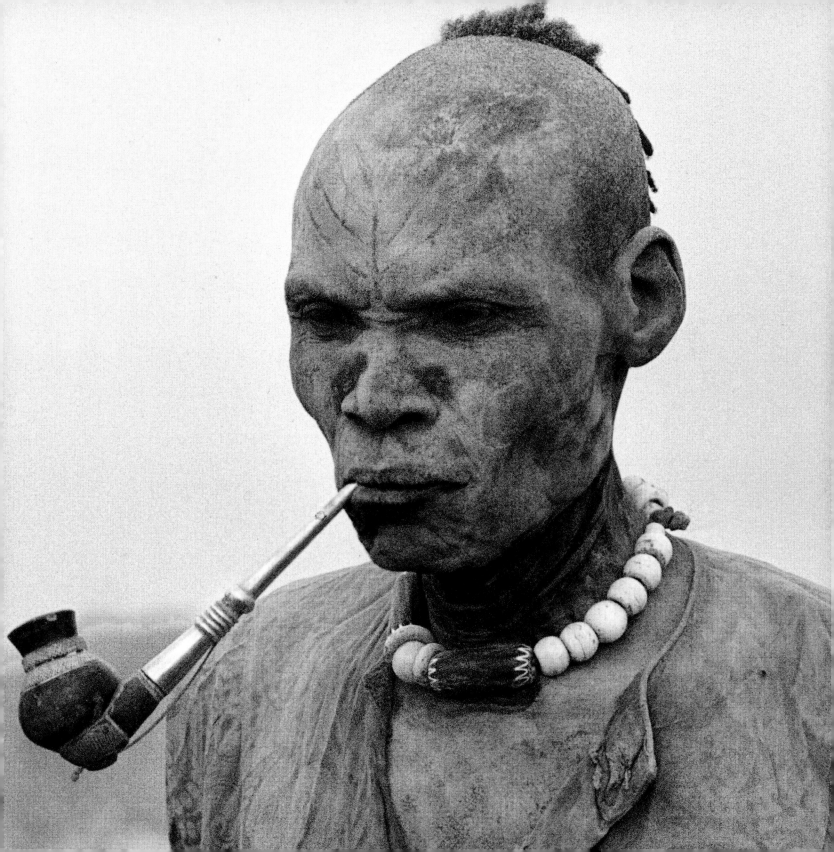

KROBO

GHANA

A wise "ritual mother" serves as
guide and mentor for young girls
undergoing the Dipo initiation
ceremony into womanhood. To
mark the end of one stage of life
and the beginning of another, she
shaves each initiate's head, leaving
only a small tuft of hair at the
crown, which will be removed when
the initiation process is complete.
Knowledgeable in tradition and
expert in ritual, elder Krobo women
play an essential role in this
transition. They are responsible for
teaching the girls the domestic
duties of womanhood, beautifica-
tion of their bodies, the arts of
dance and music, and, finally,
seductive techniques for
pleasing their husbands.

MASAI
KENYA

At the climax of the Eunoto warrior graduation ceremony, a generation of young men gathers to receive the final blessings of the elders. Th men sit in quiet reflection as the elders walk among them, chanting prayers and spraying them with mouthfuls of milk and honey beer. The elders bless them with the words "May Enkai (God) give you a long and healthy life, may Enkai give you many children and cattle, and may you enjoy true *arkasis* (wealth)." Following this benediction, the mature young men of a new generation return home to face the challenges and responsibilities of the next stage of their lives as elders.

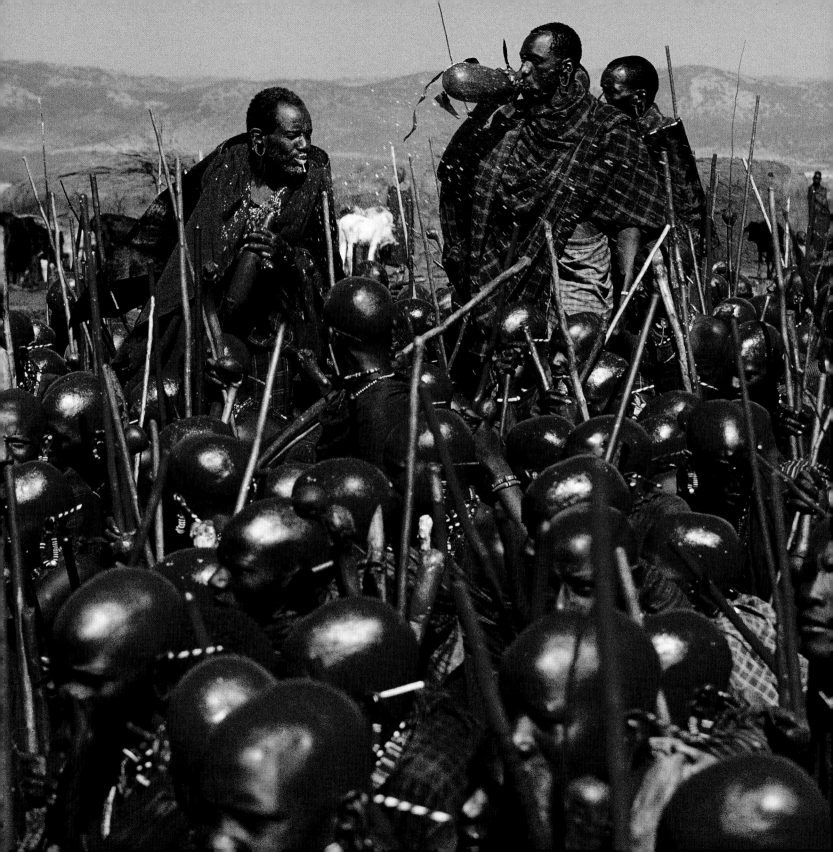

POKOT

KENYA

Proudly wearing his ostrich-
feather headdress, a Pokot elder
oversees the initiation of his son
into elderhood at the Sapana
Ceremony. As a respected elder,
will officiate over the spearing of
the sacrificial bull, ritual practices
the sacred grove, and the reading
the intestines of the slaughtered
bull to determine the
future of his son.

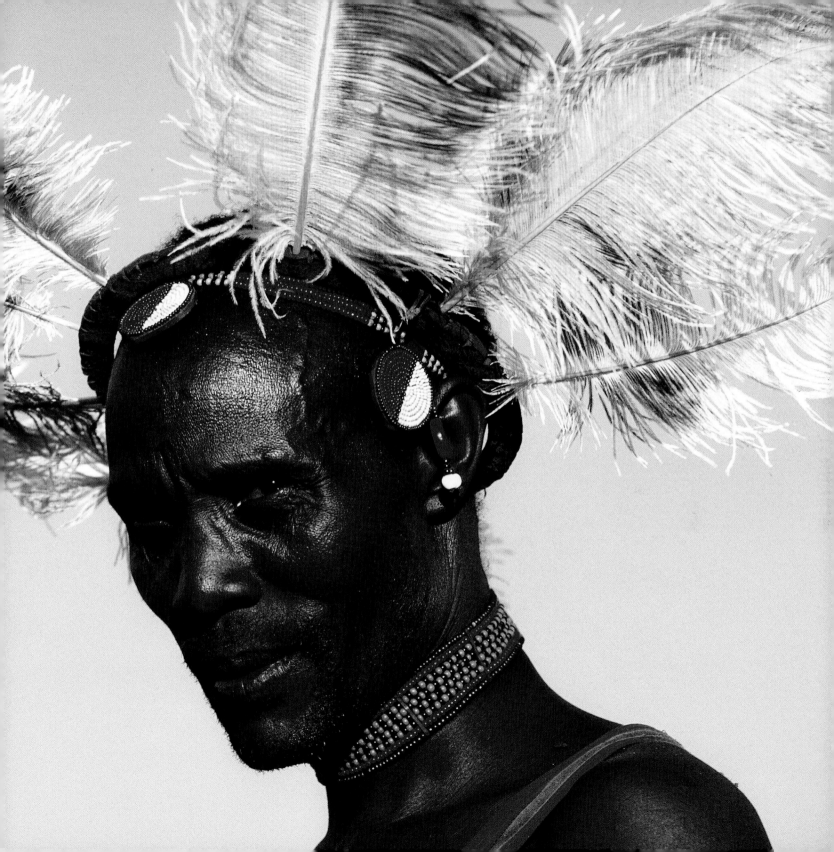

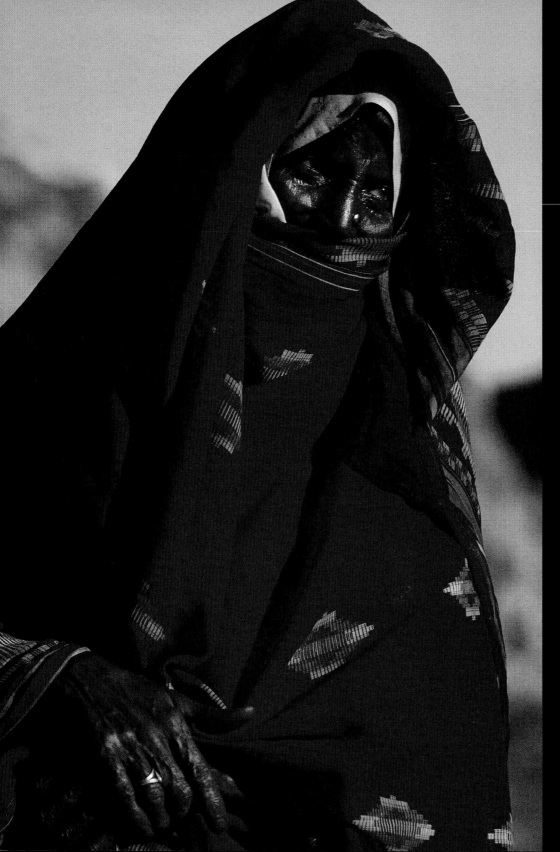

Beja
ERITREA

Fiercely independent, a Beja no[mad]
woman comes from a lineage
known for its warlike defense o[f]
tribal lands. Distrustful of out-
siders, she has learned to focus [on]
the survival of the camel herds [in]
a desert where many pastoralist[s]
compete for grazing lands.

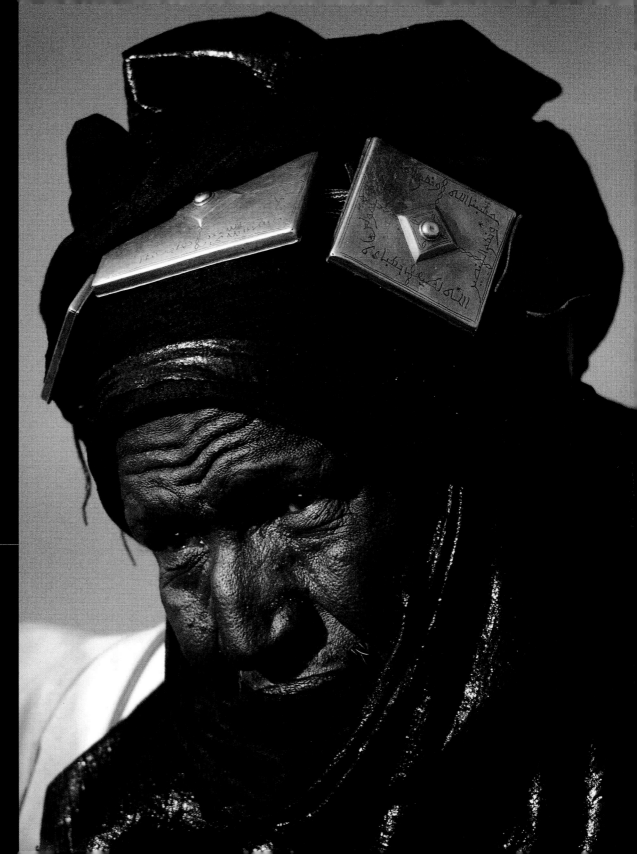

Hamadaba Muhammad, a
Tuareg chief, displays his
high status as an elder by
wearing three beautiful
brass talismans containing
prayers from the Koran. He
wears a veil of hand-beaten
indigo cloth whose dye rubs
off and permeates the skin,
giving his people the name
"blue men of the desert."

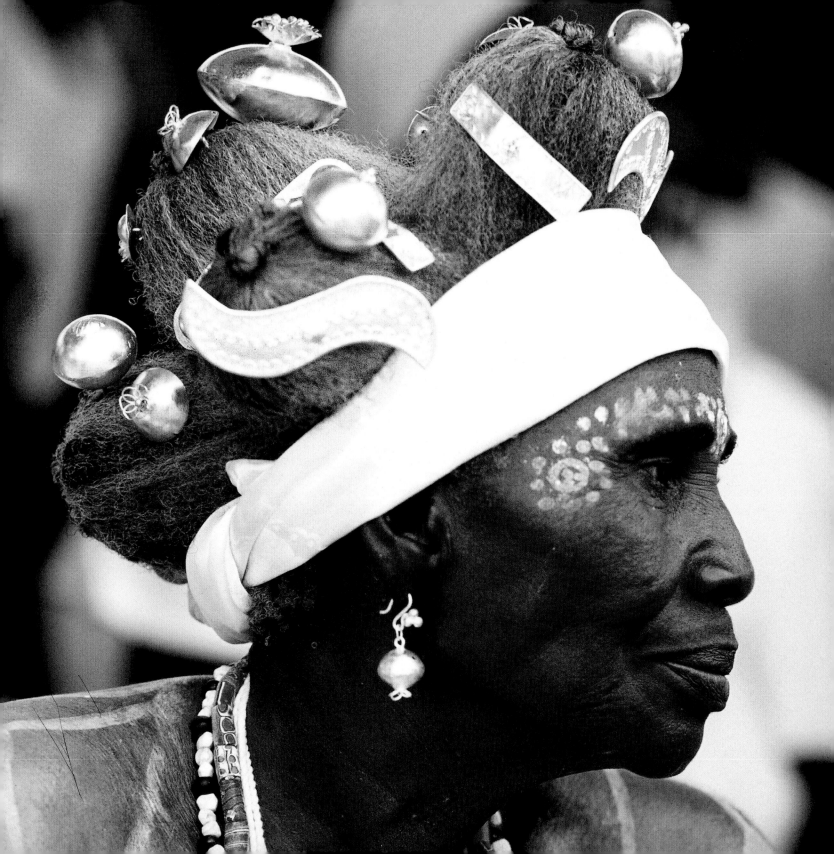

GHANA

Wearing the white head wrap, body chalk, and dramatic hairstyle associated with her vocation, a Fante priestess displays her high status. At the annual Fetu Afahye festival, she is responsible for pouring libations and eliciting the blessings of the gods to ensure the success of the deer hunt.

Anastafidat El Haj Suleimane
Ekade, the most holy religious
man in Niger, slowly passes a
string of wooden prayer beads
through his fingers as he intones
passages from the Koran. Born in
1913, he received his high-ranking
title, the Anastafidat, in 1960.
We were honored to be granted
an audience with one of the most
learned holy men of Agadez.

TUAREG

NIGER

This collection of scholarly Islamic
books, including a copy of the
Koran on parchment, belongs to
the Chief Marabout of Agadez.

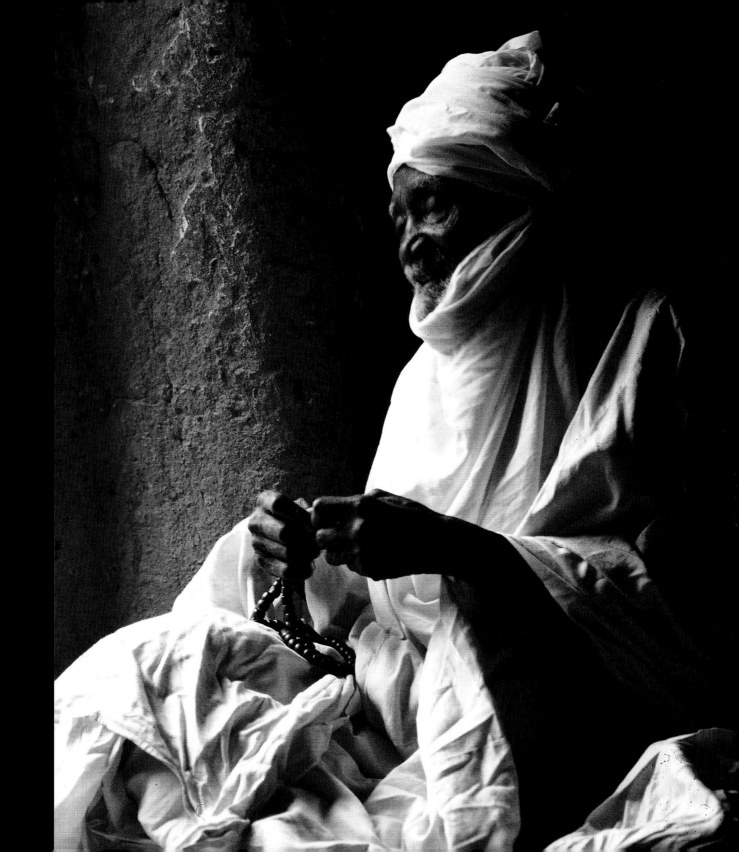

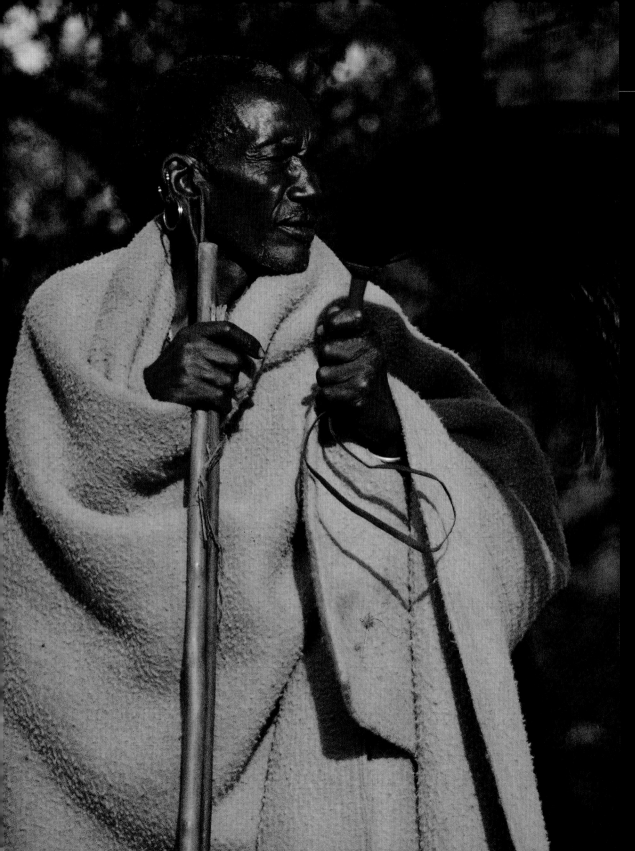

MASAI
KENYA

The dignified state of
senior elderhood brings
about a natural retirement
from some activities, but
also an increased role in
community affairs.
Reflective in his bearing, a
Masai elder wraps himself
in a warm blanket worn as a
cloak. He carries a walking
stick, symbolic of wisdom,
and a fly whisk made of
wildebeest tail hair. Arbiters
of justice, elders are respon-
sible for settling questions
of inheritance, divorce,
murder, and theft. Although
eloquence is respected, reso-
lution occurs only when a
clear consensus is reached;
no vote is ever taken.

KARO
ETHIOPIA

Karo elders, responsible
for the well-being of the
community, hold a meeting
in the cool shade of an
acacia tree. In the evenings
they gather to tell stories,
thus handing down the oral
tradition of legend
and lore.

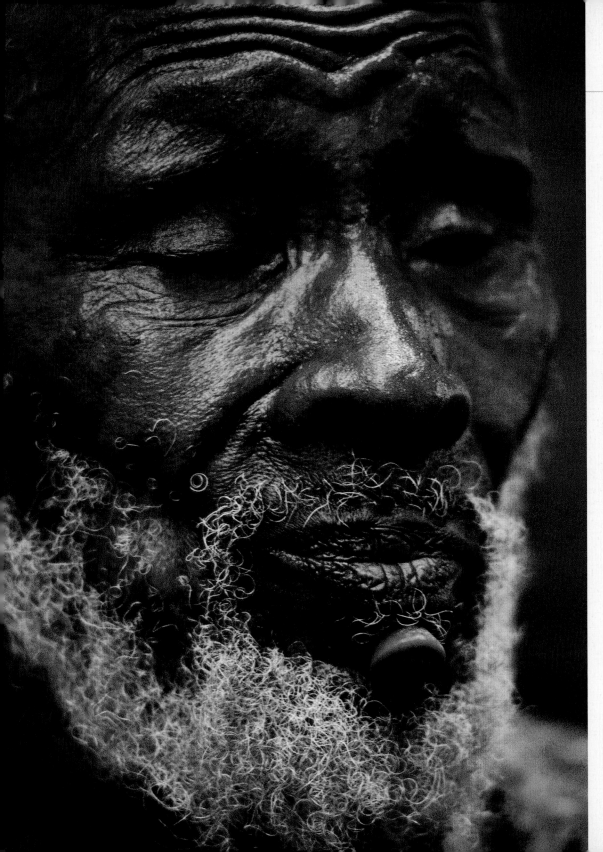

Overcoming his blindness, a
Pokot elder radiates dignity and
confidence as he independently
navigates the marketplace.

MASAI

KENYA

An elder Masai woman, despite
her handicap of blindness,
continues to play an active role as
ritual advisor to young girls during
their transition to womanhood.

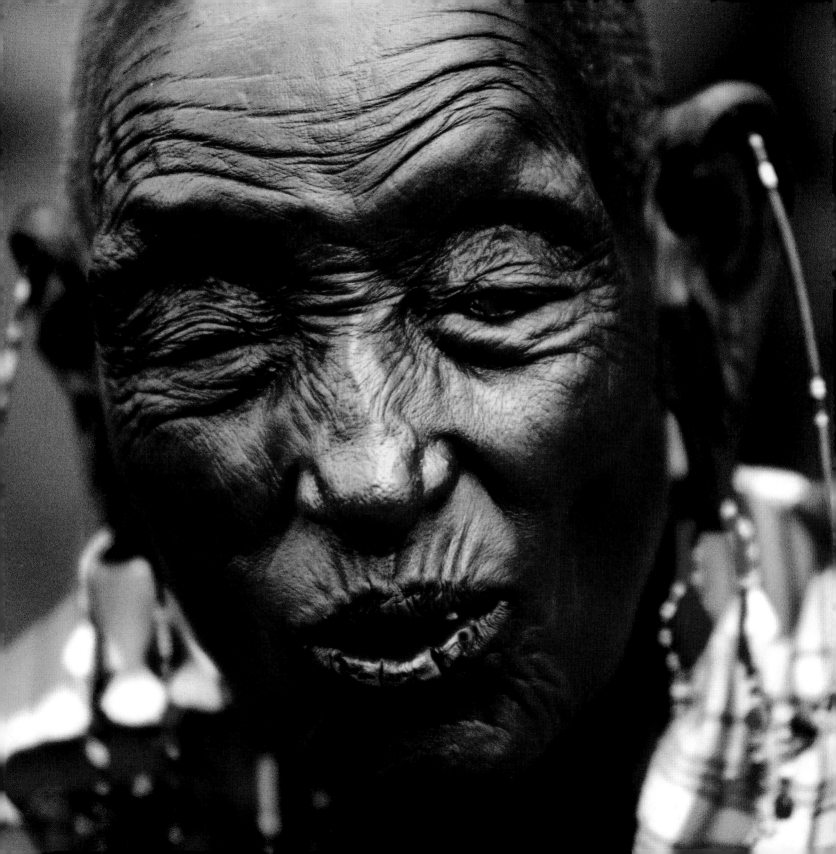

M A S A I

K E N Y A

A Masai elder lives his final stage
of life in a serene and calm way,
totally prepared for his journey to
the afterworld. He does not end
his days in loneliness and isolation,
but rather is surrounded and
supported by the community. As a
senior elder, he is respected for his
knowledge and wisdom, and
celebrated for his achievements
throughout life.

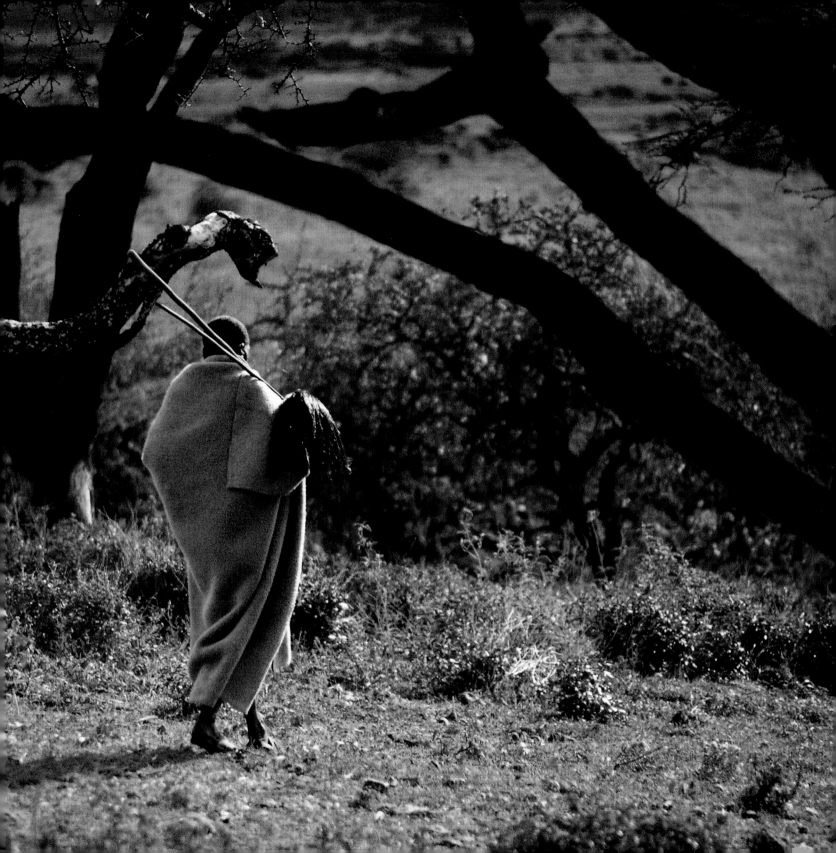

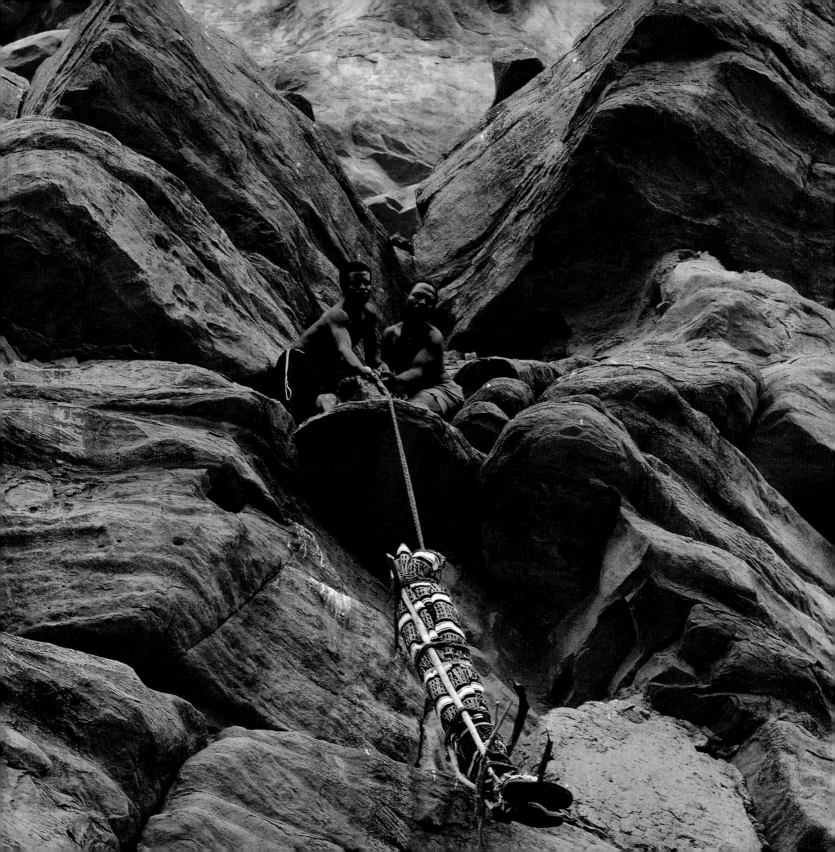

AS WE SLOWLY INCHED OUR WAY UP A CLIFF FACE 300 FEET ABOVE THE GROUND, we wondered if our visit to the ancestors might end up being more literal than symbolic. We had come to the Bandiagara Plateau in Mali to photograph the Dama funeral festival of the Dogon people. To get photographs from inside the caves of the ancestors, we knew we would have to climb ladders carved from tree trunks and be hauled up into the caves by ropes made of bark. Aware of what might happen if the ladders slipped or the ropes broke, we had written out our wills the night before.

The Dama funeral festival is a burial rite that takes place every 12 years, and although more elaborate than most, it is typical of ceremonies throughout Africa that celebrate the passage from the living world to the world of the ancestors.

Many African cultures believe that the spirit world influences every part of life, and one of the secrets for achieving health, wealth, and happiness is to honor and placate the ancestral spirits. Masks, fetishes, and grave markers——often works of art in themselves——are fashioned to represent ancestral spirits, and a variety of ceremonies are held that dramatize the relationship between the ancestors and the living.

We have often heard it said in Africa that a certain child is "an old soul"——referring to the belief that ancestors sometimes return as newborn babies, bringing wisdom for the living. When this happens, the living world and the ancestral world connect; the circle is completed, and another African journey begins.

DOGON

MALI

The shrouded corpse of an elder is hoisted by rope into the ancient burial caves of the ancestors.

RETURNING TO THE ANCESTORS

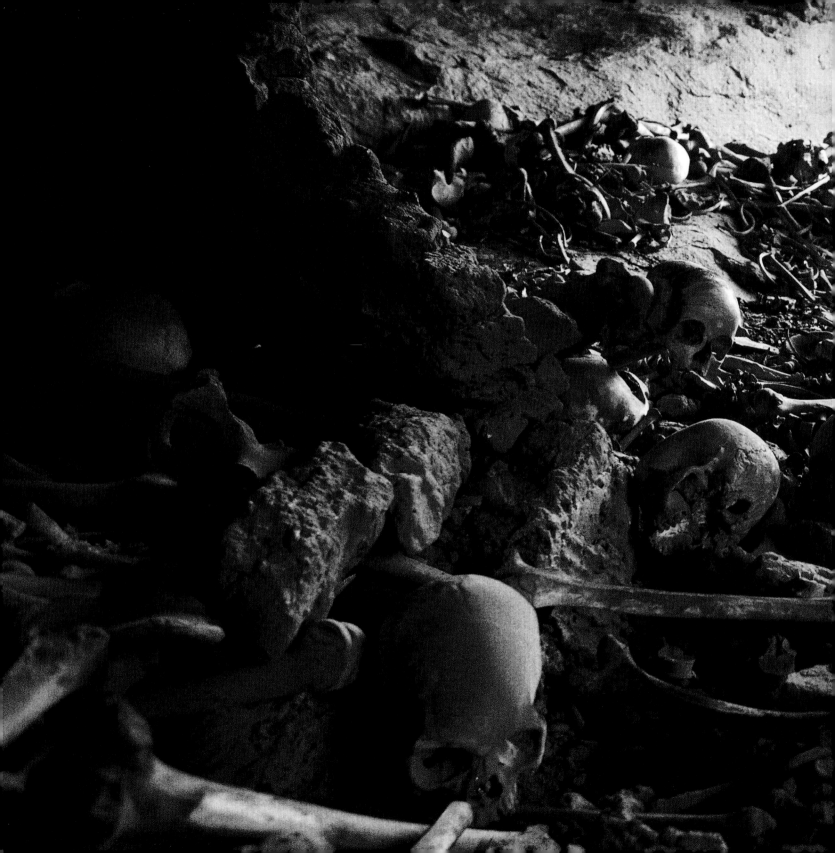

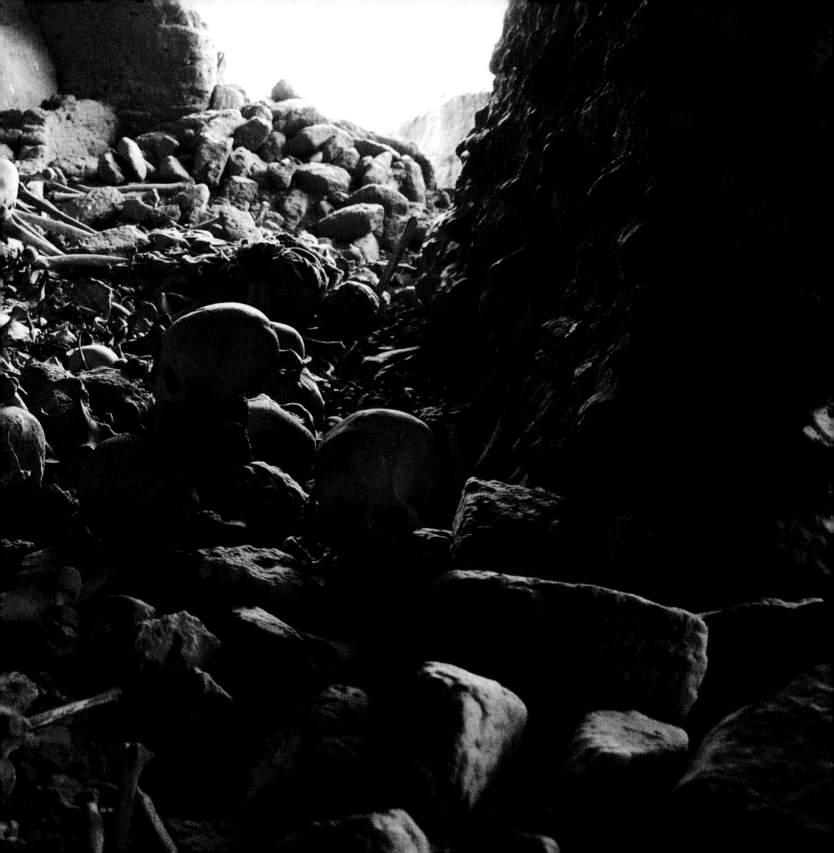

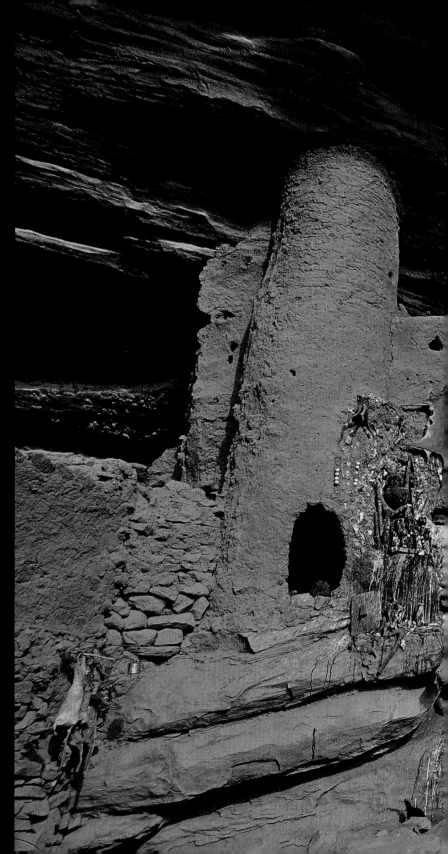

Preceding pages:

DOGON
MALI

The burial cave where the corpse will be placed is high up in the rock face and contains the bones and skulls of the ancestors. A small bowl of oil is often left at the feet of the deceased to ease weariness from the journey to the afterworld.

DOGON
MALI

Set into a cave halfway up the escarpment, the clan house of the high priest guards the world of Dogon ancestors. Its façade is covered with the skins and skulls of hunted game, in addition to countless sacrificed animals offered during the six-week period preceding the Dama funeral ceremony. Seated in front of the clan house, a high priest sacrifices a chicken to appease the ancestors and protect the world of the living.

Occurring once every 12 years, the Dama ceremony is a collective funeral designed to drive the spirits of the deceased out of the village and into the afterworld, where they will join the hierarchy of ancestors.

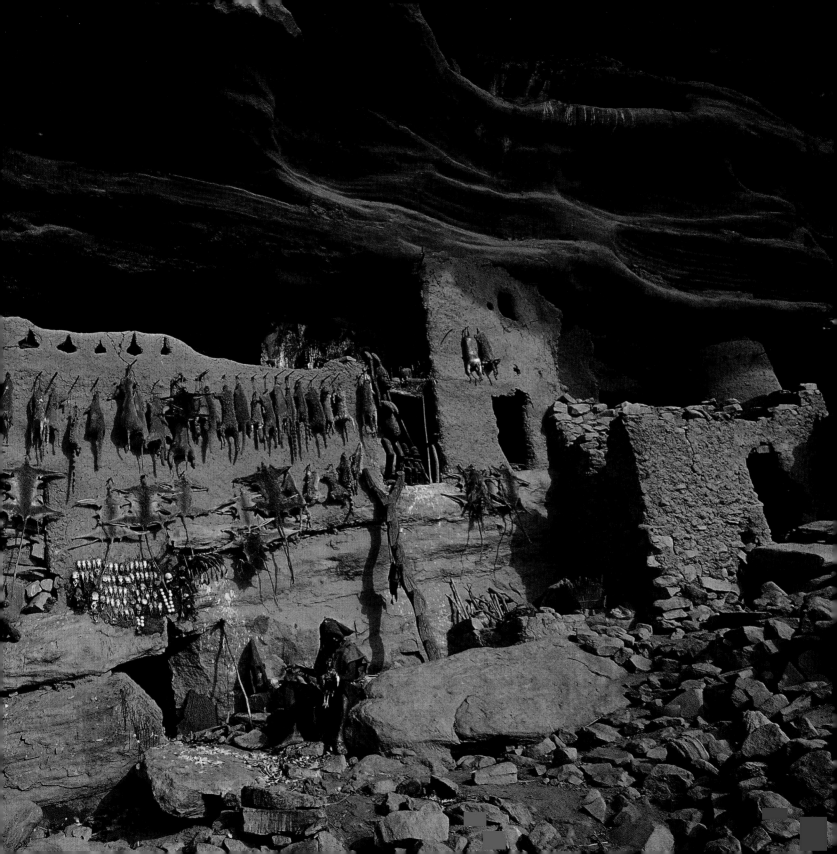

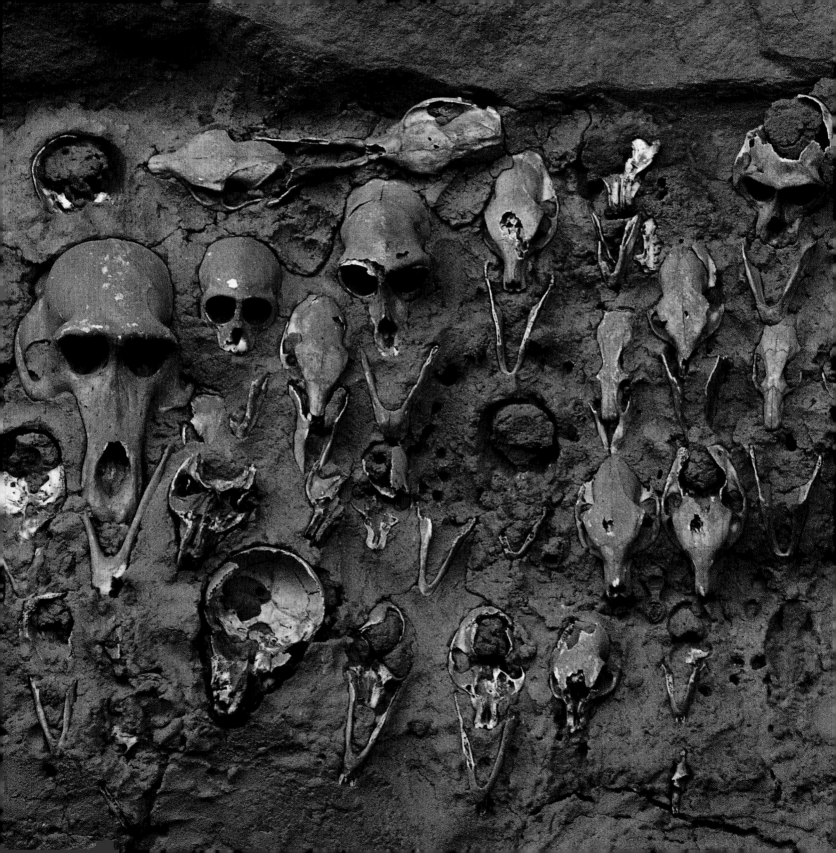

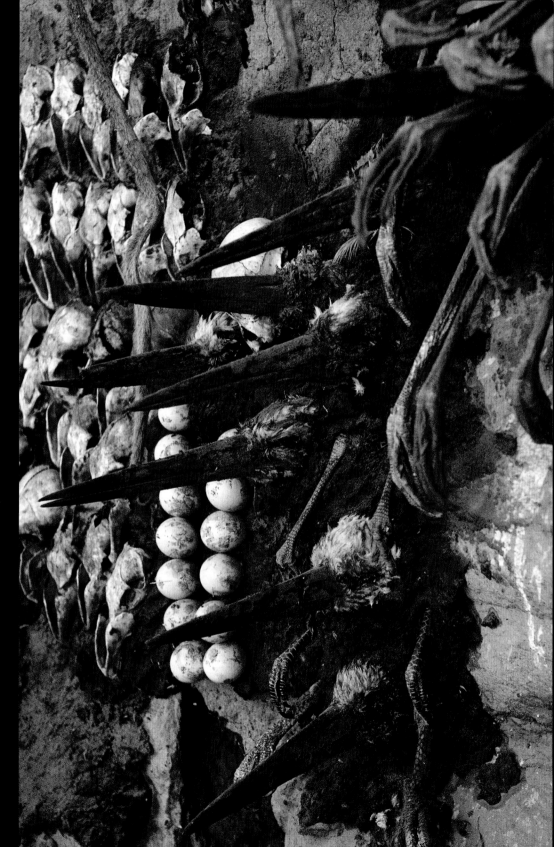

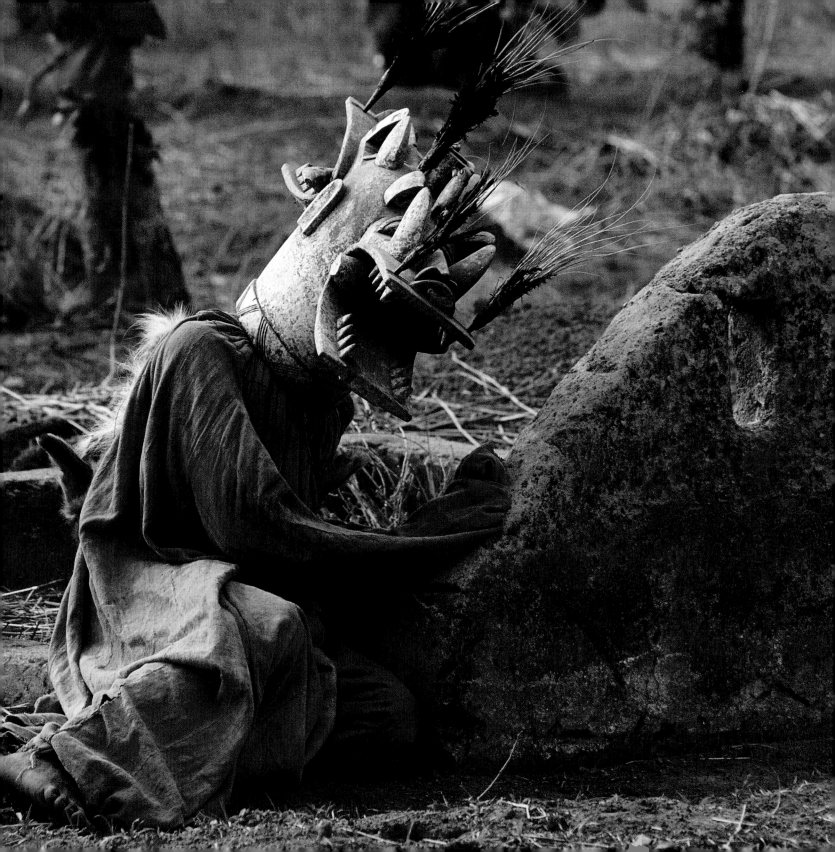

Crouching by a grave, the double-
headed Wambele masker guards the
sacred burial ground, its traditional
spirit home. Incorporating features
borrowed from many animals, such
as the tusks of warthogs and the
teeth of crocodiles, the Wambele
masker appears at Senufo funerals
to chase away the lingering spirits
of the dead and put them to rest in
the spirit world.

KONSO

ETHIOPIA

When a hero or important man
dies, Waga figures are carved in his
honor and placed in and around the
fields. On the head of the
figures, a phallic symbol is carved
to restore the power of men,
which the Konso believe has
been drained by women.

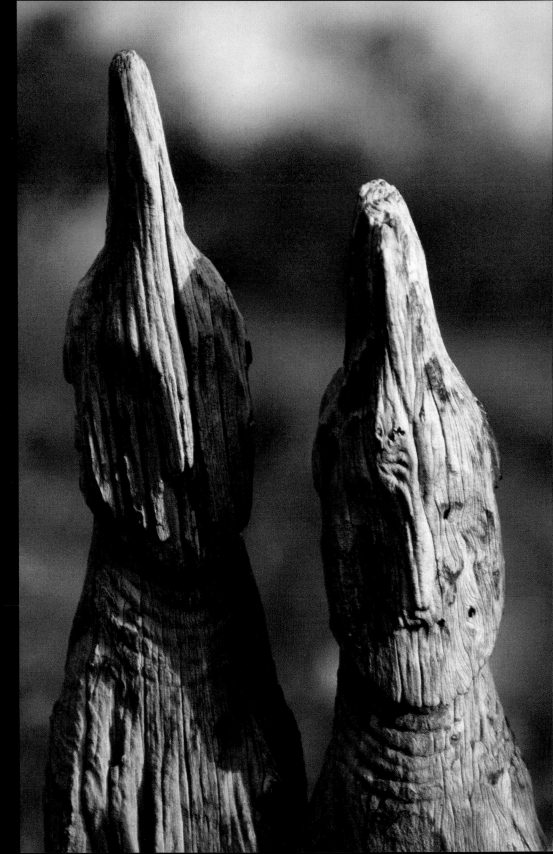

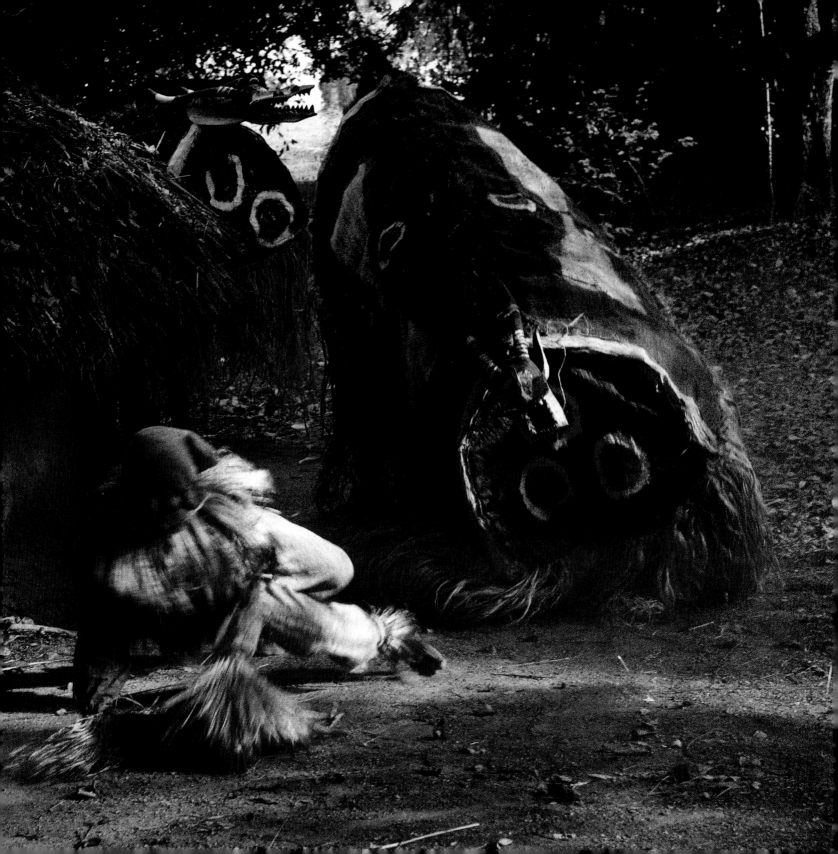

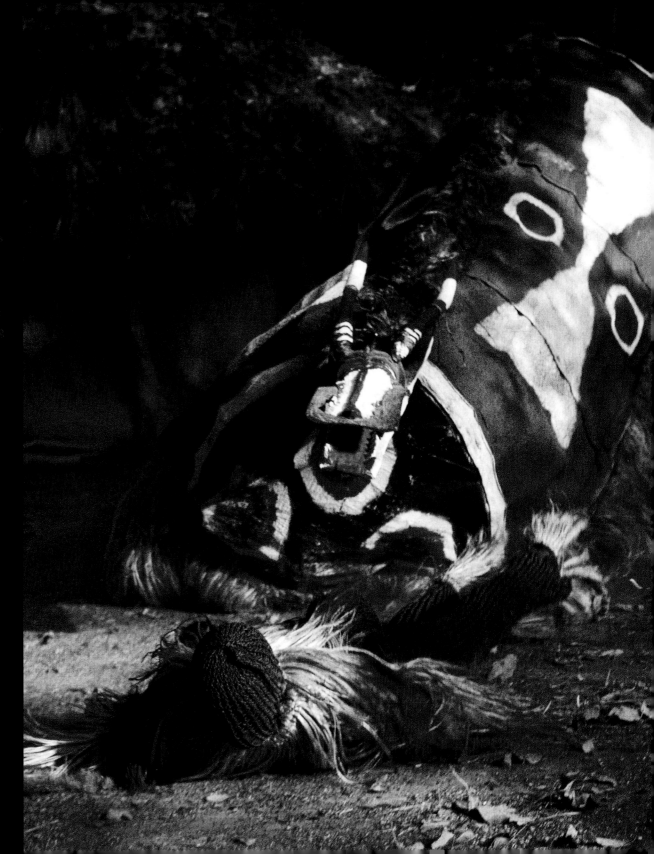

GHANA

An Ewe woman lies in state in a
small village along the coast of
Ghana. Gathering at the wake,
female relatives extol her virtues,
celebrate her life, and prepare
her for the journey ahead.

THE EERIE AND SURREAL EXPERIENCE OF PHOTOGRAPHING THE MUMMIFIED BODY of a renowned Voodoo priestess is one we will never forget. An excerpt from our journal of October 23, 1992:

"The mummified body of High Priestess Mme Amortsoe Quaye sits in state on the night of her wake. The red parrot feather sealed into her mouth with red wax indicates her status as high priestess and is said to possess the power to kill. Bathed, perfumed, and dressed in white satin, she is seated upright in a small pavilion, where hundreds of mourners come to pay their respects.

Mme Amortsoe Quaye died suddenly at age 79. It was believed that a curse from one of the priestesses she trained was responsible for her death. Each priestess approaches her and cries passionately, 'I have not killed you,' punctuating her declaration by entering into a trance and collapsing into the crowd. If the priestess lies, it is believed she will die within a week. The following morning Mme Amortsoe Quaye was buried in a "fantasy" coffin, which is a replica of the healing shrine in which she practiced her healing arts throughout her long life."

GA
GHANA

The mummified body of Voodoo
priestess Mme Amortsoe Quaye
sits in state at her wake.

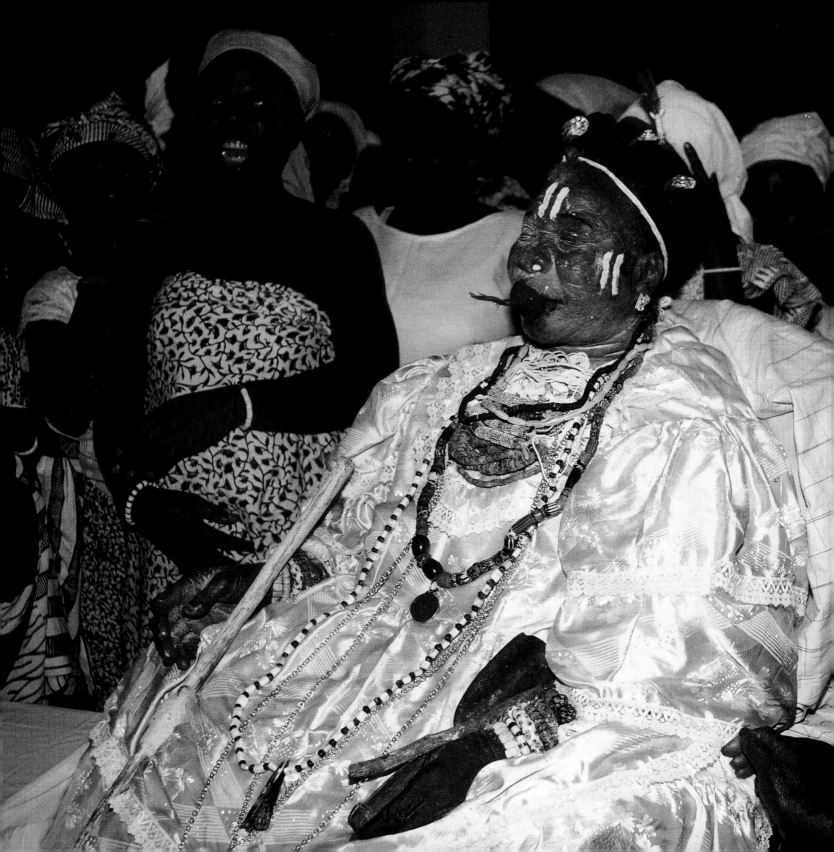

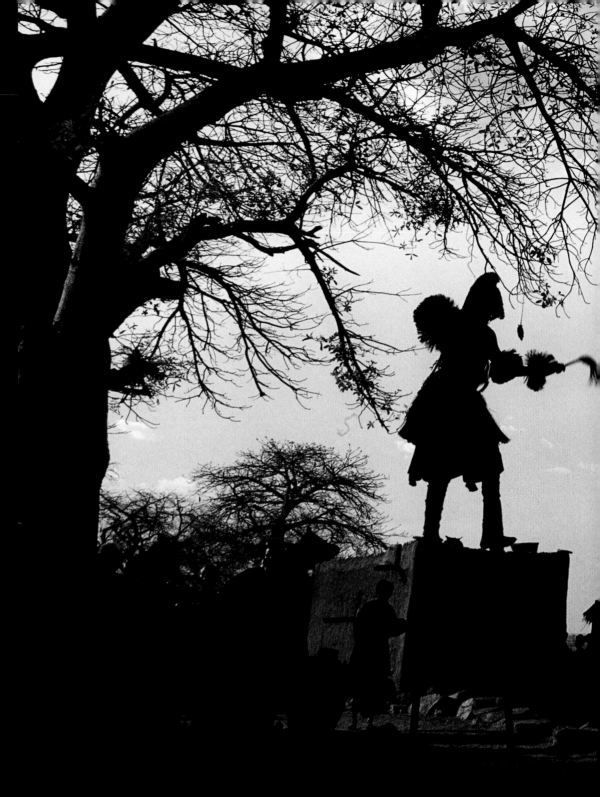

As the Dama ceremony draws to a
close, masked dancers leave the
village, their task complete.
The spirits of the dead have been
successfully initiated into their
role as ancestors, and will now
watch over and protect future
generations of Dogon.

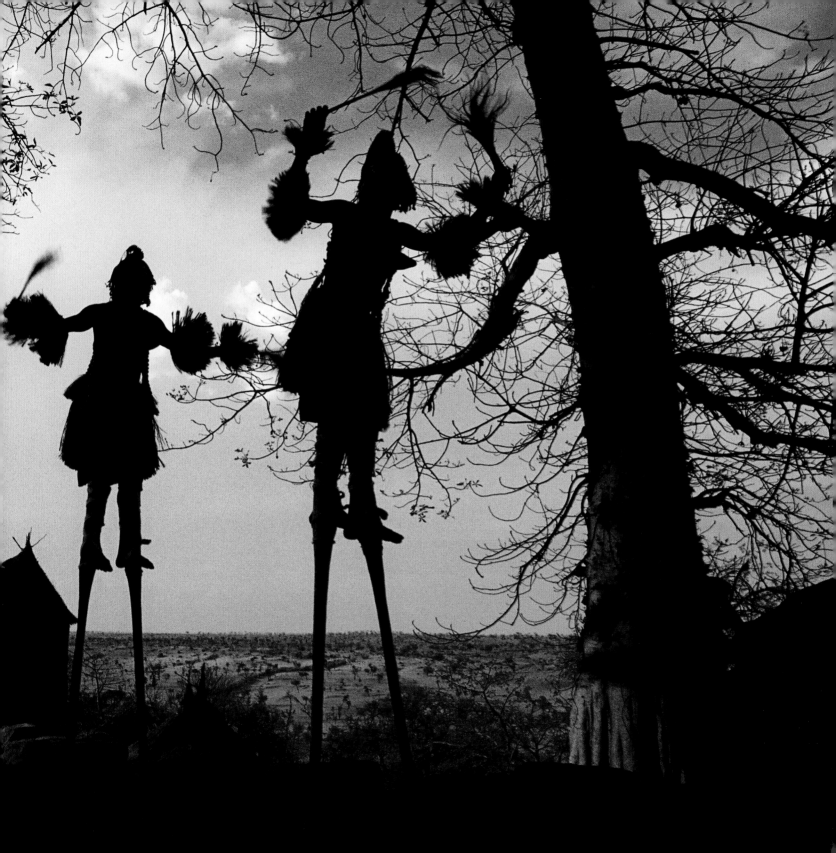

FACES OF AFRICA
Carol Beckwith and Angela Fisher

Published by the National Geographic Society
John M. Fahey, Jr., *President and Chief Executive Officer*
Gilbert M. Grosvenor, *Chairman of the Board*
Nina D. Hoffman, *Executive Vice President*

Prepared by the Book Division
Kevin Mulroy, *Vice President and Editor-in-Chief*
Charles Kogod, *Illustrations Director*
Marianne R. Koszorus, *Design Director*

Staff for this Book
Lisa Lytton, *Editor*
Rebecca Lescaze, *Text Editor*
Jane Menyawi, *Illustrations Editor*
Melanie Doherty Design, *Designer*
Gary Colbert, *Production Director*
Ric Wain, *Production Project Manager*
Meredith C. Wilcox, *Illustrations Assistant*

Manufacturing and Quality Control
Christopher A. Liedel, *Chief Financial Officer*
Phillip L. Schlosser, *Managing Director*
John T. Dunn, *Technical Director*

Library of Congress Cataloging-in-Publication Data
Beckwith, Carol, 1945–
 Faces of Africa / Carol Beckwith & Angela Fisher
 p. cm.
 ISBN 0-7922-6830-X
 1. Africa—Pictorial works. 2. Africa—Social life and customs—Pictorial works. I. Fisher, Angela.

DT4.5.B43 2004
305.896'0222'2—dc22
 2004049970

One of the world's largest nonprofit scientific and educational organizations, the National Geographic Society was founded in 1888 "for the increase and diffusion of geographic knowledge." Fulfilling this mission, the Society educates and inspires millions every day through its magazines, books, television programs, videos, maps and atlases, research grants, the National Geographic Bee, teacher workshops, and innovative classroom materials. The Society is supported through membership dues, charitable gifts, and income from the sale of its educational products. This support is vital to National Geographic's mission to increase global understanding and promote conservation of our planet through exploration, research, and education.

For more information, please call 1-800-NGS LINE (647-5463) or write to the following address:

NATIONAL GEOGRAPHIC SOCIETY
1145 17th Street N.W.
Washington, D.C. 20036-4688 U.S.A.

Visit the Society's Web site at
www.nationalgeographic.com.

e.guides

Space Travel

DK

LONDON, NEW YORK, MELBOURNE,
MUNICH, and DELHI

Author Ian Graham

Senior Editor Jayne Miller
Project Editor Robert Dinwiddie
Weblink Editors Clare Lister, Mariza O' Keeffe,
Roger Brownlie, John Bennett

Managing Editor Camilla Hallinan

Digital Development Manager Fergus Day
DTP Technical Adviser Toby Beedell
DTP Co-ordinator Sarah Pfitzner
Production Erica Rosen

Category Publisher Sue Grabham

Consultant Peter Bond

Senior Designers Owen Peyton Jones, Smiljka Surla, Yumiko Tahata
llustrators Mark Longworth, Darren Poore
Cartography Simon Mumford

Managing Art Editor Sophia M Tampakopoulos Turner

Picture Researcher Fran Vargo
Picture Librarians Sarah Mills, Karl Strange, Kate Ledwith
Jacket Neal Cobourne

Art Director Simon Webb

First American Edition, 2004

Published in the United States by DK Publishing, Inc.
375 Hudson Street, New York, New York 10014

04 05 06 07 08 09 10 9 8 7 6 5 4 3 2 1

Copyright © 2004 Dorling Kindersley Limited

Google™ is a trademark of Google Technology Inc.

A Cataloging-in-Publication record for this book
is available from the Library of Congress.

ISBN 0 7566 0533 4

Color reproduction by Colourscan, Singapore
Printed in China by Toppan Printing Co. (Shenzen) Ltd.

Discover more at
www.dk.com

e.guides

Space Travel

Written by **Ian Graham**

Google™

CONTENTS

How to use the Web site

e.guides Space Travel has its own Web site, created by DK and Google™. When you look up a subject in the book, the article gives you key facts and displays a keyword that links you to extra information online. Just follow these easy steps.

http://www.spacetravel.dke-guides.com

 Enter this Web site address...

Address : http://www.spacetravel.dke-guides.com

 Find the keyword in the book...

Shuttle

 Enter the keyword...

e ▶▶ explore.spacetravel
DK and Google bring to you the best of the Web.

Shuttle

You can only use the keywords from the book to search on our Web site for the specially selected DK/Google links.

Be safe while you are online:

- Always get permission from an adult before connecting to the Internet.

- Never give out personal information about yourself.

- Never arrange to meet someone you have talked to online.

- If a site asks you to log in with your name or email address, ask permission from an adult first.

- Do not reply to emails from strangers—tell an adult.

Parents: Dorling Kindersley actively and regularly reviews and updates the links. However, content may change. Dorling Kindersley is not responsible for any site but its own. We recommend that children are supervised while online, that they do not use Chat Rooms, and that filtering software is used to block unsuitable material.

Click on your chosen link...

Download fantastic pictures...

Shuttle orbiter

The pictures are free of charge, but can be used for personal, noncommercial use only.

Take a virtual tour of the Shuttle.

Links include animations, videos, sound buttons, virtual tours, interactive quizzes, databases, timelines, and real-time reports.

Go back to the book for your next subject...

WHY EXPLORE SPACE?

People have gazed up at the night sky for thousands of years and wondered what the countless wandering points of light were. Improved technology means we can observe and explore further into the Universe. Just as ancient explorers traveled across uncharted lands and oceans to see what was there, modern explorers venture into space. By studying space, scientists can discover what is out there, find out how the Universe began, and learn more about Earth.

astronomy

SATURN AS SEEN THROUGH A TELESCOPE

Eyepiece—observer looks through the eyepiece lens, which magnifies the image

Telescope tube moves in and out to bring the image into sharp focus

Main mirror captures light from objects and reflects it onto the side of the tube

◄ NEWTON'S REFLECTOR TELESCOPE
English scientist Sir Isaac Newton invented a new type of telescope in 1668. Telescopes had been used to see further into the Universe since Italian astronomer Galileo turned one to the sky in 1609. The first telescopes used glass lenses to gather light from the sky and bend it to a focus. They bent different colors of light unequally, so the image was distorted. Newton's telescope used mirrors to capture the light and reflect it, without bending it. This produced clearer images. The giant telescopes used today can trace their ancestry back to Newton's reflector.

THE MILKY WAY ►
Our Sun is just one of more than 100 billion stars that travel through space together in a swirling flattened spiral called the Milky Way galaxy. If the sky is clear and dark enough, you might be able to see a bright band stretching across it. You are looking sideways through the galaxy. The Milky Way is so big that if you could travel at the speed of light, 186,411 miles per second (300,000 km per second), it would take 100,000 years to cross it.

▲ LOOKING DEEPER INTO SPACE
When astronomers look into space with powerful modern telescopes, they see fuzzy regions called nebulae. Many are vast clouds of gas and dust where new stars form. The Eskimo Nebula is made from gas thrown out into space by a dying star. It is about 2,930 light years from Earth. One light year is about 5.9 million million miles (9.5 million million km).

◄ GIANT TELESCOPES
Observatories, such as the Keck Observatory in Hawaii, help astronomers to explore beyond the atmosphere and into space. Each of the twin Keck telescopes uses a mirror 30 ft (10 m) across to collect starlight. Earth's atmosphere distorts the light from stars, so most telescopes are built on mountains above the thickest part of the atmosphere. Keck is 14,700 ft (4,205 m) above sea level on top of Mauna Kea.

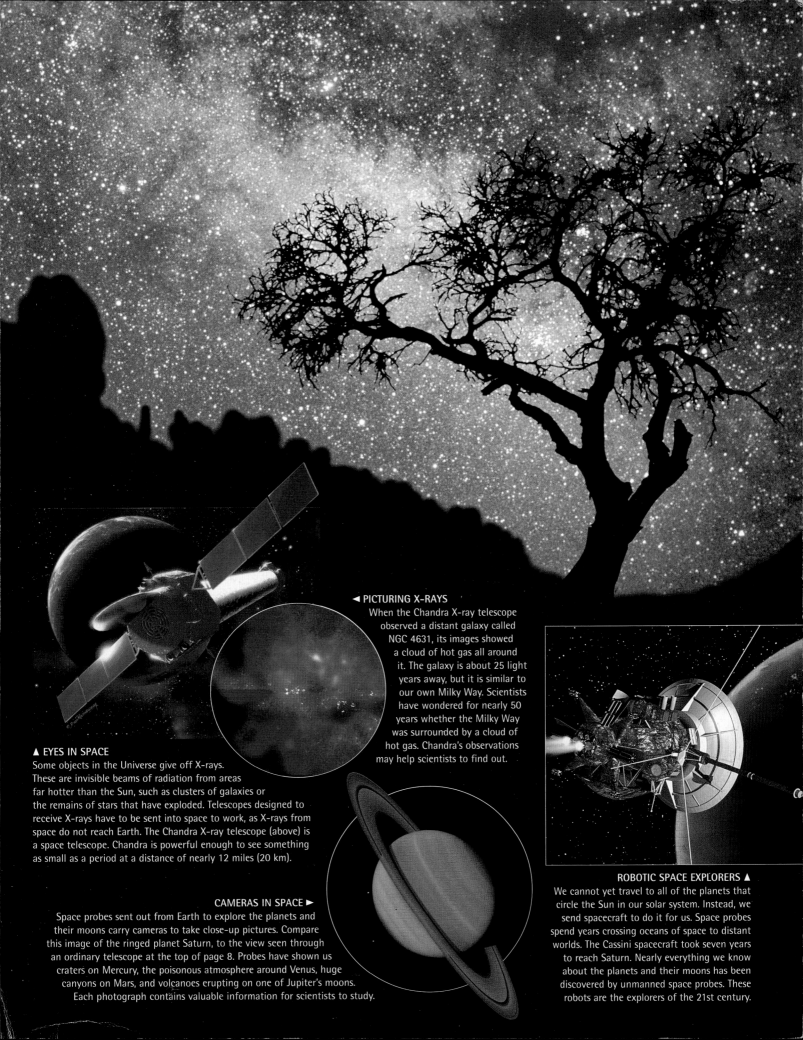

▲ EYES IN SPACE

Some objects in the Universe give off X-rays.
These are invisible beams of radiation from areas
far hotter than the Sun, such as clusters of galaxies or
the remains of stars that have exploded. Telescopes designed to
receive X-rays have to be sent into space to work, as X-rays from
space do not reach Earth. The Chandra X-ray telescope (above) is
a space telescope. Chandra is powerful enough to see something
as small as a period at a distance of nearly 12 miles (20 km).

◄ PICTURING X-RAYS

When the Chandra X-ray telescope
observed a distant galaxy called
NGC 4631, its images showed
a cloud of hot gas all around
it. The galaxy is about 25 light
years away, but it is similar to
our own Milky Way. Scientists
have wondered for nearly 50
years whether the Milky Way
was surrounded by a cloud of
hot gas. Chandra's observations
may help scientists to find out.

CAMERAS IN SPACE ►

Space probes sent out from Earth to explore the planets and
their moons carry cameras to take close-up pictures. Compare
this image of the ringed planet Saturn, to the view seen through
an ordinary telescope at the top of page 8. Probes have shown us
craters on Mercury, the poisonous atmosphere around Venus, huge
canyons on Mars, and volcanoes erupting on one of Jupiter's moons.
Each photograph contains valuable information for scientists to study.

ROBOTIC SPACE EXPLORERS ▲

We cannot yet travel to all of the planets that
circle the Sun in our solar system. Instead, we
send spacecraft to do it for us. Space probes
spend years crossing oceans of space to distant
worlds. The Cassini spacecraft took seven years
to reach Saturn. Nearly everything we know
about the planets and their moons has been
discovered by unmanned space probes. These
robots are the explorers of the 21st century.

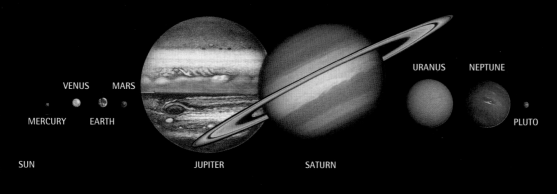

VENUS MARS

MERCURY EARTH

URANUS NEPTUNE

PLUTO

SUN JUPITER SATURN

◄ PLANETARY FORCES
All the planets and their moons exert a gravitational pull on spacecraft, although this pull is quite weak until a craft gets fairly close to the planet. For craft flying through the outer solar system, the gravity of the largest planet, Jupiter, has the biggest effect. Gravity can help an interplanetary spacecraft to reach its destination. Some probes save fuel by using one planet's gravity to accelerate them toward the next planet.

◄ SUN'S EFFECTS
The Sun affects spacecraft in many ways. First, its enormous gravity pulls them toward it. Second, it heats a spacecraft and bathes it in potentially harmful radiation. Third, sunlight striking a spacecraft exerts a tiny push on the craft. Big spacecraft are affected the most, because the sunlight acts over a larger area. The effect tends to make a spacecraft drift off-course. From time to time, the craft's engines may have to be fired to bring it back onto the correct flight path.

FLYING IN SPACE

The laws of nature that govern spaceflight were written down by the scientist Sir Isaac Newton (1642-1727) 300 years ago. Scientists who plan spaceflights today use his law of gravitation and his laws of motion to plot a spacecraft's course through space. These laws are simple, but calculating a spacecraft's flight path is difficult. The planets and spacecraft are all moving in different directions at different speeds, so the sizes and directions of the many forces acting on a spacecraft are constantly changing.

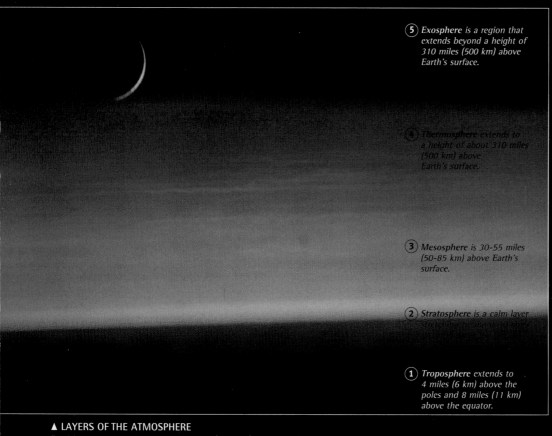

(5) *Exosphere is a region that extends beyond a height of 310 miles (500 km) above Earth's surface.*

(4) *Thermosphere extends to a height of about 310 miles (500 km) above Earth's surface.*

(3) *Mesosphere is 30-55 miles (50-85 km) above Earth's surface.*

(2) *Stratosphere is a calm layer stretching above the troposphere.*

(1) *Troposphere extends to 4 miles (6 km) above the poles and 8 miles (11 km) above the equator.*

LEAVING THE ATMOSPHERE ►
An Ariane rocket powers its way up through the atmosphere. Boosters give the maximum power necessary to lift the rocket off the ground. The vehicle accelerates slowly at the beginning of its flight, when it is at its heaviest. As the rocket rapidly burns fuel, it becomes lighter. The lighter it is, the faster it accelerates. It climbs vertically at first and then tilts over further and further until it is flying horizontal as it reaches its orbital height.

▲ LAYERS OF THE ATMOSPHERE
Earth's atmosphere is about 310 miles (500 km) deep, but has no sharp boundary, fading into space as it gets thinner in the layer called the exosphere. Spacecraft have to pass through the atmosphere to get to space. While satellites and space probes are boosted through the lowest part of the atmosphere, where the air is densest, they are enclosed in a protective aerodynamic casing, called a fairing. The fairing protects the spacecraft from the air and weather outside. It also gives them a smooth, streamlined shape that allows them to slip easily through the air.

GOING INTO ORBIT

When a rocket is used to blast an object into space, the result depends on how much horizontal speed the object is given. If the speed is relatively small (for example, 5,000 mph or 8,000 kph), Earth's gravity will soon pull the object back to the ground. Such a flight is called suborbital. The greater the speed the object is given, the further it will go before it reaches the ground. If it is given a speed of about 17,400 mph (28,000 kph), the object never reaches the ground but goes right around Earth—in other words, into orbit.

Rocket

Suborbital flight due to low speed following launch

Longer suborbital flight due to higher speed following launch

Orbital flight when object is given a speed of 17,400 mph (28,000 kph)

THRUST AND ACCELERATION ►
A rocket burns fuel to produce a jet of hot, expanding gas. The action of the gas being blasted downward causes a reaction force, or thrust, that pushes the rocket upward. This provides a classic example of Newton's third law of motion, which states that every action has an equal and opposite reaction. The upward thrust on the rocket exceeds the force of gravity pulling the rocket toward the ground. There is therefore an overall upward force on the rocket that causes it to accelerate up through the atmosphere.

Thrust acts on a rocket to accelerate it upward

Rocket propelled upward, in reaction to explosive downward flow of its exhaust gases

 rockets

Gravity acts downward, toward Earth's center

Solid-fuel boosters deliver more than 90 per cent of the total launch thrust

Main stage fuselage contains the rocket's fuel tanks

Main engine burns for about 10 minutes on launch, varying slightly according to the mission

Fiery hot exhaust gases propel the rocket upward

GRAVITY IN SPACE ►
When astronauts float through space, it seems that gravity is no longer affecting them. In fact, the force of gravity on the astronaut is almost the same as the gravity acting on someone on Earth. The difference is that the astronaut is in a state called free fall—falling without ever reaching the ground. An astronaut in free fall is weightless. If he or she were to stand on some scales, they would show no weight, because the scales would be falling, too.

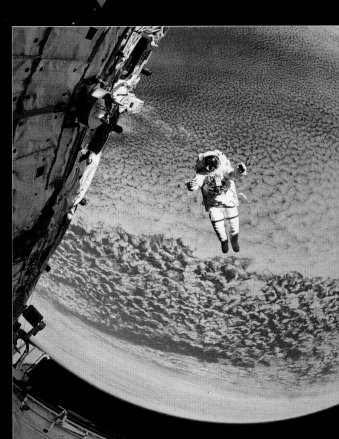

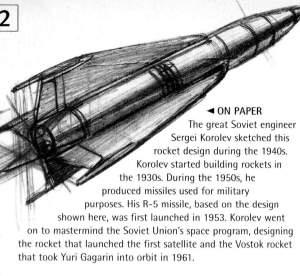

ROCKET HISTORY

The rockets that launch spacecraft today can trace their history back to Germany in the 1930s. People in other countries had been building small rockets and thinking about space travel for many years, but it was a team of scientists and engineers in Germany that led the world in rocket design. They eventually went on to build the most advanced rockets of the day, such as the V-2. Many of these scientists and engineers later developed rockets for the US and the Soviet Union, including the rockets that took astronauts to the Moon.

◄ AN EARLY START
The first liquid-fueled rocket was launched in 1926 by the American Robert Goddard. During launch and flight, oxygen gas was produced at high pressure and used to force gasoline and liquid oxygen along separate lines to the combustion chamber. Goddard's rocket climbed to a height of 41 ft (12.5 m) during a flight that lasted 2.5 seconds. Later liquid-fueled rockets had the great advantage over solid-fueled rockets that they could be turned on and off.

Igniter system at top of rocket contained match heads and black gunpowder

Rocket's combustion chamber where gasoline was burned in oxygen

Liquid oxygen line

Gasoline line

rockets

Frame that held rocket prior to launch

Liquid oxygen tank

Alcohol burner vaporized liquid oxygen, producing gaseous oxygen at high pressure

Gasoline tank

Pressure line held the pressurized oxygen gas

Base of rocket

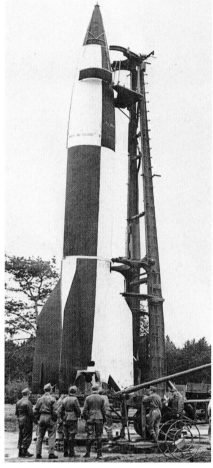

WAR ROCKET ▲
During World War II (1939-1945), Germany produced a series of new weapons. The most important was the V-2 rocket. It was developed by a team led by Wernher von Braun. The V-2 stood 50 ft (14 m) high and weighed more than 12 tons. It was fueled by alcohol and liquid oxygen and its engine burned for about 60 seconds. In that short time, it boosted the V-2 to a speed of about 3,500 mph (5,600 kph) and to a height of nearly 62 miles (100 km).

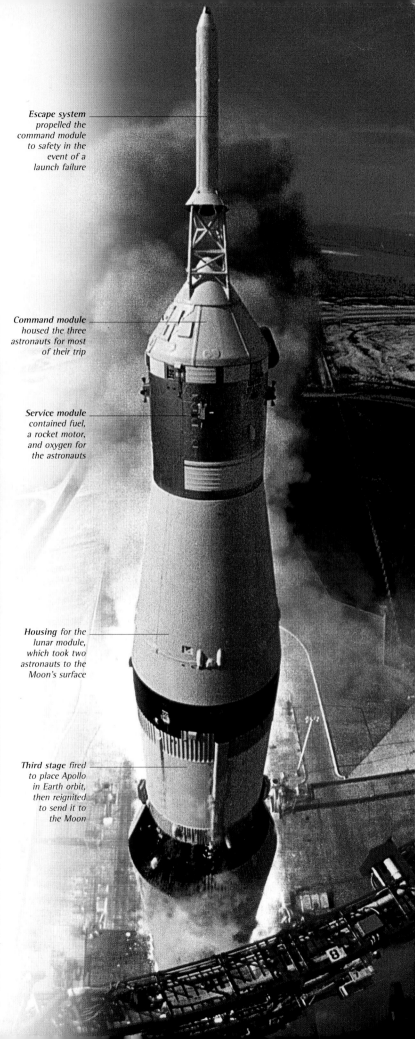

◄ MONUMENT TO TSIOLKOVSKY

This monument in Kaluga, Russia, honors Konstantin Tsiolkovsky, a Russian school-teacher who figured out many of the principles of rocketry more than 50 years before the Space Age began. Tsiolkovsky had been fascinated by the idea of space travel since his childhood and started writing about space flight in 1898. He could not afford to build and test his own rockets, so most of his work was in the form of theories and calculations on paper.

Escape system
propelled the command module to safety in the event of a launch failure

Command module
housed the three astronauts for most of their trip

Service module
contained fuel, a rocket motor, and oxygen for the astronauts

Housing for the lunar module, which took two astronauts to the Moon's surface

Third stage fired to place Apollo in Earth orbit, then reignited to send it to the Moon

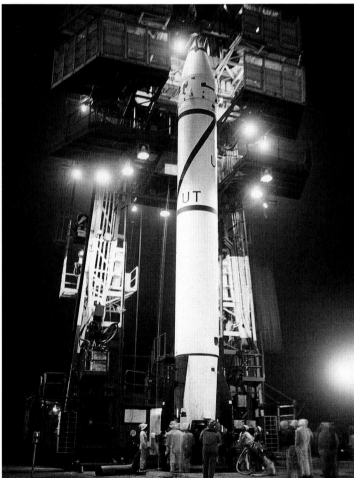

▲ LAUNCHING A SATELLITE

The Jupiter C rocket launched the first US satellite in 1958. When used to launch satellites, the rocket was known as Juno I. It was developed by Wernher von Braun and members of his V-2 rocket team, who had moved to the US at the end of World War II. The Jupiter C was developed from designs for the Redstone rocket, which went on to launch the first two American astronauts in 1961.

ROCKET TO THE MOON ►

Saturn V, the giant rocket that sent US astronauts to the Moon, was developed at NASA's Marshall Space Flight Center under the leadership of Wernher von Braun. With an Apollo spacecraft on top of its three stages, it stood 363 ft (111 m) high and weighed 3,000 tons. It could launch a spacecraft weighing 152 tons into Earth orbit or send a 53-ton spacecraft to the Moon. After the Apollo missions ended, a two-stage version of Saturn V launched the Skylab space station in 1973.

ROCKET POWER

It takes an enormous amount of energy to boost a spacecraft into orbit. Rockets powered by explosive chemical reactions are still the only vehicles capable of getting to space. A rocket is propelled by a jet of gas produced by burning fuel. Oxygen is needed to burn the fuel. Since there is no oxygen in space, rockets carry their own supply. The largest launchers are actually two or more rockets, called stages, on top of each other. As each stage uses up its fuel, it falls away to save weight.

FOUR STEPS TO ORBIT

LIFTOFF
During liftoff, Ariane 5's main engine fires first, followed 7 seconds later by its solid fuel boosters. Two minutes later, the boosters separate. In that short time, each has burned 238 tons of fuel. The boosters fall away when the rocket has reached a height of about 40 miles (65 km) and a speed of about 4,620 mph (7,450 kph).

FAIRING JETTISONED
Just over 3 minutes after liftoff, the rocket is more than 62 miles (100 km) above the ground. It has passed through the thickest part of the atmosphere, so the streamlined fairing around the payload is no longer needed. It splits in two and falls away. Different fairings are used depending on the size and shape of the payload that has to fit inside.

STAGE SEPARATION
Ariane 5's first or main stage engine is shut down about 9 minutes 42 seconds after liftoff. The rocket is now at a height of 93 miles (150 km) and traveling at 17,400 mph (28,000 kph). A few seconds later, the first stage separates from the rest of the rocket. As it falls back through the atmosphere, it breaks up and falls into the Pacific Ocean.

SECOND STAGE IGNITES
Finally, Ariane 5's second or upper stage engine fires to boost the payload into the correct orbit. The second stage engine can burn for up to about 18 minutes. The precise burn time depends on the type and height of orbit into which the payload is to be placed. Once the payload has been released, Ariane 5 has completed its work.

ARIANE 5 ▶
An Ariane 5 rocket blasts off from the European Space Agency's spaceport in French Guiana, South America. The 750-ton rocket's first flight was in June 1996 and it first successfully launched a commercial satellite into space in December 1999. It can launch satellites weighing up to 17,600 lb (8,000 kg).

Payload fairing splits in two to release payload

Payload can include two large satellites and several small microsatellites

Second stage engine boosts the payload into its final orbit

Solid fuel booster supplies extra power for takeoff

Hydrogen tank contains 25 tons of liquid hydrogen; at the top is the liquid oxygen tank

Solid rocket boosters hold 238 tons of solid propellant and burn for 130 seconds

Exhaust nozzle of first, main stage engine can be swiveled to steer the rocket

Exhaust flame of solid-fuel booster rocket

SPACECRAFT MANEUVERING

Rocket fired — Initial orbit — Elliptical orbit

Rocket firing in reverse — Initial orbit — Smaller, faster orbit

Rocket fired at an angle — Plane of orbit changes

Spacecraft boosted straight upward — Orbit stretched into an ellipse

FORWARD THRUST
Firing a rocket to speed up a spacecraft in the direction it is already moving pushes it further away from Earth into an elliptical orbit. In this orbit, the spacecraft speeds up as it comes closer to Earth and slows down as it travels further away. If the rocket is fired when the craft is at its furthest point from Earth, the orbit will become circular.

REVERSE THRUST
Turning around and firing a rocket in the direction a spacecraft is moving slows the craft down. Gravity then pulls it down into a lower orbit. As it falls, it speeds up. The closer to Earth it gets, the faster the craft must go to resist gravity and stay in orbit. If reverse thrust is used for long enough, gravity wins and the craft returns to Earth.

CHANGING THE ORBITAL PLANE
To change the plane of its orbit, a spacecraft must fire a rocket at an angle to its direction of motion. This may sound simple, but figuring out exactly how long to fire the rocket for and in which direction is quite complicated. Spacecraft rarely change their orbital plane, because it uses up large amounts of fuel.

RADIAL THRUST
Firing a rocket straight away from Earth usually has a similar result to a forward thrust. Unless the rocket burns long and powerfully enough to cause the spacecraft to completely escape Earth's gravity, the spacecraft eventually falls back toward Earth again. As it does so, the spacecraft speeds up and its circular orbit becomes elliptical.

STEERING ROCKETS ▶
As a rocket soars away from the launchpad, control systems on board monitor its direction of motion and make many tiny adjustments to keep it on a stable flight path. They steer the rocket in the right direction by swiveling its engine nozzle. Swiveling the nozzle like this is called gimbaling. A gimbaled nozzle doesn't have to move much. A rocket travels so fast and so far that it can be kept on course by very small adjustments to its direction of motion.

Rocket swings in opposite direction to nozzle orientation

Gimbaled nozzle swivels to change direction

Rocket swings round and flies in a new direction

rockets

Fiery jet is sent along the ground as the rocket is test-fired sideways

Instruments measure the rocket's exhaust

TESTING ROCKETS ▲
New rocket engines are test-fired on the ground to make sure that they work and to measure precisely how powerful they are. They have to be held down securely in test-stands to stop them from moving. Successful rockets are continually improved and tested again and again. The Vulcan engine that powers the first stage of the Ariane 5 rocket was test-fired about 300 times during its development.

Exhaust nozzle of engine being tested

◄ SPUTNIK 1
Sputnik's full name was Iskustvennyi Sputnik Zemli, ("Fellow Traveler of Earth"). Sputnik 1 was a metal ball with four radio antennae sticking out of it, each about 10 ft (3 m) long. It was launched by a modified R-7 military rocket. When it passed overhead, every 96 minutes, its bleep radio signal could be picked up on the ground below. After three weeks, its batteries were exhausted and it fell silent. On January 4, 1958, after 1,400 orbits, it re-entered Earth's atmosphere and burned up.

FIRST SATELLITES

The Space Age began on October 4, 1957, when the Soviet Union launched Sputnik 1, the first artificial satellite. Early satellites were small, simple, and powered by batteries, which lasted for only a few weeks. At first, just getting a satellite into orbit was an achievement, because rockets were so unreliable. If they didn't go off course or explode, upper stages sometimes failed to fire. Many early satellites were blown to bits or crashed back to Earth a few minutes after liftoff.

Thin outer shell was highly polished to reflect heat radiation

Inner shell was filled with nitrogen gas

Two small radio transmitters fitted under the inner shell

"The assault on space has begun"

Sergei Korolev, Russian rocket scientist

◄ EARLY SPACE STUDIES
The first US satellite, Explorer 1, was launched on January 31, 1958. It carried instruments to study cosmic rays (tiny particles whizzing through space) and discovered the Van Allen radiation belts—a doughnut-shaped region around Earth filled with charged particles trapped by Earth's magnetic field. Its radio transmissions stopped in May 1958, but it stayed in space for another 12 years and made 58,000 orbits before burning up in the atmosphere.

BUILDING SPUTNIK ►
Sputnik 1 was made from an alloy of aluminum, the same material used to make aircraft. Aluminum was chosen because it is lightweight, inexpensive, and easily shaped. The Soviet space program's chief designer, Sergei Korolev, stood at the shoulders of the metalworkers and engineers while they made and attached each part. Sputnik 1 was built from standard parts inside a simple casing.

Zinc batteries provided power to the two radio transmitters

Thermometer monitored temperature as Sputnik reached altitudes as high as 588 miles (946 km)

U.S. 'MOON' DUD
RUSS CHARGE YANKS HOLD
FALLEN SPUTNIK ROCKET
IKE'S SPUTNIK IS DUDNIK

◄ BAD NEWS
America's first attempt to put a satellite in orbit had been a failure. The Vanguard satellite was due to launch on December 6, 1957, two months after Sputnik 1. When the countdown reached zero, the rocket fired. It rose just 3 ft (1 m) off the launchpad, then fell back and exploded. Some newspapers nicknamed the satellite Dudnik or Kaputnik. Within two months, the US successfully launched Explorer 1.

satellites

SATELLITE DATA

Sputnik 1 (USSR)

Diameter: 23 in (58 cm) Mass: 185 lb (84 kg)
Orbit: 141 x 587 miles (227 x 945 km)

Explorer 1 (US)

Length: 80 in (203 cm) Mass: 31 lb (14 kg)
Orbit: 220 x 1,563 miles (354 x 2,515 km)

Vanguard 1 (US)

Diameter: 6 in (15 cm) Mass: 4.4 lb (2 kg)
Orbit: 406 x 2,404 miles (654 x 3,868 km)

Explorer 6 (US)

Diameter: 26 in (66 cm) Mass: 141 lb (64 kg)
Orbit: 152 x 26,350 miles (245 x 42,400 km)

TIROS 1 (US)

Diameter: 42 in (107 cm) Mass: 264 lb (120 kg)
Orbit: 408 x 432 miles (656 x 696 km)

Telstar (US)

Diameter: 35 in (88 cm) Mass: 170 lb (77 kg)
Orbit: 587 x 3,507 miles (945 x 5,643 km)

DECADES IN SPACE ▶

The first Vanguard satellite went into space on March 17, 1958, and is still orbiting Earth. It is a small sphere with two radio transmitters inside, though these no longer work. One was powered by a battery and the other by six solar cells stuck on the satellite's body. The radios transmitted by using six antennae. It also contains two sensors, called thermistors, which measured the temperature inside the satellite.

Radio antennae were 12 in (30 cm) long

Satellite body was made in two halves, joined by a ring around the middle

SATELLITE TELEVISION ▶

Telstar was the first of a new type of communications satellite. Satellites had relayed radio signals before, but the signals bounced off them like light off a mirror. Telstar received signals and then re-transmitted them. It could relay signals across the Atlantic Ocean for 20 minutes per orbit. It relayed the first live transatlantic television pictures and the first telephone call to travel through space on July 23, 1962. Telstar caught the public's imagination—a British pop group (the Tornadoes) even had a hit with a tune called *Telstar*.

Live TV pictures were first relayed across the Atlantic by Telstar

SCIENTIFIC SUCCESS ▲

Explorer 6 was a small scientific research satellite launched on August 7, 1959, to study radiation, cosmic rays, Earth's magnetism, and micrometeorites. It was also equipped with a TV camera. Electric power was supplied by four solar panels sticking out from the satellite like waterwheel paddles. Although one of these failed to unfold properly, the others supplied enough power to operate the camera. It sent back the first pictures of Earth from space.

Receiving antenna received radio signals from Earth

Solar cells generated electricity from sunlight

WATCHING THE WEATHER ▶

TIROS 1 was the first weather satellite. TIROS stood for Television and Infra-Red Observation Satellite. It was launched on April 1, 1960. Each of its two television cameras could take 16 pictures on each Earth orbit. Two tape recorders stored up to 48 pictures until the satellite passed over a ground station that could receive them. By the time its batteries ran out, after 78 days, it had transmitted 22,952 pictures of Earth's weather.

Transmitting antennae sent weather pictures to Earth

Shuttle's robot arm *pushes the satellite away from the Shuttle*

Instrument carrier contains equipment to study the Sun's corona

Service module contains data recorders, an altitude control system, and electronics

◄ PUTTING A SATELLITE IN ORBIT
This satellite, called a Spartan 201, is designed to study the Sun's corona (outer layer). Here it has just been lifted out of the Space Shuttle's payload bay. When the arm lets go, the satellite doesn't fall back to Earth, but stays close by. That is because the Shuttle has already boosted it to orbital speed. Most satellites orbit further from Earth than the Space Shuttle does, so satellites launched by the Shuttle have a small rocket attached to them to boost them to a higher orbit.

ORBITS

When a spacecraft's speed is boosted to about 17,400 mph (28,000 kph), Earth's gravity can no longer pull it back down to the ground. Instead, gravity combines with the spacecraft's speed to cause the craft to follow a curved path around the planet. The endless path of a spacecraft or moon around a planet is called an orbit and can be shaped either like a circle or an ellipse (a stretched circle). The speed of an orbiting craft depends on how far it is from the planet. The closer it is, the faster it has to fly to balance the pull of gravity.

VARIOUS EARTH ORBITS ►
Satellites and other spacecraft can orbit around Earth's equator or from pole to pole, or at any angle in between. They can orbit close to Earth or further away. The orbit may be circular or stretched into an ellipse. A spacecraft's orbit is chosen according to what it has been put in space to do. For example, some satellites are put into a special orbit at a fixed height above the equator, called a geostationary orbit. A satellite in a geostationary orbit goes around Earth in exactly the same time it takes Earth to spin once on its own axis, which means the satellite always sits above a particular point on the equator. This can be a very useful orbit for communications satellites.

Geostationary orbit is a circular orbit at a height of 22,250 miles (35,800 km) above the equator and in the same direction as Earth spins on its own axis

orbits

Antenna dish is kept facing in one direction while other parts of the satellite spin

THE PHYSICS OF ORBITS

If you are whirled around by a fairground ride, your body tries to fly outward, but the seat or outside wall of the ride holds you in place by exerting a force toward the ride's center. Similarly, a ball whirled in a circle on a piece of string is constantly pulled toward the center by tension in the string.

A spacecraft orbiting a planet behaves in a similar way. The planet's gravity stops the craft from flying away by pulling it toward the center of the planet and curling its path into a curve.

If the force is removed, the ball carries on in the same direction

String under tension pulls ball toward center

Force toward center pulls ball around in a circle

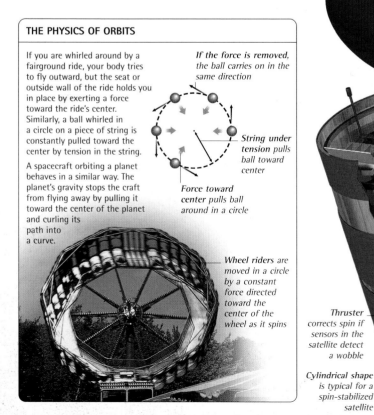

Wheel riders are moved in a circle by a constant force directed toward the center of the wheel as it spins

Thruster corrects spin if sensors in the satellite detect a wobble

Cylindrical shape is typical for a spin-stabilized satellite

Solar panel generates electricity as sunlight falls on it

Equipment is designed to fit into the satellite's cylindrical shape

◄ SPIN-STABILIZED SATELLITE
Satellites must be kept steady in space so that their antennae, cameras, or other instruments are kept pointing in the right direction. One way of stabilizing a satellite is to make use of a basic principle of physics called the gyroscopic principle. This states that if an object is made to spin, it resists any change to the direction in which it is pointing. A spin-stabilized satellite, like this HS 376 communications satellite, is kept pointing in one direction by making the main part of the satellite spin. Only its antennae and equipment like cameras are not made to spin.

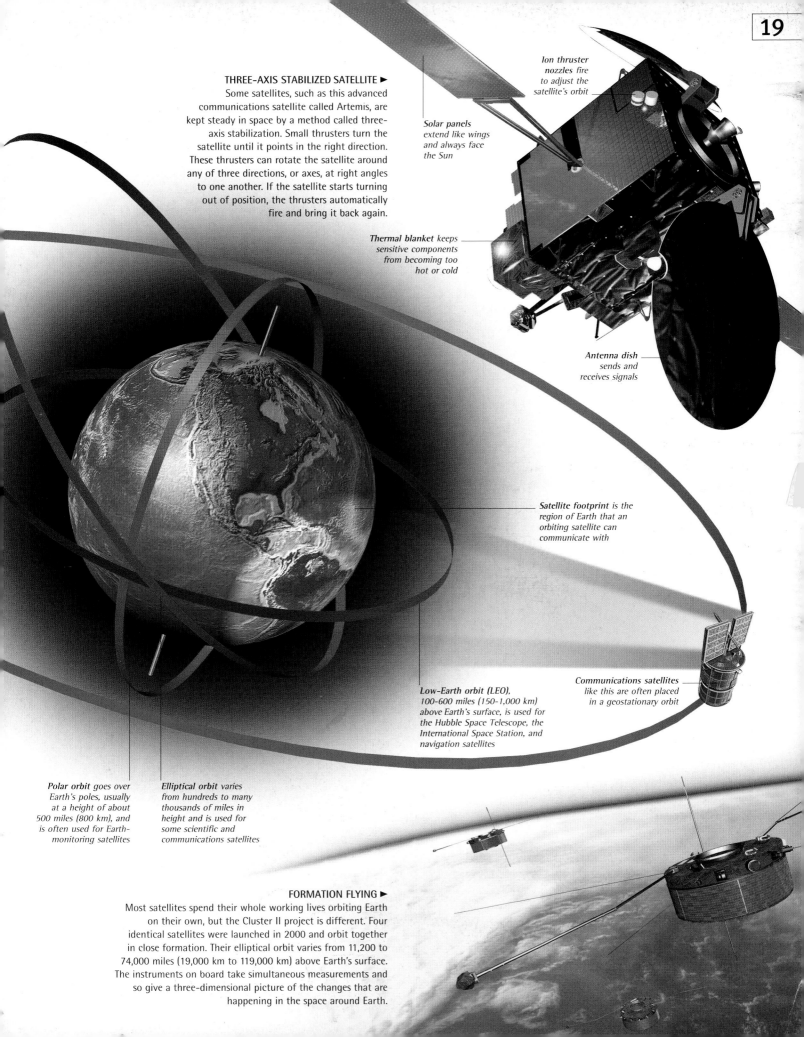

THREE-AXIS STABILIZED SATELLITE ▶
Some satellites, such as this advanced communications satellite called Artemis, are kept steady in space by a method called three-axis stabilization. Small thrusters turn the satellite until it points in the right direction. These thrusters can rotate the satellite around any of three directions, or axes, at right angles to one another. If the satellite starts turning out of position, the thrusters automatically fire and bring it back again.

Ion thruster nozzles fire to adjust the satellite's orbit

Solar panels extend like wings and always face the Sun

Thermal blanket keeps sensitive components from becoming too hot or cold

Antenna dish sends and receives signals

Satellite footprint is the region of Earth that an orbiting satellite can communicate with

Communications satellites like this are often placed in a geostationary orbit

Low-Earth orbit (LEO), 100-600 miles (150-1,000 km) above Earth's surface, is used for the Hubble Space Telescope, the International Space Station, and navigation satellites

Polar orbit goes over Earth's poles, usually at a height of about 500 miles (800 km), and is often used for Earth-monitoring satellites

Elliptical orbit varies from hundreds to many thousands of miles in height and is used for some scientific and communications satellites

FORMATION FLYING ▶
Most satellites spend their whole working lives orbiting Earth on their own, but the Cluster II project is different. Four identical satellites were launched in 2000 and orbit together in close formation. Their elliptical orbit varies from 11,200 to 74,000 miles (19,000 km to 119,000 km) above Earth's surface. The instruments on board take simultaneous measurements and so give a three-dimensional picture of the changes that are happening in the space around Earth.

FIRST SPACE PROBES

The first space probes to visit other worlds were aimed at our closest neighbor in space, the Moon. To break away from Earth orbit and head into space, they had to be boosted to a speed of 24,850 mph (40,000 kph). Once the race to land the first astronauts on the Moon was under way, the US and Soviet Union sent dozens of probes to study and photograph the Moon in great detail. Space probes flew past the Moon, crashed into it, orbited it, and made controlled landings on its surface.

Hinged panel
was one of four
that opened up
like flower petals

Radio antenna
transmitted data
from onboard
instruments

Metal sphere
contained scientific
instruments and a
radio transmitter

Television camera
took the first
photographs on
the Moon's surface

Rod antenna
was one of four
that transmitted
pictures to Earth

▲ LUNA 1
The Soviet probe Luna 1 was the first spacecraft to escape from Earth and go into space. The spherical craft, launched on January 2, 1959, was meant to hit the Moon but missed and became the first spacecraft to go into orbit around the Sun. Luna 3, launched on October 7, 1959, took the first photographs of the far side of the Moon.

probes

▲ LUNA 9 CAPSULE
Luna 9 was the first spacecraft to make a controlled or "soft" landing on the Moon. It landed in a region of the Moon called the Ocean of Storms, on February 3, 1966. As it touched the surface, it ejected an egg-shaped capsule, 24 in (60 cm) long and weighing 220 lb (100 kg). When the capsule came to rest, it opened to reveal a camera and radio antennae. They enabled Luna 9 to send the first pictures from the Moon's surface.

Spacecraft stood
10 ft (3.1 m) high
and weighed
807 lb (366 kg)

TV cameras gave
two wide-angle
and four narrow-
angle views

Television system
and omnidirectional
radio antennae

RANGER 9 COLLISION COURSE

TARGET MOON
Ranger 9 was the last Ranger craft. It was launched on March 21, 1965. Just over 64 hours later, at a distance of 1,404 miles (2,261 km) from the Moon, its cameras were switched on and it began transmitting pictures.

CLOSING IN
Ranger 9's pictures showed it had drifted 3 miles (4.8 km) off course after a flight of 259,000 miles (417,054 km). It was heading into the middle of a crater called Alphonsus, not far from the center of the Moon's near side.

CRASH!
Ranger 9's cameras took 5,814 photographs in the last 14 minutes of its flight. The final frames showed rocks and craters as small as 1 ft (30 cm) across. Then the probe crashed into the surface at 5,975 mph (9,617 kph).

RANGER 9 MOON-PROBE ▲
The US Ranger probes were designed to take close-up photographs of the Moon. The photographs were needed to find suitable landing sites for later, manned missions. The probes were deliberately crashed into the Moon, sending back pictures all the way. The pictures showed 1,000 times more detail than could be seen by telescopes on Earth. Rangers 1-6 failed, but Rangers 7-9 were successful and sent back more than 17,000 photographs.

▲ LUNAR ORBITER BLAST OFF

The first US Lunar Orbiter probe took off for the Moon on August 10, 1966. After the Ranger probes, Lunar Orbiter was the second of three US unmanned projects leading up to manned Moon-landings. The Lunar Orbiters took photographs of the Moon and made precise measurements of its gravity. Five Orbiter probes were sent to the Moon in 1966 and 1967, and all five were successful.

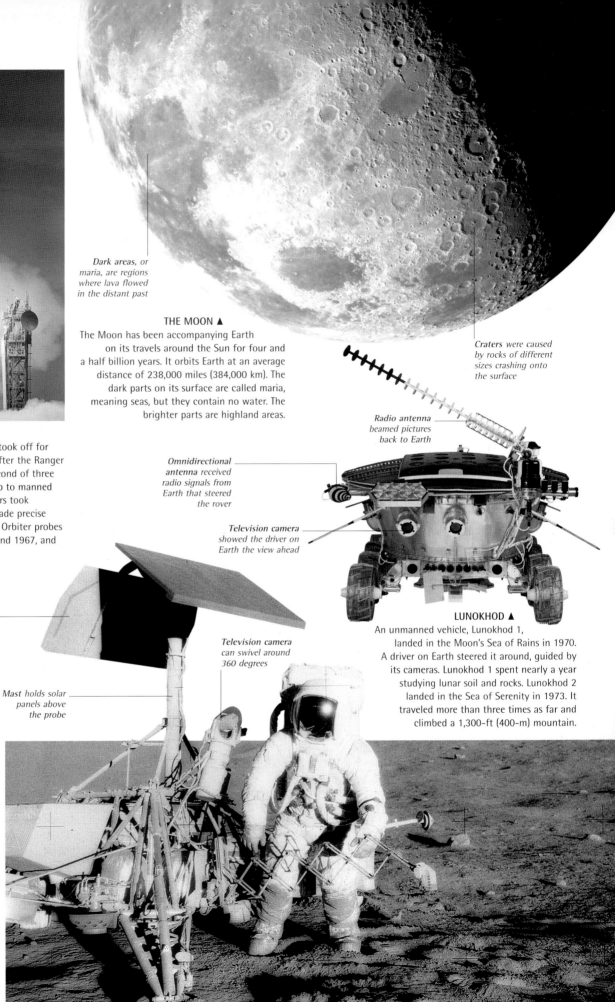

Dark areas, or maria, are regions where lava flowed in the distant past

THE MOON ▲

The Moon has been accompanying Earth on its travels around the Sun for four and a half billion years. It orbits Earth at an average distance of 238,000 miles (384,000 km). The dark parts on its surface are called maria, meaning seas, but they contain no water. The brighter parts are highland areas.

Craters were caused by rocks of different sizes crashing onto the surface

Radio antenna beamed pictures back to Earth

Omnidirectional antenna received radio signals from Earth that steered the rover

Television camera showed the driver on Earth the view ahead

Solar panels produce electricity from sunlight

Television camera can swivel around 360 degrees

Mast holds solar panels above the probe

LUNOKHOD ▲

An unmanned vehicle, Lunokhod 1, landed in the Moon's Sea of Rains in 1970. A driver on Earth steered it around, guided by its cameras. Lunokhod 1 spent nearly a year studying lunar soil and rocks. Lunokhod 2 landed in the Sea of Serenity in 1973. It traveled more than three times as far and climbed a 1,300-ft (400-m) mountain.

SURVEYOR 3 ►

Surveyor 3 landed in the Moon's Ocean of Storms on April 20, 1967. It took 6,317 photographs and dug a trench in the surface. Surveyor was the third US unmanned Moon project. Each Surveyor spacecraft was designed to make a controlled landing on the Moon and test the firmness of its surface. In November 1969, Apollo 12's lunar module landed close to Surveyor 3. The Apollo astronauts returned parts of the probe to Earth, where scientists studied how its stay on the Moon had affected them.

EARLY MANNED CRAFT

The first manned spacecraft were also called capsules: they were small and extremely cramped. Each type was built to achieve a specific objective. The US Mercury and Soviet Vostok capsules were designed to get one person into space and back to Earth again. They could keep an astronaut or cosmonaut alive in space for about a day. The next generation of Soviet spacecraft, called Voskhod, could carry more than one person, while the US Gemini spacecraft were designed to carry two astronauts on longer spaceflights, lasting up to about two weeks.

Storage compartment contained parachutes for landing

Corrugations strengthened the capsule

Astronaut entered through a hatch in the wall

Heat shield protected capsule on re-entry

MERCURY SPECIFICATIONS

Height: 9.6 ft (2.92 m)	
Base diameter: 6.2 ft (1.89 m)	
Mass: 4,265 lb (1,935 kg)	
Crew: One	
Launch rocket: Redstone (suborbital flights) Atlas (orbital flights)	
Manned missions: Two suborbital missions Four orbital missions	
Longest mission: 1 day 10 hours 20 minutes by Mercury 9 (22 Earth orbits)	
Landing method: After re-entry, the capsule parachuted into the ocean with the astronaut on board	

◄ **MERCURY CAPSULE**
The Mercury capsule was made from titanium, a strong but light metal. It contained an atmosphere of pure oxygen, sealed inside an inner hull. In space, the astronaut could turn the capsule around by firing small thrusters. Three solid-fuel rockets were fired to slow the capsule down and begin re-entry. A heat shield covered the broad end of the capsule to protect it during re-entry.

Radio antenna for communications with Earth

Re-entry capsule was the part that detached and returned to Earth

Spherical tanks held oxygen and nitrogen for life support

Instrument module contained instruments for controlling orbital flight

◄ **VOSTOK SPACECRAFT**
Vostok's re-entry capsule, where the cosmonaut sat, was a steel sphere covered with heat shield material. It contained life support equipment, TV and film cameras, a radio system, control panels, food, and water. Four metal straps attached it to an instrument module. The re-entry capsule separated from the instrument module just before it re-entered Earth's atmosphere.

first astronauts

VOSTOK SPECIFICATIONS

Height: 24.2 ft (7.35 m)	
Diameter: 8.2 ft (2.50 m)	
Mass: 10,416 lb (4,725 kg)	
Crew: One	
Launch rocket: Vostok 8K72K (also called A-1)	
Manned missions: Six orbital missions	
Longest mission: 4 days 23 hours 6 minutes by Vostok 5 (81 Earth orbits)	
Landing method: Soon after re-entry, an ejection seat in the capsule fired, and the cosmonaut parachuted to the ground	

INSIDE VOSKHOD ▲

To fit three people inside the Voskhod capsule, the ejection seat and other gear that had been fitted to Vostok were removed. It was still very cramped, so the crew did not wear space suits for the launch and landing. Voskhod 2 also carried a device called an airlock, which allowed one of its crew to make the first space walk.

VOSKHOD SPECIFICATIONS

Height: 16.45 ft (5 m)	
Diameter: 8 ft (2.43 m)	
Mass: Up to 12,526 lb (5,682 kg)	
Crew: Two or three	
Launch rocket: Voskhod 11A57 (also called A-2)	
Manned missions: Two orbital missions	
Longest mission: 1 day 2 hours 2 minutes by Voskhod 2 (17 orbits)	
Landing method: Capsule parachuted to the ground with the crew on board	

▲ VOSKHOD CAPSULE

The Soviet Union launched two manned missions between the last Vostok mission and the start of the Soyuz program. They used a modified Vostok capsule, called Voskhod. The Voskhod spacecraft were the first to carry more than one person. Unlike Vostok, the Voskhod capsules landed by parachute with the crew still inside. When probes dangling from the parachute lines touched the ground, rockets fired to soften the landing.

GEMINI SPECIFICATIONS

Height: 18.5 ft (5.61 m)	
Base diameter: 10 ft (3.05 m)	
Mass: 8,290 lb (3,760 kg)	
Crew: Two	
Launch rocket: Titan	
Manned missions: Ten orbital missions	
Longest mission: 13 days 18 hours 35 minutes by Gemini 7 (206 Earth orbits)	
Landing method: Re-entry module parachuted into ocean with crew on board	

GEMINI RE-ENTRY MODULE ▶

At the end of a Gemini mission, swimmers would be dropped from a helicopter into the water near the re-entry module. They would attach a flotation device and then help the astronauts into a raft. The Gemini spacecraft had two parts, or modules. The re-entry module, shown here, carried the two astronauts. Attached to its base was a larger part, the adapter module, which contained life support and electrical equipment.

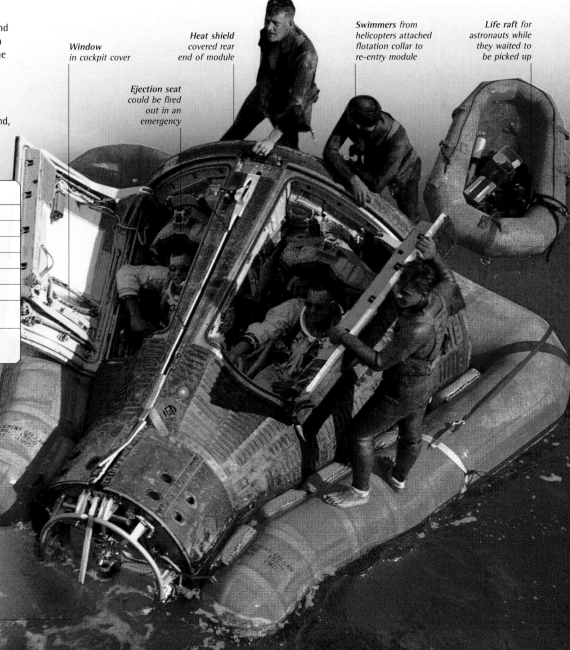

Window in cockpit cover

Heat shield covered rear end of module

Swimmers from helicopters attached flotation collar to re-entry module

Life raft for astronauts while they waited to be picked up

Ejection seat could be fired out in an emergency

Green dye made the module easier to spot from the air

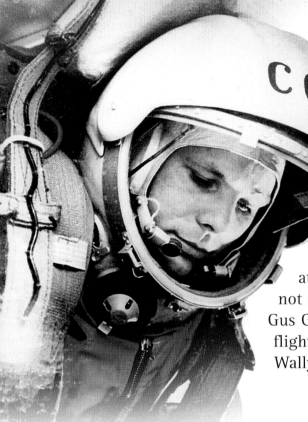

HUMANS IN SPACE

When the Soviet Union started launching animals into space in 1957, it was clear that a manned spaceflight was in preparation. Less than four years later, Yuri Gagarin became the first human in space. More soon followed—over the next 26 months, there were 12 US and Soviet manned flights. Soviet missions were shrouded in secrecy, but the US flights attracted huge attention. Two suborbital flights (ones not encircling Earth) by Alan Shepard and Gus Grissom were followed by four orbital flights by John Glenn, Scott Carpenter, Wally Schirra, and Gordon Cooper.

FRONT PAGE NEWS ►
As a result of his historic flight, Gagarin was transformed overnight from being an unknown Soviet Air Force officer into the most famous person in the world. His face looked out from newspapers and everyone wanted to meet him. Wherever he went, crowds lined the roads to see him. In Britain, he was invited to lunch with the Queen.

▲ GAGARIN
At 9:06 a.m. Moscow time on April 12, 1961, Yuri Gagarin heard the rocket beneath his Vostok 1 capsule rumble as it rose into the air. Nine minutes later, he was in orbit. As the capsule gently rotated, the blackness outside gave way to the brilliant blue Earth, then the Sun's blinding glare. He made one orbit of the Earth and then re-entered the atmosphere.

SOVIET SUCCESS ►
The trio of cosmonauts shown here sharing a joke with Soviet Premier Nikita Khrushchev all flew in space. Andrian Nikolayev was the third cosmonaut (after Gagarin and Gherman Titov) to go into orbit, aboard Vostok 3 on August 11, 1962. He made 64 orbits in a flight that lasted nearly four days. Valentina Tereshkova became the first woman in space, on June 6, 1963.

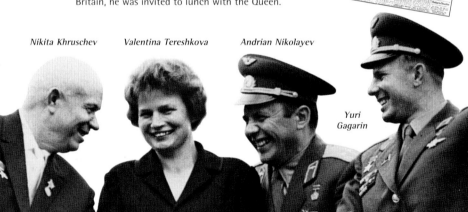

Nikita Khruschev *Valentina Tereshkova* *Andrian Nikolayev*

Yuri Gagarin

◄ MERCURY 3 LAUNCH
On May 5, 1961, a Redstone rocket carried Alan Shepard into space on the first US manned space mission, Mercury 3. The rocket was not powerful enough to put Shepard's capsule, which was given the call sign Freedom 7, into orbit. It reached a height of 116 miles (187 km), then fell back to Earth, splashing down in the Atlantic 15 minutes after liftoff and 303 miles (488 km) from the launch site in Florida.

FIRST AMERICAN IN SPACE ►
Alan Shepard was a navy test-pilot before joining NASA. After his successful Mercury flight, he was scheduled to fly in the first Gemini mission, but was grounded because of a problem with his inner ear. After surgery in 1969, he returned to flight. Less than 10 years after his Mercury mission, he stood on the Moon as commander of Apollo 14.

Capsule on Glenn's flight was given the call sign Friendship 7

Window replaced two small portholes of earlier capsules

Hatch sealed by a cover held in place by 70 bolts

Glenn's flight capsule, Friendship 7

President Kennedy presents Glenn with his medal

first astronauts

▲ FIRST AMERICAN INTO ORBIT

On February 20, 1962, American astronaut John Glenn squeezed into his capsule for the Mercury 6 mission. At 9:47 a.m., flames erupted from its Atlas booster and Glenn soared into space. During the flight, an indicator showed that the capsule had a loose heat shield and might burn up during re-entry. Glenn was told not to jettison his retro-rockets, because their straps might hold the heat shield on. He landed safely—the heat shield was not loose after all.

◄ CELEBRATED AS A HERO

Three days after Glenn's flight, President John F. Kennedy presented him with a Distinguished Service Medal to recognize his achievement. The ceremony took place at the Cape Canaveral launch site in Florida. A week later, on March 1, 1962, four million people turned out in New York City when Glenn arrived for celebrations and to address the United Nations.

ANIMALS IN SPACE

The first space travelers were animals, not humans. Animals were sent first to see if it was possible to survive a spaceflight and to test the craft carrying them. The Soviet Union used mainly dogs, and the US used chimpanzees.

DOGS

The first living creature to orbit Earth was a dog called Laika, traveling aboard the Sputnik 2 satellite on November 3, 1957. Several more test-flights were made with dogs to test the Vostok capsule.

CHIMPANZEE

Ham, a chimpanzee, was one of the most famous animals to travel into space aboard an early US space mission.

He was launched in a Mercury capsule on a suborbital flight on January 31, 1961.

MICE

Living creatures are still carried into space as the subjects of scientific experiments. The Space Shuttle carried some mice in 2001, to test a protein that may one day help astronauts resist bone loss during long missions.

SPIDERS

Skylab 3 carried two spiders, called Anita and Arabella. Scientists wanted to see if they could spin webs while weightless—they could. Spiders were carried again in the ill-fated last flight of the Space Shuttle Columbia.

"I believe this nation should commit itself to achieving the goal, before this decade is out, of landing a man on the Moon...."

President John F. Kennedy

SPACE RACE

The Soviet Union's early successes in space took the US by surprise. In 1961, the newly elected American President, John F. Kennedy, considered what to do. Some advisers urged him to cancel the space program, because the Soviets were already so far ahead. But Kennedy argued that American technology and industry should be able to match or overtake the Soviet Union. He challenged the Soviet Union to a head-on contest in space. Success was no longer a mere technical challenge, it was a matter of national pride. The Space Race was on, with both sides desperate to be the first to put a person on the Moon.

"Let the capitalist countries try to overtake us"

Premier Nikita Khrushchev

▲ KHRUSHCHEV IN CONTROL
Premier Nikita Khrushchev held power in the Soviet Union when the Space Age began. He was immensely proud that Soviet technology had beaten the US, and that the world could see it. First, a Soviet satellite flew unchallenged over American territory. Then, in April 1961, Gagarin made his epic trip to space. Soviet firsts kept coming.

KENNEDY COMMITS TO SPACE ▲
On May 25, 1961, President John F. Kennedy made an historic speech to the US Congress. It committed the US to a manned Moon landing by the end of the 1960s. It was an amazingly bold announcement, because at that time, the US had not even put an astronaut into Earth orbit. In his speech Kennedy said, "No single space project in this period will be more impressive to mankind, or more important for the long-range exploration of space."

Space Race

SOYUZ TAKES OFF ▶
After Vostok and Voskhod, the Soviet Union's next spacecraft was Soyuz. With Soyuz, the Soviet Union would make longer spaceflights, learn to maneuver in orbit, and dock with other craft. Meanwhile, a Moon-landing spacecraft and a giant rocket to launch it were being built in great secrecy. When the US won the race to the Moon in 1969, Soviet Moon-landing plans were scrapped, and Soyuz became a ferry craft to transport cosmonauts to and from a series of space stations.

THE RACE BEGINS

The event that triggered the Space Race was the launch of the first artificial satellite, Sputnik 1, on October 4, 1957. Sputnik 1 was just a small, harmless metal ball that bleeped as it passed overhead, but it worried Americans for two reasons. It showed that the Soviet Union was more advanced technologically than had previously been thought. It also showed that the Soviet Union had long-range rockets powerful enough to fly over US territory, spy on it, and possibly even attack it with nuclear missiles.

GEMINI 7 IN ORBIT ▶
This photograph of Gemini 7 was taken from Gemini 6 when the two spacecraft met up in Earth orbit. The Space Race really heated up with the Gemini missions. Over the course of just 21 months in 1965-1966, the US launched 10 two-man missions. Their aim was to learn how to do everything that would be necessary for a Moon-landing mission. Astronauts practiced maneuvering spacecraft, changing orbit, docking one craft with another, and walking in space. The Gemini 7 mission lasted 14 days—a record at that time.

Exhaust nozzle of main engine

Aft section contained a restartable rocket engine with a thrust of 16,000 lbf (71 kN)

Mid section contained propellant tanks

Radio antenna allowed the Agena to be controlled by Gemini craft

Forward section contained guidance systems and control electronics

Docking cone designed for Gemini craft to dock with

MISSION SEQUENCE

USSR	US
1961	
Vostok 1	
	Mercury 3
	Mercury 4
Vostok 2	
1962	
	Mercury 6
	Mercury 7
Vostok 3 + 4	
	Mercury 8
1963	
	Mercury 9
Vostok 5 + 6	
1964	
Voskhod 1	
1965	
Voskhod 2	
	Gemini 3
	Gemini 4
	Gemini 5
	Gemini 6 + 7
1966	
	Gemini 8
	Gemini 9
	Gemini 10
	Gemini 11
	Gemini 12
1967	
Soyuz 1	

▲ TARGET FOR GEMINI 8
US astronaut David Scott took this photograph of an Agena rocket hanging in space during the Gemini 8 mission. As he did so, his pilot Neil Armstrong inched the spacecraft toward the rocket and then docked with it. This was the first space docking. Their triumph nearly ended in disaster when a thruster (a small rocket engine) jammed on. It fired continuously and sent the two spacecraft into a dangerously fast spin. Armstrong undocked, turned off Gemini 8's main thrusters, and switched to a back-up system to stop the spacecraft from spinning.

COOPERATION AT LAST ▶
American astronaut Donald (Deke) Slayton and Soviet cosmonaut Alexei Leonov posed for photographs during the Apollo-Soyuz Project in 1975. After the Moon landings, which marked the end of the Space Race, the US and Soviet Union began cooperating in space. During this joint US-Soviet mission, an Apollo spacecraft docked with a Soyuz spacecraft. The crews visited each other's craft and carried out joint experiments. Slayton had been one of the first seven Americans selected for astronaut training in 1959, but this was his first trip into space.

APOLLO PROGRAM

The final US-manned space project in the race to the Moon was Apollo. The Apollo spacecraft was composed of three parts, or modules, launched by the giant Saturn V rocket. The tiny command module provided living quarters for the three-man crew. For most of the mission, it was attached to the service module, containing propulsion, electrical power, and life support systems. On Moon-landing missions, two astronauts would descend to the Moon's surface in the spiderlike lunar module, while the third orbited the Moon in the command module.

Command module would contain three astronauts on manned flights

Adapter was designed to contain a lunar module

Third stage put spacecraft in orbit and sent it to the Moon on lunar missions

Second stage boosted vehicle to a height of 115 miles (185 km)

◀ APOLLO 4 LIFTOFF
A Saturn V rocket rose from the launchpad for the first time at the start of the unmanned Apollo 4 mission on November 9, 1967. At 8.9 seconds before launch, the rocket's first stage engines started. Six seconds later, a deafening roar reached the spectators. As the countdown reached zero, computers released the rocket and it slowly climbed away into orbit 115 miles (185 km) above Earth. There, the third stage fired and pushed the Apollo spacecraft even higher. The flight was a great success.

First stage separated from rest of rocket about 150 seconds after liftoff

First stage engines, fueled by kerosene and liquid oxygen, boosted vehicle to a height of 37 miles (60 km)

Apollo

Adapter doors opened to release lunar module

Adapter could split in four to open

▲ APOLLO 7
The third stage of the Saturn V rocket used in the Apollo 7 mission is seen here with its attached adapter doors open. At the start of a Moon-landing mission, the adapter would house a lunar module. Apollo 7's adapter was empty. Even so, the crew put the spacecraft through all maneuvers necessary to extract a lunar module from it. The Apollo 7 mission lasted nearly 11 days and was a success, although the three crew members developed severe colds in space.

APOLLO-SATURN V SPECIFICATIONS

APOLLO SPACECRAFT

Command module (CM)
Length: 11 ft (3.5 m) Mass: 5.8 tons

Service module (SM)
Length: 25 ft (7.6 m) Mass: 24.5 tons

Lunar module (LM)
Length: 21 ft (6.4 m) Mass: 15 tons

SATURN V ROCKET

First stage (S-IC)
Height: 138 ft (42 m) Mass: 2,287 tons

Second stage (S-II)
Height: 82 ft (25 m) Mass: 488 tons

Third stage (S-IVB)
Height: 59 ft (18 m) Mass: 119 tons

Apollo-Saturn V
Height: 365 ft (111m) Mass: 3,000 tons

HEADING FOR THE MOON

A series of unmanned and manned Apollo missions led up to the first Moon-landing.

APOLLO 1

During a ground test of the new Apollo spacecraft on January 27, 1967, a fire broke out, killing the crew of Virgil (Gus) Grissom, Ed White, and Roger Chaffee. The spacecraft was later named Apollo 1.

APOLLO 2, 3

After the Apollo 1 fire, project plans changed. No missions were called Apollo 2 or 3.

APOLLO 4

On November 9, 1967, the Saturn V rocket made its first successful test-flight with an unmanned Apollo spacecraft.

APOLLO 5

On January 22, 1968, an Apollo lunar module was given its first unmanned test-flight in space.

APOLLO 6

On April 4, 1968, a Saturn V launched an Apollo spacecraft for a final unmanned test.

APOLLO 7

Launched on October 11, 1968, the manned Apollo 7 mission tested Apollo in Earth orbit.

APOLLO 8

Launched on December 21, 1968, Apollo 8 was the first manned flight to the Moon, which it orbited 10 times.

APOLLO 9

Launched on March 3, 1969, the manned Apollo 9 mission tested the lunar module in Earth orbit.

APOLLO 10

Launched on May 18, 1969, Apollo 10 was a dress rehearsal for the first Moon-landing. The lunar module was taken down almost to the Moon's surface.

EARTH RISE FROM APOLLO 8 ▲

This stunning view of Earth rising above the Moon's horizon was photographed by Frank Borman from the command module of Apollo 8, the first manned spacecraft to orbit the Moon. Borman, James Lovell, and Bill Anders made 10 Moon orbits on December 24 and 25, 1968, and transmitted the first live television pictures of the surface. After that, the only piece of Apollo hardware to test was the lunar module.

◀ DRESS REHEARSAL

This photograph of Apollo 10's command and service module (CSM) was taken by a crew member in the lunar module (LM). The Apollo 10 mission rehearsed everything for a Moon landing except the landing itself. Once the craft was in lunar orbit, two astronauts took the LM to within 9 miles (14.5 km) of the Moon's surface. The LM's top, ascent stage then separated from the descent stage and climbed to meet the CSM for the return flight to Earth.

Discarded
third stage

Lunar
module

Command
and service
module

① After orbiting Earth, the third stage engine fires the spacecraft toward the Moon.

② The command and service module (CSM) separates from the third stage and turns around.

③ Facing in the opposite direction, the CSM docks with the lunar module, which is housed in the third stage.

④ The CSM and attached lunar module turn around. The third stage is discarded.

⑤ The spacecraft maneuvers into lunar orbit.

⑥ The lunar module separates from the CSM and lands on the Moon.

▲ LANDING ON THE MOON

The Apollo spacecraft had to perform a complex series of maneuvers to achieve a Moon landing. It had to be turned and steered with great precision. Fine control of position and speed was essential for docking the command and service module (CSM) with the lunar module. The crew controlled the spacecraft by firing small thrusters arranged around the service module and lunar module. The service module's main engine was used for maneuvers that needed more power, such as entering and leaving lunar orbit.

APOLLO 11 – MOONWALK

On the morning of July 16, 1969, nearly a million people gathered around the Kennedy Space Center to see history being made. Hundreds of millions more people all over the world, one fifth of Earth's population, watched the events unfold live on television. At 9:32 a.m. local time, a deafening roar erupted from launchpad 39A and Apollo 11 climbed into a clear blue sky, carrying the first explorers in history to travel to another world. Four days later, first Neil Armstrong and then Edwin (Buzz) Aldrin stepped onto the surface of the Moon.

Aldrin, suit, and backpack weigh 60 lb (27 kg) on the Moon, one sixth of their weight on Earth

Neil Armstrong and the lunar module are reflected in Aldrin's gold-coated visor

◄ NEIL ARMSTRONG'S FOOTPRINT
Neil Armstrong made the first human footprint on the Moon as he stepped off the lunar module's footpad onto the surface. The fine gray dust recorded his footprint perfectly. Without wind or rain to wear it away, it could still be there 10 million years from now. Eventually it will disappear, leveled by moonquakes or covered with dust thrown out by meteorites hitting the surface.

Control unit allows Aldrin to adjust his life support and communications systems

Multilayered suit composed mainly of tough artificial fibers

*"one small step for man;
one giant leap for mankind"*
Neil Armstrong

BRINGING BACK MOON ROCK ►
Armstrong and Aldrin laid out several scientific experiments on the Moon's surface and collected 48 lb (21.7 kg) of lunar rocks and soil. After the astronauts left, the experiments continued working and sending their measurements to Earth by radio. Solar panels supplied electricity to the experiments, which included a seismometer to detect moonquakes.

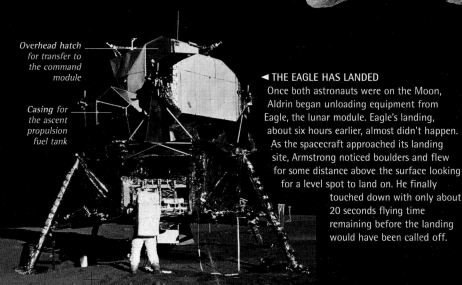

Overhead hatch for transfer to the command module

Casing for the ascent propulsion fuel tank

◄ THE EAGLE HAS LANDED
Once both astronauts were on the Moon, Aldrin began unloading equipment from Eagle, the lunar module. Eagle's landing, about six hours earlier, almost didn't happen. As the spacecraft approached its landing site, Armstrong noticed boulders and flew for some distance above the surface looking for a level spot to land on. He finally touched down with only about 20 seconds flying time remaining before the landing would have been called off.

ALDRIN ON THE MOON ►
Aldrin and Armstrong spent more than 21 hours on the Moon, including a moonwalk lasting two and a half hours. Everything was new to them. They kicked the soil to see how deep and dusty it was, tested different ways of moving around in the Moon's weak gravitational field, took photographs, and planted an American flag.

Overboot with ribbed silicone-rubber sole, worn over smaller inner boot

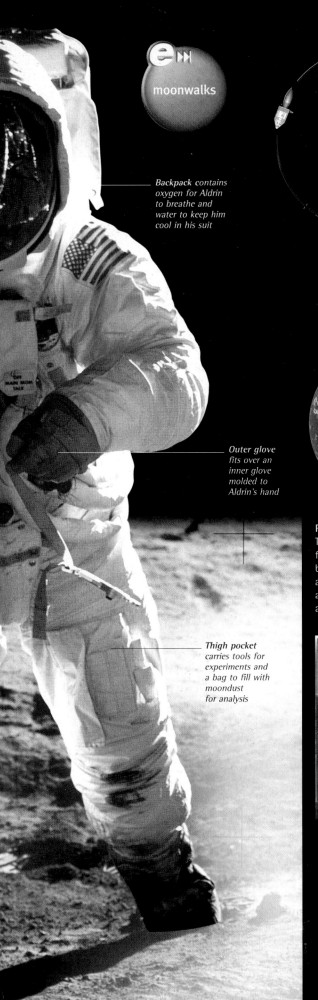

e►►
moonwalks

Backpack contains oxygen for Aldrin to breathe and water to keep him cool in his suit

Outer glove fits over an inner glove molded to Aldrin's hand

Thigh pocket carries tools for experiments and a bag to fill with moondust for analysis

(1) *Eagle's lower half remains on the Moon and acts as a launch pad for the top half, which blasts off to join the CSM.*

(2) *After the astronauts transfer to the CSM, Eagle is cast off. CSM fires its engine to return to Earth.*

(3) *The CSM approaches Earth, and the service module (SM) is jettisoned, leaving the CM with three astronauts inside.*

(4) *Heat shield protects the CM as it descends through Earth's atmosphere.*

(5) *Parachutes open and the CM splashes down in the Pacific Ocean.*

RETURNING TO EARTH ▲
The journey home began with Eagle's ascent stage blasting off from the Moon. The command and service module (CSM), piloted by Michael Collins, had stayed orbiting the Moon. Three hours after Eagle's ascent stage took off, Collins saw the craft approaching, steered toward it, and docked. Eagle was cut adrift and the CSM engine was fired to set a course back to Earth.

▲ SPACE TRAVELERS IN QUARANTINE
President Richard Nixon welcomes the crew back to Earth. The astronauts were quarantined (kept apart from other people) inside a sealed, mobile box as soon as they landed in case they had brought any dangerous microbes back with them. They spent the next few weeks in a laboratory where they underwent medical tests and debriefing. Soon after their eventual release, the three heroes were honored with a huge ticker tape parade in New York City.

SUBSEQUENT MISSIONS
After Apollo 11, six more Apollo missions were launched. All except Apollo 13 landed successfully on different parts of the Moon.

APOLLO 12
Struck by lightning as it took off, but undamaged. Two of the Apollo 12 astronauts landed in the Ocean of Storms in November 1969.

Alan Bean, Apollo 12's lunar module pilot

APOLLO 13
Abandoned its mission to land on the Moon in April 1970 after an explosion in the spacecraft. The crew returned to Earth safely.

APOLLO 14
Landed in Fra Mauro region in February 1971. Apollo 14 was commanded by Alan Shepard, the first US astronaut.

Command module after splashdown

APOLLO 15
Landed in the Hadley-Apennine mountain region of the Moon in July 1971. Apollo 15 was the first of three science missions and the first to take a lunar rover.

APOLLO 16
Landed in the Descartes highlands in April 1972. Apollo 16 was commanded by John Young, the first astronaut to orbit the Moon on two missions (Apollo 10 and Apollo 16).

APOLLO 17
Landed between the Taurus mountains and Littrow crater in December 1972. Apollo 17 was the last manned Moon landing.

Astronaut Cernan and lunar rover

SOYUZ PROGRAM

The Soyuz spacecraft was introduced in 1967. Since then, it has been modified and updated several times. An improved version, called Soyuz TM, was developed in 1986 to transport crews to the Mir space station. Soyuz TMA services the needs of the International Space Station. Most Soyuz spacecraft carry a crew of two or three cosmonauts. An unmanned version, called Progress, is used as a cargo craft to deliver supplies of food, water, and fuel to space stations.

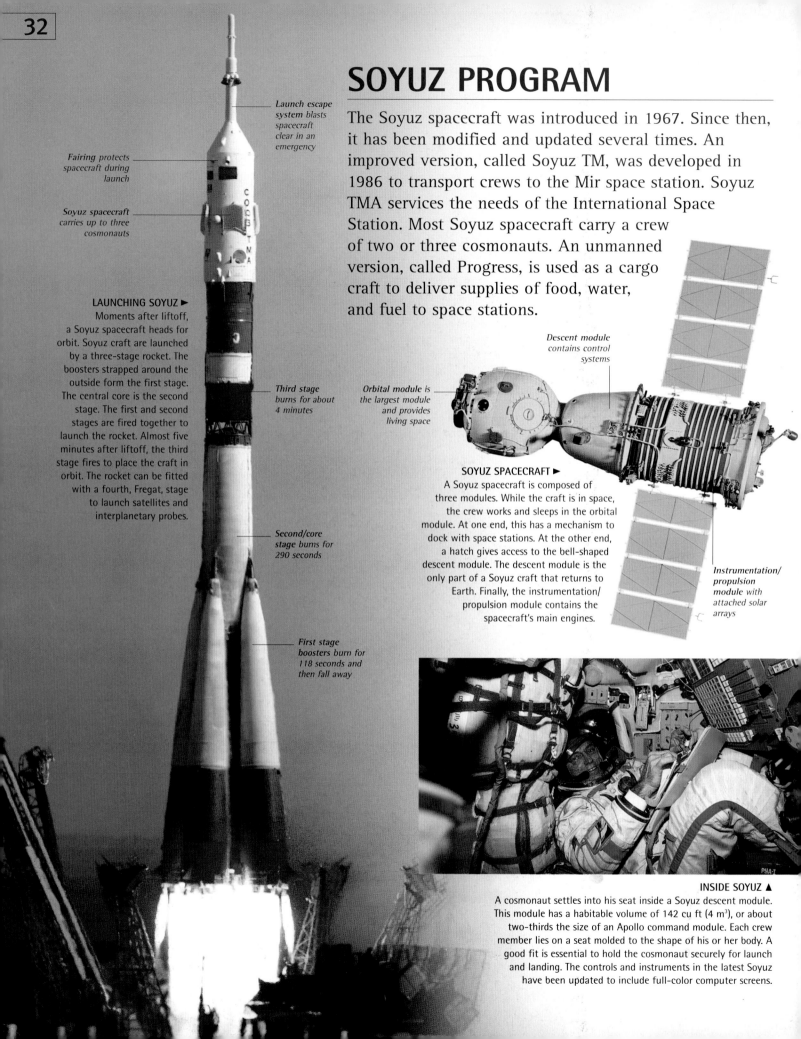

Launch escape system blasts spacecraft clear in an emergency

Fairing protects spacecraft during launch

Soyuz spacecraft carries up to three cosmonauts

LAUNCHING SOYUZ ▶
Moments after liftoff, a Soyuz spacecraft heads for orbit. Soyuz craft are launched by a three-stage rocket. The boosters strapped around the outside form the first stage. The central core is the second stage. The first and second stages are fired together to launch the rocket. Almost five minutes after liftoff, the third stage fires to place the craft in orbit. The rocket can be fitted with a fourth, Fregat, stage to launch satellites and interplanetary probes.

Third stage burns for about 4 minutes

Second/core stage burns for 290 seconds

First stage boosters burn for 118 seconds and then fall away

Descent module contains control systems

Orbital module is the largest module and provides living space

Instrumentation/ propulsion module with attached solar arrays

SOYUZ SPACECRAFT ▶
A Soyuz spacecraft is composed of three modules. While the craft is in space, the crew works and sleeps in the orbital module. At one end, this has a mechanism to dock with space stations. At the other end, a hatch gives access to the bell-shaped descent module. The descent module is the only part of a Soyuz craft that returns to Earth. Finally, the instrumentation/ propulsion module contains the spacecraft's main engines.

INSIDE SOYUZ ▲
A cosmonaut settles into his seat inside a Soyuz descent module. This module has a habitable volume of 142 cu ft (4 m³), or about two-thirds the size of an Apollo command module. Each crew member lies on a seat molded to the shape of his or her body. A good fit is essential to hold the cosmonaut securely for launch and landing. The controls and instruments in the latest Soyuz have been updated to include full-color computer screens.

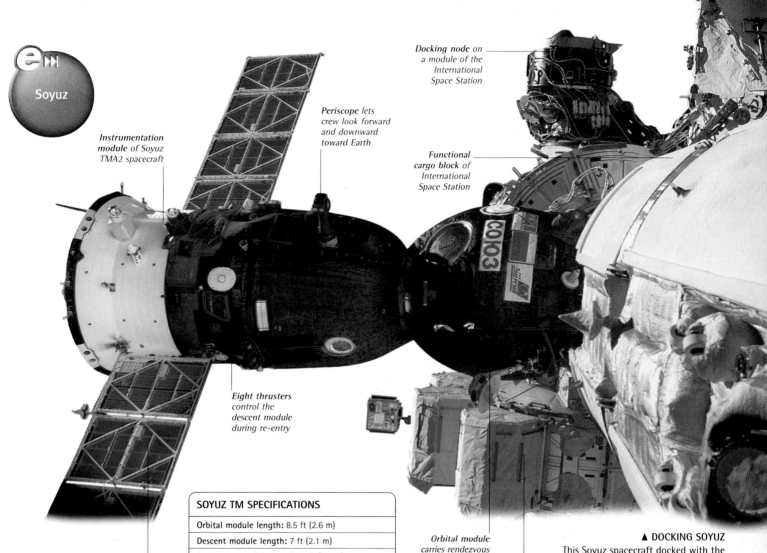

Soyuz

Instrumentation module of Soyuz TMA2 spacecraft

Periscope lets crew look forward and downward toward Earth

Docking node on a module of the International Space Station

Functional cargo block of International Space Station

Eight thrusters control the descent module during re-entry

Solar array unfolds to 14 ft (4.2 m) long in space

Orbital module carries rendezvous and docking equipment

Gas tank on outside of an airlock

SOYUZ TM SPECIFICATIONS

Orbital module length: 8.5 ft (2.6 m)	
Descent module length: 7 ft (2.1 m)	
Instrument module length: 8 ft (2.5 m)	
Total length: 23 ft (7 m)	
Diameter of habitable modules: 7 ft (2.2 m)	
Maximum diameter: 9 ft (2.7 m)	
Span of solar arrays: 35 ft (10.6 m)	
Habitable volume: 355 cu ft (10 m³)	
Crew: Two or three	
Mass: 15,586 lb (7,070 kg)	

▲ DOCKING SOYUZ

This Soyuz spacecraft docked with the International Space Station (ISS) in April 2003, after a journey from Earth that took two days. The Expedition Seven crew that it brought to the ISS occupied the space station for the following six months. At that time, Soyuz spacecraft provided the only means of ferrying crews to and from the ISS while NASA's Space Shuttle was grounded after the Columbia accident.

SOYUZ LANDING

PARACHUTES DEPLOYED
After re-entry, a Soyuz descent module releases a series of parachutes to slow its descent in stages. Two pilot parachutes emerge first. The second of these pulls out a drogue chute, which slows the module to less than 185 mph (300 kph). Then the 11,000 sq ft (1,000 m²) main parachute slows it to 15 mph (25 kph).

ROCKET BRAKING
The parachute holds the descent module at an angle of 30°, to present the maximum surface area to air-flow and so cool it down. Later, the module is moved into a fully upright position. Just before landing, with the module about 3 ft (1 m) above the ground, six rockets fire to slow its descent to 3 mph (5 kph).

TOUCHDOWN
More than 3 hours after undocking from the rest of the spacecraft, the Soyuz descent module reaches the ground. Shock absorbers built into the crew members' seats cushion the final bump on landing. Cosmonauts and astronauts have described their landing in the latest type of Soyuz craft as "soft."

RECOVERY
Soyuz descent modules land in the flat steppes of Kazakhstan, northeast of the Baikonur Cosmodrome where Soyuz craft are launched. As soon as a descent module lands, helicopters carrying medical experts arrive. The crew is taken out and helped into reclining chairs before having medical examinations.

SPACE SHUTTLE

The Space Shuttle is the world's first spaceplane. It takes off like a rocket, spends up to a month in orbit, and then lands like an airliner. Travelling at speeds of 18,000 mph (28,800 kph), the Orbiter vehicle can carry a crew of seven astronauts. Its large payload bay carries science experiments and other equipment. A remote arm can be deployed from the bay to launch satellites. Four Orbiters were built, called Columbia, Challenger, Discovery, and Atlantis. Columbia made the first flight on April 12, 1981 from the Kennedy Space Center, Florida. A fifth, Endeavour, was built in 1992.

Shuttle

SHUTTLE SPECIFICATIONS	
Orbiter wingspan:	78 ft (23.8 m)
Orbiter length:	122 ft (37.2 m)
Orbiter height:	56 ft (17.3 m)
Main engines:	weigh 7,480 lb (3,393 kg each)
Maximum speed:	18,000 mph (28,800 kph)
Weight:	165,000 lb (75,000 kg)
Payload bay:	160 ft (18.3 m) long by 15 ft (4.6 m) wide
Crew compartment:	2,525 cubic feet (71.5 m³) habitable volume
External Tank:	contains 526,000 gallons (2 million litres) of fuel
Boosters:	provide a thrust of 3.3 million 1b (1.5 million kg) at take-off
Total take-off weight:	4.4 million lb (2 million kg)

◀ SHUTTLE IN ORBIT
In space, the Orbiter opens its payload bay doors. The doors are lined with large panels that work as space radiators. A liquid coolant absorbs heat from equipment inside the Orbiter and then flows through more than I mile (1.5 km) of tubing in the radiators. Heat radiates away into space and stops the Orbiter from overheating. Mission specialists can see into the payload bay through windows at the back of the crew compartment.

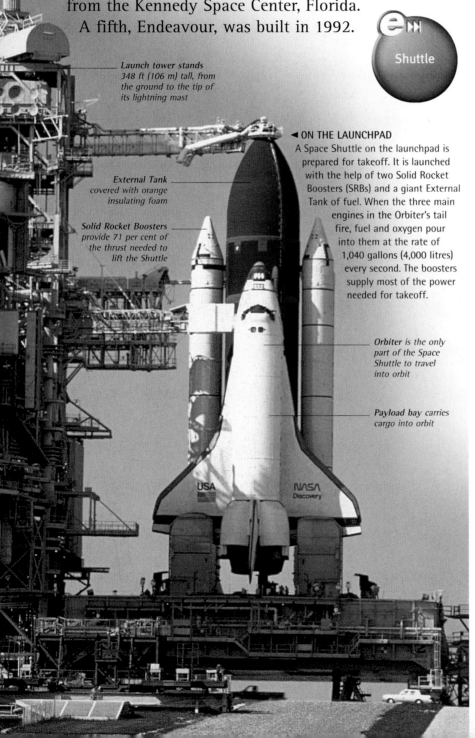

Launch tower stands 348 ft (106 m) tall, from the ground to the tip of its lightning mast

◀ ON THE LAUNCHPAD
A Space Shuttle on the launchpad is prepared for takeoff. It is launched with the help of two Solid Rocket Boosters (SRBs) and a giant External Tank of fuel. When the three main engines in the Orbiter's tail fire, fuel and oxygen pour into them at the rate of 1,040 gallons (4,000 litres) every second. The boosters supply most of the power needed for takeoff.

External Tank covered with orange insulating foam

Solid Rocket Boosters provide 71 per cent of the thrust needed to lift the Shuttle

Orbiter is the only part of the Space Shuttle to travel into orbit

Payload bay carries cargo into orbit

FROM EARTH TO SPACE

SRB SEPARATION
Two minutes after liftoff, when the Space Shuttle is about 27 miles (45 km) high, its two Solid Rocket Boosters separate and fall away. Rockets in their nose fire to push them away from the Orbiter. They parachute into the Atlantic Ocean 140 miles (225 km) from the shore.

EXTERNAL TANK SEPARATION
Just over eight minutes after liftoff, the Orbiter's main engines shut down and, a few seconds later, the External Tank separates. The tank tumbles back through the atmosphere and breaks up. Any pieces that do not burn up come down in a remote part of the Indian Ocean.

SRBS COLLECTED
When the Shuttle's Solid Rocket Boosters come down in the ocean, they float ready to be collected by ships sent out to retrieve them. The empty rocket casings are returned to their manufacturer and filled with fuel again. They are then sent back to the Kennedy Space Center to be reused.

ORBITAL INSERTION
The Orbiter is now in an elliptical orbit 40 miles (65 km) to 184 miles (296 km) above Earth. At the highest point, the Orbiter fires its engines to make the orbit circular. Without the External Tank, it cannot use its main engines. Instead it uses two engines in pods either side of its tail.

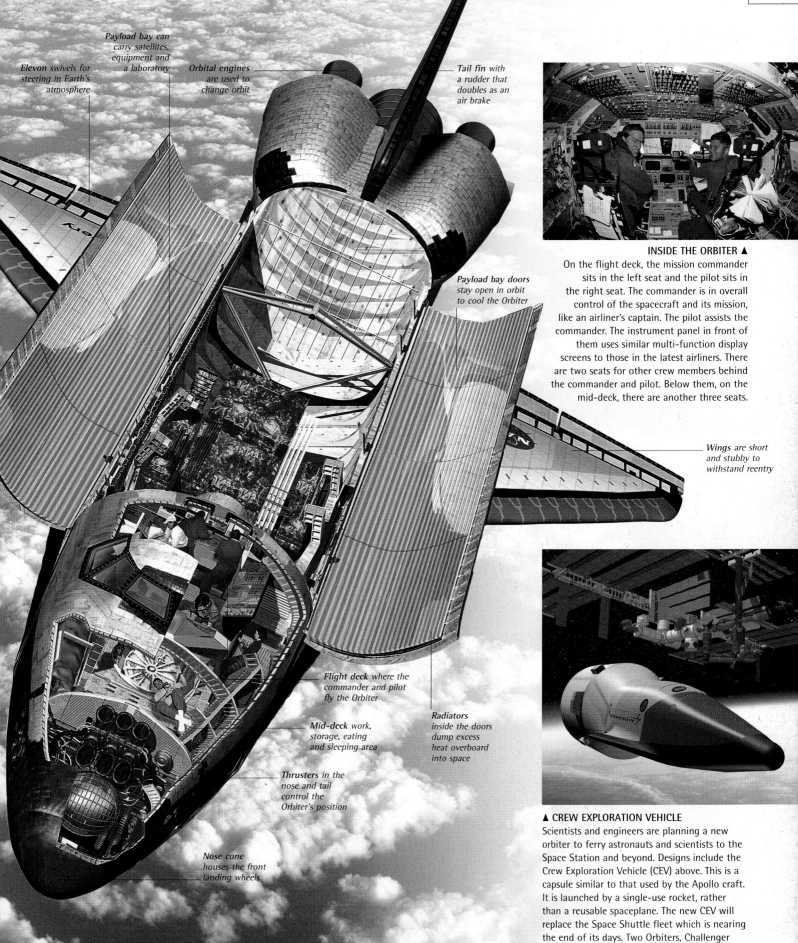

Elevon swivels for
steering in Earth's
atmosphere

Payload bay can
carry satellites,
equipment and
a laboratory

Orbital engines
are used to
change orbit

Tail fin with
a rudder that
doubles as an
air brake

Payload bay doors
stay open in orbit
to cool the Orbiter

INSIDE THE ORBITER ▲

On the flight deck, the mission commander
sits in the left seat and the pilot sits in
the right seat. The commander is in overall
control of the spacecraft and its mission,
like an airliner's captain. The pilot assists the
commander. The instrument panel in front of
them uses similar multi-function display
screens to those in the latest airliners. There
are two seats for other crew members behind
the commander and pilot. Below them, on the
mid-deck, there are another three seats.

Wings are short
and stubby to
withstand reentry

Flight deck where the
commander and pilot
fly the Orbiter

Mid-deck work,
storage, eating
and sleeping area

Radiators
inside the doors
dump excess
heat overboard
into space

Thrusters in the
nose and tail
control the
Orbiter's position

Nose cone
houses the front
landing wheels

▲ CREW EXPLORATION VEHICLE

Scientists and engineers are planning a new
orbiter to ferry astronauts and scientists to the
Space Station and beyond. Designs include the
Crew Exploration Vehicle (CEV) above. This is a
capsule similar to that used by the Apollo craft.
It is launched by a single-use rocket, rather
than a reusable spaceplane. The new CEV will
replace the Space Shuttle fleet which is nearing
the end of its days. Two Orbiters, Challenger
and Columbia, have been lost in accidents,
along with their crews.

COUNTDOWN

Preparations for launching a Space Shuttle begin up to three months before liftoff and follow a carefully planned sequence of events. The Orbiter is completely overhauled, and its main engines are removed, serviced, and rebuilt, and then rolled out to the launchpad at Kennedy Space Center, Florida. The countdown clock is started 43 hours before takeoff. "Holds," when the clock stops for up to four hours, allow time to deal with problems without delaying the launch.

▲ ENGINES ATTACHED TO ORBITER
The serviced and cleaned main engines are delivered to the Orbiter Processing Facility and refitted in the craft's tail.

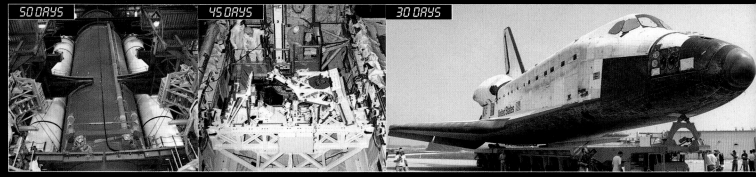

▲ EXTERNAL TANK ARRIVES
The huge External Tank arrives by barge from New Orleans. It is hoisted between the boosters on a mobile launch platform.

▲ PAYLOAD INSTALLED
Some of the payload for the mission is installed in the Orbiter's payload bay. This is a robotic arm destined for the ISS.

▲ ORBITER DELIVERED
The Orbiter is ready for its next mission. Its engines, heat-resistant tiles, computers, instruments, and electrical systems have been checked. The Orbiter is now towed to the Vehicle Assembly Building where the engines and fuel tanks are added.

▲ MAKING CONNECTIONS
The Orbiter is bolted to the External Tank at three points. The fuel and electricity supplies are connected between them.

▲ STACK COMPLETED
A crawler transporter moves the completed stack to the launchpad, two or three weeks before launch.

▲ AT THE LAUNCHPAD
With three days to go before launch, the countdown clock is started at T-43 hours (Takeoff minus 43 hours).

▲ CREW ENTERS ORBITER
The crew ride an elevator up the launch tower, walk across the crew access arm, and take their seats.

▲ CREW ACCESS ARM RETRACTS
The crew access arm pulls back from the Orbiter. Computers monitor the system thousands of times every second.

▲ SWITCH TO INTERNAL POWER
With 50 seconds left, the Orbiter cuts off electrical power from the outside and switches to its own onboard fuel cells.

▲ MAIN ENGINES FIRE
If the Orbiter's computers detect a problem as the main engines fire, they shut down the engines and halt liftoff.

▲ SOLID BOOSTERS FIRE
Once the two Solid Boosters fire, it is impossible to switch them off. No one can stop the Shuttle taking off now.

▲ SOLID ROCKET BOOSTERS BUILT
A pair of Solid Rocket Boosters arrive in sections by rail from Utah. They are built in the Vehicle Assembly Building.

28 DAYS

▲ ORBITER HOISTED
A giant crane hoists the 68-ton Orbiter off the ground and inches it toward the External Tank and Solid Rocket Boosters.

T-9 MINS

▲ GO/NO-GO FOR LAUNCH
Mission controllers check all data to make a final decision to launch. The clock is restarted at T-9 minutes.

T+2 SECS

▲ LIFTOFF
As the Solid Rocket Boosters fire, bolts holding the Shuttle down on the launch platform are cut by explosive charges.

Shuttle

▲ "WE HAVE A LIFT-OFF"
Mission time is started at 000:00:00.00 (zero hours, zero minutes, zero seconds). Steam and smoke engulfs the launch pad, as the Shuttle soars away. The mission has begun. As soon as the Shuttle clears the top of the launch tower, about seven seconds after lift-off, control is handed over from the Kennedy Space Center to Mission Control at the Johnson Space Center in Houston, Texas. Here, teams work around the clock on shifts to monitor the Orbiter's systems.

RETURNING TO EARTH

Shuttle Orbiter is 175 miles (282 km) high when its main engine fires to slow it down

Engine is fired in the same direction as the Orbiter is moving

Orbiter turns by firing its thrusters one hour before landing

Belly-first position for entry into atmosphere

Friction with the air makes the Orbiter glow brightly

COMING HOME

Every spacecraft returning to Earth has to re-enter the atmosphere. Re-entry begins with an engine burn to slow the craft down, and gravity then takes over. The Space Shuttle Orbiter dives into the air at 15,500 mph (25,000 kph), and other craft, past and present, have had to re-enter at similar speeds. Without protection, spacecraft would burn up at these speeds. Early manned craft were protected by heat shields that slowly charred. Soyuz spacecraft still use them today, but they can be used only once. In contrast, the Shuttle is protected by a variety of reusable, heat-resistant materials.

▲ HEAT-RESISTANT TILES
Almost 25,000 heat-resistant tiles and other materials cover the Shuttle Orbiter to protect it from the high temperatures it encounters during re-entry. The main body of the Orbiter is made from aluminum, which must be kept below 350°F (175°C). During re-entry, parts of the spacecraft's surface reach 2,300°F (1,260°C). The tiles radiate this heat outward, keeping the rest of the Orbiter cool.

PROTECTION FROM SCORCHING TEMPERATURES

The Orbiter is covered with materials that can withstand re-entry many times over. These materials vary depending on the temperatures experienced. The nose, the front edges of the wings, the front edge of the tail fin, and the underside of the Orbiter are heated the most. The black ceramic tiles used to cover these areas provide extra protection. Thousands of tiles that originally covered the top and some side areas of the Orbiter have now been replaced by lighter sheets of heat-resistant fabric. The weight saved enables the Orbiter to carry heavier payloads.

Reinforced carbon-carbon gives protection against temperatures of more than 2,300°F (1,260°C).

High-temperature black insulation tiles protect areas exposed to temperatures up to 2,300°F (1,260°C).

Low-temperature white insulation tiles or insulation blankets give protection up to 1,200°F (650°C).

Flexible, reusable surface insulation blankets protect areas where temperatures never rise above 700°F (370°C).

Glass, metal alloys with high melting points, and other materials are used in other areas of the Orbiter's surface.

◄ RIDING THE FLAMES

As the Orbiter plunges into the atmosphere, the crew sees flames flashing across the windows. Thrusters fire to keep the spacecraft at the right angle. Re-entering belly-first increases drag and helps to slow the Orbiter down. Sixteen minutes from touchdown, the Orbiter starts making a series of four S-shaped turns that slow it down even more. Four minutes before touchdown, the commander takes over from the autopilot for the final approach to the runway.

Shuttle

TOUCHDOWN

1 *The Orbiter glides* down through the atmosphere, descending 20 times faster than an airliner.

2 *The pilot raises the nose* 35 seconds before touchdown and, 20 seconds later, lowers the landing gear.

3 *The Orbiter touches down* at a speed of about 220 mph (350 kph), twice as fast as a commercial airliner.

After touchdown, the Orbiter releases a 40-ft (12-m) drag chute from its tail to help slow it down. Most Shuttles land at the 15,000-ft (4,572-m) runway at Kennedy Space Center, Florida, but there is a back-up landing strip at the Edwards Air Force Base in California. As soon as the craft comes to a halt, vehicles swarm around. A safety team tests the air around it for poisonous or explosive gases, while the crew are given a quick check by a doctor before they leave the craft.

SPACE STATIONS

When the US won the race to the Moon, the Soviet Union switched its attention to building space stations. Between 1971 and 1982, it launched seven successful Salyut space stations. In 1973, the US launched its first space station, Skylab. Although damaged during launch, it operated successfully for six years. Then in 1986, the Soviet Union launched the Mir space station. It was constructed in orbit by connecting up a series of modules. During 15 years in space, some of its occupants stayed for more than a year at a time.

Soyuz space ferry carried crews to Salyut 7

Propulsion module contained main engines

Main control console was located here

SALYUT 7 ▲
Salyut 7 was the last Salyut space station. During 50 months in operation, it was visited by 10 different crews and a total of 22 cosmonauts, including French and Indian cosmonauts. In 1986, it was moved to a higher orbit, and some of its equipment was moved to Mir. However, it began to spiral in toward Earth and re-entered the atmosphere earlier than originally expected.

SPECIFICATIONS: SALYUT 7

Length: 47 ft (14.4 m)	
Diameter: 14 ft (4.15 m)	
Mass: 19 tons	
Launched: April 19, 1982	
Orbit: 173 x 176 miles (279 x 284 km)	
Time in orbit: 8 years 10 months	
Re-entry: February 7, 1991	
Re-entry fate: Burned and broke up over South America, producing an impressive light show; some pieces fell to the ground in Argentina	

Solar arrays for Skylab's solar observatory

Solar observatory studied the Sun

Forward part of workshop contained sleeping compartment

Discolored exterior of workshop where micrometeoroid shield was torn off

◄ INSIDE SKYLAB
Living conditions inside Skylab were better than in any previous US spacecraft. There was much more room—enough for acrobatics. The crew quarters contained sleep compartments and a ward room where meals were prepared. Skylab's astronauts also had the luxury of a shower, although they rationed its use to once a week, to save water. They used an exercise bike to help counter the effects of weightlessness on their bodies.

◄ SKYLAB
Skylab was made mainly from leftover Apollo hardware. The largest part, the orbital workshop, was the empty third stage of a Saturn V rocket. On launch, one of Skylab's solar panels and a combined micrometeoroid/heat shield were torn off. Astronauts had to make a sunshield to stop the spacecraft from overheating. Despite this perilous beginning and the fact that Skylab was only operational for 9 months, its crews took 40,000 pictures of Earth.

Heat radiator for refrigeration system

SPECIFICATIONS: SKYLAB

Length: 119 ft (36.12 m) when docked with Apollo spacecraft	
Diameter: 22 ft (6.58 m)	
Mass: 76.3 tons	
Launched: May 14, 1973	
Orbit: 265 x 273 miles (427 x 439 km)	
Time in orbit: 6 years 2 months	
Re-entry: July 11, 1979	
Re-entry fate: Partially burned up in atmosphere, but some parts came down in the Indian Ocean and western Australia	

*Progress supply
vessel attached to
Kvant-1 module*

*Solar array attached
to Spektr, which had
four arrays covering
380 sq ft (35 m²)*

*Solar panel of
Kvant-1, which was
equipped with
ultraviolet and
X-ray telescopes*

SPECIFICATIONS: MIR

Length: 108 ft (32.9 m) when Soyuz and Progress craft were docked

Diameter: Up to 14 ft (4.35 m) per module

Mass: 135 tons

Launched: February 20, 1986 (core module)

Orbit: 239 x 244 miles (385 x 393 km)

Time in orbit: 15 years 1 month

Re-entry: March 23, 2001

Re-entry fate: Partially burned up and broke into several pieces that plunged into the South Pacific Ocean

*Antenna at end
of solar array*

*Core module
accommodated
up to six
cosmonauts*

*Spektr had
instruments
to study the
atmosphere*

*Priroda studied
the oceans and
atmosphere*

*Docking module for
US Space Shuttle to
dock with*

*Soyuz spacecraft
ferried crews to
and from Mir*

MIR ▶

Mir was the first space station to be launched in parts and built in space. After the core module was launched in 1986, five more modules and a docking compartment were added over the next 10 years. Kvant-1, added in 1987, was an astronomical observatory. Kvant-2 (1989) was an extension unit with an airlock and scientific instruments. Kristall (1990) was used for materials processing. Spektr (1995) and Priroda (1996) were remote-sensing modules.

*Kvant-2 was used
for EVAs (extra-
vehicular activities,
or space walks)*

*Soviet-manned
maneuvering unit
was dumped here
at the end of its
useful working life*

INSIDE MIR ▶

The Mir core unit housed the crew's living quarters and a working area. The living quarters contained a hygiene area and a galley, where food was prepared. The hygiene area had a toilet, sink, and shower. The working area contained Mir's control center. Soyuz spacecraft ferried crews from Earth, and unmanned Progress craft delivered supplies. The US Space Shuttle could also dock with Mir. Several US astronauts stayed in Mir for up to six months.

INTERNATIONAL SPACE STATION

The International Space Station (ISS) is taking shape in Earth orbit and is expected to be finished by around the year 2008. The size of the spacecraft, and the fact that 16 nations are involved in building it, make this the most complex space project ever. The station's main purpose is science. Its internal volume, about the same as that of a Jumbo Jet passenger cabin, will include six laboratories. Crews of up to seven scientists and astronauts will live on the station for up to six months at a time.

Solar panels generate 110 kw of power

▲ CONSTRUCTION TAKES OFF
In November 1998, a Russian Proton rocket carried the Zarya module, the first part of the ISS, into space. In December of the same year, the Space Shuttle Endeavour delivered the Unity module. In July 2000, the Zvezda service module was added. The first crew to live on-board, Expedition One, arrived in November 2000. In February 2001, the Destiny module was delivered by the Space Shuttle Atlantis, and two months later, the station's remote manipulator system, a robot arm, arrived.

BUILDING THE SPACE STATION ▲
The ISS is being constructed from pressurized cylindrical sections, called modules, connected together by a framework of beams and towers, called trusses. Parts called nodes have up to six docking ports where several modules can connect together. Spacecraft can dock with vacant ports on the nodes and modules. The US, Russia, Europe, and Japan are all contributing modules.

Thermal control panels regulate temperature inside the ISS

Space tugs deliver supplies of food, water, gases, and fuel

◄ SCIENCE LABORATORY
Astronauts work in shirt-sleeve comfort inside the ISS's laboratories, including the Columbus Laboratory provided by the European Space Agency (ESA). Columbus is a general-purpose science laboratory. Scientists will use it for research in materials, fluids, life sciences, and technology. It can house 10 payload racks, each a complete miniature laboratory. Some experiments will be remotely controlled by scientists working on Earth.

*Solar panels
rotate to point
at the Sun*

SPACE DOCKING ▲

Space Shuttles and Soyuz spacecraft have ferried crews
to and from the space station up to now, and unmanned
Progress spacecraft have delivered supplies. A new space
tug is being developed by the European Space Agency.
The 20-ton Automated Transfer Vehicle will
deliver up to 7.5 tons of supplies to the space station
every 12 months or so. The unmanned craft will navigate
its way to the ISS and dock automatically.

*The main truss
forms the
backbone of
the ISS*

*Pressurized
modules provide
living quarters
and laboratories*

ISS SPECIFICATIONS

Length: 355 ft (108 m)	
Width: 290 ft (88 m)	
Mass: 455 tons	
Pressurized volume: 42,700 cu ft (1,200 m^3)	
Solar array wingspan: 240 ft (73 m)	
Solar array area: 43,000 sq ft (4,000 m^2)	
Orbital speed: 17,400 mph (28,000 kph)	
Orbit: 249 miles (400 km) above Earth's surface	
Orbital period: About 92 minutes	
First resident crew: November 2, 2000	
Size of crew: Between 3 and 7	

A HARD DAY'S WORK IN SPACE ▲

Two astronauts cling onto a section of
the station's skeletal frame as they complete
another hard day's work on biggest
construction site in space. The ISS is being
constructed from more than 100
different parts launched by 45 space
missions. About 160 space walks lasting
nearly 1,000 hours will be needed to
connect the parts together. Once the
station is finished, astronauts will
continue to make space walks to
service external experiments and
to perform routine maintenance.

*Spacecraft dock
at ports in several
positions*

*Remote-sensing
instruments look
down on Earth*

*Radiators turn
edge-on to the
Sun to lose
excess heat*

*Solar arrays are
the biggest and
most powerful
ever used in space*

ISS

THE BODY IN SPACE

Humans have evolved to work best in the atmosphere and gravity that exist on the Earth's surface. To survive in space, astronauts have to take an Earthlike environment with them. Fresh oxygen is circulated around the craft for them to breathe. The main difference in space, is the weightlessness causing astronauts to float around. As soon as astronauts go into space, their bodies start adapting to this weightlessness. Muscles, bones, heart, and blood all undergo changes. At the end of a lengthy spaceflight, astronauts have to adapt to living with weight again.

life in space

FEELING WEIGHTLESS ►

Floating around inside a spacecraft looks fun, but at least half of all astronauts suffer an unpleasant reaction to weightlessness. On Earth, gravity exerts a force on our bodies, which gives us weight and keeps us rooted to the ground. It also pulls body fluid downward. In space, astronauts lose their sense of balance. They can also feel sick, and lose their appetites. It can take two weeks for the digestive system to fully adjust. NASA plans no space walks during the first three days of a mission, because an astronaut who vomits inside a spacesuit risks suffocation.

INSIDE AN ASTRONAUT'S BODY

STRETCHING SPINES
Astronauts are taller in space than they are on Earth. Gravity normally pulls the vertebrae, the bones of the spine, close together. In space, vertebrae can spread out a little more, lengthening the spine. This makes the astronaut around 2 in (30-60 mm) taller, and slimmer-looking. It is not a lasting effect. An astronaut's height returns to normal when he or she comes back to Earth.

WEAKENED BONE
Bones become weaker because they no longer need to support the body weight. This bone cross section shows minerals densely packed in rings to give them strength. Blood vessels run through the center. In space, calcium dissolves out of the bones into the blood. This makes bones more brittle. Astronauts returning to Earth after a long mission are more likely to suffer a bone fracture.

SPACE AGEING
In the 1980s, scientists realized that weightlessness affects the body in a similar way to ageing. Bones lose their mass in space over long periods, just as ageing bones become thinner. Loss of bone calcium is similar to a condition called osteoporosis that affects some older people, usually women. By studying the effects of weightlessness, scientists can understand the ageing process.

WASTING MUSCLES
Without the full force of gravity to work against, an astronaut's muscles quickly begin to atrophy (waste). They become smaller and weaker. The large weight-bearing muscles in the legs are affected the most, because they are used the least in space. Fortunately, most of the muscle lost during a spaceflight is rebuilt within a month of returning to Earth.

INTERNAL ORGANS
Some of the body's internal organs change or feel different in weightlessness. Astronauts often say their stomach feels fuller, possibly because their digestive system is breaking down food more slowly. The kidneys have to work harder. They remove waste materials from the blood, including calcium lost from the bones. Extra calcium can form painful lumps called kidney stones.

▲ MONITORING HEALTH

Many astronauts report problems sleeping for long periods in space, perhaps because of the excitement and pressures of the the mission, or the constant noise inside the craft. This Shuttle astronaut is taking part in a sleep experiment. He is fitted with a set of sensors to monitor his brainwave activity, and a sensor suit to study his breathing as he sleeps. Sensors stuck to the skin pick up the body's electrical activity, which is transmitted to Earth and monitored by doctors at mission control.

BIOLOGICAL EFFECTS OF LACK OF GRAVITY

Bones: Astronauts lose up to 6% of bone mass while in space, at the rate of 1-2% a month

Blood: Up to 17% of blood volume is lost after just 2-3 days

Muscles: Up to 20% of muscle mass is lost, at the rate of 5% a week

Teeth: Less saliva is produced in space, causing plaque build-up – astronauts chew gum to help them produce saliva

Nose and eyes: Astronauts sneeze a lot—as much as 30 times an hour—and suffer eye irritations. This is because of the dust and shed human skin cells floating around the craft

Head: About two pints of extra fluid moves up to the head, so astronauts feel as though they have a head cold

ESSENTIAL EXERCISE ►

This astronaut uses a cycling machine, part of the daily exercise routine lasting two hours or more. Astronauts exercise to minimize the effects of weightlessness on their body. Their figures change in space because of muscle wastage and fluids moving upward. Legs are particularly affected—they get thinner, a condition known as bird legs. Normal treadmills, rowing machines, and exercise bikes are useless in space, because astronauts would just float off them. Space exercise machines have straps or elastic ropes to hold the astronaut down and give their muscles something to work against.

Handheld weights exercise hand and arm muscles

Cycling prevents bones and muscles from wasting

SHRINKING HEART

The heart is a muscle, so in space it wastes just like the leg muscles. It normally pumps blood against gravity. In space, it has less work to do. As a result, it shrinks in size. It also slows down and pumps less blood each time it beats. Although astronauts feel normal in space, these changes reduce their ability to do hard physical work for long periods when they return to Earth.

LOSING BLOOD CELLS

Gravity normally pulls blood down toward the feet. In space, it spreads out evenly throughout the body. There is more blood than usual from the waist up. The body tries to reduce the amount of blood in the head by slowing down the heart. Astronauts also lose about 20% of red blood cells, which causes anaemia and tiredness. This can last for two or more years after the trip.

24 HOURS IN SPACE

Each day of a space mission is planned in meticulous detail. Space Shuttle trips are planned to the last second, long before the crew leaves Earth. Crews on longer missions to the International Space Station have a basic plan, which is modified during daily conferences between the crew and ground controllers. Plans have to be adaptable to allow for problems with equipment or jobs taking longer in space. Essential exercise is written into the daily mission plan, along with a little time for play.

▲ 05:30—WAKE UP, SLEEPY HEAD!
International Space Station astronauts are woken up by an alarm buzzer, but music plays to wake up Shuttle crews.

▲ 06:10—IN THE GALLEY
The first meal of the day might be fruit and cereal followed by coffee or tea and a roll—all eaten straight from the pack.

▲ 07:00—WORK PREPARATION
Each morning, a detailed, timed plan of the day's work is drawn up in conjunction with ground controllers.

▲ 07:45—ALL SYSTEMS GO
First work sessions include monitoring vital spacecraft systems and performing routine maintenance jobs.

▲ 07:55—EXERCISE
Daily exercise sessions, lasting up to an hour, work muscles that otherwise do not get used in microgravity.

▲ 12:00—WORKING ABOVE THE EARTH
Extra Vehicular Activity (EVA) involves going outside the spacecraft to carry out repairs or to assemble parts of the ISS. Some EVAs last two to three hours. Many spacewalkers can spend their entire working day outside on a tiring seven-hour shift.

▲ 13:35—A WORKING LUNCH
The crew gather in the galley for lunch, although busy Shuttle schedules mean astronauts often snack while working.

▲ 14:50—INTERVIEWS
TV and radio shows, or webcasts, are part of the job. Astronauts give interviews from space to journalists on Earth.

▲ 18:10—BACK TO WORK
The spacecraft serves as a workshop and a science laboratory. Each crew takes its own set of tools for their mission.

▲ 18:15—CONFERENCE
The crew get together to discuss how the day's work has progressed and make any necessary changes to the schedule.

▲ 19:00—DINNER IS SERVED
Two astronauts eat rice with chopsticks on mid-deck. They choose their meals months in advance, before leaving Earth.

▲ 20:00—LEISURE
It's finally time to relax. Astronauts take their own books and CDs, watch DVDs, and sometimes play instruments.

▲ 05:40—WASH AND GO
Water is limited in space, so astronauts stay clean by using washcloths and rinseless soap and shampoo.

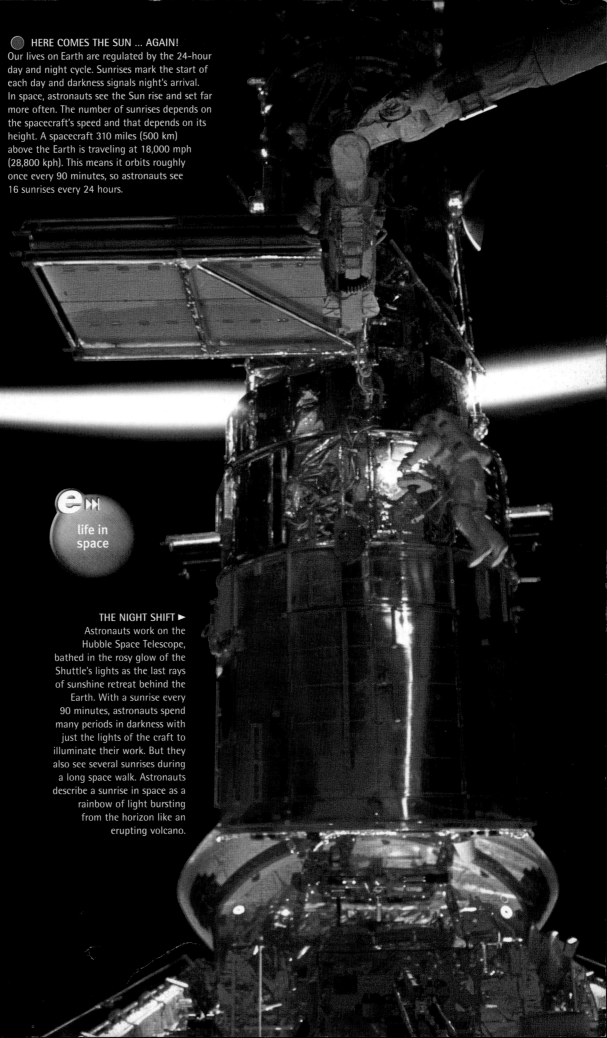

▲ 09:25—PREPARING FOR AN EVA
Two astronauts don their space suits in preparation for a spacewalk, helped and closely monitored by crew members.

▲ 17:10—MORE EXERCISE
Back to the exercise bike or treadmill for the second workout, to tone up the muscles and protect against weak bones.

▲ 21:00—SLEEP
After a demanding day's work, the astronauts strap themselves into sleeping bags for an eight hour sleep.

HERE COMES THE SUN ... AGAIN!
Our lives on Earth are regulated by the 24-hour day and night cycle. Sunrises mark the start of each day and darkness signals night's arrival. In space, astronauts see the Sun rise and set far more often. The number of sunrises depends on the spacecraft's speed and that depends on its height. A spacecraft 310 miles (500 km) above the Earth is traveling at 18,000 mph (28,800 kph). This means it orbits roughly once every 90 minutes, so astronauts see 16 sunrises every 24 hours.

e ▸▸
life in space

THE NIGHT SHIFT ▶
Astronauts work on the Hubble Space Telescope, bathed in the rosy glow of the Shuttle's lights as the last rays of sunshine retreat behind the Earth. With a sunrise every 90 minutes, astronauts spend many periods in darkness with just the lights of the craft to illuminate their work. But they also see several sunrises during a long space walk. Astronauts describe a sunrise in space as a rainbow of light bursting from the horizon like an erupting volcano.

LIVING IN SPACE

Living in space is a bit like living with several other people in a cramped trailer. Astronauts work hard, but they don't have to do some of the daily chores that have to be done on Earth. One-use food containers means there is no dish washing to do. Clothes don't have to be cleaned either, because astronauts wear disposable clothes. Garbage is disposed of in an unusual way. Space Station astronauts load their garbage into empty supply ships. These unmanned craft are then steered into the atmosphere and burn up.

Satellite's antenna used to send and receive data

Antenna dish opens once the satellite is in place

LONGLIFE CANNED FOOD

▲ EATING IN SPACE
Astronauts on early missions ate unappetizing meals of paste-like food squeezed from tubes, or dried meat cubes coated with gelatine to trap crumbs. Choices on the space menu today range from breakfast cereals and fresh fruit to steak. Astronauts have a poor sense of taste in space, so they prefer highly flavored and spiced foods. Ketchup or spicy sauce are often added to meals, which are heated in an onboard oven.

DRIED FOOD WITH TUBE FOR WATER

◄ PACKAGING FOOD FOR SPACE
Space food is packaged in airtight containers to keep it fresh until needed. Foods sterilized by heat are supplied in metal tins or pouches. Irradiated and low-moisture foods, such as dried apricots, are sealed in foil. Foods that have to be rehydrated have plastic containers with tubes to inject water. Fresh foods, such as nuts and crackers, are packed in plastic pouches. Drinks come in squeeze bottles, or as powders to be mixed with water.

VACUUM-PACKED FRESH FOOD

SPACE MENU	
Breakfast	Cereal with raisins (rehydratable with water)
	Breakfast roll (fresh food)
	Pears (thermostabilized—heat treated to preserve)
	Vanilla breakfast drink (beverage)
	Tea or coffee (beverage)
Lunch	Chicken strips in salsa (thermostabilized)
	Macaroni and cheese (rehydratable)
	Rice with butter (thermostabilized)
	Macadamia nuts (fresh)
	Apple cider (beverage)
Dinner	Shrimp cocktail (rehydratable)
	Beef steak (irradiated, treated with radiation to preserve)
	Macaroni and cheese (rehydratable)
	Fruit cocktail (thermostabilized)
	Strawberry drink (beverage)

Astronaut can easily move a satellite weighing several tons

Foot restraint secured to the payload bay holds astronaut firmly

▲ LIVING IN MICROGRAVITY

Working astronauts have to anchor themselves behind rails so they don't float away from their workstation. Weightlessness makes it easy to move around, but it also presents problems. Nothing stays where an astronaut puts it. The tiniest movement can send something floating across the spacecraft. Everything has to be held down by hook-and-loop pads or straps, or be put away. There is no defined floor or ceiling in the Shuttle—equipment is arranged over all surfaces, so crew have to orientate themselves.

life in space

Remote Manipulator System arm provides a mobile platform

◄ WORKING IN SPACE

Launching and servicing satellites is part of an astronaut's job. While working outside, the crew are always clipped to a foot restraint or safety line to stop them from floating away. Once secure, they can do things in space that are impossible on Earth. Weightlessness means that an astronaut can move a huge object by hand, such as this 1,760-lb (800-kg) satellite. However, when a massive object starts moving, a lot of force is needed to stop it.

▲ KEEPING CLEAN

Early astronauts didn't bathe at all. Space missions last much longer today, so hygiene is important. The Skylab space station had a shower, but showers are not effective in space. As water doesn't fall in orbit, a fan has to blow the water at the bather, and users have to be careful not to let droplets escape to float around. Usually, astronauts use wet cloths and rinseless cleansing liquids to keep clean and brush their teeth as they would on Earth.

GROWING PLANTS IN SPACE ►

Future space missions may depend on plants to provide food and recycle water and air. Normally, gravity makes plant roots grow downward and shoots grow upward. Without gravity, plants can't sense which way to grow, so the plants and their roots grow in all directions. They have to be watered in a different way too, because weightless water doesn't sink into soil or plant. It rests on the plant or soil in bubbles.

▲ SLEEPING ARRANGEMENTS

Astronauts are allocated eight hours of sleep in every 24 hours. Usually, crew work in shifts, so some sleep while others work during their day. Eye and ear plugs are essential. They stick their sleeping bags to a wall to stop them from floating off and banging into things. Despite the lack of a bed, astronauts report that they still turn over in their sleep. The Shuttle commander often sleeps on the flight deck in case a problem arises.

SPACE WALKS

Astronauts routinely go on space walks, or EVAs (Extra-Vehicular Activities), to work outside. Leaving the safety of the spacecraft to walk outside, 245 miles (400 km) or so above Earth, is dangerous. It takes 15 minutes to put on a space suit, but it takes much longer to prepare to leave the craft. A space suit supplies pure oxygen at less than one third the air pressure inside the spacecraft. A sudden drop in pressure, from the cabin to the space suit, could cause a condition called decompression sickness, which can be fatal. The pressure inside the craft has to be lowered gradually, over several hours, before it is safe for an astronaut to go outside.

▲ THE FIRST SPACE WALK
On March 18, 1965, Alexei Leonov became the first person to walk in space. During Voskhod 2's second orbit, Leonov crawled through an inflatable airlock and floated into space 310 miles (500 km) above Earth, at the end of a 16-foot (5-m) safety line. Ten minutes later, he tried to go back inside, but couldn't squeeze into the airlock as his suit had ballooned in the vacuum. He eventually let air out of his suit and squeezed in head-first.

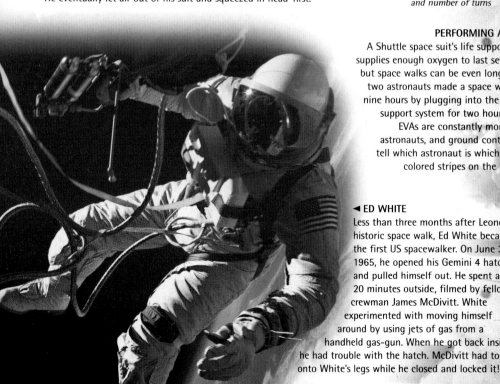

Remote manipulator arm (robot arm) has six joints and is 50 ft (15 m) long

Portable life support system supplies oxygen for up to seven hours

Helmet light bar mounted on the helmet to give extra illumination

Face visor is sprayed with an antifog solution inside, so it doesn't mist up

Tool clips hold tools while they are not in use

Pistol grip tool is computer controlled to set precise speed, force, and number of turns

PERFORMING AN EVA ▶
A Shuttle space suit's life support system supplies enough oxygen to last seven hours, but space walks can be even longer. In 2001, two astronauts made a space walk lasting almost nine hours by plugging into the Space Shuttle's main life support system for two hours. Astronauts performing EVAs are constantly monitored by cameras, other astronauts, and ground controllers. It can be tricky to tell which astronaut is which, so their space suits have colored stripes on the legs to help identify them.

◀ ED WHITE
Less than three months after Leonov's historic space walk, Ed White became the first US spacewalker. On June 3, 1965, he opened his Gemini 4 hatch and pulled himself out. He spent about 20 minutes outside, filmed by fellow crewman James McDivitt. White experimented with moving himself around by using jets of gas from a handheld gas-gun. When he got back inside, he had trouble with the hatch. McDivitt had to hold onto White's legs while he closed and locked it!

▲ FLYING FREE

During EVAs, astronauts are tethered so they don't float away, but they can fly free using gas-jet-propelled backpacks. The Manned Maneuvering Unit (MMU) was used on early Shuttle flights. A smaller SAFER unit (Simplified Aid For Extravehicular activity Rescue) has been developed for the ISS. Astronauts who drift away from the station can propel themselves back by using a joystick control to expel jets of nitrogen gas from the unit's 24 nozzles.

space walks

Checklist pad attached to the sleeve holds up to 27 pages of information

Colored stripes on space suits identify individual astronauts

Foot restraint prevents the astronaut from floating away

▲ STANDING THEIR GROUND

Weightlessness makes it easy to move around, but it also presents a problem for astronauts trying to work. If they push something, they just fly back in the opposite direction. They have to anchor themselves in place using a foot restraint, leaving both hands free for work. The ISS has sockets all over it where foot restraints can be plugged in. Astronauts can also anchor themselves to the Space Shuttle's remote manipulator arm which serves as a maneuverable but stable platform to work on.

Gripping teeth stop parts from turning the wrong way

SPACE TOOLS ►

Tools used by spacewalking astronauts may look similar to standard ones, but they are designed for the job. Bulky space gloves are pressurized with air. This makes it harder for astronauts to grip, so tools have bigger handles. Even tightening a nut can be tricky, as the astronaut, and not the nut, may turn, while the loosened nut floats off. Cordless power tools used on Earth were invented for space, as they need little exertion to use, and no electric cables.

Metal hammer weighs less in space than on Earth

HAMMER

Metal eye to clip the tool to a tether

Handle made large and easy to grip

BOLT TIGHTENER

RATCHET

WIRE CUTTER

SPACE SUITS

A space suit is more than a set of work clothes, it's a survival system. If astronauts stepped out into space without any protection, they would be unconscious within 15 seconds and all their body fluids would bubble and freeze. A space suit not only supplies oxygen to breathe, it also protects the astronaut from the vacuum of space, from temperature extremes of 250°F (121°C) to -250°F (-156°C), and from meteorite particles. There are two types of space suit. One is worn during takeoff and re-entry, the other for spacewalks.

▲ THE MERCURY SPACE SUIT
Space suits worn by Mercury astronauts in the early 1960s were developed from pressure suits designed for Navy pilots in the 1950s. The suit, worn over longjohn underwear, was made from three layers of nylon. The outer layer was impregnated with aluminum to give better flame resistance. It was worn with gloves, helmet, and lace-up flying boots, and oxygen was supplied for the astronaut to breathe. The suit was not pressurized unless the Mercury capsule lost cabin pressure.

▲ RECORD-BREAKING SUIT
The first pressurized suit worn by a pilot was made for the record-breaking American aviator, Wiley Post, in 1934. He found he could go faster by flying higher, so he had a pressure suit made to let him fly in thin air for longer. It was made of rubber covered by cotton, with a metal helmet and an oxygen supply. The suit was produced by B. F. Goodrich, which later made space suits for the Mercury astronauts.

Boots are made as part of the suit to stop air leaking out

▲ SHUTTLE EVA SUIT
The space suit worn by Shuttle astronauts on space walks is called the EMU (Extravehicular Mobility Unit). Most of the suit is made from 11 layers of different coated, noncoated, and aluminized materials, many of them invented for use in space. It houses a water cooling system, drink bag, and urine collection device. On Earth, the suit weighs up to 104 lb (47 kg) and the life support system another 148 lb (67 kg). With the camera, it weighs a total of 260 lb (117.6 kg).

1. *Tough outer layer is a mixture of three fire-retardant fibers, Gore-Tex, Kevlar, and Nomex, to protect against heat and puncture.*

2. *The five-layer Thermal Micrometeoroid Garment Liner (TMG), made from aluminum-coated fabric, deflects the Sun's heat.*

3. *The TMG is lined with a layer of material made from neoprene-coated (rubberized) nylon to prevent damage from micrometeoroids.*

4. *The restraint layer, made from Dacron, stops the pressure bladder inside it from blowing up like a balloon. Its pattern aids bending.*

5. *The innermost layer of the space suit is known as the bladder. It is pressurized and airtight, as seams are heat-sealed and overtaped.*

6. *The Liquid Cooling and Ventilation Garment is a two-layer suit made from nylon. It stretches by 300% to fit snugly to the body.*

7. *Cool water flows through 300 ft (91.44 m) of plastic tubing laced between the layers of the Cooling and Ventilation Garment.*

DRESSING FOR A SPACE WALK

LEGS FIRST
A Space Shuttle astronaut wearing a Liquid Cooling and Ventilation Garment steps into the space suit's Lower Torso Assembly (LTA).

SLIDING INTO THE TOP
Next, the astronaut rises into the suit's Hard Upper Torso (HUT), which normally hangs on the wall of the Space Shuttle's airlock.

LOCKING UP
The two halves of the suit are locked together. Helmet and gloves are added and locked in place. Then the pressure inside the suit is adjusted.

Thick gloves have rubber fingertips to help astronauts grip

Loops and clips for keeping tools from floating away

Outer shell is shiny, white Gore-Tex fabric to minimize heat absorbtion

Display and control Module monitors the life support system

Helmet visor is gold-coated to cut glare from sunlight

Helmet is made of a hard, durable polycarbonate material

Space tools are two to three times larger to be held in bulky gloves

Cameras and lights are attached to each side of the helmet

Radio antenna sends and receives radio communications signals

Life support system contains oxygen tanks, cooling water, and radios

Space suit becomes rigid when pressurized (inflated), so flexible areas are included at the joints

◄ THE SOYUZ SPACESUIT

Soyuz cosmonauts wear the Sokol (Falcon) spacesuit for takeoff and landing. The pressure suit is covered with white nylon canvas, with a hood and hinged visor. Air and coolant hoses, and electric cables can connect to the suit's body. Two chest labels show the cosmonaut's name in the Russian Cyrillic alphabet and the Roman alphabet. The spacesuit worn by cosmonauts for spacewalks is called the Orlan (Eagle) suit.

Headset contains microphones and earphones

◄ LAUNCH SUIT

A distinctive orange spacesuit is worn by Shuttle astronauts during launch and re-entry. It protects astronauts from loss of cabin pressure and the very low air or water temperatures they could encounter if they bailed out of the Orbiter. During landing, the suit squeezes the astronaut's torso and legs to stop blood from pooling in the legs after a long period in space. It also has a satellite beacon and flares, to help locate crew in water.

Metal rings on the sleeves lock onto detachable gloves

TRAINING FOR SPACE

When a space agency invites applications from people who want to be astronauts, thousands of people reply. Only one in 200 is accepted. After an initial year's basic training, the successful candidates become astronauts, but they may have to wait several years before going into space. During that time, they continue taking training courses. When they are allocated a mission, they begin intensive training for that specific mission, often using simulators—mock-ups of the craft or equipment they will have to use in space. Crews often say a real mission is easy compared to their training sessions in simulators.

training

Astronaut floats as if weightless

◄ FLIGHT TRAINING
Pilot astronauts keep their flying skills up to scratch by flying NASA's T-38 jets regularly during training. The T-38 is a two-seat training jet. Mission and payload specialists fly in the back seat to get experience of using navigation and communications systems. The Shuttle lands without engine power, so the pilot has only one chance to land it. Pilot astronauts practice landing in simulators and in the Shuttle Training Aircraft, a converted Gulfstream business jet.

Eyepieces display a computer-generated view of inside a craft

Gloves sense hand positions

VOMIT COMET ►
An astronaut can experience weightlessness without having to go into space, by using an aircraft known as the Vomit Comet! The KC-135 climbs steeply upward and then dives, over and over again. As it tips over the top of each climb, the plane and everything inside is in free fall (moving around without restraint), so everyone inside becomes weightless for up to 25 seconds. It can also simulate lunar and Martian gravity.

◄ VIRTUAL SPACE
This astronaut is using a Virtual Reality (VR) training system. VR is used to train astronauts without having to use a simulator. The astronaut sees a computer-generated version of equipment displayed on screens in front of his eyes. He might see part of the ISS or the Shuttle payload bay. He can move around in the virtual space and pick up virtual objects and move them around, because his gloves have sensors linked to the screens.

◄ UNDERWATER TRAINING

NASA's Neutral Buoyancy Laboratory is one of the world's largest swimming pools. It's 202 ft (31 m) long, 102 ft (31 m) wide, and 40 ft (12.5 m) deep, and contains 6 million gallons (20 million liters) of water. It's big enough to hold a full-size mock-up of the Shuttle payload bay. Astronauts use the tank to train for EVAs (spacewalks). The buoyancy of the water lets them float as if they were in space.

Full-size equipment is used in the training tank

Air bags make equipment float as if weightless

Video cameras record progress in the tank

Divers prepare equipment and act as lifeguards

ASTRONAUT SELECTION AND TRAINING DATA

Career backgrounds: Three types of astronauts take part in space missions—pilots, mission specialists, and payload specialists

Pilot astronauts: The commander and pilot—the astronauts who fly the craft. They must have at least 1,000 hours' experience of flying jet aircraft.

Mission specialists: Coordinate all onboard operations, perform spacewalks, and handle the payload.

Payload specialists: Chosen from scientists or engineers outside NASA to carry out particular experiments or operate specific payloads.

Numbers: NASA takes 20-30 new candidates every two years.

Selection: The process takes about eight months and includes interviews, medical examinations, and orientation tests.

Training: There is a minimum of two years' training before they are assigned a flight. Then, they train for up to a year for that mission.

Height: Candidates are usually between 64 and 76 in (160 cm and 185 cm) tall.

Education: Most astronauts have an advanced (Master's) degree.

▲ SCIENTIST ASTRONAUTS

Until 1972, all astronauts were pilots. They were trained to carry out specific scientific experiments for their missions. In 1972, the Apollo 17 lunar module pilot was Dr Harrison Schmitt (above), a trained geologist. Schmitt conducted tests to find out if the Moon was volcanically active. Since then, astronauts have come from a variety of backgrounds, among them many highly trained scientists who are assigned missions because of the experiments that will be taking place on board.

FLIGHT SIMULATORS ▼

Soyuz crews train for missions in the Soyuz cockpit simulator in Star City—the Russian space training center, near Moscow. Pilot astronauts practice their missions hundreds of times in simulators, which have identical controls and displays to those in the spacecraft. US Space Shuttle crews train in the Shuttle Mission Simulator in Houston, where they can practice launch, ascent, and docking. A straight up 90° tilt simulates acceleration and takeoff.

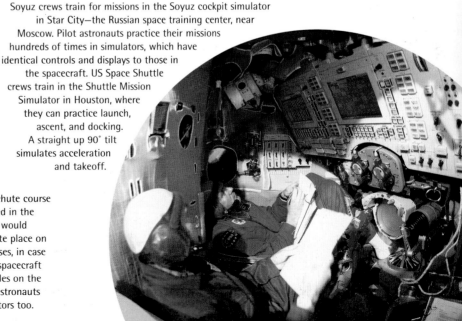

◄ SURVIVAL TRAINING

Emergency training includes a parachute course and how to use the survival suit used in the spacecraft. Astronauts who bail out would probably land in water or in a remote place on land, so they also take survival courses, in case they are marooned for days. Soyuz spacecraft are used as emergency escape vehicles on the International Space Station, so US astronauts visit Russia to train in Soyuz simulators too.

SPACE RESCUE

Spacecraft designers and mission planners work hard to make space missions as safe as possible. However, rockets are so powerful, fuel is so explosive, and spacecraft are such complex machines that accidents still happen. Apollo 13 was launched at 13:13 Houston time on April 11, 1970. On April 13, 205,000 miles (330,000 km) from Earth, the crew heard a bang. An oxygen tank had exploded. The spacecraft quickly lost power and oxygen. Engineers, scientists, and astronauts fought for four days to bring the spacecraft home.

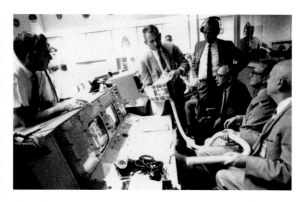

A SOLUTION FROM HOUSTON ►
Mission control instructed the Apollo 13 crew to power down the command module, to save it for re-entry, and move into the lunar module (LM). With three astronauts instead of the two it was designed for, the LM's chemical air scrubber could not cope. Spare filter cartridges from the command module would not fit the LM's air filters. Engineers on Earth had to design something to take carbon dioxide out of the air using only items the astronauts had with them.

"Houston, we've had a problem"

Jack Swigert, command module pilot

A MAKESHIFT REPAIR ►
Conditions in the lunar module were cramped, cold, and uncomfortable. It was equipped to support two men for less than 50 hours. The three Apollo 13 astronauts would be inside for at least 84 hours. The amount of carbon dioxide in the air, from the crew breathing out, started rising. Following step-by-step instructions from ground control, John Swigert (far right) and James Lovell had to make an air filter using spare cartridges, a plastic bag, an air hose from a spacesuit, and tape. It worked.

THE ROUTE HOME

Mission controllers debated whether to turn Apollo 13 around and bring it home or let it continue around the Moon. They decided that firing the service module's engine to come home was too risky. Sending the spacecraft around the Moon was also risky as it had only half the electrical power it needed for the return journey. The craft continued to the Moon, using the lunar module's engine to put the craft back on course for Earth. This shows Apollo 13's route from takeoff at 000:00:00.

Apollo 13's flight path

(1) *004:01:00 (hours, mins, secs)*
Command and service module docks with the lunar module on the way to the Moon.

(2) *030:40:49*
A midcourse correction puts Apollo 13 on course for its Moon landing.

(3) *055:54:53*
The crew hears a loud bang as an oxygen tank explodes. Two hours later, they enter the lunar module.

(4) *077:33:10*
The spacecraft reappears from behind the Moon, 25 minutes after disappearing behind it.

(5) *105:18:28*
The lunar module engine is fired for 14 seconds to fine-tune the spacecraft's course.

(6) *138:01:48*
The wrecked service module is jettisoned. The crew see, and photograph, the damage for the first time.

(7) *140:10:00*
The command module is powered up for re-entry into the Earth's atmosphere.

(8) *141:30:00*
The lunar module is discarded and the command module begins its journey through the atmosphere.

DAMAGE REPORT ▶

About five hours before splashdown, Jack Swigert threw the SM JETT switch to jettison the service module. As it floated away, the crew peered through the command module windows to watch it go. They could hardly believe their eyes when they spotted the damage. One whole equipment bay, from the engine bell at the bottom all the way to the top, had been blasted out by the explosion. Shreds of insulation material and tangled wiring trailed from the mangled metalwork.

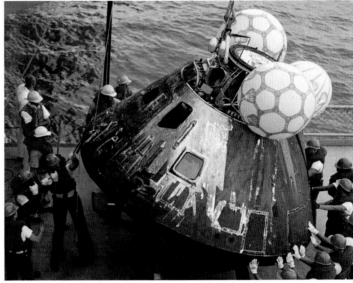

▲ SPLASHDOWN

As the command module re-entered Earth's atmosphere, the usual four-minute radio blackout began. Controllers hoped the command module was undamaged or the crew would not survive. After four minutes, they called the crew. After 33 tense seconds, they answered. Minutes later, the command module landed. The crew was flown to safety and the command module was hoisted out of the sea.

e ⏭
space rescue

*"Gentlemen,
it's been a privilege
flying with you"*
James Lovell

RETURN TO EARTH ▶

Lovell, Swigert, and Fred Haise were cheered by sailors as they stepped from the recovery helicopter onto the *USS Iwo Jima*'s deck. Below decks they were given medical examinations. Haise was suffering from a kidney infection and a high fever caused by the freezing conditions and shortage of water in the spacecraft. All three astronauts were dehydrated, tired, and they had lost weight. Lovell lost more than 13.2 lb (6 kg) in six days.

INVESTIGATION TECHNIQUES

If a spacecraft fails in space, investigators may never know the cause. If it fails in the atmosphere, the wreckage is studied closely for clues.

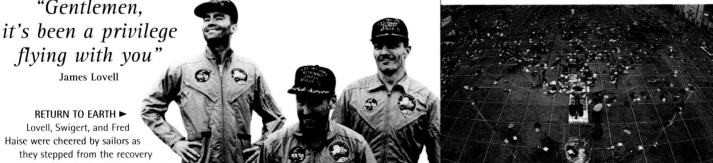

The Space Shuttle Orbiter Columbia broke up while re-entering the atmosphere on February 1, 2003. Wreckage fell over 27,800 sq miles (72,000 km²) of the US. Every piece found was gathered and brought to the Kennedy Space Center, where it was laid out on a hangar floor. Investigators also studied data received from the Orbiter, a film of the launch, and images from space. They concluded that insulation falling from the external tank had damaged Columbia's left wing, causing the Orbiter to break up during re-entry. Discovering the cause means that a similar accident can be prevented in the future.

Hexagonal body
with two solar
panels attached

Ground link dish used
for communications
with ground station

Radio dish is 16 ft
(4.9 m) wide and can
be steered to track
other spacecraft

◄ RELAY SATELLITE
A network of Tracking and Data Relay Satellites (TDRS)
circles Earth, providing radio communication
between ground stations and spacecraft in
Earth orbit. The Space Shuttle, International
Space Station, military satellites, and science
satellites communicate through the TDRS
system. Each satellite measures up to 57 ft
(17.4 m) across and bristles with radio antennae.

SPACE COMMUNICATION

Reliable radio communication is vital for spaceflight.
Ground controllers need to monitor a spacecraft's
operation and transmit commands to it. They need to talk
to astronauts in manned craft and during space walks. In
the early days of spaceflight, ground controllers could
communicate with a spacecraft in Earth orbit only when
it was in sight of a ground station. When it disappeared
below the horizon, contact was lost. Now, a network of
satellites around the world keeps ground controllers in
constant communication with orbiting craft.

A 3-ft (90-cm)
parabolic antenna
dish operates
using microwaves

Radio
communications
system is housed in
front part of Orbiter

Communications
system is attached
to the backpack

Microphones and
earphones in
headset

Helmet contains air,
allowing astronaut to
speak into microphone
as well as breathe

◄ SPACE WALKING AND TALKING
During a space walk outside the Space
Shuttle Orbiter, astronauts keep in
touch by radio. The headset inside
the helmet has two microphones
and earphones. Cables from
these and from biomedical
sensors pass through the
suit to a communications
system attached to the
backpack (biomedical sensors
are small devices that monitor
the astronaut's heartbeat and
other body processes). The astronaut
controls the system using switches on
the control box on the space suit's chest.

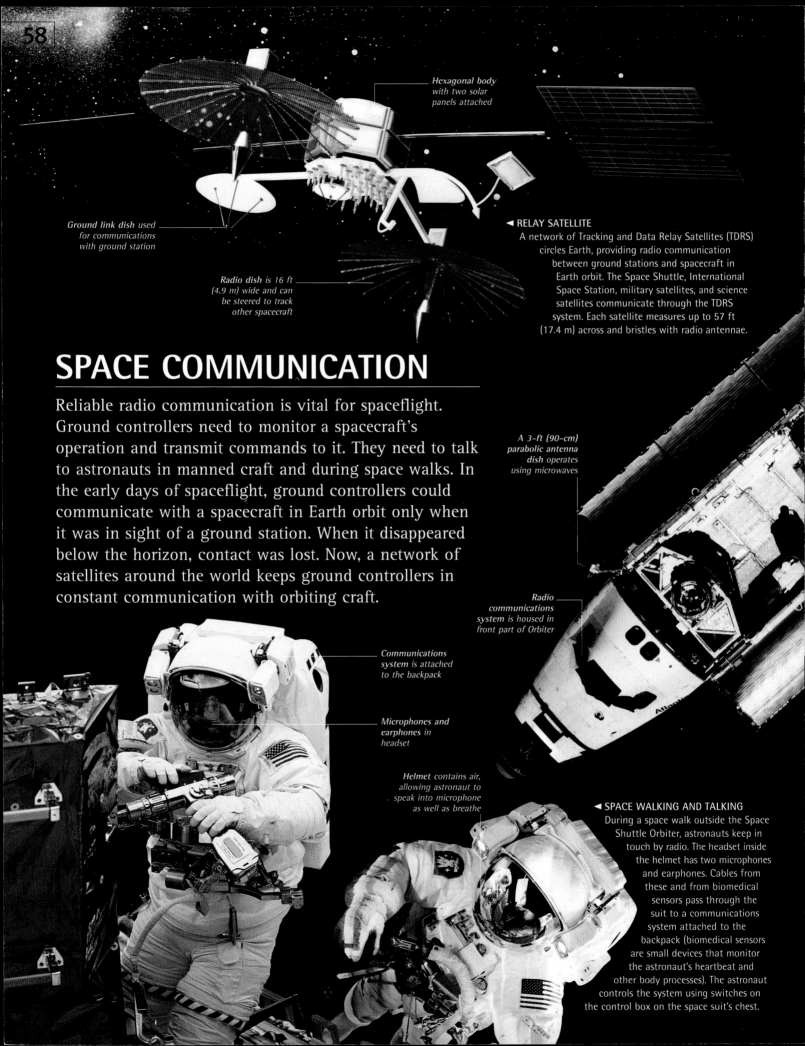

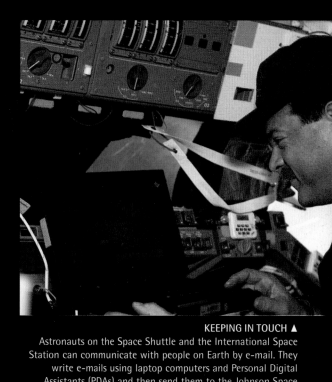

KEEPING IN TOUCH ▲
Astronauts on the Space Shuttle and the International Space
Station can communicate with people on Earth by e-mail. They
write e-mails using laptop computers and Personal Digital
Assistants (PDAs) and then send them to the Johnson Space
Center in Houston, Texas. Many of the messages are sent to
NASA staff about the mission, but the astronauts can also
send e-mails to their families. Keeping in touch with home
is particularly important for astronauts on long missions.

**◄ ORBITER
COMMUNICATIONS**
The Space Shuttle Orbiter has four
separate radio communications systems.
Three of them carry voice, engineering data,
and science data. One of these also handles
communications with astronauts outside the Orbiter.
The fourth communications system is a high-
bandwidth one that carries television pictures. Inside
the Orbiter, astronauts connect to the communications
system by plugging their headset into one of the audio
terminals dotted around the crew compartment.

TWIN COMMUNICATORS ►
A ground station at White Sands, near Las
Cruces, New Mexico, handles radio traffic to
and from spacecraft orbiting Earth. The traffic
passes to and from the spacecraft via Tracking
and Data Relay satellites. The White Sands
ground station houses two almost identical
terminals. The system was developed because
one ground station and a network of satellites
provides a better service, and also costs less,
than a worldwide network of ground stations.

space talk

SCIENCE IN SPACE

Scientific research has been carried out in space since the very first spaceflight. Radio signals from Sputnik 1 were used to study how the atmosphere affects radio waves. Modern scientific satellites study the Earth from space and the Universe beyond. Science experiments are also carried out on manned space missions. Scientists use space experiments to remove the effect of gravity and learn more about materials, to understand living organisms better, and to study the effects of weightlessness on the human body.

Head houses a skull with a plastic brain

Radiation monitors attached to head and torso

Skin made from fireproof material

▲ CRYSTALS GROWN IN SPACE

Crystals are used in computers, cameras, DVD players, and a variety of scientific instruments, as well as in medical research. Crystals grown on Earth are distorted by gravity—the growing crystals are pulled against the walls of their container. Crystals grown in space tend to be larger and better quality because they can spread out freely. Studying crystal growth in space is leading to ways of growing better-quality crystals on Earth.

science in space

FLAMES IN SPACE ▶

Flames look very different in space. Without gravity, the hot gases do not rise to form the familiar teardrop shape of a flame on Earth. In space, a flame spreads out in all directions. As it burns more slowly and evenly, there are no color variations. Flames have been studied in experiments carried out in the Space Shuttle. The research helps engine manufacturers who want to develop new, cleaner-burning engines. Understanding how flames behave is also important in developing ways of fighting fires in spacecraft.

FLAME ON EARTH IS ELONGATED WITH A YELLOW TIP

SPACE FLAME IS SPHERICAL AND BLUE

▲ PHANTOM TORSO

The Phantom Torso is a model of a human body used in radiation research in the International Space Station. The Earth's atmosphere blocks some of the Sun's radiation. When astronauts go into space, they lose the atmosphere's protection. Scientists are concerned about the radiation hazard. The Phantom Torso contains real bones and plastic organs packed with hundreds of sensors to measure radiation. The data produced will help scientists to predict the radiation doses humans would receive on long spaceflights.

◀ MICROGRAVITY GLOVEBOX

The International Space Station is equipped with a workstation for scientists called the Microgravity Science Glovebox. It is a sealed 56-gallon (255-liter) box where astronauts can do experiments without any risk of gases or liquids escaping into the rest of the spacecraft. Two glove-ports let astronauts reach inside and handle things without breaking the seal. Video cameras are linked to Earth so scientists here can monitor activities inside the box. The box is also equipped with its own laptop computer to control experiments and record results.

SPACELAB MISSIONS

Spacelab was an orbiting laboratory carried in the Shuttle's payload bay. There were 25 Spacelab missions, including:

Spacelab–1, 1983: 73 experiments included astronomy, life sciences, and material research.

Spacelab D1, 1985: Funded by Germany, tests included botany, biology, and crystal growing.

Astro 1, 1990: Ultra-violet and X-ray telescopes were used to observe the Universe.

SLS 1, 1991: First Spacelab mission dedicated solely to life sciences.

Spacelab J, 1992: Crew brought back the first animal embryos fertilized and developed in space.

Neurolab, 1998: Last mission, it studied the effects of microgravity on the nervous system.

Blacked-out goggles minimize distractions

Cable carries data on the astronaut's head position to a computer

Tape recorder records astronaut's comments

Headphones block distracting noises

▲ EXPERIMENTING ON ASTRONAUTS

Space Shuttle payload specialist Martin Fettman was spun on a rotating chair by mission specialist Rhea Seddon to study the effect on his balance. His headset sensed his head movements, so they could be compared to similar experiments on Earth. They worked inside Spacelab SLS-2, a laboratory carried in the Shuttle's payload bay in 1993. It was one of many experiments carried out to study the effects of weightlessness on the human body. The whole mission was dedicated to life sciences research.

TETHERED SATELLITES ▶

Satellites tethered to the Shuttle have been used to try to generate electricity. The satellite collects data for science experiments and houses thrusters that keep the tether tight. The action of the tether cutting through the Earth's magnetic field produces an electric current. This may lead to a new way of generating electricity for space stations. On the first experiment, the tether jammed after only 840 feet (256 m) of the 12 miles (20 km) had been unreeled. On the second, it broke and the satellite flew away!

▲ EXPERIMENTS ON THE MOON

All the Apollo missions took experiments to the Moon. They collected data about moonquakes, magnetism, heat flow through the surface, and the solar wind. Instruments left behind continued to send back data for decades. Three reflectors left were hit by laser beams fired from Earth—this helped scientists to discover that the average distance between the centers of the Earth and the Moon is 239,000 miles (385,000 km), and that the Moon is receding from Earth at about 1.5 in (3.8 cm) a year.

MAPPING HEAT ▲

The Cosmic Background Explorer (COBE) satellite was launched in 1990 to map the heat given out soon after the Universe began. This cosmic background radiation had first been detected in 1965, but COBE made a very accurate map of it. COBE's instruments were sensitive enough to detect changes of only a few millionths of a degree. The different colors in the map are tiny variations in energy intensity. Scientists think these ripples became the matter that formed the stars and galaxies.

◄ NAVIGATION SATELLITE
The European Galileo project is a new satellite navigation system. Navigation satellites allow people to locate their position anywhere on Earth. The satellites send radio signals, which are picked up by a receiver programmed with the satellite orbits. By calculating how far away it is from at least three satellites, the receiver can work out its own exact position on Earth's surface. Car navigation systems combine satellite and road map data to guide drivers.

Satellite orbits at a height of 14,430 miles (23,222 km)

Navigation antennae transmit time signals

Laser communications system

Antenna dish for communicating between satellites

Solar array assemblage is 33 ft (10 m) long

SATELLITE DATA

Everyone uses satellite data in one way or another. Satellites relay telephone calls, TV signals, and Internet traffic. They provide navigation services and take measurements of the land, sea, and atmosphere. They map different types of rock and vegetation. Their pictures of rainforests can reveal illegal logging. They monitor the weather and track hurricanes so that people in their path can be warned. Measurements of temperatures, sea currents, and waves help scientists to understand the oceans. Spy satellites monitor military activity.

COMMUNICATIONS ▲
Satellites form an essential part of the worldwide communications network. They relay telephone calls, including those from cellphones. The European Space Agency's Artemis satellites provide navigation and communication services. They can communicate with other satellites by laser, allowing images of Earth taken by other satellites to be received on Earth in as little as 30 minutes.

**e ►►
satellites**

Star tracker helps the satellite to navigate

Radio antenna transmits data to Earth

Thermal blanket protects against temperature extremes

Radiometer measures sea surface temperature

▲ ENVISAT
Data from the European environmental satellite, Envisat, helps scientists to measure changes in the environment. The satellite orbits Earth from pole to pole, making observations of the land, oceans, atmosphere, and ice. This photograph shows plumes of smoke trailing away from fires raging near the coast of Venezuela. The fires indicate that forests are being cleared for agriculture. Analyzing data from satellites like Envisat can help identify climate changes caused by global warming.

Radar altimeter records wave height and shape of ocean surface

Solar array covers 700 sq ft (70 m²)

Radio antennae *can transmit to the whole Earth or to small areas*

Solar panel *supplies electricity*

MILITARY SATELLITES ▲

Some countries use satellites for spying and defense. Satellites like the one shown above are used by US military forces for secret data communications. The US Space Tracking and Surveillance System (right) is due to start working in 2006-2007. It includes satellites that will spot missiles on launch, track their flights, and relay information to ground-based defense systems. These will destroy the missiles when they re-enter the atmosphere.

Satellite 1 *gives early warning of attack*

Satellite 2 *tracks missiles*

Missiles in midflight

Missiles destroyed on re-entry

Missiles launched

Solar sail *balances the spacecraft*

Infrared sensors *create images by detecting heat*

Payload *includes cameras and infrared sensors*

PHOTOGRAPHING THE PLANET ▶

Earth resources satellites take photographs for all sorts of purposes, from making maps to monitoring land usage. Landsat 7 takes detailed pictures of strips of ground 115 mile (183 km) wide. Its cameras can detect both visible and infrared light. The photograph shows the Capitol building in Washington D.C. It was made by using a computer to combine photographic data from several different satellites.

Solar array *provides 1.5 kw of electrical power for the satellite*

WEATHER SATELLITE ▶

The Geostationary Operational Environmental Satellite (GOES), like many other weather and environmental satellites, is in a geostationary orbit, which means it always looks down on the same part of Earth. The false-color infrared image above, taken by GOES, shows a hurricane over the Caribbean. An infrared camera detects heat rather than light so the image shows information about temperature variation that is not visible in normal photographs.

Solar array *rotates to track the Sun*

HUBBLE SPACE TELESCOPE

In April 1990, a telescope the size of a large bus was launched into Earth orbit. It was named the Hubble Space Telescope (HST), after the American astronomer Edwin Hubble. Soon after it was launched, astronomers found that it would not produce a sharp image. An error of just one-fiftieth the width of a human hair had been made in the manufacture of the telescope's main mirror. In 1993, the Space Shuttle returned to the telescope and astronauts fixed the problem. Since then, the telescope has taken thousands of spectacular photographs of the Universe.

HUBBLE DATA
Length: 44 ft (13.2 m)
Diameter: 14 ft (4.2 m) (without solar arrays) 40 ft (12.0 m) (with solar arrays)
Solar arrays: 40 x 9 ft (12.0 x 2.8 m)
Mass: 11.1 tons
Orbit: 355 miles (569 km) above Earth
Speed: 17,500 mph (28,000 kph)

▼ HUBBLE IN OPERATION
Light enters the narrow end of the telescope and travels down to the primary mirror. It then bounces back up to a small secondary mirror and finally passes through a hole in the primary mirror to arrive at an instrument package. This contains cameras that can photograph stars, objects in our solar system, and galaxies. One camera, the Faint Object Camera, can detect objects five times fainter than the dimmest object visible with a telescope on Earth.

Hubble

▲ COMMANDING HUBBLE
The telescope is controlled from the Space Science Institute in Baltimore, Maryland. Its flight operations team sends commands that turn it to point in the right direction. To make sharp images, it must stay pointed in one direction with extreme accuracy, equivalent to focusing on a dot the width of a human hair at a distance of 1 mile (1.6 km). Hubble operates all day, every day. It transmits enough data to fill a dozen DVDs every week.

High-gain antenna
receives commands from Earth

Secondary mirror
has a diameter of 12 in (30 cm)

Primary (main)
mirror is 8 ft (2.4 m) in diameter

Solar array
unfurls during deployment

Instrument module
contains cameras and other instruments

◀ LAUNCHING HUBBLE
The Hubble Telescope was launched onboard the Space Shuttle Discovery on April 24, 1990. The Orbiter's robot arm gently lifted it out of the payload bay. The solar arrays were designed to unfurl automatically. The first one deployed successfully, but the second one stuck. Astronauts suited up in case they would have to fix the problem, but a second attempt to deploy the array succeeded.

Remote manipulator
arm deploys Hubble

CHANDRA X-RAY IMAGE

HUBBLE OPTICAL IMAGE

VLA RADIO IMAGE

KPNO OPTICAL IMAGE

Aperture door closes to protect the telescope

Handrail for astronauts to hold while servicing the telescope

Magnetometer senses telescope's movement through Earth's magnetic field

Solar array contains 25,000 solar cells

High-gain antenna sends images and data to Earth

WORKING TOGETHER ▶

Images of one object made by different types of telescope, showing different features, can be combined to form a single image. This picture was created using optical images from the Hubble Telescope and the Kitt Peak National Observatory (KPNO), an image from the group of radio telescopes called the Very Large Array (VLA), and an image from the Chandra X-ray Observatory. It shows a galaxy, called C153, being ripped apart as it races through a cluster of other galaxies at 4.4 million mph (7 million kph).

◀ SPITZER SPACE TELESCOPE

The Spitzer Space Telescope, formerly known as the Space Infrared Telescope Facility (SIRTF), was launched on August 25, 2003. It makes images from the heat given out by objects. It has to be in space to work, because most infrared heat rays are blocked by Earth's atmosphere. The telescope, which is 34 in (85 cm) wide, can see through clouds of dust and gas, and can reveal objects that are normally hidden from optical telescopes. It can also detect cool stars and planets orbiting other stars.

Sunshield keeps telescope cool

Optical telescope with 21-ft (6.5-m) diameter main mirror

JAMES WEBB TELESCOPE ▶

The James Webb Space Telescope (JWST) will continue Hubble's work from about the year 2011. Its mirror is more than twice the diameter of Hubble's. Large mirrors are hard to make, so the James Webb telescope's mirror is made from 18 smaller segments. It will be placed about 1 million miles (1.5 million km) from Earth. A sunshield will stop solar radiation from overheating the telescope, which will operate at a temperature of about -400°F (-240°C).

HUBBLE GALLERY

The Hubble Space Telescope has given astronomers an unimaginable view of the Universe. Some of the most beautiful images captured by the telescope show objects called planetary nebulae. These are vast clouds of gas and dust thrown off by dying stars. Hubble has also pictured colliding galaxies, jets of matter speeding through space, and some of the most distant galaxies ever seen.

Hubble

EGG NEBULA
Dust ripples outward from an ageing star 3,000 light years away. One light year equals 5.9 million million miles (9.5 million million km), the distance light travels in a year. False colors have been added to show how light is reflected by the smoke-sized bits of dust.

ROTTEN EGG NEBULA
The Calabash Nebula is also called the Rotten Egg, because it contains sulfur, which smells like rotten eggs!

TORNADOES IN THE LAGOON NEBULA
This funnel-like structure is a pair of gas clouds spiraling around a central hot star, 5,000 light-years away.

TWIN JET NEBULA
Hubble captures twin jets made from gas streaming away from a central star at 186 miles (300 km) per second.

RING NEBULA
In one of the most famous planetary nebulae, the Ring Nebula, a dying star floats in a blue haze of hot gas.

CAT'S EYE NEBULA
This 1,000-year-old planetary nebula features shells, jets, and knots of gas surrounding one or two dying stars.

ESKIMO NEBULA
This dying, sunlike star is known as the Eskimo Nebula, because it resembles a face surrounded by a fur hood.

THE REFLECTION NEBULA
NGC 1999 is also called the Reflection Nebula, because dust around it reflects starlight, like fog around a street lamp.

EAGLE NEBULA
Hubble found these columns of cool hydrogen gas and dust where new stars are forming in the Eagle Nebula.

RETINA NEBULA
This rainbow of colors is a side view of a doughnut-shape of dust and gas thrown out by a dying star.

CYGNUS LOOP SUPERNOVA
Gas flies out from the explosion of a star, a supernova, 15,000 years ago. A supernova is brighter than a galaxy.

A SWARM OF ANCIENT STARS
This swarm of stars, known as NGC 6093, or M80, is one of the densest clusters in our galaxy, the Milky Way.

THE QUINTUPLET CLUSTER
Hubble zoomed in on this cluster of young stars, close to the center of our galaxy, but hidden from Earth by dust.

X MARKS THE BLACK HOLE
An "X" visible at the center of nearby spiral galaxy M51 marks a black hole with a mass equal to a million Suns.

EXPANDING HALO
This shell-like shape is an expanding ball of gas and dust illuminated by a red supergiant star, V838 Monocerotis.

THE LIFE CYCLE OF STARS
The giant nebula, NGC 3603, includes stars of all ages, from newly formed stars at the center to old supergiants.

LOOKING INTO THE PAST
These are among the oldest galaxies seen by Hubble, forming a few hundred million years after the Big Bang.

JUPITER
Hubble has taken beautiful images of the planets in our solar system. This one focuses on Jupiter's atmosphere.

STAR FORMATION
Long streaks of gas whirling around the galaxy NGC 3079 were probably caused by a burst of star formation.

STAR NURSERY
Hubble pinpointed an area of activity in one arm of the spiral galaxy M33, a region where new stars are forming.

BIRTH OF A STAR
The dwarf galaxy, NGC 1569, is a hotbed of star formation, producing clusters of brilliant blue young stars.

SPINNING TADPOLE
The blue stars in this spiral galaxy are massive stars, 10 times hotter and a million times brighter than our Sun.

A MEETING OF GALAXIES
These two galaxies, NGC 2207 (left) and IC 2163, are spinning into each other. The stronger gravitational pull of the larger galaxy has distorted its smaller partner, sending stars and gas flying out into streamers 100,000 light years long.

A DUSTY SPIRAL
The arms of this majestic spiral galaxy are rich in clouds of dust and glowing hydrogen gas emitted by young stars.

SPACE JUNK

Wherever rockets and spacecraft go, they leave pieces of debris, or junk, behind. This space junk ranges from microscopic specks of paint and metal to whole spacecraft. Space debris is a problem, because it can collide with working satellites and manned spacecraft. Traveling at speeds of 17,500 mph (28,000 kph), even pea-sized pieces can cause serious damage. The first known collision happened in July 1996 when the French Cerise satellite collided with debris and tumbled off course. Most of the debris orbiting Earth came from exploding rockets.

space junk

▲ A NEEDLE IN THE HAYSTACK

Space junk is tracked by radar. NASA's main source of data on pieces of ½-12 in (1-30 cm) across is the Haystack X-Band radar operated by the Massachusetts Institute of Technology. It can spot an object the size of a pea over 373 miles (600 km) away, so craft in the area can be alerted. Scanners like Haystack have shown that most debris orbits within 1,242 miles (2,000 km) of Earth, with thick bands at 497 miles (800 km), 621 miles (1,000 km), and 932 miles (1,500 km).

Each dot is a piece of space junk orbiting the Earth

Moon-buggy's metal parts will not rust in space

Soft fabrics in the seats are most likely to perish

Titanium wheel treads will not corrode

Debris travels at speeds of about 18,000 mph (29,000 kph)

More than 100,000 pieces of debris are ½-12 in (1-30 cm) across

▲ MOON SCRAP

The Moon is littered with junk from Earth. There are space probes that crashed or landed there before the manned landings. The descent stages of six Apollo lunar modules still stand on the surface. Three of them have had lunar rovers parked beside them since they were abandoned in the 1970s. Without air or moisture, they will not rust or rot. The only thing stopping the lunar rovers from being driven away, now or in a thousand years, is a dead battery!

JUNK IN ORBIT ▶

Earth is surrounded by space debris. Pieces in the lowest orbits, below 373 miles (600 km), spiral back into the atmosphere within a few years. At a height of about 497 miles (800 km), debris can stay in orbit for decades. Debris more than 621 miles (1,000 km) above Earth may stay in orbit for a century or more. Nothing can be done about debris in orbit, but space-faring nations have introduced guidelines to minimize orbital debris in the future.

SKYLAB FALLS TO EARTH ▶

The largest pieces of junk are old space stations. When they have ended their working life, they re-enter the atmosphere. The last of three crews left the US space station Skylab on February 8, 1974. Its orbit gradually decayed (lowered) until it re-entered the atmosphere on July 11, 1979. Skylab was too big to burn up. Pieces as big as 1,000 lb (373 kg) landed in the Indian Ocean and Australia. In 2001, Russia's Mir space station shattered into 1,500 pieces 45 miles (72 km) above Earth before landing in the Pacific Ocean.

BEYOND THE EARTH ▶

Apollo 17's lunar module travels to the Moon, visible inside the S-IVB rocket (top). The particles surrounding it are paint and insulation flakes shed when the S-IVB, the third stage, separated from the Saturn V rocket. Once it had delivered the astronauts into orbit, the useless S-IVB was put on course to hit the Moon to test the seismometers (shock wave detectors) left there. Debris from earlier discarded spacecraft that traveled to the Moon now orbits the Sun.

More than 11,000 pieces of debris are 4 in (10 cm) across or larger

◀ MICRO-TROUBLE

Microscopic particles of debris cause damage because of their high speed. This ⅙ in (4 mm) pit was made in a Space Shuttle window by a flake of paint measuring less than ¹⁄₅₅ in (0.5 mm)! After 15 years in space, the Mir space station was covered with dents and pits. The International Space Station is more heavily shielded than any other spacecraft, to protect it from dust and debris.

1/6 INCH (4 MM)

Energy flash on the target inside a NASA test chamber

Tens of millions of junk particles are smaller than ½ in (1 cm) across

IMPACT STUDIES ▶

This flash was produced by an object hitting a solid surface at 17,500 mph (28,000 kph). Experiments like this, at NASA's Hypervelocity Ballistics Range in California, simulate what happens to a spacecraft hit by a piece of debris. In 1985, a satellite was deliberately smashed to pieces in orbit to see what would happen to the debris. The impact produced 285 pieces, which were each tracked. By January 1998, all but eight had re-entered the atmosphere.

GOING TO THE PLANETS

Space probes have been exploring the solar system since the early 1960s. They have flown past, orbited, crashed into, landed on, or driven across every planet except Pluto. They bristle with instruments to learn as much as possible about our planetary neighbors. Probes sent to the outer planets are also equipped with nuclear power generators, because there is too little sunlight to use solar panels. These robotic explorers have sent back thousands of stunning images and revealed many secrets.

Mariner 10 revealed Mercury's crater-scarred surface

▲ MARINER REACHES MERCURY

Mariner 10 gave scientists their first close-up view of Mercury. Launched in 1973, it was the first probe to visit two planets. The gravitational pull of Venus was used to swing the 1,109 lb (503 kg) probe around and propel it toward Mercury. Mariner 10 was the first probe to use this maneuver, called gravity assist. Between 1974 and 1975, it flew within 146 miles (271 km) of Mercury three times, taking 2,800 photographs.

Odyssey took thermal images of Mars to show scientists its mineral content

◄ MARS

Mars has fascinated people for generations. In 1965, Mariner 4 took photographs looking for signs of life, but found none. Two Viking probes landed in 1976 and tested soil, but the results weren't clear. A tiny rover called Sojourner landed in 1997, sending back 550 images. In 2001, Odyssey entered Mars' orbit to study climate and geology. In 2004, two larger rovers, Spirit and Opportunity landed. Other probes have mapped its surface, still searching for life-forms.

Galileo photographed Jupiter and its moons, including Europa

◄ JUPITER

Jupiter is the solar system's biggest planet. More than 1,300 Earths would fit inside it. A vast storm, called the Great Red Spot, has been raging there for the past 300 years. Pioneer 10 took the first close-up pictures of Jupiter in 1973. Pioneer 11 and two Voyager probes followed. In 1995, after a six-year flight, Galileo went into orbit around Jupiter and dropped a mini-probe into its atmosphere. It found that the gas giant is mostly hydrogen.

VENUS ►

Radar data collected by a series of probes, including Pioneer, Venus, and Magellan, was used to make this false-color image of Venus. The planet is hidden beneath a thick, poisonous atmosphere, but radar can see through it and map the surface. Computers use the data to create 3-D views (far right). The Soviet Venera 3 probe was the first to land on Venus in 1965.

PLUTO

◄ SEEING SATURN

Saturn is the solar system's most beautiful
planet, with its broad, flat rings made of pieces
of rock and ice. This false-color photograph shows
bands of clouds in the atmosphere. Launched in 1973,
Pioneer 11 followed its twin probe Pioneer 10 across the asteroid
belt. After visiting Jupiter, it reached Saturn in 1979 and located two
undiscovered moons and another ring. Both Pioneer probes have now left our
solar system. Voyagers 1 and 2 visited Saturn in the early 1980s. The Cassini space
probe arrived in 2004. Cassini carries a mini-probe, called Huygens. It is designed
to explore Titan, one of Saturn's moons, which may have liquid oceans.

*Pioneer 11 took
the first close-up
photographs
of Saturn*

VOYAGE TO URANUS ►

This false-color picture shows Uranus's rings, discovered in
1977. Uranus is an odd planet. It is tipped over on its
side and spins in the opposite direction to Earth.
When Voyager 2, the only probe to visit Uranus,
arrived in 1986, its south pole pointed straight at
the Sun. The probe also discovered ten previously
unknown moons. Uranus is a gas giant, like
Jupiter and Saturn. It is covered by a hazy,
blue-green atmosphere made from
hydrogen, helium, and methane.

*A radar image of Venus with
different colors representing
heights on the surface*

probes

*Voyager 2 confirmed the
existence of Uranus's rings
(above), then went on to Neptune*

NEPTUNE ▼

Neptune is the furthest gas planet from the Sun. Only tiny Pluto is
further away. When Voyager 2 arrived in 1989, it photographed
a giant storm (below), nicknamed the Great Dark Spot.
When the Hubble photographed Neptune in 1996, the
storm had disappeared. Neptune has the fastest winds
in the solar system at 1,350 mph (2,500 kph). Like
Jupiter, Saturn, and Uranus, it also has rings.

3-D IMAGE OF VENUS

*Magellan, built from
leftover parts of other
spacecraft, reached
Venus in 1990*

USA

MISSION MARS

Two Mars Exploration Rovers (MER), called Spirit and Opportunity, landed on opposite sides of Mars in January 2004. As part of NASA's long-term Mars Exploration Program, their main aim was to seek evidence for the existence of water on Mars in the past. Spirit touched down in Gusev Crater and Opportunity landed in the Meridiani Planum. The landing sites were chosen because Gusev Crater may once have been a lake and Meridiani Planum has minerals that are normally associated with water.

ACIDALIA PLANITIA

METEORITE IMPACT CRATERS

LUNAE PLANUM GANGES CHASMA

VALLES MARINERIS GIANT CANYON SYSTEM

SOLIS PLANUM

SWIRLING DUST STORM

RADIATION LEVELS ON MARS

These maps show radiation levels all over Mars. They are hundreds of times higher than on Earth. Astronauts should be able to survive a mission to Mars, but for now it is safer to send robots to explore.

False-color map highlights radiation levels

In the US, the annual radiation dose is 1.5 millisievert (150 millirem) at sea level. Millirems and millisieverts are units of radiation dose.

KEY: *annual radiation dose on Mars*

| 20 rem/year | 22 | 24 | 26 | 28 | 30 |

◄ HOSTILE ENVIRONMENT

Mars is the most Earthlike of all the planets. It has polar ice caps, an atmosphere, weather and seasons, but it is still a very hostile environment compared to Earth. The Martian atmosphere is 100 times thinner than Earth's and made mainly from carbon dioxide. The Viking spacecraft that landed there in 1976 recorded night temperatures as low as -148˚F (-100˚C). The surface is dry and dusty. Winds sometimes whip up the fine dust into sand-storms that can rage at 249 mph (400 kph).

◄ EVIDENCE OF WATER?

Opportunity took this false-color photograph of a rock outcrop on Mars in an area called Shoemaker's Patio. It shows finely layered sediments, giving the rocks a striped appearance. Tiny round grains, nicknamed blueberries, are spread all over the rocks. These features, or concretions, are known to form in wet conditions. They may be strong evidence pointing to the existence of water in the past.

MARS DATA

Diameter at equator: 4,222 miles (6,794 km)
Average distance from Sun: 141.6 million miles (227.9 million km)
Year (time to orbit Sun): 687 days
Day (time to spin once): 24.62 hours
Mass: 0.11 x Earth's
Gravity: 0.38 x Earth's
Average temperature: -81˚F (-63˚C)
Moons: 2 (Phobos and Deimos)

▲ RUSTY RED PLANET

This panoramic picture shows the part of the planet where the Spirit rover landed. Mars' dusty surface is red because it contains a lot of iron chemically combined with oxygen—rust! The shallow depression on the left of the rock-strewn area is a 656-foot (200-m) crater called Bonneville. The crater was probably caused by a massive meteorite slamming into the Martian surface. Mars has been repeatedly hit by meteorites, leaving a layer of debris over it.

LANDING ROVERS ON MARS

PLUNGING TO THE PLANET
The lander enters the atmosphere at nearly 12,428 mph (20,000 kph). Friction between the craft and the atmosphere heats it to 2,642°F (1,450°C). The atmosphere acts like a brake and slows the craft down.

RETRO-FIRE
About 29,526 ft (9,000 m) above Mars, a parachute is deployed. Twenty seconds later, the heat shield falls away. Air bags inflate to protect the lander. Then rockets fire and bring it to a halt 33 ft (10 m) above the surface.

TOUCHDOWN
The lander is released from the parachute and falls to the surface. It bounces and rolls for nearly a mile before it comes to a halt. Then it transmits its first radio signal to Earth to announce its arrival.

DRIVING AWAY
The air bags are deflated and the lander opens up to form a platform and ramps. The lander unfolds its solar panels to generate electricity. Then it is carefully steered down one of the ramps and onto the Martian surface.

MARS ROVER ▶

The robotic geologists, Spirit and Opportunity, stand 5 ft (1.5 m) high and weigh 408 lb (185 kg). Six wheels powered by electric motors take them roving over Mars, and they are equipped with cameras and instruments to find interesting rocks and analyze them. Soon after each sunrise, they receive commands from Earth and work until sunset. Data collected by the two robotic explorers includes soil analysis and photographs. The data is transmitted directly to Earth or to a spacecraft orbiting Mars.

Navigation cameras provide a view of the terrain to help NASA scientists plan the rover's movements

Mars

Panoramic cameras take high-resolution, wide-angle pictures of the Martian surfaces

Pancam mast assembly (PMA) supports panoramic and navigation cameras and rotates 360° to view in different directions

Low gain antenna for radio communications

High gain antenna relays findings to a Mars-orbiting spacecraft or to NASA's Deep Space Network (DSN)

Solar panels generate electricity from sunlight

Robotic arm carries a rock abrasion tool to grind rock samples and a microscopic imager to view them in close-up

Two spectrometers analyze rocks

Rocker-bogie mobility system for scrambling over rocky terrain

ASTEROID ALERT

The solar system formed from a cloud of gas and dust that collapsed in on itself about 4.5 billion years ago. Clumps of matter in the cloud attracted more matter onto them. The clumps collided and joined together, making bigger objects and eventually forming the planets. Asteroids are chunks of rock that did not form into planets and have survived to the present day. Most orbit the Sun between Mars and Jupiter, but collisions occasionally send one into a new orbit that may bring it closer to Earth, posing the risk of a disastrous impact.

DACTYL

IDA

◄ ASTEROID AND MOON
Asteroids are smaller than planets and exert a much weaker gravitational pull. Even so, asteroids can attract small objects toward them. In 1993, as the Galileo space probe made its way to Jupiter, it passed an asteroid called Ida. Ida is about 36 miles (58 km) long, and its cratered surface suggests that it is about one billion years old. Galileo's photographs revealed that Ida has a companion. It is being orbited by its own tiny moon, called Dactyl.

Communication antenna is 6 ft (1.5 m) in diameter

Solar arrays generate 1.8 kW of electrical power

NEAR SHOEMAKER PROBE

LANDING ON AN ASTEROID ►
The Near Earth Asteroid Rendezvous (NEAR) was the first space mission designed solely to study an asteroid. In February 2000, the NEAR Shoemaker probe approached an asteroid called 433 Eros. Ground controllers maneuvered the spacecraft into orbit around the asteroid. After a year in orbit, photographing Eros from as little as 3 miles (5 km) away, the spacecraft was commanded to land on the asteroid in February 2001.

Thruster used to steer probe

| 3 MILES (5 KM) |

METEORITES ►
Billions of pieces of rock, most as small as grains of sand, enter Earth's atmosphere from space every day. Most burn up in a streak of light called a meteor, or shooting star. Meteorites are larger rocks that reach the ground. Most meteorites are made of rock. A few are made of iron or a mixture of rock and iron. Some meteorites originated from the Moon or Mars, but (like asteroids) most consist of material from the early solar system.

▲ IMPACT CRATER
Asteroids have hit Earth in the past. This crater in Arizona was caused 50,000 years ago by the impact of an asteroid that was roughly 150 ft (45 m) across. Known as the Barringer crater, it is ¾ mile (1.2 km) wide and 658 ft (200 m) deep. An even bigger object, which may have been an asteroid or a comet, struck Earth off the coast of Mexico 65 million years ago and is thought to have hastened the extinction of the dinosaurs.

▲ THE TUNGUSKA EVENT
In 1908, a huge explosion was traced to the Tunguska River region of Siberia. Scientists who investigated found an amazing sight. Whole forests had been flattened up to 19 miles (30 km) away from the impact point. There was no crater, so the object probably exploded in mid-air. Scientists believe it must have been a comet or an asteroid made of loosely-bound material. It weighed up to one million tons.

EFFECTS OF ASTEROIDS HITTING EARTH

SIZE OF ASTEROID	POSSIBLE DAMAGE
165 ft (50 m)	Most of the asteroid would burn up or explode in the atmosphere. The remainder would be slowed down so much that it could do little damage outside the impact site.
165–330 ft (50–100 m)	Cities the size of London, Tokyo, or New York could be destroyed. Hundreds of square miles of land would be devastated and forests flattened.
3,300 ft (1 km)	Enough dust would be thrown up into the atmosphere to reduce temperatures and dim sunlight around the world, causing environmental damage in most countries. Up to 1.5 billion people could be killed.
6 miles (10 km)	The impact would cause earthquakes worldwide. Red-hot ash thrown up into the atmosphere would cause widespread fires as it rained down. Chemicals released by the impact would destroy the ozone layer and cause acid rain. So much dust would be thrown up that temperatures would fall and sunlight would be dimmed enough to kill crops all over the world. Most of the human race would die.

OVERHEAD VIEW

Asteroid belt is about 115 million miles (170 million km) wide

SIDE VIEW

Asteroid belt

Sun

Earth

Jupiter

Venus Mars

Mercury

▲ THE ASTEROID BELT

Most asteroids orbit the Sun in a broad band called the asteroid belt, which is located between the orbits of Mars and Jupiter. The belt extends from about 185 to 300 million miles (330 million km to almost 500 million km) from the Sun. There are also two groups of asteroids in the same orbit as Jupiter. Known as the Trojans, one group orbits the Sun ahead of Jupiter and another group follows the giant planet.

asteroids

ROCKS IN SPACE ►

Asteroids range in size from large boulders to rocks hundreds of miles across. Most are lumpy, not spherical like planets, because their gravity is too weak to pull them into a round shape. The largest, Ceres, was the first to be discovered, in 1801. Ceres is 584 miles (940 km) wide and orbits at an average of 258 million miles (415 million km) from the Sun. It contains one-third of the total mass of all asteroids in the solar system.

RIDING A COMET

Comets have fascinated people since ancient times. They are chunks of dust and ice that originate in the outer reaches of the solar system. Occasionally, a collision or a tug of gravity from a star or planet changes a comet's orbit and sends it closer to the Sun. As it approaches the Sun, ice and frozen chemicals in the comet melt and evaporate. They form tails of gas and dust that stream away from the comet. Now spacecraft are being sent to study comets close-up, and even land on them.

Tails always point away from the Sun

Dust tail can be over 6 million miles long

ORBITING A COMET ►
The Rosetta spacecraft will orbit Comet 67P/Churyumov-Gerasimenko after a ten-year journey through space. The comet was discovered in 1969. The 2.5-mile (4-km) wide ball of ice and dust is traveling at 85,000 mph (136,000 kph). Maneuvering the spacecraft into orbit around the comet is very tricky, because the spacecraft's flight path is affected by dust and jets of gas coming from the comet, and also by its weak and irregular gravity.

Head is a solid nucleus surrounded by a coma of gas and dust

◄ INSIDE A COMET
Hale-Bopp was the brightest comet for over 20 years when it passed the Sun in 1997. Millions of people on Earth saw it. Most comets are less than 10 miles (15 km) across. Hale-Bopp's nucleus, the solid part in the middle, is 25 miles (40 km) across. As it neared the Sun, it developed two tails—a yellow dust tail and a blue gas tail. It passed within 86 million miles (138 million km) of the Sun on April 1, 1997. Hale-Bopp will return in 2,392 years.

Gas tail can be hundreds of miles long

GIOTTO

In 1986, a European spacecraft called Giotto met up with the most famous comet of all, Halley's Comet, and took close-up photographs of it. The comet is named after English astronomer Edmond Halley (1656-1742). He realized that comets seen in 1531, 1607, and 1682 were the same comet returning every 76 years. He predicted it would return in 1758. He was right.

▲ HALLEY'S COMET IN 1066...
Halley's Comet appears on the Bayeux Tapestry. This medieval embroidery shows the story of the Norman Conquest of England in 1066. One of the scenes on the 229-ft (70-m) long tapestry depicts a bright star with a long, fiery tail. Calculations have shown that this is actually Halley's Comet. The comet is also portrayed in a fresco on the birth of Christ by Italian artist Giotto di Bondone, painted in 1304. In fact, appearances of Halley's Comet have been recorded all the way back to 240 B.C.

▲ ...AND TODAY
Halley's Comet is still making its regular appearances today. The 10½-mile (16-km) long chunk of rock and ice made its latest appearance in 1986. It passed within about 55 million miles (88 million km) of the Sun. It is expected to return in the year 2061. Some comets have much shorter or longer orbits than Halley. Comet Encke returns every 3.3 years, while Comet Hyakutake, last seen in 1996, will probably not return for another 14,000 years.

ROSETTA'S COMET ENCOUNTER

ORBITER
Rosetta will be the first craft to orbit a comet, one of the most difficult maneuvers ever attempted. It will be the first to accompany a comet as it travels toward the Sun. It will study the comet for nearly two years, and carries a craft that will land on the surface of the comet's nucleus.

LANDER
The orbiter has to be guided with precision to ensure that the lander is ejected in the right direction to land on the comet's nucleus. As the lander touches down, it anchors itself on the surface by firing two harpoons into the nucleus. Its legs automatically adjust themselves to keep upright.

EXPERIMENTS
The lander will analyze the chemical composition of the comet's surface and drill into the nucleus to analyze material from below the surface. It will also test the strength of the surface, its texture, ice content, and how porous it is. Data will be transmitted to Rosetta to relay back to Earth.

Solar panels, 45 ft (14 m) long, rotate to face the Sun

Navigation cameras help to keep the craft on course

Cameras take high-resolution images of the comet's nucleus

Radio antenna uses radio waves to study the comet's orbit

The CONSERT experiment will probe the comet with radio signals

Philae, the 220-lb (100-kg) lander, will land on the nucleus

Steerable high gain radio dish, 7 ft (2.2 m) wide, is used for communication with Earth

comets

ROSETTA MISSION SCHEDULE

PLANNED PHASE	PREDICTED DATE
Rosetta launched by Ariane 5	March 2004
First Earth gravity assist	March 2005
Mars gravity assist	March 2007
Second Earth gravity assist	November 2007
Third Earth gravity assist	November 2009
Rosetta enters hibernation	July 2011
End of hibernation	January 2014
Rendezvous with comet	May 2014
Global mapping	August 2014
Lander delivery	November 2014
Perihelion (closest to Sun)	August 2015
End of mission	December 2015

▲ ROSETTA SPACECRAFT
Rosetta's flight path to Comet Churyumov-Gerasimenko takes it around Earth three times and Mars once, using the planets' gravity to swing it around onto the right course. The spacecraft has a cube-shaped body measuring 10 ft by 7 ft by 6 ft 6 in (2.8 m by 2.1 m by 2.0 m), and weighs 6,614 lbs (3,000 kg). More than half of this is propellant. The scientific package, carrying 20 scientific instruments, weighs only 363 lb (165 kg).

SATURN'S RINGS

Saturn is the sixth planet from the Sun. It is encircled by a broad band of rings. These were a mystery when astronomers saw them for the first time in the early 1600s. They are still not fully understood, even though they have now been studied by telescopes and space probes. In 2004, the Cassini space probe arrived at Saturn to study the giant gas planet and its rings and moons. It carried a miniprobe, called Huygens, to investigate Saturn's largest moon, Titan. Scientists think that the air in Titan's atmosphere is similar to the air that existed on Earth billions of years ago.

Five instruments analyze Titan's atmosphere

Gold foil insulates and protects instruments

▲ HUYGENS

The 700-lb (318-kg) Huygens probe enters Titan's atmosphere at 13,500 mph (21,600 kph). The atmosphere slows it to 900 mph (1,440 kph), then it descends to the surface by parachute. In the two hours it takes to reach the surface, its camera takes more than 1,100 images. Onboard instruments sample the atmosphere and radio their results to the Cassini spacecraft. The probe is named after Dutch astronomer Christiaan Huygens (1629-1695), who discovered Titan.

CASSINI-HUYGENS ▶

Cassini-Huygens is a joint NASA-ESA mission. ESA's contribution is the Huygens probe. The Cassini spacecraft, named after the Italian astronomer Giovanni Cassini who first spotted and charted Saturn's moons, is touring the Saturn system for four years. The tour includes 74 orbits of Saturn, 44 flybys of its largest moon, Titan, and numerous flybys of Saturn's other moons. The spacecraft is powered by three nuclear electricity generators. Its science package includes instruments designed to study Saturn's gravity and its magnetic field. It also carries a digital imaging system to photograph Saturn and its moons.

Boom carries instruments to measure Saturn's magnetic field

Saturn

High-gain radio dish is 13 ft (4 m) in diameter

PLANETS WITH RINGS

JUPITER
Saturn is not the only planet with rings. All the giant gas planets (Jupiter, Saturn, Uranus, and Neptune) have rings, although none is as visible or complex as Saturn's. Voyager 2 photographed this faint ring system around Jupiter in 1999.

URANUS
Voyager 2 photographed rings around Uranus in 1986. This false-color image was taken from 2.6 million miles (4.2 million km) away. Astronomers discovered them in 1977 when they noticed that a star dimmed as it passed behind each ring.

NEPTUNE
Neptune's rings, photographed by Voyager 2 in 1979, are so faint that they are invisible from Earth. The darkest parts of the rings dimmed starlight passing through them, but astronomers were not sure if they were rings until Voyager visited Neptune.

SATURN'S RINGS ▶
Saturn's rings are made from billions of chunks of ice and rock of all sizes. The rings are very broad, but also extremely thin. As seen from Earth, they are about 168,000 miles (275,000 km) across, but their overall diameter is around 258,000 miles (415,000 km). They are possibly only about 328 ft (100 m) thick. No one knows where the rings came from. They may be the remains of comets, asteroids, or moons that were smashed apart by collisions.

Pan Atlas Prometheus Janus Telesto Helene Titan
Pandora Epimetheus Calypso Hyperion Phoebe
Mimas Enceladus Tethys Dione Rhea Iapetus

SATURN'S MOONS ▲

Until 1977, astronomers had spotted nine moons orbiting Saturn.
Since then, the Hubble Space Telescope and space probes have found
more. Pioneer 11, Voyager 1, and Voyager 2 flew past Saturn between 1979
and 1981. By the time the Cassini space probe approached Saturn in 2004, the
number of discovered moons had risen to 31. Saturn's largest moon,
Titan, is bigger than the planets Mercury and Pluto. As a moon,
it is second in size only to Jupiter's moon, Ganymede.

SATURN ►

Saturn is the solar system's second biggest planet.
About 746 Earths would fit inside it. For such a big
planet, it spins remarkably quickly. It rotates about
once every 10 hours – more than twice as fast as
tiny Earth. It orbits the Sun nearly 10 times
further out than the Earth and takes 29.5 years
to circle it. Saturn is the only planet that is
less dense than water. If you could find a big
enough pool, Saturn would float in it.

*Two identical engines
are fitted—one is used,
the other is a back-up*

*Rings are composed of
about 1,000 ringlets*

*Huygens probe
travels inside this
dish-shaped aeroshell*

LOOKING CLOSER AT THE RINGS

BRAIDING
The Voyager 2 probe took
pictures of a ring (called the
F ring) twisting around itself.
Scientists call it braiding. They
think the braiding is caused by
the gravity of two tiny moons,
Pandora and Prometheus.

MOON EFFECTS
Saturn's many moons exert an
influence on the rings. The
gravitational pull of each
moon attracts billions of ring
particles. This may be the
reason for some of the gaps
and fine details in the rings.

SPOKES
Scientists are puzzled by dark
lines on the rings, like spokes
on a wheel. They are thought
to be fine dust raised above
the rings by an electrostatic
effect (electrically charged
particles being forced apart).

COLOR
Photographing the rings
through colored filters shows
extra detail. This Voyager 2
image is composed of frames
taken through clear, orange,
and ultraviolet filters from 5.5
million miles (8.9 million km).

DEEP SPACE NETWORK

NASA's Deep Space Network is responsible for tracking, commanding, and receiving data from space probes throughout the solar system. Some of the spacecraft are so far away and they use such small transmitters, that radio signals received from them are about 20 million times weaker than a watch battery. To receive such weak signals, the Deep Space Network uses huge dish-shaped antennae up to 230 ft (70 m) across. To dispatch commands to the most remote spacecraft, the same giant dishes are used to send radio signals from immensely powerful, 400-kilowatt transmitters.

Deep Space
Network

▲ DISH LOCATIONS
The Deep Space Network's antennae are located at three sites: **1** Madrid, Spain, **2** Canberra, Australia, and **3** California. The sites were chosen because they are spaced out at roughly 120 degrees, or one third of the way around the world, from each other. As the Earth turns, at least one of the receiving stations is always in contact with a space probe. This ensures a 24-hour observation, with overlapping time to transfer the radio link to the next station. The locations are also surrounded by mountains that shield them from radio interference. The map shows the time differences between the three countries.

▼ DISHES IN THE DESERT
The American part of the Deep Space Network is the Goldstone Complex, 45 miles (72 km) northeast of Barstow, in the Mojave Desert in California. Goldstone is the center of the Deep Space Network and it has the most dishes. In addition to the big 230-ft (70-m) dish, it also has six 112-ft (34-m) dishes and one 85-ft (26-m) dish. The first spacecraft it communicated with were the interplanetary space probes Pioneer 3 in 1958 and Pioneer 4 in 1959.

FROM SPACE TO SPAIN ▶
The Spanish Deep Space Network complex is located near the village of Robledo de Chavela, 35 miles (56 km) west of Madrid. It became operational in 1965, replacing an earlier ground station near Johannesburg, South Africa. A new 112-ft (34-m) dish was built at the Madrid complex at the end of 2003 to add another 70 hours of tracking time per week. The increase in capacity was necessary because of the large number of space probes exploring the solar system.

AUSTRALIAN ARRAYS ▶
The Australian complex was first used in 1964 and participated in the Mariner 4 mission to Mars. It is located in the Tidbinbilla Valley, 22 miles (35 km) southwest of Canberra. The 98-ft (64-m) Parkes radio dish, named after the nearby town of Parkes, also handles Deep Space Network communications. It was linked to the Canberra and Goldstone dishes to receive signals from the Galileo spacecraft, a technique called arraying.

▲ TRACKING STARDUST

One of the missions being tracked by the Deep Space Network is the Stardust mission to collect particles of dust from a comet and return them to Earth. The Stardust spacecraft was launched on February 7, 1999, and it will return to Earth with its precious samples in 2006. The Deep Space Network will track Stardust during its journey to Comet Wild-2 and back, send the command signals to keep it on course, and receive the data it sends back.

Gas and dust trail from Comet Wild-2

High-gain antenna sends data to Earth

DATA ON THE DEEP SPACE NETWORK

Tracking distance: A 230-ft (70-m) dish is capable of tracking a spacecraft more than 10 million miles (16 billion km) from Earth.

Tracking time: The radio signal from Voyager 1 takes 12 hours and 39 minutes to reach Earth.

DSN power: Transmitter power needed to command a distant probe is 400,000 watts.

Probe power: Typical space probe transmitter power is 20 watts.

Power from probe: Power recieved on Earth from distant space probe is one billionth of one trillionth of one watt.

Most distant probe: Voyager 1 is 8.5 billion miles (13.6 billion km) from the Sun.

STARDUST'S DISCOVERIES ►

On January 2, 2004, after a journey of 2 billion miles (3.2 billion km), the Stardust probe successfully flew through the gas and dust coma around the nucleus of Comet Wild-2 and collected dust samples. It came within 150 miles (240 km) of the icy nucleus and took the most detailed close-up pictures of a comet ever captured by a spacecraft. The images received by the Deep Space Network show what looks like a pock-marked rock 3 miles (5 km) across, with dust and gas jets streaming out of its surface.

LONG-DISTANCE PHOTOGRAPHY

RAW DATA FROM THE PROBE

When a spacecraft camera takes a picture, light from the object strikes a microchip called a CCD (Charge-Coupled Device). The chip's surface is divided into a grid of hundreds of thousands of light-sensitive picture elements, or pixels. The brightness of each pixel is changed into a number, from 0 (black) to 255 (white). The same view is also photographed through color filters. Then all the numbers are converted to digital code and transmitted to Earth.

FORMING AN IMAGE

The stream of digital data from a spacecraft is received by the Deep Space Network and relayed to the Jet Propulsion Laboratory (JPL) in Pasadena, California. JPL's computers form the data into a series of lines. They change the digital code back into numbers, and the numbers into spots of light of the right level of brightness. The black-and-white pictures taken through colored filters are also combined to form false-color images.

PROCESSING PICTURES

The first pictures created often have faults where data had become corrupted or is missing. The pictures are processed by computer to improve their quality by removing faults and unwanted noise, (background data). Ultraviolet, infra-red, and radar data from space probes are processed to make pictures too, by giving false colors to the different numbers in the data. False-color images show information that is normally invisible, such as heat, speed, or height.

SEARCHING FOR LIFE

The Universe is so vast that many astronomers think it is unlikely that Earth is the only planet hosting life. The outer planets were thought to be too cold and dark. Then the discovery of creatures in the cold, dark world at the bottom of Earth's oceans showed that life could exist in such conditions. Scientists look for signs of life in the solar system by analyzing images and soil samples sent back by probes. They also look for life in the Universe by searching for radio signals that intelligent beings might have sent. The work is called SETI, the Search for Extraterrestrial Intelligence.

Sunshade stops sunlight from entering telescope

Deployable cover

Solar arrays also shield telescope from Sun

Photometer records data from stars

Star tracker

Antenna beams images and data to Earth once a week

◄ SEEKING OTHER EARTHS
In 2007, NASA plans to launch a spacecraft called Kepler to look for extra-solar planets (outside the solar system). Its telescope will scan 100,000 stars every 15 minutes. If a planet passes in front of any of the stars, its brightness will dip and Kepler will detect it. Scores of extra-solar planets have been found already, but they are all gas giants like Jupiter. Kepler will be able to detect small, Earthlike planets.

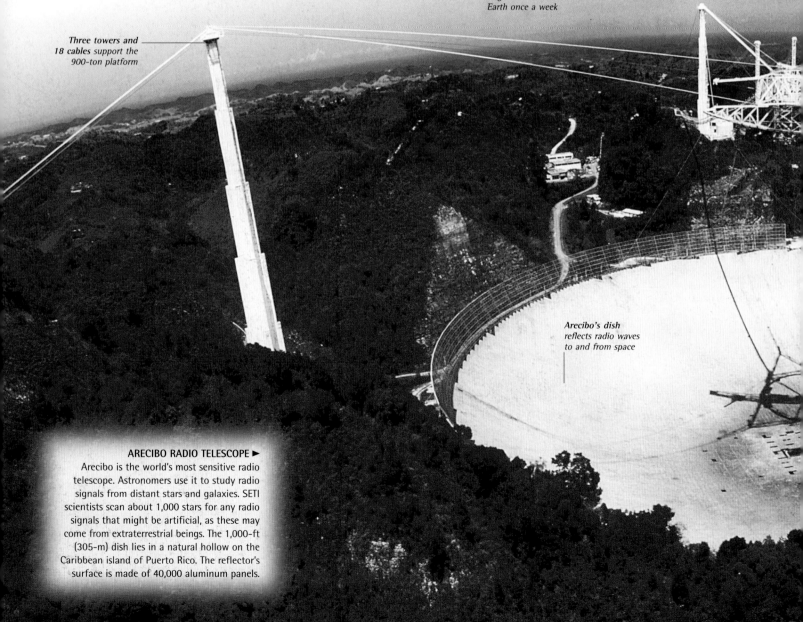

Three towers and 18 cables support the 900-ton platform

Arecibo's dish reflects radio waves to and from space

ARECIBO RADIO TELESCOPE ►
Arecibo is the world's most sensitive radio telescope. Astronomers use it to study radio signals from distant stars and galaxies. SETI scientists scan about 1,000 stars for any radio signals that might be artificial, as these may come from extraterrestrial beings. The 1,000-ft (305-m) dish lies in a natural hollow on the Caribbean island of Puerto Rico. The reflector's surface is made of 40,000 aluminum panels.

◄ EUROPA

Jupiter's moon Europa is about the same size as Earth's Moon, but Europa is covered with ice. Lines as long as 1,850 miles (3,000 km) on its surface look like cracks in the ice. Scientists think there may be a liquid ocean underneath. If it contains water, there may be life there too. In 2012, NASA is planning to send the Jupiter Icy Moons Orbiter to scan Europa and two other moons, Granymede and Callisto, which may have oceans beneath ice.

PAST LIFE ►

Photographs of Mars taken by orbiting spacecraft show features that look very similar to riverbeds and flood plains on Earth that were formed by flowing water. The Mars Exploration Rovers have found layered rocks that look like seabed sediments. These features suggest that water did flow on Mars long ago. This means that even if Mars is a dead planet today, scientists may be able to find evidence of past life in its rocks, or even microorganisms living below the dead surface.

SENDING MESSAGES ►

In 1974, the Arecibo radio telescope transmitted a coded message toward the M13 star cluster. M13 contains 300,000 stars and lies near the edge of our galaxy, 21,000 light years away. The message consisted of 1,679 bits of information. If intelligent beings receive the code, they should be able to rearrange it into 73 lines of 23 bits. In this form, it shows a series of shapes, including the Arecibo dish, our solar system, and a human. If life forms do work it out, a return message would take about 48,000 years to get here from M13.

Binary code gives the numbers one to ten

Symbols represent the chemicals hydrogen, carbon, oxygen, nitrogen, and phosphorus

Twisted lines stand for DNA, the molecule that passes on the blueprint of life

Human figure and Earth's population

Solar system, with Earth out of line to highlight it

Arecibo radio telescope with radio waves

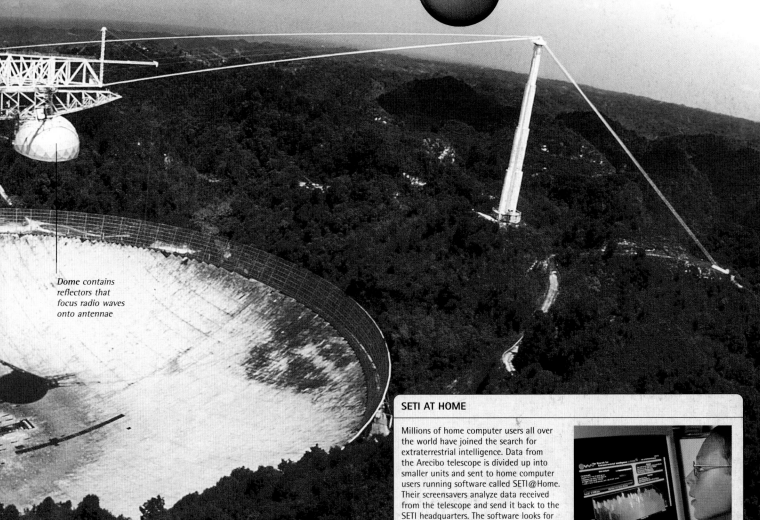

Dome contains reflectors that focus radio waves onto antennae

ET life

SETI AT HOME

Millions of home computer users all over the world have joined the search for extraterrestrial intelligence. Data from the Arecibo telescope is divided up into smaller units and sent to home computer users running software called SETI@Home. Their screensavers analyze data received from the telescope and send it back to the SETI headquarters. The software looks for very narrow-band radio signals, which are most unlikely to come from natural sources. These would show up as spikes flickering on the screen.

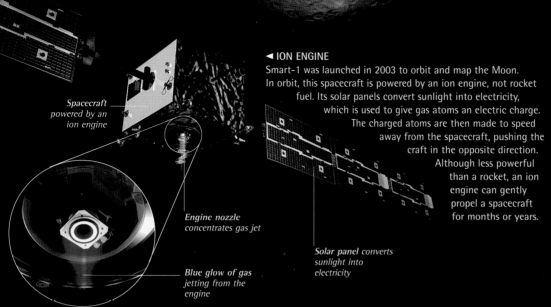

◄ ION ENGINE

Smart-1 was launched in 2003 to orbit and map the Moon. In orbit, this spacecraft is powered by an ion engine, not rocket fuel. Its solar panels convert sunlight into electricity, which is used to give gas atoms an electric charge. The charged atoms are then made to speed away from the spacecraft, pushing the craft in the opposite direction. Although less powerful than a rocket, an ion engine can gently propel a spacecraft for months or years.

Spacecraft powered by an ion engine

Engine nozzle concentrates gas jet

Solar panel converts sunlight into electricity

Blue glow of gas jetting from the engine

THE FUTURE IN SPACE

Scientists and engineers are planning new manned and unmanned space missions for the future. In 2004, President George W. Bush announced that the US intends to send astronauts back to the Moon by 2020 and to Mars after that. One of the most exciting unmanned missions will search for signs of life on Earthlike planets orbiting other stars. Looking further into the future, spacecraft will need new engines that improve on the fuels and rockets used today. One of these, the ion engine, has already been test-flown on several unmanned missions.

▲ MOON BASE

Robots such as the rovers that have been put on the Moon and Mars have been a great success, but some scientists think that human exploration is much more effective. It is likely that humans will return to the Moon in the 21st century. After that, the next stop is Mars. If astronauts do one day make the six-month flight to Mars, separate cargo craft will probably already have delivered supplies for them, along with a module to live in.

Heat radiator sheds excess heat into space

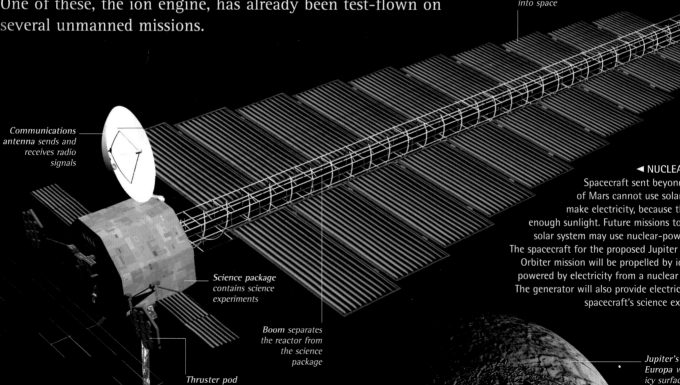

Communications antenna sends and receives radio signals

◄ NUCLEAR POWER

Spacecraft sent beyond the orbit of Mars cannot use solar panels to make electricity, because there is not enough sunlight. Future missions to the outer solar system may use nuclear-powered craft. The spacecraft for the proposed Jupiter Icy Moons Orbiter mission will be propelled by ion engines powered by electricity from a nuclear generator. The generator will also provide electricity for the spacecraft's science experiments.

Science package contains science experiments

Boom separates the reactor from the science package

Jupiter's moon Europa will have its icy surface probed

Thruster pod houses an ion engine

Radar antenna probes below the surface of moons

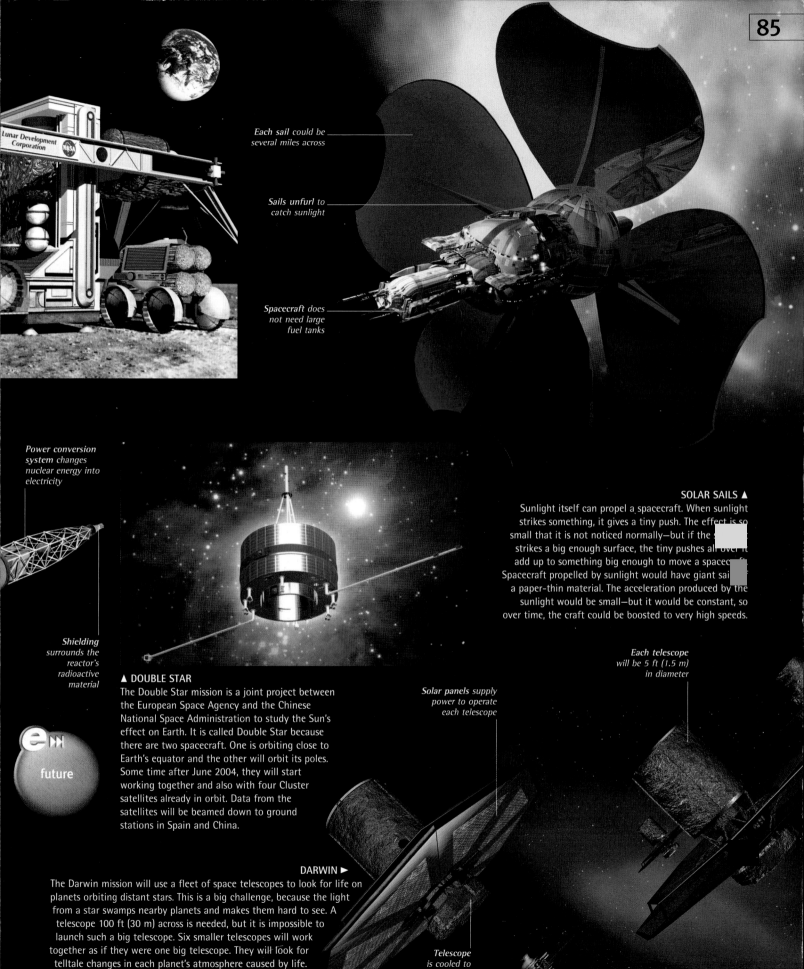

Each sail could be several miles across

Sails unfurl to catch sunlight

Spacecraft does not need large fuel tanks

SOLAR SAILS ▲

Sunlight itself can propel a spacecraft. When sunlight strikes something, it gives a tiny push. The effect is so small that it is not noticed normally—but if the s... strikes a big enough surface, the tiny pushes all over it add up to something big enough to move a spacecraft. Spacecraft propelled by sunlight would have giant sails a paper-thin material. The acceleration produced by the sunlight would be small—but it would be constant, so over time, the craft could be boosted to very high speeds.

Power conversion system changes nuclear energy into electricity

Shielding surrounds the reactor's radioactive material

▲ DOUBLE STAR

The Double Star mission is a joint project between the European Space Agency and the Chinese National Space Administration to study the Sun's effect on Earth. It is called Double Star because there are two spacecraft. One is orbiting close to Earth's equator and the other will orbit its poles. Some time after June 2004, they will start working together and also with four Cluster satellites already in orbit. Data from the satellites will be beamed down to ground stations in Spain and China.

future

Each telescope will be 5 ft (1.5 m) in diameter

Solar panels supply power to operate each telescope

DARWIN ▶

The Darwin mission will use a fleet of space telescopes to look for life on planets orbiting distant stars. This is a big challenge, because the light from a star swamps nearby planets and makes them hard to see. A telescope 100 ft (30 m) across is needed, but it is impossible to launch such a big telescope. Six smaller telescopes will work together as if they were one big telescope. They will look for telltale changes in each planet's atmosphere caused by life.

Telescope is cooled to -445°F (-265°C)

SPACE TIMELINE

The Space Age began in 1957, although the rocket technology underlying space travel can be traced back to some key developments earlier in the 20th century. Since 1957, virtually every year has seen significant developments in space exploration.

timelines

1926 Robert H. Goddard launches the first liquid-fueled rocket.

1944 The V-2 rocket, from which all modern space rockets are derived, is developed by Germany as a weapon toward the end of World War II.

1957 Soviet Union launch Sputnik 1, the first artificial satellite.

Laika is the first dog in space, traveling aboard the Sputnik 2 satellite.

1958 First US artificial satellite, Explorer 1, is launched.

1959 The Soviet space probe Luna 1 is the first to leave Earth orbit.

Luna 2 is the first space probe to reach the surface of a celestial object—the Moon.

Luna 3 probe returns the first photographs of the far side of the Moon.

The first seven American astronauts, called the Mercury Seven, are selected.

1960 The first weather satellite, TIROS 1, is launched.

The Soviet Union puts two dogs, Strelka and Belka, into space and returns them safely.

1961 The first manned spaceflight by the Soviet cosmonaut Yuri Gagarin in the Vostok 1 spacecraft.

First US manned spaceflight by Alan Shepard in the Mercury 3 spacecraft.

President John F. Kennedy announces America's intention to land humans on the Moon by the end of the 1960s.

The Soviet space probe, Venera 1, is the first to fly by Venus, although contact with it is lost before it reaches Venus.

1962 The first US manned orbital spaceflight, Mercury 6, with John Glenn on board.

First successful communications satellite, Telstar 1, sends the first direct TV pictures from US to Europe.

The pop record *Telstar*, by the Tornadoes, climbs to number one in the singles charts in both the UK and US.

The US space probe Mariner 2 flies by Venus and sends back data about the planet.

1963 Valentina Tereshkova becomes the first woman to fly in space, aboard Vostok 6.

1964 First three-person spacecraft, Voskhod 1, is launched.

Ranger 7, a US space probe, crash-lands into the Moon, giving the first high-resolution images of the lunar surface.

1965 First space walk, by a crew member (Alexei Leonov) of the Soviet spacecraft, Voskhod 2.

The first US two-person spaceflight, Gemini 3.

The US space probe Mariner 4 flies by Mars, the first spacecraft ever successfully to do so.

1966 First soft-landing of a spacecraft on the Moon, the Soviet craft Luna 9.

NASA launches the first Earth observation satellite, ESSA-1.

Both the Soviet Union and the US put space probes, Luna 10 and Lunar Orbiter 1, into orbit around the Moon.

The first American soft-landing on the Moon, by the Surveyor 1 space probe.

1967 Fire during Apollo 1 ground test kills three astronauts.

First test-flight of the Saturn V rocket, launching the unmanned Apollo 4 spacecraft.

The Soviet space probe Venera 4 is the first to descend through the atmosphere of Venus and send back data.

Vladimir Komarov dies during re-entry of the Soyuz 1 spacecraft.

1968 The first US three-man spaceflight, Apollo 7.

First manned spacecraft to leave Earth and orbit the Moon, Apollo 8.

The film *2001: A Space Odyssey* is released; though many are baffled by the plot, it gives a scientifically accurate picture of various aspects of living and traveling in space.

1969 Two Apollo 11 astronauts are the first humans to walk on the surface of the Moon.

A second Moon landing is made by two Apollo 12 astronauts.

1970 An explosion occurs aboard the Apollo 13 spacecraft as it travels to the Moon, but the crew of three return safely to Earth.

The Soviet space probe Venera 7 is the first to make a controlled landing on Venus.

Luna 16 is the first robotic space probe to land on the Moon, take a sample, and send it back to Earth.

The Soviet robotic vehicle Lunokhod is landed on the Moon and begins to explore.

China and Japan launch their first artificial satellites.

1971 The first space station, Salyut 1, is launched by the Soviet Union.

Three cosmonauts die during re-entry of Soyuz 11 after becoming the first crew to live on a space station.

The US space probe Mariner 9 becomes the first human-built object to orbit Mars, where it detects huge volcanoes and deep canyons on the planet's surface.

1972 The Soviet probe Mars 2 is the first human-made object to reach the surface of Mars.

NASA launches Pioneer 10, the first space probe to travel to the outer planets.

Last Apollo moon-landing, Apollo 17.

First Earth Resources Technology Satellite, ERTS, is launched.

1973 First US space station, Skylab, is put in orbit.

Pioneer 10 is the first space probe to fly past Jupiter and take close-up pictures of the planet and some of its moons.

1974 The US probe Mariner 10 is the first space probe to fly past the planet Mercury.

1975 The Soviet space probe Venera 9 is the first to send pictures back from the surface of Venus.

The United States and the Soviet Union cooperate in space for the first time when an Apollo craft docks with a Soviet Soyuz craft.

1976 Two US space probes, Viking 1 and Viking 2, land on Mars, send back numerous pictures of the planet's surface, and look for life.

1977 Voyager 2, the only space probe to visit four planets (Jupiter, Saturn, Uranus, and Neptune), is launched, closely followed by Voyager 1.

1978 The first of 24 Global Positioning System navigation satellites is put in Earth orbit.

Czech Vladimir Remek becomes the first non-American, non-Soviet citizen to fly in space.

1979 Pioneer 11 is the first space probe to pass by Saturn and take close-up photographs of its rings.

First launch of Europe's Ariane rocket.

The Voyager 1 and Voyager 2 space probes fly by Jupiter and return dramatic pictures of the planet, its rings, and some of its larger moons.

1980 The Voyager 1 probe sends back pictures of Saturn, revealing it has thousands of ringlets.

The Pioneer Venus 1 probe discovers mountains higher than Mount Everest on Venus.

1981 The first US Space Shuttle mission, Columbia, STS-1.

1982 The last Russian Salyut space station, Salyut 7, is launched.

1983 The world's first infrared astronomical satellite, called IRAS, is launched.

Dr. Sally Ride becomes the first American woman in space on board the Space Shuttle Challenger.

First Spacelab flies on the Space Shuttle.

Pioneer 10 becomes the first object made by humans to leave the solar system.

President Ronald Reagan announces the Strategic Defense Initiative, a space-based system designed to defend the US from attack by nuclear missiles; it is dubbed Star Wars by opponents.

1984 The first untethered space walks are made by Space Shuttle astronauts, using manned maneuvering units.

1986 The first part of the Russian Mir space station is launched.

Space Shuttle Orbiter Challenger explodes just after launch, with loss of all seven of its crew members.

The Japanese space probes Suisei and Sakigake make successful flybys of Halley's comet.

European Space Agency Giotto probe makes a successful flyby of Halley's comet.

Voyager 2 space probe flies past Uranus, returning pictures of the planet, its numerous rings, and moons.

1989 Voyager 2 flies past Neptune, returning pictures of the planet, its rings, and moons.

1990 Magellan space probe begins to orbit the planet Venus and maps its surface.

Hubble Space Telescope is launched.

1991 European Remote Sensing satellite (ERS-1), Europe's first environmental satellite, goes into orbit.

The Soviet Union breaks up and is partially replaced by a Commonwealth of Independent States (CIS), consisting of Russia and ten smaller countries. The former Soviet Union's space program effectively becomes Russia's space program.

1992 The ESA/NASA space probe Ulysses swings by Jupiter and goes into an orbit that will take it over both of the Sun's poles.

The COBE satellite maps the cosmic microwave background radiation for the first time.

1994 Ulysses probe makes first flight over the Sun's south pole.

1995 Galileo space probe goes into orbit around Jupiter.

Russian cosmonaut Valeri Poliakov returns to Earth after spending a record 438 days in space, aboard the Mir space station.

The Solar and Heliospheric Observatory mission (SOHO) is launched into a solar orbit.

1996 NASA confirms that water has been detected on the Moon by the Lunar Prospector spacecraft.

The French satellite Cerise is the first to collide with a cataloged piece of space junk.

1997 NASA's Pathfinder space probe lands on Mars and releases the Sojourner rover onto the planet's surface.

1998 First part of the International Space Station is launched.

1999 The powerful Chandra X-ray Observatory is launched into Earth orbit by the Space Shuttle Columbia.

2000 Two Russian cosmonauts and an American astronomer become the first occupants of the International Space Station.

2001 NEAR Shoemaker is the first space probe to be landed on an asteroid, Eros.

The Mir space station burns up in Earth's atmosphere after 15 years in orbit.

NASA's Deep space 1 probe successfully flies by comet Borrelly.

2002 Mars Odyssey spacecraft starts mapping the planet Mars and looks for water.

2003 Space Shuttle Orbiter Columbia breaks up and is destroyed when re-entering Earth's atmosphere, with loss of all seven of its crew members.

2004 President George W. Bush announces America's intention to send more astronauts to the Moon by the year 2020 and to use Moon missions as a stepping stone for future space exploration.

Stardust spacecraft flies through the coma of Comet Wild-2 and captures thousands of fresh cometary dust particles.

Spirit and Opportunity rovers successfully land on the surface of Mars.

Cassini-Huygens space probe scheduled to go into orbit around Saturn.

2005 Deep Impact probe scheduled to encounter Comet 9P/Tempel 1.

2006 Mars Reconnaissance Orbiter mission is scheduled to reach the planet Mars.

2011 NASA's Messenger space probe is scheduled to start orbiting the planet Mercury.

2012 European Space agency's BepiColombo spacecraft, which includes two Mercury orbiters, is scheduled for launch.

2014 European Space Agency's Rosetta space probe is scheduled to encounter the comet 67P/Churyumov-Gerasimenko and put a small lander on its surface.

MOON LANDING SITES

More than 55 spacecraft have reached the Moon since 1959. Some flew by it, went into orbit around it, or orbited it and then returned to Earth. Below is a summary of 19 of the more important missions that have actually landed or crash-landed on the Moon up to 2004.

maps

(1) LUNA 2 (USSR)

Landing date: September 14, 1959
Location: Near Autolycus crater
Details: The first spacecraft to land on any object outside Earth, though it crash-landed.

(2) AND (3) RANGERS 7 AND 8 (US)

Landing dates: July 28, 1964 and February 20, 1965
Locations: Near Mare Nubium (Sea of Clouds) and Mare Tranquillitatis (Sea of Tranquillity)
Details: Each spacecraft transmitted a series of pictures as it crash-landed on to the Moon.

(4) LUNA 9 (USSR)

Landing date: February 3, 1966
Location: Western side of Oceanus Procellarum (Ocean of Storms)
Details: The first craft to soft-land on any object outside Earth. Luna 9 sent photographs and TV pictures back to Earth for 3 days.

(5) SURVEYOR 1 (US)

Landing date: June 2, 1966
Location: Near the center of Oceanus Procellarum (Ocean of Storms)
Details: The first successful soft-landing by a US spacecraft on any object outside Earth. The spacecraft found it had landed in a 1 inch- (2 cm-) thick layer of dust.

(6) LUNA 13 (USSR)

Landing date: December 24, 1966
Location: Western side of Oceanus Procellarum (Ocean of Storms)
Details: As well as returning TV pictures and data, the probe tested the lunar soil's density and measured its radioactivity.

(7) SURVEYOR 3 (US)

Landing date: April 20, 1967
Location: Eastern side of Oceanus Procellarum (Ocean of Storms)
Details: The probe was the first to carry a surface soil-sampling scoop. Samples were placed in front of the spacecraft's television cameras for image transmission back to Earth.

(8) AND (9) SURVEYORS 5 AND 6 (US)

Landing dates: September 11 and November 10, 1967
Locations: Mare Tranquillitatis (Sea of Tranquillity) and Sinus Medii (Central Bay)
Details: Performed soil surveys and sent back large numbers of photographs to Earth.

(10) APOLLO 11 (US)

Landing date: July 20, 1969
Location: Western side of Mare Tranquillitatis (Sea of Tranquillity)
Astronauts: Neil Armstrong and "Buzz" Aldrin
Details: The first mission in which humans walked on the lunar surface. During their 21.5-hour stay on the Moon, Armstrong and Aldrin walked a distance of about 800 ft (250 m), set up scientific experiments, took photographs, and collected lunar samples.

(11) APOLLO 12 (US)

Landing date: November 19, 1969
Location: Eastern side of Oceanus Procellarum (Ocean of Storms)
Astronauts: "Pete" Conrad and Alan Bean
Details: Conrad and Bean set up scientific experiments, examined the nearby Surveyor 3 spacecraft, collected lunar samples, and took photographs during two moonwalks. Their stay on the Moon lasted 31.5 hours.

(12) LUNA 16 (USSR)

Landing date: September 17, 1970
Location: Mare Fecunditatis (Sea of Fertility)
Details: This probe drilled into the Moon's surface, took a sample, and then successfully sent the sample back to Earth.

(13) LUNA 17 (USSR)

Landing date: November 17, 1970
Location: Mare Imbrium (Sea of Rains)
Details: Delivered the first Lunokhod rover to the Moon's surface. Lunokhod journeyed over the Moon's surface for 10 months and returned over 20,000 photographs.

NEAR SIDE OF MOON

(14) APOLLO 14 (US)

Landing date: February 5, 1971
Location: Fra Mauro region
Astronauts: Alan Shepard and Edgar Mitchell
Details: During their stay on the Moon, the two astronauts set up science experiments, collected Moon rocks, and took photographs. Shepard hit two golf balls. Their stay on the Moon lasted for 33.5 hours.

(15) APOLLO 15 (US)

Landing date: July 30, 1971
Location: Hadley Rille highland region
Astronauts: David Scott and James Irwin
Details: During their 67-hour stay on the Moon, Scott and Irwin made three extra-vehicular activities (EVAs) or Moon explorations. This was the first mission to employ the Lunar Roving Vehicle, which was used to explore regions within 3 miles (5 km) of the landing site.

(16) APOLLO 16 (US)

Landing date: April 20, 1972
Location: Descartes highland region
Astronauts: John Young and Charles Duke
Details: During their 3-day stay on the Moon,. Young and Duke made three EVAs (Moon explorations). They drove 16 miles (27 km) using the Lunar Roving Vehicle, collected 210 lb (95 kg) of rock and soil samples, took photographs, and set up scientific experiments.

(17) APOLLO 17 (US)

Landing date: December 11, 1972
Location: Taurus-Littrow region
Astronauts: Eugene Cernan and Harrison Schmitt
Details: Schmitt, the first scientist on the Moon, and Cernan made three EVAs (Moon explorations) totaling over 22 hours. During this time they covered 18 miles (30 km) in the Lunar Roving Vehicle, and collected 243 lb (110.5 kg) of rocks and dust. The total duration of their stay on the Moon was 75 hours.

(18) LUNA 21 (USSR)

Landing date: January 15, 1973
Location: Mare Serenitatis (Sea of Serenity)
Details: Delivered the Lunokhod 2 lunar rover, which journeyed over the Moon's surface for a total of 4 months.

(19) LUNAR PROSPECTOR (US)

Landing date: July 31, 1999
Location: A shadowed crater not far from the Moon's south pole
Details: It was hoped that the impact of the probe would liberate water vapor from suspected ice deposits in the crater and that the plume would be detectable from Earth. However, no plume was observed.

MARS LANDING SITES

The 10 spacecraft listed below are the only ones that have landed, or are thought to have landed, on Mars up to 2004. Others have flown by Mars or gone into orbit around it.

(1) MARS 2 (USSR)

Landing date: November 27, 1971
Location: Hellas Planitia
Details: Crash-landed while a dust storm was raging on the surface of Mars.

(2) MARS 3 (USSR)

Landing date: December 2, 1971
Location: Near Terra Sirenum
Details: Soft-landed and operated for 20 seconds before failing, possibly due to a dust storm on Mars. One dark, fuzzy image of the Martian surface was returned.

(3) MARS 6 (USSR)

Landing date: March 12, 1974
Location: Margaritifer Sinus region
Details: Communication with lander craft was lost just before landing.

(4) VIKING 1 (US)

Landing date: July 20, 1976
Location: Chryse Planitia
Details: Soft-landed and transmitted images of the Martian surface, took soil samples, and chemically analyzed them for composition and signs of life. Viking 1 studied Mars' atmosphere and weather, and deployed Marsquake-measuring devices. Communications ended on November 13, 1982.

(5) VIKING 2 (US)

Landing date: September 3, 1976
Location: Near Utopia Planitia
Details: Very similar to the Viking 1 mission (above) except for the location and the fact that communications ended on April 11, 1980.

(6) MARS PATHFINDER (US)

Landing date: July 4, 1997
Location: Chryse Planitia
Details: After a soft-landing, the Pathfinder lander deployed a small rover (Sojourner) and made measurements of conditions on Mars. The lander returned almost 10,000 images. The rover explored the Martian surface, analyzed rocks and soil, and returned a total of 550 images. Communications ended on September 27, 1997.

(7) MARS POLAR LANDER (US)

Landing date: December 3, 1999
Location: Toward the south pole of Mars
Details: Contact with the lander was lost as it began the final stages of its descent.

(8) BEAGLE 2 (EUROPEAN SPACE AGENCY)

Landing date: December 25, 2003
Location: Isidis Planitia
Details: Declared lost after no communications were received following the scheduled landing.

(9) SPIRIT ROVER (US)

Landing date: January 4, 2004
Location: Gusev crater
Details: After a successful soft-landing, began exploring Mars. The mission's main goal was to search for and analyze rocks and soils that may hold clues to past water activity on Mars.

(10) OPPORTUNITY ROVER (US)

Landing date: January 25, 2004
Location: Meridiani Planum
Details: Mission goal was the same as for Spirit rover; soon found direct evidence for the existence of past water on surface of Mars.

WESTERN HEMISPHERE OF MARS

EASTERN HEMISPHERE OF MARS

SPACE TRAVEL BIOGRAPHIES

These biographies provide short descriptions of the lives of some notable people who have traveled in space (selected from a total of well over 400 who have been in space since 1961) or were important pioneers of spaceflight science and technology.

biographies

EDWIN "BUZZ" ALDRIN born 1930

Known by the childhood nickname Buzz, Edwin Aldrin was the second person ever to walk on the Moon. As the pilot of Apollo 11's lunar module, he stepped onto the lunar surface 19 minutes after Neil Armstrong on July 21, 1969. Born in New Jersey, Aldrin received a degree in engineering and then became a pilot with the Air Force. After further studies in astronautics, Aldrin was selected for astronaut training in 1963. Before his trip to the Moon, he had made a record 2½-hour spacewalk during the Gemini 12 mission. Aldrin retired from NASA in 1971 and became one of the world's leading advocates of space exploration through writing and public speaking.

NEIL ARMSTRONG born 1930

Neil Armstrong achieved worldwide fame for being the first person to step onto the Moon, as the commander of Apollo 11, at 2:56 a.m. Greenwich Mean Time on July 21, 1969. Born in Ohio, Armstrong had flying lessons as a teenager and gained his pilot's license before he was legally old enough to drive a car. He studied aeronautical engineering at college, became a Navy fighter pilot, and later a test-pilot for NASA. Armstrong made his first spaceflight as command pilot for the Gemini 8 mission in 1966, and three years later made his historic voyage to the Moon. A lunar crater close to the Apollo 11 landing site is named Armstrong in his honor. Armstrong left NASA in 1971 and became a university professor before going into business.

SERGEI AVDEYEV born 1956

The Russian cosmonaut Sergei Avdeyev holds the record for the most time spent in space, with 748 days accumulated on three flights in the 1990s. Born in Chapayevsk in south central European Russia, Avdeyev graduated in 1979 from the Moscow Institute as an engineer-physicist. In 1987, he was selected for cosmonaut training. His three spaceflights were as a flight engineer aboard the Mir space station in 1992-1993, 1995-1996, and 1998-1999. His body has been examined and monitored many times over by doctors researching the consequences of space travel.

EUGENE CERNAN born 1934

Eugene Cernan is best known for being the last person to have stood on the Moon, as commander of Apollo 17 in 1972. Born in Chicago, Cernan received a degree in engineering before becoming a US Navy pilot. NASA selected him as an astronaut in 1963. His first spaceflight, in 1966, was aboard Gemini 9. On this mission, Cernan became the second American to walk in space. In 1970, Cernan was lunar module pilot on Apollo 10, which traveled to the Moon but did not land. During the Apollo 17 mission, Cernan and his companion Harrison Schmitt set records for the longest time moving around on the lunar surface (over 22 hours) and largest return of lunar rocks (243 lb or 110.5 kg). Cernan left NASA in 1976 to go into business.

EILEEN COLLINS born 1956

NASA astronaut Eileen Collins was the first woman to command a Space Shuttle mission. Born in New York State, Collins holds several degrees in science, mathematics, economics, and management, and worked as an Air Force pilot before selection for astronaut training in 1990. She has made three Space Shuttle flights, in 1995, 1997, and 1999, the last as Shuttle commander. A highlight of the 1999 mission (Shuttle mission STS-93) was the deployment of a special space telescope (the Chandra X-Ray Observatory), which is designed to help scientists study phenomena such as exploding stars and black holes.

MICHAEL COLLINS born 1930

Michael Collins was one of the three astronauts on the Apollo 11 mission that put the first people on the Moon in 1969. Collins was in charge of the command module Columbia, which stayed in lunar orbit as his colleagues, Neil Armstrong and Edwin "Buzz" Aldrin, visited the Moon's surface. Born in Rome, Italy, Collins graduated from the US Military Academy in 1952 and then became an Air Force test pilot. In 1963, he was selected for astronaut training and in 1966 made his first spaceflight aboard Gemini 10. Collins resigned from NASA the year after his Apollo mission. He worked as a museum director at the Smithsonian Institution in Washington D.C. and later entered business.

CHARLES "PETE" CONRAD 1930-1999

Charles "Pete" Conrad was the third US astronaut to set foot on the Moon, as commander of the Apollo 12 mission in 1969. Born in Philadelphia, Conrad received a degree in aeronautical engineering before becoming a pilot with the US Navy. In 1962, he was selected for astronaut training. As well as his Apollo 12 journey to the Moon, Conrad flew on two Gemini missions (Gemini 5 and Gemini 11) and was commander of Skylab II, the first crew to man a US Space Station. In 1973, he left NASA to pursue a business career.

MICHAEL FOALE born 1957

British-born Michael Foale holds the record for being the NASA astronaut who has spent longest in space. By the end of April 2004, he had spent a total of 374 days in space, including stints on six Space Shuttle missions, one stay on the Russian space station Mir, and as a commander of the International Space Station. Born in Lincolnshire, England, Foale completed a degree in physics in 1978 and a PhD in astrophysics in 1982. He then moved to Houston, Texas, to work for the US space program and was selected as an astronaut candidate in 1987. In 1997, he spent 145 days living and working on Mir and narrowly escaped death when an unmanned cargo craft accidentally collided with the space station during a docking test.

YURI GAGARIN 1934-1968

The Russian cosmonaut Yuri Gagarin was the first person ever to fly in space, aboard the Vostok 1 spacecraft in 1961. The 108-minute flight, during which he traveled 25,000 miles (40,000 km), was his only trip into space. Born in the village of Klushino in the Smolensk region, Gagarin studied at an industrial college in his teens while learning to fly airplanes. In 1957, he became a pilot in the Soviet Air Force, then joined the cosmonaut corps and four years later was chosen as the first person to journey into space. After his spaceflight, Gagarin became internationally famous and a world hero. He received many honors, including the renaming of his hometown as Gagarin. He was killed in an airplane crash in 1968 while training for another flight.

JOHN GLENN born 1921

John Glenn was the first American to orbit Earth, aboard the Mercury 6 spacecraft. His flight took him on three orbits of Earth in less than 5 hours. Born in Ohio, Glenn served in the Marine Corps during World War II, and later in Korea. In 1954, he started work as a test pilot and in 1957 made the first nonstop supersonic flight from Los Angeles to New York. In 1959, he was selected for astronaut training, and was back-up pilot for the first two Mercury missions. During his Mercury 6 flight, he became the third American in space and the third person to orbit Earth. After retiring from the space program in 1964, Glenn took up politics, and in 1974 was elected Senator in Ohio. In 1998, he became the world's oldest astronaut at age 77 when he flew on a Space Shuttle mission.

ROBERT GODDARD 1882-1945

Robert Goddard was an American physicist and rocket engineer who, in 1926, launched the world's first liquid-fueled rocket. Born in Massachusetts, Goddard became fascinated by the idea of space travel from an early age and, after obtaining a degree in physics, put his mind to developing a space rocket. In 1919, he published his theory of rocketry, and in the 1930s he launched his first stabilized rocket. The US space program grew out of his pioneering efforts, although his work was largely ignored until after his death. NASA's Goddard Space Flight Center, Maryland, is named for him.

VIRGIL "GUS" GRISSOM 1926–1967

In July 1961, Virgil Grissom became the second American to go into space, aboard the Mercury 4 spacecraft. Four years later, his second space flight aboard Gemini 3 earned him the distinction of being the first person to fly in space twice. Grissom was born in Indiana, and after earning a degree in mechanical engineering, became a jet pilot who saw action in the Korean War. In 1959, he was selected for astronaut training. His successful flight on Mercury 4 lasted just over 15 minutes. After the capsule splashed down in the Atlantic it started sinking, and Grissom only just managed to swim clear. He died in 1967 as a result of a fire in the Apollo 1 spacecraft.

MAE JEMISON born 1956

Mae Jemison was the first African-American woman in space, flying aboard the Space Shuttle Endeavour in 1992. Born in Alabama, she has degrees in both chemical engineering and medicine and was working as a doctor in Los Angeles when in 1987 she was selected for astronaut training. She resigned from NASA in 1993, not long after her Space Shuttle mission, and founded an organization committed to the advancement and beneficial uses of space technology and exploration.

SERGEI KOROLEV 1906-1966

Sergei Korolev was a Ukrainian-born designer and engineer who directed the Soviet Union's space program during its early years. His name is linked with many of the great achievements of the first decades of the space age. He was responsible for the Cosmos, Vostok, and Soyuz series of spacecraft. He also played a key role in the launch of Sputnik 1 (the first satellite in space), the first human spaceflight by Yuri Gagarin, and the first space walk, by Alexei Leonov.

ALEXEI LEONOV born 1934

Alexei Leonov is famous for being the first person to walk in space. Born in Listvyanka, Siberia, Leonov is a former jet pilot and was selected for cosmonaut training in 1960. On March 18, 1965, he was launched into orbit aboard Voskhod 2 along with fellow Russian Pavel Belyayev. During the flight, Leonov spent over 20 minutes outside the capsule. This was longer than originally planned because excess pressure in his space suit meant that he had great difficulty re-entering the spacecraft's hatch. Leonov made a second flight 10 years later, making history when his Soyuz craft docked with an American Apollo craft, joining the two nations in space.

YANG LIWEI born 1965

Yang Liwei was the first Chinese person to travel in space, in 2003 aboard the Shenzhou V spacecraft. Born in China's Liaoning Province, Yang Liwei became an Air Force pilot and was selected for cosmonaut training in 1998. The Shenzhou spacecraft that Yang traveled in, similar to a Soyuz spacecraft, was launched from Jiuquan Satellite Launching Center on October 15, 2003. The successful flight lasted over 21 hours and ended with the re-entry capsule landing the next day on the grasslands of the Gobi Desert, in central Inner Mongolia.

JIM LOVELL born 1928

Jim Lovell is best known as the commander of the ill-fated Apollo 13 spacecraft, bringing it back to Earth after it had been crippled by an explosion in an oxygen tank on the way to the Moon. Lovell also flew on the Gemini 7 and Gemini 12 missions and the epic six-day journey of Apollo 8—humanity's maiden voyage to the Moon. Born in Ohio, Lovell spent four years as a test pilot for the US Navy before selection in 1962 for astronaut training. He retired from NASA and the Navy in 1973 and spent several years in business. Lovell was depicted by the actor Tom Hanks in the film *Apollo 13*, based on Lovell's book *Lost Moon: The Perilous Voyage of Apollo 13*. Lovell made a brief appearance at the end of the movie, playing the captain of the recovery ship *USS Iwo Jima*.

SHANNON LUCID born 1943

American astronaut Shannon Lucid holds the record for the most time spent in space by a woman. In 1996, she spent 188 days in space, living and working aboard the Russian Mir space station. Lucid's total time in space is 223 days. This total includes her Mir mission as well as four Space Shuttle missions. Born in Shanghai, China, Shannon Lucid grew up in Oklahoma, earned several science degrees, and worked as a biologist before being selected for astronaut training in 1978.

HERMANN OBERTH 1894-1989

Hermann Oberth was a Romanian-born scientist who pioneered the development of space rocketry. His work on the theories of rocket propulsion and guidance systems in the 1930s resulted in the V-2 rocket. In the 1950s, he worked on the American space program. Oberth's understanding of the interconnections of fuel consumption, rocket speed, distance and duration of flight, and other factors, helped establish the laws that govern modern rocket flight.

VALERI POLIAKOV born 1942

The Russian doctor and ex-cosmonaut Valeri Poliakov holds the record for the longest single stay in space, aboard the Mir station, 438 days from January 8, 1994 to March 22, 1995. He also stayed on Mir for 241 days in 1988-1989, and for several years held the record for the most time spent in space. Born in Tula, Russia, Poliakov graduated as a doctor in 1965 and was selected for astronaut training in 1972. In connection with his spaceflights, Poliakov took part in an unusual medical experiment. Before each mission, some of his bone marrow was removed so that it could be compared with another sample of bone marrow taken when he returned after months of weightlessness. Poliakov retired as an astronaut in 1995 and now works for a public health ministry in Moscow.

SALLY RIDE born 1951

Sally Ride became the first American woman to travel into space in 1983, when she was launched aboard the Space Shuttle Challenger as a mission specialist. Ride's 6-day journey made her the third woman to travel into space (after Valentina Tereshkova in 1963 and Svetlana Savitskaya in 1982). Born in Los Angeles, Ride was a nationally ranked tennis player in her teenage years. A physicist by training, in 1977 she answered a NASA advertisement for Space Shuttle astronauts and was accepted. In addition to her 1983 flight, she made a second Shuttle flight in 1984. Ride helped the movement toward a more equal role for women in the American space program. In 1987, she left NASA and for many years was a Professor of Physics at the University of California.

HARRISON SCHMITT
born 1935

Harrison Schmitt is famous for being the only scientist to have visited the Moon, as lunar module pilot for the Apollo 17 mission. A geologist by training, Schmitt was born in New Mexico. He was selected by NASA as an astronaut-scientist in 1965. As well as training for space flight, he taught other Apollo crew members how to collect suitable rocks on the Moon and later took part in the analysis of those rocks. Schmitt left NASA in 1975 to enter politics and for six years was a Senator for New Mexico.

HELEN SHARMAN
born 1963

Helen Sharman was the first British person to travel into space, aboard the Soviet Soyuz TM-12 spacecraft in 1991. Sharman spent 8 days in space, 6 of them aboard the space station Mir. Born in Sheffield, England, she obtained a chemistry degree in 1984, and worked for five years as a research scientist. In 1989, she answered an advertisement: "Astronaut wanted—no experience necessary". Not long afterward, she found that she had been selected as a trainee cosmonaut for a Soviet space mission. One of the main aspects of her 18-month training program was to learn Russian. Since her return from space, Helen Sharman has continued to work as a scientist and broadcaster.

ALAN SHEPARD
1923-1998

Alan Shepard was the first American in space, as the occupant of the Mercury 3 spacecraft, which was blasted into space on May 5, 1961. The flight lasted just 15 minutes and did not orbit Earth. Instead, the Mercury capsule landed in the Atlantic Ocean 303 miles (488 km) down range from its launch pad at Cape Canaveral, Florida. Born in New Hampshire, Shepard obtained a degree in aeronautics in 1944 and later became a test pilot for the US Navy. In 1959, he was chosen among the first group of seven American astronauts. As well as his Mercury flight, Shepard was commander of the Apollo 14 mission that landed on the Moon in 1971. During one moonwalk, Shepard famously hit two golf balls for hundreds of yards over the Moon's surface. Shepard retired from NASA in 1974 and went into business.

VALENTINA TERESHKOVA
born 1937

Valentina Tereshkova was the first woman to fly in space. In June 1963, she made 48 Earth orbits aboard the Vostok 6 spacecraft. Born near Yaroslavl in western Russia, Tereshkova left school at 16 to work in a textile factory. She also became an amateur parachutist, and in 1962 was selected for space flight. After her 71-hour Vostok 6 flight, at the end of which Tereshkova parachuted to the ground, she was made a Hero of the Soviet Union. It was to be another 19 years before another woman traveled in space.

DENNIS TITO
born 1940

Dennis Tito is an American multimillionaire who in June 2001 became the world's first space tourist, traveling for 8 days on board the Soyuz TM-32 spacecraft and the International Space Station. During the trip, Tito spent hours gazing at Earth and taking photographs. He paid $20 million to go on the mission. Born in New York City, Tito earned degrees in astronautics and aeronautics and worked as a scientist at NASA's Jet Propulsion Laboratory before founding an investment management company. After his space journey, he described it as a "trip to paradise."

GHERMAN TITOV
1935-2000

Gherman Titov was the second person in space (after Yuri Gagarin), flying on board the Soviet spacecraft Vostok 2, which orbited Earth for 24 hours on August 6-7, 1961. Unlike Gagarin, Titov was briefly allowed to take manual control of his spacecraft during the flight. Born in the Altai region of Siberia, Titov graduated as a Soviet Air Force pilot and was selected for cosmonaut training in 1960. Just short of age 26 at the launch of Vostok 2, he is the youngest person ever to have flown in space. Following his flight, Titov worked in various senior positions in the Soviet Union's space program until his retirement in 1992. In 1995, he entered politics.

KONSTANTIN TSIOLKOVSKY
1857-1935

Konstantin Tsiolkovsky was a Russian pioneer of the theory of spaceflight. He produced theories of rocketry but did not have the resources to build a rocket. By 1898, he had produced a theory that showed how much fuel a rocket would use and how its velocity was related to the thrust of its engines. He was the first person to propose the use of liquid propellants for rockets. He also worked out that multistage rockets would be needed to leave Earth's gravity and showed how these could be stacked on top of one another.

WERNHER VON BRAUN
1912-1977

Wernher von Braun was a German-born rocket engineer responsible for the development of several important liquid-fueled rockets in Germany and the US. During World War II, he led the development of rockets for the German army, in particular the V-2 rocket. Because this was used as a weapon against cities in England, Belgium, France, and the Netherlands, and because thousands of people enslaved by the Nazis were killed while working on von Braun's missile projects, he is a controversial figure. At the end of the war, von Braun and his team surrendered to US forces. The team eventually joined NASA and was responsible for the launch of the first US satellite and for the Saturn V rocket, which was used to launch the Apollo missions to the Moon.

CARL WALZ
born 1955

Carl Walz is co-holder of the record for the longest single US spaceflight. During Expedition 4 of the International Space Station in 2001-2002, he and NASA astronaut Daniel Bursch spent nearly 196 days in space. A veteran of four spaceflights (the other three were Space Shuttle missions), Walz was born in Ohio and trained as a physicist. Selected as an astronaut in 1990, overall he has spent 231 days in space.

EDWARD WHITE
1930-1967

Ed White achieved fame in 1965, when he became the first American to go for a space walk, outside of the Gemini 4 spacecraft. White was outside Gemini 4 for 21 minutes, and became the first man to control himself during a space walk using a gun filled with compressed gas. When told to return to the spacecraft, White said, "It's the saddest moment of my life." Born in Texas, White earned a degree in aeronautical engineering in 1959 and then became an Air Force pilot. He was selected for astronaut training in 1962. White died in 1967, along with Gus Grissom and Roger Chaffee, as a result of a fire in the Apollo 1 spacecraft.

JOHN YOUNG
born 1930

American astronaut John Young was commander of the Apollo 16 mission to the Moon in 1972, the first Space Shuttle flight in 1981, and a second Space Shuttle flight in 1983. He also flew in two Gemini missions (Gemini 3 and 10) during the 1960s, and made 31 lunar orbits in Apollo 10, the dress rehearsal for the first Moon landing. Born in California, Young earned a degree in aeronautical engineering before becoming a test pilot in the US Navy. In 1962, he was selected as an astronaut. During the Apollo 16 mission in 1972, Young and Charlie Duke collected some 210 lb (95 kg) of moon rocks and drove over 16 miles (27 km) in a lunar rover on three separate explorations. John Young continues to work for NASA and, as an active astronaut, remains eligible to command future Space Shuttle missions. In preparation for prime and backup crew positions on 11 spaceflights, it is calculated that Young has spent more than 15,000 hours in astronaut training, mostly in simulators and simulations.

GLOSSARY

Terms in *italics* are other glossary entries.

Airlock A sealed chamber in which air pressure can be changed. Astronauts use an airlock to transfer between a pressurized spacecraft and the airless environment of space.

Antenna A device used to send and receive radio signals between a spacecraft and a ground station on Earth or another spacecraft.

Atmosphere A layer of gas held around a planet or moon by its *gravity*.

Celestial object Any object in space, such as a planet, asteroid, moon, *star*, or *galaxy*.

Communications satellite An artificial *satellite* that is used for transferring TV, radio, or telephone signals from one place to another.

Cosmonaut An astronaut from the former Soviet Union or present-day Russia.

Dock To link up one spacecraft with another.

Electromagnetic radiation A form of energy that can travel through the *vacuum* of space.

Electromagnetic spectrum A range of different types of *electromagnetic radiation*, including *radio waves*, *infrared radiation*, light, *ultraviolet radiation*, *X-rays*, and gamma rays.

Elliptical orbit An *orbit* in the shape of an ellipse (a stretched or squashed circle).

Environmental satellite A type of artificial *satellite* that monitors aspects of Earth's environment, such as weather patterns.

Extra-vehicular activity (EVA) Any activity in which an astronaut or *cosmonaut* goes outside the spacecraft. Also called a space walk.

Fairing The protective aerodynamic casing around a rocket's *payload* during launch.

Force A push or a pull that can change the velocity of an object.

Free fall A situation in which an object is traveling in space or orbiting a planet or moon and, in the case of a spacecraft and its occupants, the craft's engine is turned off.

Fuel cell A device that produces electrical energy by combining hydrogen and oxygen.

Flyby An encounter between a *space probe* and a planet, moon, comet, or asteroid in which the probe does not stop to orbit or land.

Galaxy A collection of millions or billions of *stars*, gas, and dust held together by *gravity*.

Gravitational assist A spacecraft's use of a planet or moon's *gravity* to change its speed or direction of travel.

Gravity A *force* that attracts objects together. The higher the *mass* of the objects, and the closer they are, the greater the gravitational attraction between them.

Heat shield A coating of heat-resistant material on the outer shell of a spacecraft.

Infrared radiation A form of invisible *electromagnetic radiation*. Radiant heat is a form of infrared radiation.

Ion An electrically charged atom or group of atoms.

Ion engine A means of propulsion in space that relies on shooting a fast-moving stream of *ions* out of the spacecraft; this moves the craft itself in the opposite direction.

JPL The Jet Propulsion Laboratory, a part of *NASA* that operates unmanned spacecraft.

Lander A part of a *space probe* designed to land on a planet, moon, asteroid, or comet.

Light year The distance traveled by light through a *vacuum* in a year, about 5.9 million million miles (9.5 million million km).

Lunar Related to the Moon. Being in lunar *orbit* means being in orbit around the Moon.

Magnetic field Magnetism generated by a planet, *star*, or *galaxy*, that extends into space.

Magnetometer A scientific instrument used to detect and study the *magnetic fields* of planets and other *celestial objects*.

Manned maneuvering unit A special jet backpack used by some astronauts to help them move around in space.

Mass The amount of matter an object contains, measured in pounds or kilograms.

Micrometeoroid shield A protective casing on the outside of a spacecraft, designed to reduce damage caused by the impact of small objects traveling at high speed through space.

Microgravity A state of almost total *weightlessness* experienced when in *free fall*.

NASA The National Aeronautics and Space Administration, an agency responsible for the American civilian space program.

Orbit The curved path of one object around another under the influence of *gravity*.

Orbiter A spacecraft designed to go into *orbit* around Earth or another *celestial object*.

Payload The cargo that a rocket or shuttle carries into *orbit*, such as an artificial *satellite* or a scientific instrument.

Radar A method of detecting the position and motion of a distant object by using a narrow beam (or pulses) of *radio waves*, which are transmitted to and reflected from the object.

Radio telescope A type of telescope that detects *radio waves* instead of light.

Radiothermal Describes a power source that uses some radioactive material to produce heat, which is then converted into electricity.

Radio wave A form of invisible *electromagnetic radiation*. As well as being used for space communications, radio waves are emitted by various types of *celestial object*.

Re-entry The return of a spacecraft into Earth's *atmosphere*.

Remote-sensing satellite An artificial *satellite* that gathers information about Earth by using a variety of sensors.

Retro-rocket A small rocket engine that is fired opposite to a spacecraft's direction of motion, to reduce the craft's speed.

Rover A type of *lander*, or part of a lander, that is designed to move around on the surface of a planet or moon.

Satellite An object in *orbit* around a more massive object. The planets of the *solar system* are natural satellites of the Sun. Artificial satellites are launched into orbit for purposes of research, observation, or communication.

Simulator A machine that recreates the conditions of spaceflight.

Soft-land A controlled landing of a spacecraft onto the surface of a planet or other solid *celestial object*.

Solar array See *Solar panel*.

Solar panel A surface covered in devices that convert light into electrical energy.

Solar system The Sun and all the objects that orbit the Sun, such as planets and asteroids.

Solar wind A continuous outflow of charged particles radiating from the Sun.

Space probe A spacecraft sent from Earth to explore other parts of the *solar system*.

Star A hot, massive, ball of gas whose energy output is produced by nuclear reactions.

Star tracker A camera system linked to a computer that can help a spacecraft navigate by reference to *star* positions.

Suborbital The path of an object that leaves and then re-enters the *atmosphere* without going into *orbit*.

Supernova The massive explosion of a giant *star* at the end of its life, with release of fantastic amounts of light and other energy.

Thrust A sustained *force* in a particular direction produced by a rocket.

Thruster A small rocket used by spacecraft for maneuvering.

Ultraviolet radiation A form of invisible *electromagnetic radiation*.

Vacuum A region containing no matter. Most of space is a vacuum or a near-vacuum.

Weightlessness A condition in which an astronaut or *cosmonaut* or the contents of a spacecraft seem no longer to be affected by *gravity*, because they are in *free fall*.

X-ray A form of invisible *electromagnetic radiation*. Certain types of high-energy, very hot *celestial objects* emit X-rays.

INDEX

A page number in **bold** refers to the main entry for that subject.

ACKNOWLEDGMENTS

Dorling Kindersley would like to thank Alyson Lacewing for proof-reading; Sue Lightfoot for the index; Jenny Siklós for Americanization; Tony Cutting for DTP support; and ILC Dover Inc. for information on space suits for the Space Shuttle..

Dorling Kindersley Ltd. is not responsible and does not accept liability for the availability or content of any web site other than its own, or for any exposure to offensive, harmful, or inaccurate material that may appear on the Internet. Dorling Kindersley ltd. will have no liability for any damage or loss caused by viruses that may be downloaded as a result of looking at and browsing the web sites that it recommends. Dorling Kindersley downloadable images are the sole copyright of Dorling Kindersley Ltd., and may not be reproduced, stored, or transmitted in any form or by any means for any commercial or profit-related purpose without prior written permission of the copyright owner.

Picture Credits